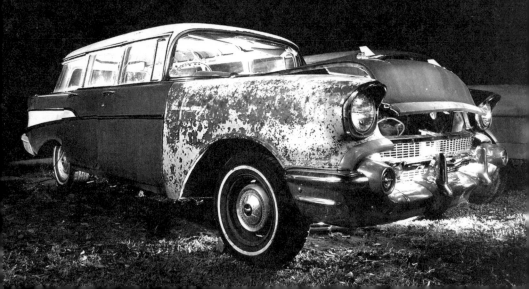

AUTO *Biography*

A CLASSIC CAR, AN OUTLAW MOTORHEA

 itbooks AN IMPRINT OF HARPERCOLLINS*PUBLISHERS*

Biography

57 YEARS OF THE AMERICAN DREAM

EARL SWIFT

AUTO BIOGRAPHY. Copyright © 2014 by Earl Swift. All rights reserved. Printed in the United States of America. No part of this book may be used or reproduced in any manner whatsoever without written permission except in the case of brief quotations embodied in critical articles and reviews. For information address HarperCollins Publishers, 10 East 53rd Street, New York, NY 10022.

HarperCollins books may be purchased for educational, business, or sales promotional use. For information please e-mail the Special Markets Department at SPsales@harpercollins.com.

FIRST EDITION

Designed by Lorie Pagnozzi

Library of Congress Cataloging-in-Publication Data has been applied for.

ISBN 978-0-06-228266-8

14 15 16 17 18 OV/RRD 10 9 8 7 6 5 4 3 2 1

For Mike D'Orso, Fred Kirsch, and Richard C. Bayer

Friends, mentors, champions

CONTENTS

PART 3

Out with the Old

203

PART 4

Pedal to the Metal

263

AUTO *Biography*

PART 1 *Drives Like a Dream*

1

BEHOLD TOMMY ARNEY: six-one, two-forty, biceps big as most men's thighs and displayed to maximum effect in the black wifebeater that is his warm-weather fashion essential. Thick neck. Goatee. Hair trimmed tight on the sides and to a broomlike inch on top, having grown too thin to facilitate the lush mullet he favored for the better part of two decades. Big, calloused mitts roughened by wrench turning and car towing and several hundred applications of blunt-force trauma, of which dozens resulted in his arrest. Self-applied four-dot tattoo on his left wrist, signifying his years as guest of the state. A belly nourished by beer, whiskey, Rumple Minze, and buckets of both haute cuisine and Buffalo chicken wings—of the latter, seventy-two at one sitting—but ameliorated by excellent posture: He leads with his chest, shoulders thrown rearward, daring the world to take a swing at him.

Few scars, considering. Under his right arm is the ghost of a surgery he endured without general anesthesia, its healing compromised when, a few hours after he was wheeled from the OR, he snuck out of the hospital for a beer at a nearby strip club, got into a fight, and reopened the incision in such a manner that he drenched himself, the club, and a neighboring 7-Eleven in blood.

Point of information: He owned the strip club.

On his skull, a dent wrought by repeated blows with a heavy stick of lumber. Two breaks in the bones of his nose. And here and there, faded nicks recalling a melee outside a Norfolk, Virginia, sailor bar,

during which he says he warned away an advancing K-9 cop by hollering, "Don't set that dog on me, or I'll fuck up your dog"—then made good on the threat by clamping his beefy hands around the charging animal's neck, squeezing until it passed out, and beating the cop with his own German shepherd.

Speaking of which: He can be intemperate with the language. He once announced in court that if it were up to him, the opposing counsel would be executed. "I like to fucking cuss," he's said while introducing a buddy, "but this motherfucker, he fucking cusses like a *motherfucker*." He called one municipal attorney on whose good graces he relied a "stupid motherfucking cunt," then, having had time to reconsider, told her, "I'm sorry I called you a stupid motherfucking cunt."

In the twenty years since I first met Tommy Arney, I've heard many labels applied to him. Crazy. Brash. A rough customer. Charming. Funny. Shrewd. A case could be made for any and all of them, to which I'd add: a scholar. He has devoted more than thirty years to study in his field. His expertise is such that people come hundreds of miles to tap it. He is a historian, a curator of memories, a student of America's popular culture in the mid-twentieth century.

Though, admittedly, that is not the first thing most people notice about him.

A FRIDAY IN September 2010 in Moyock, North Carolina, a roadside burg that hugs the Virginia line—tattoo parlors, discount cigarette joints, prefab warehouses, and (hard to miss) Arney's place, Moyock Muscle, a scrubby five acres crowded with roughly four hundred old cars.

Most aren't much to look at. A few restored classics gleam in Moyock Muscle's showroom, which occupies the front half of an oversized Quonset hut on the property's southern edge (Corvette Stingrays, a couple of Chevy coupes from the mid-thirties, a souped-up, blaze-

orange Nova), but the real trade is in "project cars"—beaters, some little more than rust-brown skeletons, sought by motorheads looking to stay busy for a few hundred weekends.

This particular afternoon finds Arney in the showroom office, eating lunch with members of his regular crew. He's known Skinhead, his right-hand man and best friend, for most of his adult life. He hired Victoria Hammond, aka Slick, as an exotic dancer when she was twenty; now thirty-eight, she manages all of his business affairs. Painter Paul not only runs Moyock Muscle when Arney isn't around, he lives next door to him, in a knot of suburban houses the boss owns. The Arney Compound, its occupants call it. What Hyannis Port might be like, were the Kennedys skilled at applying sleeper holds.

Lunch is muted, for Arney and company are exhausted. They've spent the past month trying to whip Moyock Muscle into compliance with the demands of Currituck County, the closest thing to government in this part of Carolina. The county people are displeased that among the first things a southbound traveler sees on crossing into the state is a chaos of derelict cars, some stacked three high. They're unhappy that Arney displays his wares less than twenty feet from state Route 168, in violation of county ordinance. It's their view that the place could use some landscaping—ornamental shrubs and trees, perhaps, or an earthen berm to soften the visual impact of massed Detroit iron going to seed. They also appear to be of the mind that Moyock Muscle isn't a car lot so much as a junkyard. That annoys Arney. That annoys him a great deal.

Not as much, however, as the disrespect he senses whenever he speaks with them. They know next to nothing about him, don't know that he's a scholar, a felon, an elementary school dropout, yet they dare to condescend. At a recent meeting at the county courthouse, Arney became so irritated by a smart-mouthed and slightly built young planning official ("that little teeny fucker," he calls him) that it was all he could do to restrain himself. "Back in my younger days, I'd have

slapped the fuck out of that little prick," he tells his crew between bites, "and I mean *at* the fucking meeting."

For all that, he's tried to abide by the county's wishes, knowing that to do otherwise will invite pain. The crew has pulled a long string of bruising days at the lot, crushing and hauling away cars that Arney forced himself to admit he'd never sell. He's reduced the inventory by three hundred vehicles and arranged the survivors in neat rows. Anyone familiar with the Moyock Muscle of five weeks ago would scarcely recognize the place.

He hasn't got around to everything the county asked him to do, though, and he's out of time to try. He had until today at three o'clock—right about now—and look: In walk two officials from the county planning department, folders of paperwork in hand. Arney, chewing, watches them cross the showroom. One is the man he came close to pounding, the other a slender, bearded young fellow who politely announces they've arrived for a look around. Arney nods and suggests they have that look, then come see him with questions.

He watches them leave. "My original plan was to come down here and walk around the whole place with them," he tells us. "I thought about it and thought about it. Woke up this morning at six twenty thinking about it, and I decided I wouldn't walk around with them, because that's where I'd get aggravated."

"You did right," Skinhead says.

"You don't need to get worked up," Slick agrees. "It's unbelievable, the attitude they have."

"Well, they're young." Arney sighs. "And they've got an education. And they have the authority to be fucking assholes."

The crew is cleaning away the crumbs when the county men return. The bearded fellow notes the improved state of the property but adds, as expected, that much remains to be done: Arney will have to pull the inventory away from the lot's edges and do something about the landscaping. Then he gets to the county's underlying concern: Most of

these cars, he says, look way beyond repair. Too far gone to save. Too far gone to sell. I mean, he says, what are the odds that someone will actually buy some of these wrecks? They're scrap.

"They're project cars," Slick offers.

"Project cars," the planner says. Evidently, the term is new to him.

"Project cars," Slick says again. "People buy cars to fix them up. They don't want them perfect. We get a lot of guys who buy cars to work on with their sons, as a bonding experience."

The county men stare at her. "Here," Arney says, wiping his mouth with a paper napkin and rising to his feet. "Let me educate you young men."

On other days, in other venues, such a sentence leaving his lips might carry a certain menace, for an education at Arney's hands has been known to usher lengthy convalescence. He has stabbed at least two men. He has bitten, chewed, and swallowed a mouthful of neck from a third, and ripped the scrotum from another. And when an associate lied to him once too often, Arney knocked him unconscious and bored twice through his kneecap with a Black & Decker cordless drill. Unsatisfied, he drilled into the top of the man's head. He failed to hole through before the bit snapped.

Today, he simply leads the way outside, into the bright heat of late summer, where, in the company of his sun-chapped bulk, the county men look fresh-scrubbed and pencil-limbed and unnaturally pale. So, for that matter, do I, bringing up the rear. We weave a path through a platoon of aged sedans and hardtops, chrome flashing in the sun, until Arney stops beside a 1970 Chevy Chevelle. "See this car?" he asks. "Just look at it for a minute."

We scan the car. It's rough. Black paint has turned cloudy. Rust has consumed the rocker panels. Chrome peels from the bumpers. A tire is flat.

Arney pops the hood. It opens with a groan. "Not looking good," he announces, and points to an empty space behind the grille. "The battery box is gone. All rusted away." He steps around the car's right

side. "See this?" He runs his hand over what was once the cowl, a narrow steel panel between the hood and windshield. It has decayed to nothing. "There should be a piece of metal here, but it's gone. All turned to shit." The visitors exchange a glance. He seems to be making their case.

Arney leans under the hood, points to the car's wheels. "You shouldn't be able to see those from in here," he says. "The inner wheel wells, both of them—gone. And look at this engine." A piece of plastic sheeting has been laid over the Chevy's big V8 and weighted in place with a foot-long piece of two-by-four. Arney lifts away the makeshift cover to expose a portal into the engine's guts. "Doesn't even fucking have a carburetor," he says. "This is where the carburetor would go, but instead, it's got this." He re-covers the hole and drops the hood.

"So," Arney says, folding his arms over his chest. "How much would you pay for this car? How much do you think this car is worth?" He eyes the county men. They stare back, saying nothing. He gives them a gentle nudge. "Not fucking much, probably."

"Right," the bearded planner says.

"Right," Arney says with a nod. He stands silent for a moment, and I detect the slightest hint of amusement in his eyes. "Well, it might interest you to know," he says, "that just yesterday, I had a man from Connecticut pay me forty-five hundred dollars for this car. Not only did he pay me forty-five hundred dollars, he's paying me another eight-fifty to take it up to him in Connecticut."

Arney pats the car's hood. "See, this is a 1970 *Chevelle*. It's one of the most collectible cars there is. People search the country for this par-ticular car in this condition. That fellow from Connecticut had been looking all over, and when he found this one, he was as happy as he could be. So what you might think is junk, another man's going to see as treasure."

He turns away from the Chevy and with a sweep of his arm takes in the hundreds of beaters that surround us. Within view are a couple of

wasted Plymouths, a dozen old Fords, ancient General Motors models of every stripe. A thrashed American Motors Javelin. A two-tone but faded Studebaker Commander. "The same goes for all of these cars," he says. "Somebody wants every one of them, and they'll be willing to spend some money to get what they want. Because this"—here he stabs at the Chevelle with a thick index finger—"is American history. And the people who buy a car like this understand that."

The tenor of the visit shifts.

LET THE RECORD show that on the day Tommy Arney utters this business about American history, he has not cracked a text devoted to the subject, not once; in fact, Arney says, he has not read any book intended for adult consumers in his fifty-four years of life, and doesn't often pick up a newspaper or magazine, either. He is not illiterate, though he often describes himself that way. But having achieved only a fifth-grade education, and not a particularly high-flying one at that, he's not much of a reader.

He's right, just the same: The cars he sells are fossils of the twentieth-century American experience, of a place and a people utterly devoted to the automobile and changed by it in uncountable ways. He doesn't need a book to tell him so. The evidence is plain on any summer's day, as travelers from Virginia and points farther north stream past on Route 168, bound for the beaches of North Carolina's Outer Banks. One after another peel from the herd and into Moyock Muscle, park among the forebears of their sleek SUVs, sedans, and minivans, spy familiar shapes sugared in rust, and find themselves transported back to moments of great personal import that they shared with cars exactly like the junkers before them—moments softened and dimmed by the years but restored to high relief, if only for seconds, by the smell of a Buick's ancient vinyl, or the style of the numbers on an old Chrysler gauge, or the bulbous, vaguely cheery prow of a '48 Ford pickup.

Many feel compelled to seek him out, to share with him the power contained by the metal, rubber, and glass on his lot. Some can bandy around engine sizes and performance specs, but most don't; they're excited by encountering a long-ago and (so they all say) simpler time in their lives, moved by a remembrance of childhood joys, or clumsy teenage reconnaissance, or critical junctures as lovers, spouses, parents— memories interwoven with, and inseparable from, those of riding in cars, in a car exactly like *this*, behind *this* skinny melamine wheel.

He's witnessed hundreds of these intimate reunions, and has come to understand that as unique as they might feel to the person involved, they vary only so much: What makes Americans who and how we are is in no small measure tied to our status as the most automotive people on the planet. We may have individual experiences while on the road, but one individual experience doesn't stray far from the next; driving is driving. As driving is also close to ubiquitous, Arney's cars are time capsules of not only automotive engineering and design, but Americanism itself. Like he said, they're our history.

Across Moyock Muscle's rust and ruin, over on the property's northern fringe, sits a relic of particular note, a Chevy station wagon languishing under a thick carpet of grime and flaking metal. Even by the standards of its setting, it's in deplorable shape: Its turquoise paint is sun-bleached, salt-pocked, and cracked like a dry lake bed. Its body is dented and creased. Flat tires give it a strong list to port. Its interior is stripped to bare and rotting steel, floorboards chewed away, backseat gone, the headliner's vinyl trim ripped from its moorings and draped like bunting.

The driver's window is shattered, and long exposure to the elements has left two craters in the front seat, each a foot across, one lined with feathers. Gauges are missing from the dash, along with much of the steering wheel. The clock is shattered. A thick, rusty chain snakes into the cabin through rough holes in the floor, an inelegant swap for brackets that once held the transmission in place. Under the hood, the

radiator, battery, and a host of minor components are absent. Even if they weren't, the car wouldn't start. Its engine hasn't turned in years.

That it's a 1957 Chevy, among the most universally beloved models to ever roll off an assembly line, makes its decrepitude all the more obvious, because just about everyone knows how the car *should* look. Chrome-laden front end, bumper and grille united in a gleaming, thick-lipped pout. Bumper guards jutting like tusks from the corners of its wide mouth. Bright, two-tone paint. And a departing flourish: fins, chrome-edged and massive, jutting a foot aft of the tailgate. Sixteen feet, eight inches of Eisenhower-era flash.

As it is, "classic" isn't a label the wagon brings to mind. It seems beyond salvation. A goner. So consumed by rot and rust that it isn't even worth recycling: To look at it, there's little to scrap, let alone save. Except that an invisible asset sets this hulk apart from the other cars in the yard. Unimpressive though it might be in the present, the wagon has a well-documented past.

Unless a car has had just a few owners, or always been held by collectors, such a past is elusive. Most states pitch their motor vehicle records after a handful of years. The typical used-car buyer doesn't long remember the seller's name, and vice versa. Details blur; often, the only reliable givens about a vehicle's past are those of its birth, encrypted in the numbers and letters stamped on its body and engine—figures that say nothing of its journey after leaving the assembly line.

This car, though: Arney acquired this one knowing that it had passed through twelve pairs of hands before his. There was the middle-class boilermaker who bought it fresh from the factory, and that man's veterinarian grandson, and a shipyard worker who took his poodle to the grandson's clinic. Then came a guy who ran a body shop, a fun-loving couple in the outer suburbs, and a struggling single mother. A gay physician and his partner. A pawnshop owner, briefly, followed by a navy sailor; after that, a high school dropout whose father was obsessed with old Chevys, and who'd grown up among

scores of them. Next, a born-again Christian garbageman enamored of anything old. And finally, an electrician and weekend hot-rodder who happened to know both the garbageman and Tommy Arney. Which is to say, a dozen men and women from a dozen walks of life, of varied background and varying means—a cross section of America in the late twentieth century and early twenty-first, all of them players in a single narrative for having sat behind the wheel of this Chevy.

This provenance, as Arney sees it, is central to the car's value, right up there with its beauty, its mechanical merits, its storied place in American culture. He has watched the travelers pull off Route 168 to meet their pasts long enough to understand that the wagon transcends mere transportation, or performance, or design. It tells a story. It *is* a story, that of individual Americans, traces of whom it carries in its blemished skin and worn upholstery—their joy and anguish, hard days and easy, childhood and old age. Each dent and tear recalls a scene, a plot twist.

So it is that the Chevy heads the list of Moyock Muscle heaps that Arney has deemed worthy of rescue. Of all the choices on the lot, it's this one he says he'll next spend tens of thousands of dollars returning to its former glory.

TOMMY ARNEY AND I go back to 1993. We met two nights after Christmas that year at his go-go bar, the Body Shop, to which I ventured as a reporter for the *Virginian-Pilot*, the daily newspaper in Norfolk. Arney had made news of late, having taken Virginia's Alcoholic Beverage Control Board to court over an arcane state regulation that prevented him from serving hard liquor; he could pour beer and wine into his customers all day and night, but for reasons understood only by the ABC, he could not dispense the hard stuff in the presence of a woman's exposed midriff or buttocks, both of which were essential to his business model. So he'd fought the law, the law lost, and I went to the Body Shop that night to talk to him about it.

I stepped into the bar with a mixture of curiosity and trepidation, because all I knew about Arney was that he'd supposedly manhandled a police dog. I'd heard two versions of the tale, both of which painted him as an almost comically fearsome character. One had Arney biting the dog before it could bite him, thereby removing a goodly portion of the creature's ear and compelling it to quit the fight. The other, less specific account had him so demoralizing the animal that it fled for cover under a police SUV. Both versions ended with the German shepherd emotionally crippled and retired from service.

The Arney who waited for me in the bar's perpetual dusk looked as if he could vanquish an entire pack of timber wolves. He could have passed for a pro wrestler. Dark ringlets spilled to his shoulders. We shook hands—his, hard and thorny and enveloping mine—and took up seats at a table near the stage, where a slim blonde in sequined bra and panties was lying on her back and thrusting her hips to the wildly amplified bass beat of an old Culture Club song.

"I love the Body Shop!" Arney yelled over the music. He smiled, cranked back a Michelob Light, and I noted that his wrists were as big around as wine bottles. "I tell that to my girls all the time: 'I looove the Body Shop!'"

Over several hours and beers he explained why he so loved it. Despite what I might think, he told me, the go-go business wasn't about sleaze or sex. It wasn't predatory or immoral. What it was, really, was a safe, nurturing platform for male bonding. "The guys in a go-go bar, they're in there either talking about work or cars. They're not talking, really, about girl stuff," he said. "They'll look up at the runway and enjoy the girl. They'll tip her. But they go back to playing their game of pool, or talking about cars.

"Don't misunderstand me: The guys come in to see the girls. But they come in to see the girls and relax. And as they relax, they talk about things they enjoy talking about.

"Which is cars."

I met the station wagon ten years later. Suffice to say for now that in the course of another newspaper assignment I encountered the Chevy when it was still on the road but in rapid decline, its prospects bleak, and came to know it well. Even so, within a few months the car and I lost touch, much as I'd fallen out of contact with Arney after our first meeting; though I had fond memories of him—of his humor, and the canny intelligence that lurked in his eyes, and his lecture linking Detroit and pole-dancing—and though I kept an ear open for word on what he was up to and how he was faring, we'd exchanged hellos only once in the intervening decade, when I ran into him at a local supermarket.

Then, in 2009—five years after meeting the car and fifteen after meeting Arney—I was reacquainted with both machine and man at once. It happened that Arney knew the wagon, too; what's more, he knew that I knew the car. And he told me that he planned to fix it up. He'd start before the new year—meaning January 1, 2010.

Not long after, I learned that there was another label people hang on Arney with some regularity: distracted. The new year came and went. In March, he vowed that he'd jump on it in April. In April, he told me that he'd probably be starting around Memorial Day. To be fair, in the interim there were urgent demands on his time. For one thing, he was preparing to open a restaurant and bar, a country-western joint called Bootleggers, which involved ripping out the guts of an old store-front and draping its walls with NASCAR memorabilia and murals of Reba McEntire, Brad Paisley, and other country music stars, and hanging the new establishment's name in massive blue neon capital letters over the door. That took time—more than expected, because Arney exchanged heated words with a building inspector over some purported code violations at Bootleggers, causing the inspector to fear for his physical well-being, which riled said inspector's bosses at City Hall and sparked the intervention of lawyers. Come Memorial Day, the car was still slumped in the yard, shedding electrons.

Other distractions have preyed on him in the months since. Arney owns a lot of property besides Moyock Muscle, mostly small commercial buildings in dodgy neighborhoods, which had renters until the recent economic collapse; his mortgage payments now dwarf his income, have erased his savings and shredded his net worth. Plus, there's the gnawing reality of an ongoing FBI probe into his affairs, involving the bank loans he obtained to pay for some of those properties. The bank has tipped into insolvency, a federal grand jury is poring over its records, and Arney is aware that any moment now, the marshals might be at the door.

Not least, he has himself to battle, for Arney doesn't require bona fide distractions to become distracted. He has been hamstrung by a short attention span since his boyhood, has a tendency to dive into a project with great gusto, only to lose interest before—often just before—it's finished. Moyock Muscle and a warehouse he owns across the road are repositories for a couple dozen half-restored cars, and another few that are missing just an odd piece here or there, but which, for whatever reason, he hasn't managed to bring home.

So it defied long odds that in July 2010 Arney used a forklift to pluck the wagon from the weeds of Moyock Muscle's front lot and carry it around back, toward the outbuildings in which Painter Paul plies his craft. Arney slid the forks under the car off-center, so that once eight feet in the air the Chevy teetered, tail-heavy, and looked sure to back-flip onto an old Dodge before a couple of bystanders leaped for the front bumper and held on. That aside, it was an auspicious day. Arney gave the car a close once-over, and while he didn't like all that he saw— so much of the sheet metal was shot that Painter Paul faces months of just cutting and welding—he ducked under the car while it was lifted and declared most of its undercarriage "good as shit." He was eager to start. He said it would happen August 16. Alas, the county started making noise about Moyock Muscle being an eyesore. And here we are. August 16 was a month ago. The car sits.

Arney watches the county men leave, then walks back into the showroom. "I'll tell you what," he tells the crew, "that went pretty fucking well. I feel really fucking good about it. I think those motherfuckers learned something."

"That little dude give you any trouble?" Skinhead asks.

Arney shakes his head. "He didn't say one fucking word."

The crew chuckles.

Okay, Arney says, enough sitting around. A recycling truck is coming by to pick up the catalytic converters they pulled out of the cars they crushed. The devices contain platinum, and there are scores of them—big money. Skinhead and Painter Paul head outside.

Arney follows them out after a while, watches as they load the truck. The wagon squats nearby, dandelions thick around its wheels. Its thirteenth owner glances over its way. The coming months will decide whether the car's story ends here or acquires another chapter. It is up to Arney, the product of a reclamation no less ambitious than that required by the Chevy, a wreck of a boy and disaster of a man transformed by will and restless ambition into what he is today—whatever that might be—to fix it, to scatter it, to let it crumble to dust, or to sell it for scrap.

For the moment, the choice seems clear. "I've got a few things I have to get done," he murmurs. "Won't take long, but it's shit I have to do.

"And after that," he says, "we're going to get to work on that '57."

2

TOMMY ARNEY KNOWS the inventory on the Moyock Muscle lot so well that if you mention any car out there, however hidden by its neighbors, however forlorn or run-of-the-mill, he'll know exactly which car you mean, will muster a near-photographic image in his mind and catalog of its strengths and weaknesses. He knows whether it has an engine and, if so, the particulars of that power plant. He knows whether it was running when he acquired it. He can say what he paid for it, what he's asking for it, and what, if anything, he's been offered for the car in the past. Often, his recollection includes a seldom-seen option or other distinctive feature, the importance of which might elude the layman—such as when I hear him tell a customer several times that a 1973 Chevy Nova on the lot has "factory-tinted windows."

So it is that when a customer asks about a 1956 Mercury, Arney tells him that when he bought that car, the seller cried. Or that he notices, while on the move and from thirty feet away, that a rust-chewed Firebird, partially obscured by other decaying cars in an especially disorganized corner of the lot, is missing its steering wheel—and, on closer inspection, recognizes that an enterprising thief has unbolted one of its bucket seats from the floor, evidently planning a second visit to pick it up. ("Motherfuckers!" he cries. "Some people are just sinful, ain't they?")

And such is the power of his recall that within a few days of the county's visit, as he slumps in the Quonset after hours of crushing cars

in withering heat—his eyes closed, his black wifebeater tawny with salt and windblown dirt, his arms, face, and jeans veneered in grime—and he's approached by a middle-aged fellow about a 1965 Impala Super Sport outside, he can say without opening his eyes, let alone consulting paperwork: Perfect body. Great car. The price is $7,500 firm. Then ask: "You want me to tell you a story about it?"

Sure, the customer says, and Arney comes to life. "You ever heard of a guy named Eddie Card?" he asks. The customer is uncertain. Well, Arney tells him, Card is "about eighty years old, and he's a crazy son of a bitch. He's the craziest son of a bitch there's ever been." Card once owned a transmission repair place in Norfolk, and this car sat in that shop for thirty years—that's why it's in such good shape. Some years ago, Arney adds, he happened by Card's shop and was amazed to see the old man attempting to install a transmission in a 1961 Corvette by himself. It was a heavy transmission, too, with a cast-iron shell, so Arney offered to help. Card declined the offer: "He said, 'Get the fuck away from me, and let me be. I've fucking got it.' I called Skinhead over, and he wouldn't let either of us near the car. Told us to go fucking find something to do." Arney grins. "Crazy as shit. But he installed that transmission."

His head is filled with such trivia, and he keeps it all straight despite the riot of clutter around him—which, arrayed among weeds that in some spots bristle waist-high, includes a half-dozen semi-trailers stuffed with scrap metal; stacks of chrome bumpers, wooden pallets, and warped plywood; many hundreds of worn tires, the majority still mounted to rusted steel wheels; a platoon of broken air compressors; piles of exhaust pipe and mufflers; engine blocks; fenders and hoods; eight lawn mowers, four wheelbarrows, and three shopping carts; a fiberglass septic tank; and an incalculable wealth of bolts, nuts, rods, springs, batteries, and small electric motors.

That doesn't include what's crammed into the seven buildings on the property, or the dominant species of disarray, the vehicles for sale—

heavy trucks, carnival bumper cars, and nearly everything between. A few are grouped according to make or model, but the bulk of the collection is squeezed wherever it will fit—a Corvair wagon between a '56 DeSoto and an Olds convertible, a toothy '49 Buick beside a Datsun roadster, a Lincoln limousine next to a squadron of Cushman meter-maid carts.

Against this crowded backdrop, among so many seldom-seen competitors, the Chevy wagon might easily be overlooked. It is too common a survivor to draw attention like the Buick or the DeSoto, and too ravaged a specimen to excite. But a man who remembers something about every car on the lot was bound to be intrigued by one with a complete resume, especially if it reaches back more than half a century.

The wagon interests Arney on other counts, too, foremost among them that he has a demonstrated weakness for the '57 Chevy—how it looks, how it drives, how it makes him feel. This is not, in itself, remarkable, because of the thousands of automobile models that have rolled off assembly lines since the dawn of the Motor Age, of the hundreds of makes produced just in America, the 1957 Chevrolet is among the handful that, with the mere mention of its name, instantly conjures a mental image among not only car buffs but the mechanically ignorant. If you're over fifty—and certainly if you're over sixty—you can close your eyes and summon its details. Even if you're quite a bit younger, the car serves as visual shorthand. To foreigners, it is a quintessentially American emblem of postwar brashness, of confidence, power, and excitement—and maybe of red, white, and blue excess, too. Show a photo of a '57 to a kid in Punjab or Phuket or Tierra del Fuego, and he'll know he's looking at an American car. A teenager here at home might not know a Honda from a Hyundai, but odds are he'll be able to pick a '57 Chevy from a lineup.

Arney's feelings for the model surpass that general-population love. A neighbor's example was the first car he remembers admiring, as a kid of five or six, and he's owned many himself in the intervening decades;

of the motor pool he commands today, his favorite vehicle is a black '57 two-door into which he's dropped a late-model Corvette engine. A likeness of that very coupe appears on the big Moyock Muscle sign stretched across the Quonset's façade. Arney used to display another of his '57s at the Body Shop—a picture window near the pool tables looked into a garage in which the car sat, polished to a mirror shine and lit like a museum's Renoir. A quick look around his usual haunts reveals a host of lesser clues to his fandom. In his garage at home, he has a videocassette rewinding machine shaped like a '57 Chevy, and framed on the wall is a picture of a '57 hardtop parked outside the Body Shop, painted by a man Arney's younger brother, Billy, knew in the penitentiary. In his home office, a foot-long model of a souped-up '57 occupies a place of honor on the bookshelf behind his desk, and a cassette player shaped like a Chevy's front end sits on a file cabinet. Over the office in the Moyock showroom hang several renderings of the car, painted on metal.

On top of all that, it seems that Arney was foreordained to choose this car to save. He's of the same vintage, for starters: At about the time he was conceived, in the summer of 1955, Chevrolet's designers were putting their finishing touches on the classic-to-be. When he was born, in March 1956, General Motors was preparing its dies and stamping gear for the new car's body panels. At about the point he was taking his first steps, this particular wagon's body—welded into a tough, heavy box, then painted, carpeted, and upholstered—was leaving the Fisher Body works in Cleveland on a train car.

What happened next is narrated by a narrow strip of aluminum riveted to the driver's doorjamb, practically the only piece of metal on the car that still gleams as it did when new. Stamped into the metal is a vehicle identification number, or VIN, a sequence of letters and numbers unique to this Chevy: VB57B239191.

The *V* indicates that the car was equipped with a V8 engine. The first *B* identifies it as part of Chevy's midlevel 210 line, the number 57 its

vintage. The next figure in the sequence, the second *B*, announces that the car was built in Baltimore, where Chevrolet operated a gargantuan assembly plant for seventy years, beginning in 1935. When the wagon's body arrived from Cleveland that summer of 1957, the factory was Baltimore's largest manufacturer, with an assembly line six miles long that spit out a new Chevrolet every minute.

At the plant's "body drop," the Cleveland shell was mated to a frame built in Philadelphia, an engine cast in Michigan, tires manufactured in Ohio. The VIN's final six numbers pinpoint the wagon's place in the production run, and thus, roughly when it came to be—most likely, late in the second week of July.

Its chrome flashing, its two-tone paint bright, the car was rolled from the factory and onto another train, this one bound for Norfolk. Arney's family, until then living in the mountains of North Carolina, moved to the port city at about the same time. His childhood hadn't gone to hell at that early juncture, but that was pretty much foretold, as well. You could look at Arney's family and see trouble coming just as surely as you could decipher the Chevy's VIN.

His mother's people hailed from an isolated pocket of wooded mountainside north of Boone, North Carolina, where the nearest settlement was a place called Meat Camp. There they traded pistol shots and DNA with other tribes of the forest, and bred among themselves, as well, until generations on, when some of them moved down off the mountain, they carried some fairly serious craziness in their blood.

His aunt Ruby, his mother's sister, punctuated many disputes with gunfire, including numerous spats with her husband, whom she winged several times, and with her children, who fired back. One of his uncles was quick on the draw, too, and gravely wounded a man over a jukebox selection. His cousin gutted a man in a knife fight. A sister wounded her husband with a .357 Magnum blast to the chest. And though Arney didn't learn the truth for years, the man whose surname he carries was not his father—his mother had been messing around

with a truck driver, and that fellow, Arney's real father, was accused of a shooting himself.

As for Fern Arney, Tommy's mother—well, she might not have been as crazy as some of her kin. But she was crazy enough.

BACK TO AN earlier point: Car and man are about the same age, and arrived in Norfolk at the same time. While the Arneys settled into an apartment, the wagon was parked a few blocks away, outside Colonial Chevrolet's modernist, glass-walled showroom. Chevy's bow-tie trademark hovered overhead in neon. Painted across the windows was the legend: "1957 Chevrolet—Picture of perfection!"

The dealership occupied the seam between the business district, to the south, and an inner suburb of once-grand mansions carved into apartments during World War II, and slipping into ever-seedier condition since. Much of Norfolk felt and looked as if the war hadn't ended: Sailors from the Norfolk Naval Station, the service's largest base and home to its Atlantic Fleet, prowled the town in loud, beery knots. The harbor bristled with radar masts and shipyard cranes, reeked of bunker fuel and tugboat smoke. Warplanes and helicopters crisscrossed the downtown sky.

Away from the base and the harbor, a vacation getaway waited: Norfolk and its outlying villages boasted twenty-five miles of white-sand beaches, amusement parks, a lovely botanical garden, and some of the best fishing and duck hunting in America. A few courageous up-and-comers were colonizing farmland and forest at the city's edge in new brick ramblers. Still, most of the population, in and out of uniform, was roughhewn, burred, urban—and most important to the salesmen at Colonial, tight with a buck. Norfolkians had a long-standing affection for Chevys, which included the least expensive cars built by General Motors. Trade was brisk.

Chevrolet didn't offer an array of sedans, compacts, and land yachts

in 1957: Besides the Corvette, the company's only model—or what we'd call a model today—was simply called a Chevy; distinctive nameplates such as Impala, Chevelle, and Nova came later. Every Chevy on the lot measured seventy-four inches wide and about two hundred long. All boasted the same 115-inch wheelbase. Most shared a heavy, rectangular steel frame, suspension, steering gear, windshield, dashboard, and instrument array. Coming or going, they were difficult to tell apart: Their front ends were identical, as were most of their tails.

But within its single model, the Chevy assumed a great many forms. The '57 came as a two-door or four-door sedan; a two-door or four-door hardtop; a two-door or four-door, six-passenger wagon; a four-door, nine-passenger wagon; a two-door delivery wagon; a sporty and expensive two-door "Nomad" wagon; and a convertible. A buyer's decisions were just beginning, because within those styles he had to choose among three of what we nowadays call trim levels: the economical 150, with a bare-bones interior, a single color of body paint, and little chrome decoration on its flanks; the midline 210, with nicer seats and interior decoration, a little more chrome bling, and two-tone paint; and the Bel Air, the all-luxe version, with aluminum trim on its flanks, golden accents, and far greater cachet.

Whatever he picked, the buyer of 1957 got a good-looking machine, perhaps the best-looking in American history, though that wasn't the consensus at the time. The Chevy was not greeted as an instant classic. Its sales set no records; in fact, 1957 Fords outsold it, the first time that had happened since the Depression. Its reception from the automotive press, though positive, now reads as oddly detached; reporters ranked it neither above nor below competitors long since forgotten by pretty much everyone.

Under its skin, the car differed little from the Chevys of 1955 and 1956, and the innovations that it did offer failed to excite the buying public in the manner its creators had hoped. Its optional fuel injection, the first offered on an American production car, was expensive

and balky, and most buyers gave it a pass. An optional three-speed automatic transmission proved less sturdy and reliable than the cheaper two-speed automatic it was expected to replace. A new, optional 283-cubic-inch engine, rebored from an existing Chevy motor, was a very big deal, indeed—it was destined to be a Chevrolet mainstay for the next decade and beyond—but few recognized that at the time.

So what did the car have going for it? In a word, *optimism.* The Chevy was a fusion of disparate parts that somehow not only worked well together, they gave the car an aura of fun, of happily nosing into the future. And in 1957, that future was airborne: Slotted into its curving hood were a pair of mock gunsights rendered in chrome, among the car's many nods to military aviation. Its taillights mimicked jet exhausts. Its instruments were clustered in a dash that evoked a plane's cockpit. Its fins resembled the tail of a Cold War fighter.

Slipping behind the wheel, the buyer of 1957 joined the Jet Age.

THE WAGON HAD not been on display for long when its first owner appeared on Colonial's lot. He was a curious piece of casting, for Nicholas Carl Thornhill was not a Jet Age sort of fellow. Bald, paunchy, and sixty years old, he was neither an easy mark for advertising, nor a man much concerned about fashion or his own image, nor someone who'd buy a flashy new set of wheels just for the sake of having them. He'd put off buying a new car for years: Thornhill was a conservative spender, and handy enough with tools to keep his home machinery running long past its prime. One day that fall, however, Thornhill decided that his needs were no longer met by his aging Chevy sedan. It was time.

So with his son Bruce, and his grandson, Bruce Jr., Thornhill left his home in Portsmouth, Virginia, for the twenty-minute drive to the dealership. On the way they passed the bustling naval shipyard where Thornhill had worked for twenty-seven years. They rolled past down-

town department stores busy with shoppers and through a tunnel under a river, the Elizabeth, that separated Portsmouth from Norfolk and formed part of the largest natural anchorage on the East Coast. They drove by the marquees of one movie palace after another in downtown Norfolk, and among the girlie shows and beer joints aimed at sailors on liberty.

On the lot, Thornhill narrowed his search to a wagon; an avid gardener, he wanted room for his plants, soil, and tools. He chose a vehicle from the middle of the lineup, a 210 Townsman six-passenger wagon with an all-vinyl interior and a V8 under the hood. It was gorgeous. Its paint gleamed; most of its body was swathed in a deep turquoise that Chevrolet called "Highland Green," and its roof in a "Surf Green" so pale that at a distance, it looked white, among the best-looking combinations Chevy offered. Its chrome winked and flashed.

The base sticker price was $2,456. Thornhill paid cash, and plunked down extra for a heater and an AM tube radio. His son drove the old Chevy home. Nicholas and his grandson took the wagon. It was a car on its maiden voyage, its glass spotless, its tires fresh. It was sure to turn heads.

As he made that drive, Thornhill occupied a remarkable vantage point on modern American history: He had witnessed the rise of the automobile from plaything of the rich to household essential in a scant few years, then evolve to reshape the nation's cities, redefine its notions of time and distance, remake its every habit—where people lived, where they worked, what they ate, what they did in their spare time. No invention had so quickly gone from incarnation to societal dominance as had the automobile in the United States.

Born in 1897, Thornhill was four years younger than the first gasoline-powered American car, the Duryea Motor Wagon, and four years older than the world's first mass-produced model, the curved-dash Oldsmobile. He was six by the time anyone drove coast to coast, and seven when the first practical headlight made motoring an all-day

affair. He was well into his teens when the electric starter heralded the end of hand-cranking and the advent of female drivers, and had been around for a quarter century when fully enclosed cars made motoring comfortable in all kinds of weather.

And as powerful, wealthy, and tentacled as General Motors was in 1957, Thornhill was eleven years older than the company, and fourteen older than its bestselling brand.

Folks in rural Alabama, where Nicholas Thornhill grew up, had long been marooned on their properties by mud and the slow pace of their horses and wagons, and like farmers across America seized on the horseless carriage. The young Thornhill watched as motoring exploded, partly because Henry Ford introduced the rugged, cheap, and easily maintained Model T, and partly thanks to William C. Durant, the grandson of a Michigan governor and a man with a gift for hustle and horse-trading: Durant bought a foundering car company, Buick, and combined it with later purchases—Oldsmobile, Cadillac, and Oakland—under a single corporate umbrella. He called the outfit General Motors.

Its expansion was so breakneck that GM soon developed a nasty cash-flow problem. Alarmed, his backers deposed Durant and assumed control of the business. Durant responded by creating new car companies, one of them named for his partner—a famous French race-car driver of the day, Louis Chevrolet. Chevys were such a success that in 1915 he was able to regain control of GM, before losing it for good after World War I.

His replacement was a man with no experience running a car company; Alfred P. Sloan Jr. had spent his working life making roller bearings. But he had a head for marketing, and it was plain to Sloan that GM was competing against itself. Though Cadillac was established as the company's luxury brand, all of its other divisions were pitching to the same customers. His solution was to refashion the brands into a hierarchy based on price. At the bottom was Chevy, aimed at the

young buyer, the blue-collar worker, and the conservative; it would be a car for the everyman who might otherwise opt for Ford's Model T. One rung up the price ladder was Oldsmobile, its cheapest offering a touch more expensive than the top Chevrolet; another step up was Oakland, later renamed Pontiac, its prices only marginally higher than Oldsmobile's; then Buick and, retaining its place at the top of the line, Cadillac. GM's 1926 annual report boasted that it built "a car for every purse and purpose." When Nicholas Thornhill walked into Colonial Chevrolet, carving the market remained fundamental to GM's corporate strategy, and Chevy was firmly established as the company's all-American car for the all-American masses.

In 1931, one of Sloan's engineers had an epiphany while measuring the cars in GM's stable: The dimensions of some models differed by next to nothing, yet each division engineered its wares independent of the others, in some cases turning out virtual duplicates—and spending a lot of unnecessary time, effort, and money in the process. Why not economize, the engineer suggested, by producing a few body cores that would be shared among all GM cars, and to which each division would then add its own unique grilles, fenders, hoods, and rear ends?

Sloan seized on the idea and streamlined production to four sizes of car—the smallest, designated the "A" body, was shared by Chevrolets and small Pontiacs, the "B" by big Pontiacs and small Oldsmobiles and Buicks, and so on. Strip away its upholstery and carpeting, its chrome and wires and moving parts, and the steel box formed by a Chevy's roof, floor, and pillars was the same used in the low-end Pontiac.

The line's shared bones went undetected by most buyers, thanks to the company's efforts to give each division its own signature style. In 1935 it introduced the "Silver Streak," a fluted chrome stripe running up the middle of a Pontiac's grille, over its hood, and down its trunk; the streak was Pontiac's trademark for twenty-three years. Forties Buicks acquired vertical grilles and a line of portholes down their front quarters, three on low-end trim levels, four on the ritzier Road-

master. Oldsmobiles had wide, elliptical mouths, chrome rockets on their hoods, and small taillights that rode high on their rears.

Cars might change from year to year—actually, they never failed to do so from the late forties into the seventies—but the styling cues carried over. The only GM brand that lacked them was Chevrolet, for which the corporate bosses thought identifying gewgaws unnecessary; everyone knew what the most popular car in the world looked like. Often, Chevy models borrowed inspiration from the other divisions.

And so the '57 came to boast a front end that in its proportions and celebration of chrome struck the automotive press as surprisingly upscale for a car of the masses, that bore more than a passing resemblance to the year's small Cadillac. For the price of a Chevy, one got the body of a Pontiac and high-end looks—a car both humble enough to be within the reach of the working-class stiff and stylish enough to advertise his respectability, perhaps even modest prosperity. To announce that he was bound for the great middle class, if not already there. That he *belonged*.

It also made the low-end car a heck of a buy. That, more than fighterplane trim, might have spurred the wagon's first owner to open his wallet. Nicholas Thornhill knew a good value when he saw one.

FIFTY-THREE YEARS LATER, Earl Thomas Arney is sitting in his four-door, dual-axle Ford F350, about as big as a truck can get and still be considered a pickup—at more than twenty feet long and nearly eight wide, too massive to squeeze into most parking spaces, and a seemingly impossible chore to parallel park. It's four feet longer than the '57 wagon.

He's halted the behemoth on a narrow Norfolk street ten minutes from Colonial Chevrolet—or where the dealership used to be, before it joined its customers out in the suburbs—in front of a tumbledown bungalow in the middle of its block. We're on a driving tour of Arney's

childhood, he and I, and this is the building he most considers his boyhood home.

"Years after we lived here, I came back, and I asked the people who were in the house if I could look around," he says from behind the wheel, his tone contemplative. "I thought that being in that house, seeing it again or walking through it, would help me understand what happened to me, and why things happened the way they did." He sighs. "Thought it would help me find myself, help make me a better person."

"Did it?"

He grunts, shakes his head. "Fuck, no."

The family's move to the city was an act of desperation. Fred Arney, Tommy's legal father, had been unable to calm Fern's appetite for other men in Lenoir, the furniture factory town in the Blue Ridge foothills of western Carolina where they'd both been raised. He'd go to sea with the navy and Fern would be pregnant when he returned, and simple math dictated that he wasn't responsible; Tommy was Fern's fourth child by at least the third man. During one of his deployments, she even moved herself and the kids in with a local truck driver, Earl Thomas Green, who'd sired Tommy and for whom the boy was named. When the Arneys decamped for Norfolk, Fern was pregnant again, this time with twins, their father the same Mr. Green.

The family lived in a succession of rentals before settling in the shack we now examine from the truck. Everything about the place seems undersized: It can't be more than twenty feet wide, and its porch is too shallow to offer protection from the rain. The front yard is a tiny strip of crabgrass and bald earth. Fred Arney enclosed a back porch to create an extra bedroom, but even so, the quarters were tight: He, Fern, and six kids shared a single bathroom and eight hundred square feet of living space.

Over the front door hangs a wooden bald eagle, head turned to the left, wings spread wide, sheathed in the same tired white paint as the house. I ask Arney if he remembers it. He shakes his head, then stops.

"Wait a minute," he whispers. "Wait a fucking minute. Fred Arney nailed that son of a bitch up there. I can picture him doing that." We stare at the eagle in silence for a long moment. "Shit. I didn't remember that until right now, sitting here," Arney says. "If I had remembered, I'd have stole the motherfucker."

The house's current occupant has been peering at us from inside the front door. He steps out now, an unkempt, hillbilly-looking old-timer, and hollers at us to get the truck away from his driveway, that we're blocking it. In truth, the driveway is just a strip of rutted grass alongside the house, but Arney smiles and waves an apology, and eases the giant Ford down the street.

He has fond memories of Fred Arney, who he says woke every day smiling. Others in the family don't remember him so rosily, but most agree that the sailor chose to overlook the fact that he shared no blood with his brood. Arney recalls Fred giving him hugs and silver half dollars, and having a sense that he was looked after. The navy kept calling Fred away for months at a stretch, though, and during each, Fern would stray.

What she lacked in looks—she was a short, stout woman, with blunt features and the dark complexion of her Cherokee heritage—she evidently made up for in recklessness. The kids knew that if their mother wasn't home, they'd likely find her drinking with strange men in a bar up the street.

Arney points out the place as we roll past. "We'd go in and try to get her to come home," he says. "She wouldn't come."

Instead, she'd tell them to get lost, often using one of her pet names for them: "little motherfuckers."

3

LUNCH AT MOYOCK Muscle typically comes late. Painter Paul Kitchens, summoned to the midday meal in a 3:30 P.M. call from Tommy Arney, steps from the sweltering haze of the body shop, an all-metal prefab shed on a concrete pad that has baked all day under a cloudless Carolina sky, and into an afternoon at least fifteen degrees cooler but warm and sticky nonetheless. He passes within a few yards of the '57 Chevy wagon as he makes a turn from the shed's mouth, which faces north, and onto a southward path worn smooth by his work boots. This is within days of the county's visit. The wagon hasn't been touched.

The path takes him past a wayworn horse trailer that shields prying eyes from the weeds Painter Paul favors for taking a leak—the body shop and a neighboring paint shed lacking a functional toilet—then through a break in a six-foot chain-link fence that separates the shop area from the sales floor, as it were, and around and among several dozen cars that block the way to the Quonset.

Paul is forty-one, but comes across as younger. His face, nearly as wide as it is tall, is predisposed to crinkly smiles that reveal several chipped or broken incisors, creating the aura of a kid waiting for his permanent teeth to come in—an impression reinforced by his hair, cut to a quarter-inch burr, and his voice, which is high-pitched and becomes more so when he's excited or angry. Shirtless, encased in a paste of sweat and silicone dust, he has almost reached the Quonset—and air-conditioning—when he's intercepted by a couple of clean-cut

college boys from Virginia Beach, asking about the price of an old Buick a ways across the lot.

Painter Paul asks whether they saw a price on the windshield. Well, maybe, one says—they saw the number "4,000," but weren't sure whether that was the price. Yes, Paul tells him, that's the price, and if you want a different one, you'll have to talk to the boss. He steps into the building.

Arney trudges in a minute later, crusted with some of the dirt he's kicked up while crushing cars with an excavator. "Couple fellows out there interested in buying that '70 Buick," Paul tells him. The two fellows in question enter the Quonset as he speaks.

"They can do that," Arney replies quietly. "They can do it if they give me four thousand dollars." He falls into his chair and stares, whipped, at his bagged lunch, which Slick delivered minutes ago from the kitchen at Bootleggers. The prospective buyers loiter among the showroom's Corvettes, then venture a few feet closer. "So," he says, not looking their way, "you want to buy a car?"

They approach the counter. Yes, says the taller of the two, an olive-skinned kid, early twenties. The Buick out there. "I'll sell it to you for four thousand dollars," Arney says. He unfolds the top of his lunch bag, reaches inside, extracts a Styrofoam to-go box.

"Four thousand?" the kid says.

"Yeah," Arney says. "I bought it from an old man's son. He said it was running when we parked it. That's about all I can tell you about it."

"Oh," the kid says, nodding. "What's wrong with it—does it run rough, or something?"

Arney opens the box, digs in the bag for a plastic fork. "I have no idea," he replies. "I don't know anything but what I just told you."

The kid nods again. "Can we test-drive it?" he asks. "It runs, right?"

Arney stabs his fork into a catfish fillet. "Are you listening?" he says. "Pay attention. I bought it from this old man. I parked it over there. I haven't done anything with it."

The kid visibly gulps. "When did you park it—like, two days ago?"

Arney snorts. "No," he murmurs, "I parked it a long time ago." He looks up from his meal. "Why? Did you come by here two days ago and it wasn't here?"

"Well, no," the kid says.

"Because I was going to say, you must have been asleep."

"No," says the kid. "I was just wondering." He glances at his companion, scans the showroom, stares down at his feet, and works up the fortitude to return his eyes to Arney. "So you haven't looked at it?"

Arney has just taken a bite, and chews for a while before answering. "What I do is, I buy cars from people," he says. "I park 'em on the lot, and if somebody happens by and wants to buy 'em, I sell 'em to them, as a project car. You follow me?" If he kept every car on the lot in running shape, "I wouldn't sleep," he says. "I only get four hours of sleep a night as it is." He shoots a glance at Painter Paul, who affirms the statement with a quiet "That's right."

"Now," Arney says, turning toward the kid, "what I *could* do is, if you pay me four thousand dollars for that car, I'll get it running for you."

"You could do that?" The kid sounds surprised and pleased.

"I'd be happy to do that," Arney says.

"How much would it cost?"

Arney gazes at the ceiling. "Oh, two or three hundred dollars," he guesses.

The kid looks at his wingman, says: "That'd be cool." The second kid nods.

"Bring me some money," Arney suggests. "You bring me four thousand dollars, and I will drop everything and get that car ready for you."

They leave. Arney watches them go. "Think they'll be back?" I ask him.

"I doubt it." He turns his attention back to his catfish. "I think we've probably seen the last of those motherfuckers."

It's the answer I expect. The two aren't ready for an old car—you

could hear in their questions that they don't have the first clue how to buy, let alone operate, a piece of machinery close to twice their age. They need reliable daily transportation, not a project.

"But what the fuck," Arney adds. "I could be wrong." He peers at me, shrugs. "Maybe they fucking *will* come back."

Here's the thing: They might come back because a lot of people, probably most people, don't use their heads when they buy a car. Not, at least, to the degree that they should—the degree that would save them money, produce a purchase that answers their needs, and block the psychological static that accompanies buying a car but contributes nothing to an intelligent choice.

More often than not, we pick our cars with our hearts—not for their utility, or their economy, or their reliability, or their safety, but for the way they look and how good we'll look behind the wheel, and the effect this visual combination of driver and car will have on others, especially of the opposite sex. For what they say about the size of our wallets, our position in the social hierarchy, or our manliness. For how they smell and how they sound. For how they make us feel: for the way a stomp on the accelerator throws us back against our seats, for the rush that comes when they lunge forward from a stop, for the exhilaration that climbs, along with g's, on taking a curve at high speed. All of which is germane to what makes driving fun but doesn't have a thing to do with what makes a car good for us.

Still, those are the things that sell. Those are the measures we use to judge automotive worth. We go into thousands of dollars of debt to make purchases that, in a great many cases, are rationally indefensible. We buy the cars we want, not the cars we need.

This is central not only to Arney's enterprise, but that of every auto dealership in the country, not to mention the corporations that build the cars they sell; if we didn't buy with our hearts, there'd be no reason to consider a '70 Buick, or any other vehicle that didn't move us without fuss from one place to another. We'd seek no more horsepower

than was absolutely necessary. We wouldn't require monster stereos, built-in DVD players, or heated seats. We'd all be driving Honda Fits.

Not just Fits—*used* Fits, because everyone knows there's no good reason to buy a new car, as 14.5 million Americans did in 2012. It loses value faster than virtually any other investment.

My own purchasing history illustrates our collective car-buying folly. My first car was a 1973 Mazda RX-2, a sedan of Japanese quality, practical size, reasonable safety, none of which moved me. What did? Under the hood lurked an early and imperfect version of Mazda's powerful rotary engine, which shot the car like a rocket. Alas, it proved an unwisely exotic choice for a flat-broke college student—I blew the engine's seals three times in a year. I replaced it with a new 1978 Fiat sedan. Not only did it drop in value as I left the showroom, but being a 1978 Fiat, it was poised to drop its drivetrain as well. I knew it was reputed to be a dog, but saw only its clean lines, its lovely metallic paint, and its modernist dashboard, and I delighted in its seats, which were big and cushy and well bolstered. After three years, those seats were about the only parts that worked.

Next up was a used MG Midget, a microscopic British two-seat roadster—again, a car of legendary unreliability, which I knew, and knew full well. It didn't matter. I loved its looks. I loved its mock-leather cockpit. I loved the idea of driving, and being seen driving, such a car. As it happened, I got lucky: Its engine didn't seize until two weeks after I sold it to a friend, who didn't talk to me much after that.

My instincts for self-preservation were slow to mature. I now bought an aging Triumph TR4, another English sports car. Crazed with lust for its tailfins and knockoff wire wheels and sonic growl—for every little thing about it—I gave its innards just a cursory once-over before stroking a check for what soon proved a grand mal automotive and financial disaster.

Lust. Lust was my undoing in these early transactions. When in time I wised up, and chose cars better suited to my means and needs, I

found that I no longer felt the same brand of all-consuming hunger that my sexier, ill-fated purchases had inspired. Perhaps my Hondas and Toyotas have lacked the whiff of danger, the long-shot gamble, necessary for such heady emotion. But I can't claim to have felt none at all, because every car I've bought has inspired some level of lust in me.

The same is true of just about every American, for car ownership passes through several predictable stages, not unlike those of a doomed marriage. You buy a new car after a showroom courtship and tantalizing foreplay, consumed with an all-be-damned yearning for its curves, its smooth and supple surfaces, that sweet, responsive ride. Its eagerness to perform. Its smell. This lust yields, over time, to a love that blends the romantic and parental: You show off your car, luxuriate in its company, treat it with care and respect, protect it from harm. Eventually, love fades to a companionable reliance; your car becomes a trusted friend, and your relationship, almost self-sustaining—gone is any expectation that it'll turn heads or grace you with a particular prestige, as well as any that you'll indulge it with your past fervor.

Years may pass before this contented dependence is shaken, but in time it'll happen. The car's mechanical heart will falter, its metal will fatigue, and your old friend will surprise and inconvenience you—in little ways at first, with tiny gaffes that multiply in number and bound in cost until you feel doubt with every turn of the key, a pang of anxiety whenever you punch the gas to pass a truck, a wave of despair as your mechanic swipes your credit card.

For the vast majority of cars, this fourth stage is terminal: From here, they're bound for the crusher. A statistically insignificant few, however, are rescued from oblivion by their stature as classics, curiosities, or heirlooms. They enter a fifth stage, as objects of a renewed desire—a more scholarly yearning, this time around, its heat tempered by the responsibility and expense of antique ownership. And a scant few will, over time, transcend appreciation to become objects of worship—such an obsessive love one finds among the most devoted collectors of vintage wines, antiquarian books, and the ephemera of fame and infamy.

If you buy a used car, you'll experience the early stages, though they're going to be somewhat compressed. Lust may be fleeting. Love may last a day or two, rather than months or years. You may be cursing your new purchase before you've exhausted its first tank of gas. A safe general rule, I think, is that the older and more traveled the car you buy, the faster you'll pass through the first three stages and reach the fourth, heartache, and its substages—those being doubt, disappointment, and disgust.

IT'S A SAFE bet that Nicholas Thornhill had experienced the first three stages of ownership when he decided to replace his decade-old Chevy sedan. Chances are, he had not moved far into the fourth, if he reached it at all, for he opted to keep his old car, rather than trade it in—and he was a man who knew his way around machinery, and would have known when to junk a beater.

Likewise, it's probably safe to assume that he felt some measure of lust for the '57 wagon. Granted, it would have been a quiet sort of lust—very, very quiet—because this was a man of few needs, simple pleasures, and a humble past. Thornhill was the last of thirteen children born to George Duke Thornhill and Katherine Teresa Cassidy, who married in Xenia, Ohio, in 1877. George's people had owned a sawmill, and were counted among Xenia's better Protestant families. Katy May, as his wife was known, was a Catholic; on the union, the Thornhill elders arranged for the couple to relocate, willingly or otherwise, to a farm near Athens, in northern Alabama. They sent along two train cars of housewares and furniture to soften the newlyweds' landing.

The pair farmed for several years, their labors augmented by their growing brood of children. By the time Nicholas came along, twenty years into the marriage, the Thornhills had entrusted care of the crops to tenants whose shacks were sprinkled around their spread, and George had gone to work for the Louisville & Nashville Railroad—the

L&N, or "Old Reliable," which maintained a huge shop complex and switching yard a few miles to the south in Decatur. In time, Nicholas joined his father there, as did most of his seven brothers. They were part of an industry that snaked its way into American life to a much greater degree than railroading does today, for in Thornhill's youth, any long-distance travel in the United States was by train. Few rural roads were "improved" in any manner, and next to none were paved in the modern sense. At best, a lane in the open country might have a macadam surface—several layers of broken stone, in rare cases bound with a sprinkling of asphalt; at worst, it was a rough, rutted path of ungraded dirt that with the first hint of a shower turned into a bog that would suck the shoes off a horse. Early motorists—the smart ones, anyway—left home prepared for breakdowns and flat tires, but their foremost challenge wasn't mechanical. It was mud.

By his late teens, Thornhill was a welder and a boilermaker for the L&N, skilled enough at metalwork that the railroad sent him far afield to tend to company projects. He had grown into a compact, handsome young man, with thick dark hair and full lips, a ready smile, and a droll sense of humor, and when, on an assignment to Springfield, Missouri, he met an athletic beauty named Alma Violet Arnold, sparks flew.

They married in Springfield, moved to Alabama, and before long Alma was pregnant. Their first child, Polly, was born in 1918, while Nicholas was away in the navy. After the Armistice they settled into a white frame house, a two-story place with a wraparound porch and a few gingerbread touches, shaded by pines and maples, and had another couple of kids—Jack, who arrived in 1923, and Bruce, two years later. Nicholas discovered a passion for gardening, and planted a vegetable patch beside the house that he tended with the children's help between shifts at the rail yard. They kept a cow and Alma raised chickens, hatching their eggs in an incubator. So in 1928, when the L&N announced it was shuttering its Decatur shops and Nicholas found himself without a job, the family was largely self-sufficient, at least in terms

of food. And when the Depression settled on northern Alabama and many went hungry, the Thornhills shared eggs with their neighbors and enjoyed homegrown luxuries: On hot summer days, Alma would rinse out the cotton bags in which the chicken feed was packaged, slip them over watermelons that Nicholas had grown, and lower them into the well out back to cool.

Eventually, searching for work, Thornhill drove his Model T north to Tidewater, Virginia, a knot of cities at the mouth of the Chesapeake Bay that he'd come to know during his brief stint in uniform. The region's economy was dominated by the business of waging war: The naval station in Norfolk, home to an armada of ships and the first naval airplanes, was the most obvious component of the biggest concentration of military might in the world. Huge coastal guns jutted from the dunes of Virginia Beach. Army bombers flew overhead from Langley Field, among the country's earliest air bases. The Norfolk Naval Shipyard, actually in Portsmouth, across the Elizabeth River from its namesake city, had built and repaired warships since before the American Revolution. Newport News Shipbuilding and Drydock, across the harbor, turned out America's heaviest battleships and cruisers, and was preparing to build the world's first purpose-built aircraft carrier.

The naval shipyard was hiring. Thornhill claimed a job as a boilermaker, started work at once, and Alma and the children moved north the following year. They settled in Newtown, a dense neighborhood of blue-collar shipwrights just outside the yard's gates.

Bruce, the youngest, was the first of the kids to marry and move out, before he'd even turned seventeen. He didn't go far: He took a job at the shipyard, too, and he and his new wife, a high school classmate, set up house just around the corner. Within days, the Japanese bombed Pearl Harbor, and work at the yard exploded. An army of laborers was imported to meet the demand for men-of-war. Uniformed sailors descended on Portsmouth by the thousands.

Across the water, Norfolk underwent an even more dramatic trans-

formation, from sleepy southern port to command post for the fight against Nazi Germany. Long convoys of Liberty ships steamed from its harbor, decks packed with men and arms. The city's population more than tripled. Cheap housing, thrown up seemingly overnight, crowded the land around the naval station and shouldered aside summer rentals lining the Chesapeake Bay beachfront. And there was no avoiding sailors, not in the world's biggest navy port. They spilled into town in hordes to hunt down relief from the boredom and fear of life under way, and the good times they sought, and often found, put them at odds with the locals: They picked fights with civilians and each other, passed out drunk in front yards, cussed and threw up on the streetcars, wolf-whistled at high school girls. One downtown row of old storefronts got so rowdy with beer, strippers, and fistfights that it was billed as the wickedest street in the country. A wartime yarn held that a disgusted homeowner posted a sign on his lawn reading: "Dogs and Sailors Keep Off the Grass." Whether the sign really existed is sketchy, but the story was treated as fact by navy men, and encouraged a nickname sailors knew Norfolk by for the rest of the century: Shit City.

When the fighting ended and the fleet returned, Tidewater, like the rest of the United States, was squeezed by a desperate housing shortage. In answer, new homes sprang up in both Norfolk and Portsmouth in dense clots of cheap "two-and-ones"—two-bedroom, one-bath, look-alike frame cottages on tiny lots. They were Spartan and dark by today's standards, but they were just the ticket for returning GIs. War had crammed a generation of American men into foxholes and barracks and steel hulls, had stripped them of privacy and any say in their own fates, had forced them to wallow in their own blood and filth and stink for days, weeks, sometimes months at a time. Now the nation's veterans craved a lifestyle that refuted the hardships they'd endured, those long years of noise and chaos, death and fear, and, not least, of living practically on top of each other. They sought order, quiet, and

control over their surroundings. More than anything, they wanted elbow room.

And so cookie-cutter neighborhoods bloomed, the prices of their houses kept within a recent sailor or soldier's reach by cheap land and assembly-line construction of the sort that had turned out B-25s, tanks, and Liberty ships. Hitting the market at the same time were the first postwar American cars. Sales were off the charts.

The Korean conflict came and went, and the Thornhills witnessed their city again transformed. Out beyond the two-and-ones on Portsmouth's ragged edges, swamp and slash pine now vanished under tracts of new houses that looked nothing like those that had come before. They had big windows and three or more bedrooms and multiple bathrooms and all-electric kitchens, and they were set back from sinuously curved streets on lots that dwarfed those closer to the city. Many included an additional room for the family car.

Midwifed by the explosion in auto ownership, Portsmouth and America at large had a new middle-class ideal—which was reinforced in the daily papers Thornhill read, with their splashy ads for split-level floor plans, electric ranges and dishwashers, lawn mowers and swing sets. Magazine advertisements peddled products and subtexts: One, ostensibly for Texaco gasoline, showed a posse of mischievous Dalmatian puppies snatching steaks and wieners from a backyard grill; another, for Pendleton, pictured a well-groomed young homeowner in a flannel shirt barbecuing kebabs. Gleem toothpaste pushed images of families gathered on suburban patios. No matter the product, no matter the pitch, cozying up to suburbia's clean, wholesome, and stressless image seemed a good idea.

No dummies, Chevrolet and other automakers got into the act, positioning their cars as part and parcel of the town and country lifestyle. Thornhill may have already been mulling his upcoming purchase when, in January 1957, an ad in *BusinessWeek* boasted about the Chevy's power. "That new V8 in the '57 Chevrolet is as quiet as a con-

tented cat and as smooth as cream," its copy read. "And it's cat-quick in response when you ask for action!" The accompanying image wasn't of a Chevy chewing up the road, but of a modernist suburban house with two cars in the driveway, a Corvette and a Bel Air Sports Coupe. Standing beside them was a clean-cut dad, child in his arms, listening to the Bel Air's engine.

The reputed idyll just out of town was even more overtly championed on TV. The same autumn that Thornhill bought the Chevy, *Leave It to Beaver* debuted on CBS with a famously idealistic take on the adventures of a wide-eyed prepubescent boy of the white suburbs. The crises that Theodore "Beaver" Cleaver faced were low-grade, but the settings in which he managed them were amazing: Beaver's house was substantial, its furnishings quietly stylish, its every room—including the kids' bedrooms—purged of so much as a micron of dust. School presented mild crushes, no humiliations, no terrors. The surrounding neighborhood was a quilt work of baseball diamonds, weedless yards, and woods free of animal or human predators. Beaver's mom, boarding school and state college alumna June, wore pumps, pearls, and dressy frocks while vacuuming; his dad, the wise and judicious Ward, was a successful white-collar professional who wore crisp dress shirts and tightly knotted neckties seventeen hours a day, drank oceans of coffee, drove a late-model car (he was among those who picked a '57 Ford Fairlane over that year's Chevy), and rarely lost his temper—and when he did, he didn't raise his voice.

Pretty as this picture was, it seemed a riotous mess next to the placid harmony of *The Adventures of Ozzie and Harriet*, airing over on ABC. The "adventures" of the suburban Nelsons—father Ozzie, mother Harriet, and polite sons David and Ricky—included hours spent discussing articles in the evening paper, engaging in light, loving banter, and attending dances, concerts, and circuses together. Each of their evenings featured "a fine, big dinner." Ozzie, his source of income vague but clearly ample, was put together even while tinkering in the

garage; in one episode, he mowed the lawn while wearing a tie, a smart cardigan, and black oxfords. Like Ward Cleaver, he never raised his voice; on the contrary, he was mild, self-effacing, a touch uncertain. Harriet stayed busy at the local women's club, and by darning socks, cooking in her knotty-pine kitchen, and gently giving her husband the business. The boys were never inconvenienced or embarrassed by their parents, let alone consumed with self-hatred or rage.

See, for example, the "Road Race" episode, which aired on January 8, 1958, shortly after Thornhill bought the wagon: Ricky's pal pulls into the Nelson driveway in a hot rod he's built with the help of specialty shops "downtown," prompting Ozzie to ruminate on how kids of his day needed no such help—they could put together a car with "just a hammer and a pair of pliers." Ricky offers a counterargument in the form of a question: "Well, don't you think the modern cars are better, Pop?" Ozzie replies that he supposes so, as "everything improves," but adds that "under certain conditions, I'm not sure the old cars couldn't hold their own with the modern hot rod."

The exchange leads to an inevitable showdown—a race pitting youngsters in the hot rod against Ozzie and Harriet, piloting an open clunker from the twenties that Ozzie has restored to running shape in a scant few hours, without special tools or getting himself mussed. The race ends with no losers—it's a dead heat—and with everyone having learned something or other and sharing a good laugh.

At best, this rendering of fifties America was incomplete; at worst, it came across as a cruel joke. Just on the ride home from the dealership, Thornhill and his grandson passed drugstores, restaurants, and movie houses where blacks could not sit with whites, and buses whose black riders had to yield their seats on demand, and schools that the races did not share. They drove among century-old wooden tenements, some without indoor plumbing, occupied almost exclusively by blacks. They traveled a divided city, no different from most cities in America, north or south. Little Rock, Arkansas, was in turmoil over school integration

just then; President Eisenhower sent the 101st Airborne into the city days before *Leave It to Beaver* premiered.

Real life didn't much resemble the TV fantasy for most whites in Portsmouth, either, the Thornhills among them. Nicholas wasn't much for lounging around the house in a necktie. Newtown wasn't an antiseptic subdivision of neat lawns and modern ranchers; its simple, worn cottages looked onto a grid of straight, narrow streets in the shade of the yard's massive cranes and the haze-gray masts of ships in the ways.

Real life was messy. Real life was complicated and heartbreaking and loud. Nothing on TV or in the picture-perfect suburbia of advertising spoke to Thornhill's experiences. His second child, Jack, struggled with a speech impediment and learning disabilities, and lived with Thornhill for all of the older man's life. And there was the family's central tragedy: Not long after arriving in Portsmouth, a year behind Nicholas, Alma learned that he'd been carrying on with a woman who lived a few streets over. The *Portsmouth Star* of February 7, 1933, reported what happened next:

> Police were called to her residence around 3:30 yesterday morning, about which time police believe she shot herself in a second-floor bedroom.
>
> E. T. Glover, city coroner, following an examination declared the case unquestionably a suicide. He said Mrs. Thornhill was suffering from a nervous disorder and committed the act while in an extremely high-strung frame of mind.

At thirty-five, Thornhill found himself the sole parent of three confused and angry children. They blamed him for their mother's death, felt lost in a big city they didn't yet know, struggled with a sense of isolation that persisted for years. Beaver's problems were small, indeed.

Seventeen years after Alma's death, long after the kids were grown, Thornhill did remarry, his bride a two-time widow from Windsor,

North Carolina, named Mary Drew Early. She, too, lived in Newtown, a short stroll from the Thornhill place. He and Jack moved into her house.

But the TV ideal again made itself scarce: One of Mary's brothers lived in the house and she had four children, besides, and the marriage suffered, Thornhill's daughter would later conclude, from "too much family on both sides." Mary abandoned the household two years in. Thornhill and Jack moved into another house in Newtown, then to a cottage out on Portsmouth's western edge, just shy of where the city gave way to truck farms. He wasn't yet divorced, but Thornhill had not shared a home with Mary for more than five years when he decided to buy a new car.

IF THE THORNHILLS fell short of the cultural ideal, the Arneys, crowded into their tiny shotgun shack three miles away in Norfolk, shredded it. When Tommy was six or seven, Fred Arney returned from a sea voyage to find that his wife had invited another man to move in with her and the kids—one Robert Larry Strickland, five years her junior, whom she'd met, per habit, at a nearby bar. Fred recognized that the long-running charade was over. The couple divorced.

The new man of the house made a pittance as a laborer for a tent company, though he was unreliable about showing up for work; most months, the family subsisted on Fred Arney's child support checks. Alcohol figured prominently in its nightly rituals. Arguments were loud and often violent, and Strickland settled many with his fists. In one of their disagreements, Fern suffered a cerebral hemorrhage and spent a month in a coma. Strickland told the authorities that she'd suffered a fall. Tommy told them that Strickland had slammed her head against a radiator in the bathroom. Whatever the case, Fern was a different person when she regained consciousness—jittery, forever chewing her nails, easily exhausted. Still, the fighting continued. She and Strickland each had the other arrested on a regular basis.

Against this backdrop of discord and neglect, Tommy ran wild.

At his most innocent, he and his kid brother, Billy, trespassed onto the neighbors' boat piers to cannonball into a shallow, foul-smelling branch of Norfolk's Lafayette River, or stole empty Coke and Pepsi bottles from back porches to trade for pocket change at a drugstore down the block. As they grew older—Tommy being eight or nine— they took to sneaking into the garage of a motorhead neighbor to steal his tools. They'd wait a bit, then knock on his front door and sell the tools back to him for a buck or two. The neighbor played along, even when they ripped him off several times a day.

Some of Tommy's antics weren't so innocent. Consumed with hatred for Strickland and rage over his mother's refusal to leave the man, her willingness to forgive the beatings she took from him, and worse, her willingness to forgive the abuse he meted out to her children, Tommy sought relief, and briefly found it, by assaulting kids in the neighborhood. His blossoming penchant for violence saw him expelled from the fourth and fifth grades and forced to repeat both. At twelve he had a rap sheet.

In time a Norfolk judge, weary of seeing his mother and Strickland before the bench, suggested they both faced jail if they didn't clear out of town. They listened. Leaving behind Tommy's three older siblings— brothers Johnny and Mike and sister Freda—Fern, Strickland, and the household's three remaining children packed up and drove south. They turned up at Strickland's mother's place in Tarboro, North Carolina, in the wee hours, hung around for a few days, then pushed on to nearby Rocky Mount. And there Tommy's life, already hard by any fair measure, got worse.

The five moved into a dilapidated frame shack lacking hot water and scattered with a few pieces of battered furniture and a rented TV. It stood, paint peeling, roof drooping, in the shadow of Rocky Mount's bus station, where Tommy hit up traveling servicemen for spare change. He and Billy roamed the streets late on school nights. They were caught trying to extort money from a classmate by threatening to

tell his mother they'd seen him smoke. They showed up to class filthy and half dressed.

And the change of setting had no effect on the violence between the home's adults. "One day [Strickland] was choking her against the kitchen door, and I couldn't stop him," Arney tells me. "I ran out into the back yard where there was a '55 Ford that wasn't running, and I grabbed a lug wrench out of it and ran back inside and swung that lug wrench just as hard as I could into his right knee. He screamed and let go of my mom, and I could tell from his scream that I'd hurt him bad."

It was Tommy's introduction to the value of good tools.

TOMMY RAN. HE lived under an overpass for three days, during which Billy and his twin, Debbie, stole out of the house to sneak him food and sit with him. Eventually, a classmate of Tommy's came by the hiding place with his father, brother, and uncle; they took him home with them, and petitioned the court for temporary custody of the boy. Tommy liked the family, felt safe in his new surroundings, and even the situation at home promised to improve: In April 1969, a month after Tommy turned thirteen, county officials opened a child neglect case against his parents.

But the intervention failed to save him. At school, another classmate "would pick on this one girl every day," he tells me. "Before the teacher would come into the classroom in the morning, he would pick at her and make everybody in the class laugh at her." As he remembers it, he called the kid into the coatroom and told him to stop. The kid laughed, said, Don't worry about it. Tommy replied: I *am* going to worry about it.

The kid didn't know that his challenger had been fighting a grown man at home for years. He took a swing, missed, and Tommy hit him hard. He did it again. Again. At about that point, a few punches into the fight, he lost track of where he was, what he was doing, entered a sort of trance; conscious thought ceased. Then he heard his name be-

ing called, looked over his shoulder, and his teacher was standing there along with the principal and both were screaming for him to stop.

The school expelled him. Principal Corinne Pitt described the assault as "without any provocation" on a form documenting his dismissal, adding: "At the time his facial expression was one of blankness and unawareness of what he was doing to the child. He was quite unconcerned about injuring the child and seemed unable to realize the danger of what he had done." His behavior was "so very unpredictable," she wrote, "that I do not believe it is safe for us to keep him any longer."

Then, in a letter to a judge weighing the boy's fate, Pitt added a remarkable plea on his behalf: "Tom Arney presents a pathetic picture—a child torn from within with self doubts and a great deal of insecurity—a child unable to understand the realities of his everyday life in any manner which will help him cope with his many overwhelming problems. He is the result of an environmental background which has seemed to give him a feeling of defeat and defiance.

"He needs professional help more desperately than any child I have ever worked with," she wrote. "I do not believe he will be able to maintain any balance of normal life unless such help can be secured for him—a special type of help which is not too easily available.

"With the right kind of help, I believe Tom can overcome many aberrations of personality and behavior he now exhibits. Without help Tom's life will be far more pathetic, meaningless, and unstable than it is now.

"At the present time," she warned, "Tom is a child without a chance."

4

NICHOLAS THORNHILL, FRUMPY boilermaker, was an unwitting trendsetter as he drove his new wagon across Portsmouth to his modest cottage. Behind the wheel, he looked the embodiment of the suburban lifestyle that had, in large part, eluded him.

Witness a TV ad for the '57 Chevy wagon: Dad, mom, and three kids of the ideal suburban family race around a tidy and well-appointed home, amassing a pile of suitcases as they ready for a trip. "But where on earth do you suppose they'll put all that luggage?" a cheerful male narrator asks over an orchestral rendition of the Chevy theme song—"See the USA in Your Chevrolet," a jingle so catchy that in the fifties it became singer Dinah Shore's signature number. The camera cuts to the driveway. "Ah, here's the answer—a new Chevrolet family-engineered station wagon!"

We close in on a Bel Air wagon, rear hatch opened to reveal the car's cavernous cargo hold. "Just look at the room for luggage, even with all the seats in use!" the voice-over cries, as bag after bag materializes in the space—suitcases, makeup case, hatbox, eleven pieces in all. Cut to three adorable white children sleeping side by side. "With the backseat folded down, there's even more room," the narrator says, "with a special family convenience for long trips—or even the drive-in."

The baby boom was on: 4.3 million Americans were born in 1957; the country's women each bore a lifetime average of 3.7 children. Station wagons were a boon to suddenly mushrooming families. In 1953

they'd represented only 5 percent of total U.S. car production; four years later, they accounted for 13 percent. As *Popular Science* observed: "Where the perambulator rolleth and the power mower hummeth, the station wagon cometh." Only Cadillac, Lincoln, Imperial, and Nash-Hudson didn't include wagons in their lines.

Of all the Chevy styles, the company's station wagons were among the most coveted. The descendants of taxicabs especially designed for transporting luggage-laden travelers to and from railroad depots—hence their name—they were status symbols, the SUVs of their day, priced substantially higher than identically equipped sedans and the subject of admiring press attention. And they sold not only to suburban households but to urban apartment dwellers who aspired to the got-it-made lifestyle they advertised. "It could be," *BusinessWeek* guessed, "that the wagons, in addition to their great utility, now appeal strongly to style-conscious buyers." *Popular Science* compared them to mink stoles as "a symbol of opulence," explaining: "As a sop to man's vanity, the wagon is unsurpassed. Parked at the country club or the supermarket, it lends social status to the owner."

Like its competition, Chevy constantly updated its offerings to the buying public. Every three years its cars were reinvented from the tires up, reengineered inside and out—new chassis, new suspensions, new bodies. The year following these major changeovers, the company's "A" body core, the box it shared with small Pontiacs, would be unchanged; its front and rear ends would be tweaked, their sheet metal reshaped, taillights swapped out, grille reconsidered. In the third year, the core would be left alone, the stem and stern again edited. The year after that, the cycle would start anew.

The aim was to excite automotive America's yen for the right now, and to instill disaffection in the country's drivers for whatever cars they owned, no matter how recent their purchases: Get them to buy this year's model, then immediately brand that model yesterday's news, and get them champing for the next. "Our big job is to hasten obsoles-

cence," GM design chief Harley Earl observed in the mid-fifties. "In 1934, the average car ownership was a span of five years. Now it's two years. When it is one year, we will have a perfect score."

It fell on Earl, more than anyone else at GM, to effect this "dynamic obsolescence," as he termed it. The '57 Chevy's new engine notwithstanding, the mechanical innards of the company's cars usually didn't change much from year to year—GM's engineering was conservative, its bosses content to let others take the risks associated with new technology. So it was styling that usually sold Chevrolets and the rest of the GM line. "If you go by a school yard and the kids don't whistle," Earl was known to say, "back to the drawing board."

"Mistearl," as his workers called him, brought a style to GM that went beyond sheet metal. Athletic, always deeply tanned, the six-foot-four designer favored bespoke pastel suits, bright shirts and ties, two-tone shoes, and the company of celebrities. He knew a lot of them—he'd crafted custom car bodies for Mary Pickford, Roscoe "Fatty" Arbuckle, and dozens of other Hollywood luminaries before moving to Detroit.

His people knew to stay true to a handful of principles Earl espoused with evangelical intensity. Every finished GM car should be recognizable as the product of a specific year, and of General Motors, and of its division: A Pontiac should look like a Pontiac, a Buick like a Buick, and both like children of the same corporate parent. Every GM car should hint that it shared blood with the previous year's model, but clearly improve the breed. Finally, it should be handsome, damn handsome—enough that drivers of previous model years would want it on sight.

He ascribed to a few more precepts on how his stylists might achieve this. A car's front end—its headlights, grille, bumper—was especially important to its looks: "The face," he told his people, "it's all in the face." He encouraged them to take risks, to shove aside tradition. "Go all the way," he advised, "then back off."

And there was Earl's most cherished tenet, summarized in three words: longer, lower, wider. "My primary purpose for twenty-eight years has been to lengthen and lower the American automobile, at times in reality and always in appearance," he explained in 1954. "Why? Because my sense of proportion tells me that oblongs are more attractive than squares, just as a ranch house is more attractive than a square, three-story, flat-roofed house or a greyhound is more graceful than an English bulldog."

His first GM offering, the LaSalle of 1927, had been celebrated not only for its clean lines, two-tone paint, and sensuously curved fenders, but because it stood inches lower than the competition, and Earl had never stopped whacking at the height of GM's cars. The company's sedans stood an average six feet tall in 1930. The '57 Chevy was a full foot shorter.

By the mid-fifties, Earl rode herd on a staff of 650, split among separate studios for each of the five divisions. He was a tough boss, prone to temper tantrums and profane outbursts and sky-high expectations. Junior designers often put in eighty hours a week at the studio, knowing that Earl was nonetheless likely to fire them for the slightest error—or, for that matter, no reason at all: He fired designers he didn't like. He fired those he didn't consider manly. He fired one, reputedly, because he didn't like the way the man walked. He fired some at least once a year, sometimes for just minutes; Earl was known to dispatch assistants after a just-canned man to beg him back.

Still, Earl's presence made for a dynamic, always interesting workplace. GM wasn't much accustomed to executives who burst into its suites wearing jodhpurs and riding boots, or spouting a blend of high fashion and the gutter. The best of the designs he oversaw reflected his flamboyance. The first "concept car," the convertible Buick "Y Job" of 1938, featured hideaway headlights, push-button door latches, and the industry's first electric windows, and barely reached Earl's hip. Its smooth-bodied styling would be a template for the GM cars of just

after World War II. Another concept car, the Corvette—the company's answer to the British two-seat roadsters winning allegiance among American drivers, particularly veterans—blew away auto show audiences in January 1953. So did the Corvette's station wagon spinoff, a two-door, low-slung beauty with a fluted roof, which in modified form became the Chevy Nomad of 1955.

Behind each new design lurked a keen understanding of human behavior. Earl strove to create machines that inspired wonder and projected an image, one that a motorist assumed—or that onlookers ascribed to him—when he took the wheel. A Pontiac was youthful and sporty; so, too, was the driver who owned one. A Cadillac had to inflame the desires of the buyer who could afford it, while creating a hunger in everyone else for the station in life that would permit such a purchase. And all the company's cars had to constantly produce new takes on the images it sought to convey, year after year. Motorists could never be left to enjoy their wheels for long. They had to have something new thrust under their noses, to feel the ache of dissatisfaction, to mull an upgrade—and ultimately, to keep the machinery of dynamic obsolescence churning.

The strategy dovetailed with the life expectancy of cars built in the fifties, for they didn't age well. Bodies rusted through in a handful of years. Tires wore out at fifteen thousand miles. Though his owner's manual opened with the boast that Thornhill's wagon was "the newest and finest Chevrolet ever built—designed to serve you faithfully and economically for many thousands of miles," flipping through its pages revealed that the machine's running gear was really quite delicate.

It had to be broken in. "It is recommended that your speed for the first 500 miles be confined to a maximum of 60 MPH," the manual read, "but do not drive for extended periods at any one constant speed, either slow or fast"—a precaution that would "assure proper 'mating' of all moving parts in the engine, transmission and rear axle." It had to be warmed up before one stomped on the gas; what's more, its optional

push-button radio had to be warmed up before stations could be pre-set. And it required a wearying amount of maintenance: The manual recommended that Thornhill check the battery every two weeks, flush the radiator in spring and fall, change the oil and air filter every two thousand miles, take it to the dealer for a full tune-up every five thousand, and once a month (or every thousand miles) lube the chassis, turn the distributor lubricant cap, fill the distributor hinge cap oiler, and top off the fluids in the transmission, rear axle, radiator, brake master cylinder, and steering gearbox.

This was a distant ancestor of the modern car, from another age altogether. In 1957, much of the country relied on telephone party lines. The polio vaccine was just two years old, the transistor radio three. The first commercial computers, slow and stupid next to the weakest modern PCs, cost millions of today's dollars and occupied entire rooms. And the only way to Europe for most travelers was aboard a ship. The fastest, the SS *United States*, flagship of the U.S. merchant fleet, took four days to travel from New York to Southampton, England.

How primitive was the Chevy? Here's how: It had as much in common with the first spindly, tiller-steered horseless carriages as it has with the computer-controlled autos of today. If you were to draw an automotive timeline beginning with the first wheezy buggies and ending with the 2014 model year, you'd find the '57 Chevy near the midpoint not only in time, but in technology.

For all of his efforts, Thornhill's warranty from Chevrolet covered him for a measly ninety days or four thousand miles, whichever came first. So, looking to protect his investment, Thornhill built a garage in his backyard and parked the wagon inside. From the little house he and son Jack shared west of town, the shipyard was a twenty-minute commute, a trip he made in the Chevy every day; in his off hours he took meticulous care of the car, keeping it clean, staying true to the laborious maintenance schedule.

The Chevy became central to a host of family memories: Sunday

drives with the windows down to escape the summer heat. Trips out of the city on which Thornhill would point out grazing black cattle to his granddaughter, Janet, and tell her they made chocolate milk. Years passed. Thornhill retired. The city morphed around him. A new web of superhighways inched its way into town, bridging the rivers that had divided the region from its earliest days. Newtown was bulldozed. A white exodus emptied central Portsmouth. Norfolk razed its downtown slums, only to lose its downtown shoppers; at night, the city center lacked only tumbleweeds to perfect the lonesome ambiance of a spaghetti western. Vietnam, an old French problem when Thornhill bought the Chevy, became the region's principal business.

When Bruce Jr. left home for veterinary school in the fall of 1965, it was in the wagon. Thornhill and Bruce Sr. twice drove him down to the University of Georgia, his gear piled in the cargo hold. In the spring of 1967, Janet, about to graduate from high school, applied for a spot on the majorette squad at North Carolina's Elon College, and Thornhill drove her and her mom to the tryouts in the wagon.

He was slowing down by then. He'd long before lost most of his hair; now the fringe turned silver. Thornhill devoted himself to the huge garden he planted behind his house and to entertaining his grandchildren. His fried chicken gained small renown. Visitors usually headed straight for the kitchen.

When he entered the hospital in October 1972, Nicholas Thornhill was that most unorthodox of Chevy owners: He'd held on to the wagon, a car designed for brief service, for fifteen years. By that time, a great many of the 1.56 million Chevys churned out in 1957 had vanished from the road. Most 210 Townsman wagons, of which 127,803 had been produced, were relegated to the scrap heap.

Thornhill's feelings for the car had passed from lust into love, and by all accounts had never left this second stage of ownership: He'd doted on his Chevy, treated it as a cowboy might his trusted steed, as a mechanical spouse, throughout his time with it. When he died, at

seventy-five, the car was still in fine shape. It passed to his grandson, Bruce Thornhill Jr.

IN NORTH CAROLINA, Edgecombe County officials were wary of letting thirteen-year-old Tommy Arney mix with other children in the juvenile center, so the boy was held in the county jail until he was summoned to court. His foster family elected not to take him back; the judge asked Tommy whether he wanted to go home. As he remembers it, he replied that he wanted nothing to do with Strickland. Even as he said it, he was sure he'd be back in the house before the day was through—that his mother would claim him, would choose her own child over a mooching lout.

Had he read the papers associated with his case, he might not have been so confident. His mother and Strickland had complained to the county two weeks before the classroom attack that Tommy had been a troublemaker for years, that he was rough and fresh-mouthed and violent and hell-bent on getting his way, that he was seemingly immune to punishment and a bad influence on his younger brother and sister. That he was "impossible," as a May 1969 county summary reported, and that they hoped he'd "be removed from the home permanently."

Tommy's half brother, Johnny Coggins—the product of Fern's teenage first marriage, and six years Tommy's senior—testified that Tommy was nothing but trouble, that he was "mentally sick," and that he'd made up the stories about Strickland beating the kids and braining Fern against the radiator. Tommy's younger siblings, the twins Billy and Debbie, told the county that he acted as he pleased and rebelled when he failed to get what he wanted.

About the only kind word for Tommy came from Pauline Davis, Fern's sister, still living back in Lenoir, who urged that the county take all the children from the home—and those children by now included a new daughter, a toddler named Lisa for whom Debbie, herself only

eleven, provided most of the care. Tommy's aunt "said that her sister's marriage to Mr. Strickland has had a very degrading effect on her and that Mrs. Strickland has become less competent as a parent since the brain hemorrhage," a county official reported. "Mrs. Davis reported Mr. Strickland to be a drinker, loafer, and leech. His influence is such on Mrs. Strickland that she has lost concern for her children except in that they receive support money from Mr. Arney which is not used for the children." Aunt Pauline also reported that Tommy was "the only child in the family brave enough to report the true situation."

That might have worked against the boy. When the judge asked whether she wanted Tommy back, Fern Arney replied that the state could keep him.

Two days after his court hearing, now a ward of the Edgecombe County Department of Social Services, Tommy was shipped to the state's Juvenile Evaluation Center in Swannanoa, a mountain burg east of Asheville. A combination of penal institution and mental health facility, the center assigned social workers and doctors to evaluate the boy and plot a course for his salvation.

At first, his behavior was angelic, at least by the standards of his past: "Upon his arrival at the Reception Unit Thomas began a very earnest effort at trying to adjust," reported a staff "Social Diagnosis." He "exhibited no overt manifestations of the explosive, 'seizure' type episodes which directly led to his commitment. He was tractable and presented only occasional disciplinary problems."

But he also gave his keepers reason to think that he might have some demons hiding behind that good citizenship. He reminded them of "a dormant volcano which is rumbling deep within and can explode at most any time." They saw that he was expending "an unusual amount of energy in trying to suppress his hostile urges." And as time passed, those urges got the better of him. His eruptions, combined with his "tumultuous history" and a battery of tests, led the center's doctors to conclude that he might be epileptic. An electroencephalogram pro-

duced an abnormal record, "consistent with a convulsive disorder of deep level origin."

With that, doctors prescribed him medication for epilepsy, and one psychiatrist—who, according to Tommy's medical records, "had problems himself"—told him flat out that he was crazy. State officials later judged that diagnosis "wrong and harsh," but not before it had powerful "effects upon Thomas," causing him "to be distrustful of psychologists and psychiatrists." It's almost needless to add that it did nothing to cool his temper.

After several months, Tommy was moved to Cherry Hospital in Goldsboro for further study and examination. He didn't settle down— to the contrary, he says he organized and led a mass breakout of the hospital's juvenile charges. After eight weeks, in June 1970, he was transferred to the C. A. Dillon Youth Development Center in Butner, a half hour north of the state capital at Raleigh. The word "Butner" alone spells trouble to Carolinians, who know the town's chief industry is wrangling criminals: The feds maintain a vast complex of prisons there, the state a penitentiary and an array of treatment centers. It's a place that errant kids are taught to fear—keep it up, a Tar Heel parent might say, and you're bound for Butner.

In his first six months at C. A. Dillon, Tommy got into a lot of fights ("His peer relations have not been good," his minders observed) and consequently spoke with a lot of counselors. In one such conversation, the handler brought up the coatroom attack back in Rocky Mount. Tommy could remember the fight in fine detail, an impossible feat for an epileptic. The medicine stopped at once. "Behavioral improvement was seen following this," a Dillon official reported.

Indeed, a November 1970 evaluation found him to be well-groomed, mannerly, respectful, engaged, open to supervision, and a hard and willing worker. "Thomas has improved very much in the last two months," his examiner wrote. "He realizes what it takes to grow up and be a responsible young man. Thomas has learned a lot from

C. A. Dillon School. He has benefit[ted] very much from the program." He still needed to check his temper, the official wrote, but concluded: "Thomas would make someone a good son to raise."

State and county officials judged him ready for a foster home, and began casting about for one. Months passed. No one seemed willing to take a chance on a now-fourteen-year-old boy with a history of violence. Dillon staff began to worry that Tommy would backslide, and his own recollection is that his behavior did worsen, with a vengeance—that he got into constant fights, had regular sex with the girls with whom he was locked up, and engineered an overnight escape on which a farmer shot him in the leg. He guesses that his record was sanitized to boost his prospects for adoption, because none of this mayhem shows up in the state paperwork I've seen; instead, biweekly reports chronicle his continued good behavior through the spring and summer of 1971. The edgiest document from the period was a psychological evaluation, conducted that February, that judged him "brash, restless, and impatient," and his tone "challenging."

"He worked quickly and carelessly, and several times he broke off to pace around the room," the psychologist wrote of Tommy's approach to an IQ test on which he scored 96, at the low end of average. "He could probably do better if he were able to settle down and concentrate. He accepted the challenge of some items and on these achieved at slightly higher level. On other items, which frustrated him, he scattered the test pieces angrily and gave up well before the time limits had expired."

Tommy had a sizable capacity for "reckless, impulsive, and aggressive behavior," the psychologist wrote, because he felt "rejected, abandoned, and betrayed, and despairs of foster parents being found for him." He had no interest in school, he told the doctor: "The thing he wants most is to pump gas at a service station."

That August, a break came Tommy's way. Dillon officials landed him a spot at the Kennedy Memorial Home, a sprawling Baptist orphanage near Kinston, away to the southeast on the Carolina coastal plain.

But in place of deliverance, he found confusion there—in the home's strange and strict rules, in the cloying warmth of his house parents, and especially in school: Kennedy enrolled him in the eighth grade at a public junior high, and Tommy sensed immediately that he was in over his head. He hadn't been in a classroom on a regular basis since fifth grade, back in Rocky Mount, and hadn't finished that. He read and wrote with the competence of a small child.

About a month in, a teacher called on him to read a passage aloud. He told her that he'd prefer that she call on someone else, to which she countered that he could read the passage or go to the principal's office. He walked out of the classroom. Early the next morning, he walked out of the Kennedy Home.

He hitchhiked north to Durham, and the home of a C. A. Dillon counselor with whom he'd been close. The counselor and his family took him in for the night, and he spent much of the next day there, too, discussing his situation. Kennedy Home records say that he "reached out to this family in the hope that they would make a home for him," and that when he realized it was not to be, decided to keep running: He convinced the counselor he was headed back to the orphanage, and instead boarded a bus for Norfolk.

Three years had passed since Fern and Strickland had taken half the family south to Rocky Mount. Tommy had not spoken since to the other half, his three older siblings, and had no idea whether they were still in town. He knew someone who might be able to tell him, however: an older woman who'd lived a few doors down from the family. When he arrived at Norfolk's bus terminal late at night, he asked the clerk at the ticket kiosk to look up her number. The clerk replied that she was busy, handed him a phone book, and suggested he look it up himself. "Ma'am," he told her, "I don't know how."

She looked up the number. The neighbor, groggy with sleep, said she remembered him ("Where on earth have you *been*?") and that she still saw his older brother Mike now and then: Mike's girlfriend lived

just up the street, and he was over there quite a bit. She paid for a cab to carry Tommy over, fed him a meal, and pointed the way to the girl-friend's house.

From the sidewalk he could see Mike, five years his senior, sitting in the front room. Tommy watched him through the screen door for a while, excited and scared, then climbed to the porch and knocked. He heard his brother mutter, "Who the fuck is that?"

"How you doing?" he said from the door. "My name is Tom."

That's what he called himself at the time, rather than Tommy. Not because he liked the way it sounded, but because he could spell it.

5

THIRTY-NINE YEARS AFTER his homecoming, Tommy Arney coasts his big red pickup down Norfolk's Colley Avenue, a few blocks from the shack where he lived as a boy. The balance of his teens unfolded along this stretch of road, among its small storefronts, restaurants, and apartment houses; every building, every lot, holds significance. He stops the truck at Forty-Second Street, nods to a corner where a Sunoco service station once stood.

"That's where I lived when I got back to Norfolk from the orphanage," he tells me. Mike Arney, happy and somewhat bewildered to see him, first cleared a space for his younger brother in his rented room, a few blocks up Colley. Within days, the landlord judged that to be one Arney too many on the premises, so Mike arranged with a friend who managed the Sunoco for Tommy to sleep in the station after hours, first in its compressor room, among bathroom supplies and cases of motor oil, and later in the women's restroom, which had its own entrance around back.

Tommy spent months there, slipping out each dawn to go to work for a roofing company, meeting his older brother each evening for what was often his only meal of the day, then sneaking back into the bathroom. He lost the roofing job when his bosses learned he was underage. He lost his next job at a sheet metal company the same way.

Eventually, the cops caught up with him—he was a truant, on top of an escapee—and tossed him in the local juvenile detention home.

Arney figures he was turned in by his mother, who'd returned to Norfolk with Strickland while he was at the orphanage. At the least, she notified the authorities that he was in town: "I don't want him to get in trouble and I don't want to get in trouble over him being here," she wrote to the Kennedy Home. "He don't stay with me he just stays any where he can, with his brothers. He won't go to school."

Tommy again relied on Mike to get him out of trouble, and again, Mike came through: He was friendly with a two-fisted, gun-toting old Irishman who owned a waterfront pub next door to the Sunoco, and he convinced Jim O'Neil to take custody of the boy and put him up in his Virginia Beach town house. In return, O'Neil would get a worker he could pay next to nothing.

Brokering the arrangement was a Norfolk lawyer named William L. Taliaferro (a surname that dates back centuries in Virginia, and which in the Tidewater is pronounced "Tolliver"), a former merchant seaman who'd recently passed the state bar exam after graduating from law school at Memphis State. He was fifteen years older than Tommy, and was destined to become almost a father figure to him—a mentor, advisor, and trusted confidant, as well as his attorney in scores of criminal and civil matters.

So at sixteen Tommy went to work at the Shamrock Inn, first as a dishwasher and janitor, eventually moving up to cook. It was an austere existence: He was on the clock every day from early morning into the wee hours for twenty dollars a week, plus meals and a bed, and O'Neil, his almost constant company, was a hard-edged character with few kinds words for him. But it marked an improvement, and a significant one, over his life on the street—and, for that matter, his life before that. And it was probably just what the boy needed, because Tommy learned to cook, a skill that was to prove vital to him later in life, and because O'Neil worked him so long and so hard that he had little opportunity to get into trouble.

In retrospect, that last part might have been of most service to

Tommy. Because when, after sixteen months, he could take no more of O'Neil or the job and quit for another as helper in an auto body shop—a post he held only briefly, and which was followed by a succession of likewise brief stints shoveling coal, assisting plumbers, running a pizza joint, and rebuilding automotive starters and generators at an electric shop—he found the time to find trouble, and for trouble to find him.

By way of example, Arney steps on the gas, aims the pickup north on Colley, pulls into a church parking lot. Across the street is a gas station that's been converted to a Jazzercise studio. Next to it is a small frame building that once housed a bar called the Coach House, one of his mother's old haunts. "I was out here one night, and I see this guy slap a girl outside the Coach House," he tells me. "So I say, 'Why'd you fucking slap her?' And he says: 'It's none of your fucking business.' And I say, 'You don't think so? You hit her again, motherfucker, and we'll see if it's my business.'

"The guy and girl split up. The girl goes over beside the Coach House, and she's crouched down, crying. The guy goes over to a phone booth at the Esso. I check on the girl, ask if she's okay. She says she is, that he's calling a ride for her. So then I walk over to the phone booth." He points out a square of discolored concrete at the edge of the parking lot. "I punched him in the head while he was in the phone booth, then I snatched him out and beat the fuck out of him." He shakes his head. "I was a fighting motherfucker."

He was that. Most of his stories from his teenage years in Norfolk involve violence. Most also share narrative details that bespeak a code of conduct, of justice, that was forming in his mind. Of said code, Article the First: Don't go looking for trouble, but if it comes your way, eliminate it. Stop it cold. Article the Second: If you must start trouble, do so as a countermeasure to intolerable behavior.

When, outside a sub shop a few blocks from here, a stranger pulled a knife on him and demanded money, Tommy warned him against the

act—and when the bandit wouldn't back down, punched him in the head, took his knife away, stabbed him nine times in the left side, and dropped him to the sidewalk. Afterward, Tommy threw the weapon onto the roof, washed his hands in the restaurant's bathroom, and ordered a sandwich.

Another example: He was out drinking with his half brother, Johnny—the same sibling who'd testified against him down in Carolina—and after midnight, hungry, they pulled into the all-night coffee shop of the Nansemond Hotel, a rambling old beachfront place where Tommy's sister Freda worked as a waitress. They'd just settled into a booth when Freda came to them, crying. She'd had to wash her hands a few minutes before, so she'd removed her rings and placed them on the counter. They were gone when she turned back around. A sailor sitting a couple of feet away had denied touching them, though no one else had come anywhere near.

"I was a crazy motherfucker, you have to understand," Arney tells me. "I was a mean fucker. So I walk over to this guy, this sailor, and I say, 'Hey, buddy, why'd you take her rings?' The guy says, 'What's it to you?' And I said, 'Well, I'm her brother, for one thing. And if she don't get her rings back, I'm going to fuck you up.' He says, 'I'll give her the rings back. But I'm going to fuck *you* up.' "

They stepped into the parking lot, started to square off, and Johnny yelled that the sailor had a knife. Tommy slugged him. The sailor came back at him with the blade. Tommy punched him again. The knife hit the asphalt. Tommy picked it up. "I yelled, 'Motherfucker, you want to stab *me*?' " he recalls. "And I stabbed him a bunch of times."

Justified, in its way. In this case, even the "victim" thought so: Before the police could sort out who had done the stabbing, the sailor told investigators he was to blame for the whole mess and would not press charges. Tommy walked.

But another element creeps into these accounts of his burgeoning penchant for violence. This was a kid who might not have instigated

much trouble, technically, but whose response to even mild challenge was nuclear in its intensity—he was *all in*, every time, with no thought to the proportionality of his response versus the other guy's sins. Whatever said other guy had done, he got an explosion in return. He got hurt.

The people who tangled with Arney usually failed to recognize the danger until it was too late. He topped six feet, but he wasn't bulky with muscle, and his boy's face and first, wispy attempt at a mustache didn't inspire fear. Pity the smart-aleck college students who smirked at his curse-laden speech as they stood in line behind him at a fast-food joint, or exchanged snide whispers in his presence; hypersensitive about his own schooling, resentful of theirs, Arney assumed they were mocking him and beat them bloody. Pity any jerk who laughed at the wrong moment, or held eye contact too long, or demonstrated any shortage of respect for Arney and his kin, because said jerk would have to be taught some manners, and he'd pay for the lesson with teeth.

Pity, even, the biker Arney encountered at a grocery store during this period: It's a safe bet he didn't suspect that his life was about to change. It was just after Arney got his first apartment, and he was subsisting on canned chicken noodle soup. He was at the store, loading a cart with a week's worth, when, a short ways off, a greasy character in motorcycle leathers picked a noisy and threatening dispute with a much smaller man, humiliating the fellow in front of his wife and the biker's old lady. After that, the biker evidently misidentified Arney as fair game: He strode up to him, glared at the cans piled in his cart, and said: What if *I* want some fucking soup?

To which Arney replied: Have some. He slammed the man's left temple with a soup can he'd palmed, hit him with all his might—then, as the biker lurched backward, again smashed the can into his skull, and again, and again, until blood spattered the linoleum and dripped from the shelves and the biker's old lady was wailing and screeching for help. Arney walked away without a backward glance. "I didn't even think about it afterward," he tells me. "The minute I walked out of that store,

it was out of my mind. I didn't think about it again for years. I almost forgot it happened."

He was breaking the law in nonviolent style, too. While siphoning fuel from a parked car almost within sight of where we sit (a crime he perpetrated whenever his tank got low), he inhaled and swallowed a mouthful of gasoline, a mistake that earned him a hospital stay. Serious legal trouble was only a matter of time, and it came on Halloween in 1974, when he and his brother Billy and some friends ran out of beer while out on the town. Somebody in the car suggested that they resupply at a shuttered grocery store, so they pulled behind the place and pried open the back door. They were wandering around inside, drinking wine and eating bologna, when one of the group came across two safes in a back room.

They forced one open. The other was too tough to crack on the spot, so they lugged it out to the car. It was heavy, hundreds of pounds—as soon as they heaved it into the trunk, the car's rear end dropped to the pavement, and they dragged bottom as they peeled off for home. A few minutes later, a pair of patrolling cops spotted a Mercury Comet throwing up a rooster tail of sparks.

Arney emerged from the episode a felon. He got off with a suspended sentence and probation, but not before spending several months awaiting trial in the Norfolk City Jail. It wasn't much different from his life on the outside: Tossed into a communal cell with twenty or thirty other men, inside of an hour he'd be pounding someone senseless.

A FEW MILES across town, the Chevy was in the comparably stable and civilized hands of Bruce Thornhill Jr., who lived in a quiet suburb and operated a busy veterinary practice southwest of Portsmouth. The Chevy had some sentimental value to the younger Thornhill, but above all it was his daily driver out the once-rural George Washington Highway—U.S. 17, a stretch of four-lane blacktop now straddled by metastasizing subdivisions and strip shopping centers. The car was

thus entering a long middle age as a workhorse, its value directly tied to its reliability, its sturdiness, its ability to haul loads. It was a tool. It was a means.

This third stage in our relationship with our cars—companionable reliance—is, in most cases, the longest; it's the stage, too, at which many cars are put on the market and bought secondhand. It has morphed in definition and duration over the years, for just as improved medical care and healthier lifestyles have made age fifty the new forty (or even the new thirty-five), the cars of today take far longer to reach this rather unromantic juncture than they did a few years ago, and they remain in it longer.

Consider that a modern car is barely warmed up at thirty thousand miles. A lot of new cars don't even need a tune-up until well past that point. One can keep a Toyota or Honda or newer American car for a dozen years without a major repair, and it's not a stretch to drive a car for fifteen and still get a decent price for it. A car of 1957, on the other hand, was middle-aged at thirty thousand miles, and was last able to fetch a decent resale price at somewhere around sixty thousand. A car reaching a hundred thousand was used up, and a rarity; on the roads of the period, that translated into a *lot* of hours at the wheel.

Among Dr. Thornhill's clients was Sidney Pollard III, a Portsmouth native and the owner of a poodle. On his visits to the clinic, Pollard often admired the doctor's car in the parking lot. The Chevy, no classic when new, was starting to assume the trappings of one in the early seventies, especially after the success of George Lucas's 1973 film, *American Graffiti.* The movie had done much to recharge the reputations of a host of late-fifties cars that were now becoming increasingly rare on the street; next to them, the styling of newer cars seemed bloodless.

The '57 Chevy in particular was coming into its own as an object of desire. Perhaps it's because it survived in sufficient numbers to whet collectors' appetites, unlike its contemporaries—Chryslers that disintegrated at the mention of rain, and Fords that racked up repairs with their miles, and Ramblers that no one, mindful of their reputations as

economy cars, wanted to keep for long. Perhaps it took a few years for the arbiters of taste to recognize that its fins achieved a sublimity of size and shape that would elude all the competition's designs, and all of Chevrolet's later efforts, as well. Maybe its tough but pretty face, its full grouper's lips, endeared it to those normally unmoved by Detroit product. It might have been the simple fact that the first millions of baby boomers, having weathered assassinations, Vietnam, and Watergate, were feeling nostalgic about their teen years.

Whatever the case, the car had become an emblem of simpler times and of Detroit's vanishing style and swagger. The wagon called to Pollard. He was so taken with it that he shot a glance at the clinic's lot whenever he drove past, until one day he spotted a "For Sale" sign in one of the car's windows.

Bruce Jr. let him inspect the goods. Pollard found a metal spring poking through a small tear in the front bench seat. A few florets of rust interrupted the paint job; in one spot behind the right front wheel, they'd blossomed into a two-inch hole. Otherwise, the car was wonderfully preserved. Thanks to the elder Thornhill's religious maintenance, it looked much as it had the day it rolled off the Colonial Chevrolet lot, more than eighteen years before.

Pollard took it to a friend who ran a machine shop for a mechanical once-over. Its only internal defect was a burnt exhaust valve, an easy fix. So the twenty-six-year-old Pollard became the Chevy's third owner. He paid Thornhill three hundred dollars for it.

In Pollard the Chevy found an ideal partner. It used to be that virtually any boy growing up in America could pop the hood on a car and identify the drivetrain's various components, and through the early seventies, those components were relatively few and plain to see. Most could probably tell you what those components did—could explain how a carburetor blended air and gasoline in the proportions necessary for ignition, how the distributor regulated the sparks that touched off combustion, and what the valve covers covered, exactly. Many boys could make simple repairs to the running gear—indeed, had to possess

that knowledge just to keep their machines on the road. Some might have been up to more complicated tasks, such as packing the wheel bearings, adjusting the timing, or tackling a brake job.

And a few would possess an understanding of all things mechanical, could diagnose a problem by sight, smell, or sound; not only understood, cerebrally, the principles that governed the internal combustion power plant but seemed to intuit them on some primal, brain-stem level. A wrench was appendage, more than tool. Intricate machinery held no mystery.

Sid Pollard was one of those kids.

He didn't lament the wagon's age or relatively primitive engineering. Just the opposite was true: He'd gravitated toward vehicles that required attention since high school, when he'd owned a succession of Renaults and a '65 Mercedes—cars not exactly celebrated for their reliability, but far more interesting than the never-fail Japanese cars that seemed to breed in American driveways in the seventies, cars that gave him little excuse to tinker. As Ozzie Nelson had boasted a generation before, he could fix most any problem under the hood, for at least long enough to get home, with only a hammer and pliers.

Besides, Pollard adored the way the Chevy looked—the heavy chrome of its prow, the paint job straight out of Miami, its slab sides and wraparound rear glass. The bright Chevy emblem in the grille, and the wide, shallow V on the hood, a stylistic boast to the world that the car packed a V8. The way the tailgate folded down while the hatch window above it swung up. Everything about it, really: It was a big green summary of everything Sid Pollard loved about cars.

THE '57 CHEVY inherited some of its classic good looks from the 1955 model, for the two were variations on a theme, the first and last renditions of a single three-year design cycle. In the middle of 1951, a full six years before Pollard's wagon rolled out of the Baltimore plant,

GM drafted the specifications for the "A" body its 1955 cars would share with those of the succeeding two years, and it became the task of corporate engineers and draftsmen to translate those specs into a general shape. This roughed-in "A" body core was passed on to the Chevy styling studio, which was led by designer Clare "Mac" MacKichan, a vastly talented craftsman who answered to Harley Earl, and who now had before him a fresh-slate assignment—a car that was to be new from the tires up. In the years since the war, Chevy had fallen behind Ford and Chrysler in both styling and performance. MacKichan's job was to inject a fresh, youthful vigor into what the public was coming to view as an old man's car.

The design team started with a couple of assumptions. One, the new car wouldn't have traditional fenders, nor any hint of them. Unlike the '54 Chevy, which swelled around its rear wheels in a vestigial nod to the running board days, the new car would fully incorporate its wheels into its flanks. Second, it would most likely have a one-piece, wraparound windshield, a first for Chevrolet.

Beyond that, MacKichan had nothing but latitude, and he ran with it. He and his people came up with a bold look for the '55 model. Its hood would dip while its front fenders ran high, reversing the traditional arrangement; in profile, the line along the top of the fenders—called the belt line—would run flat to the windshield, then dip an inch or so, and at this new height continue under the windows in a straight shot to the tail.

Seen from the side, it worked—its high fenders seemed defiant challenges to any air that might get in their way. From the front, it didn't fare so well: The diving hood ended with an inward curl over a wide, thin grille, and to modern eyes the combination suggests a toothless mouth. Still, MacKichan and Earl liked it enough that they had the design reproduced as a clay model. It seemed on its way to mass production.

Only then, happily, an engineering problem intervened: The Chevy was getting a new engine to go along with its modern sheet metal—the

company's first V8, which would replace a six-cylinder that dated to 1929—and the thing wouldn't fit under the dipped hood. MacKichan and company tried raising both the hood and fenders to accommodate it, but the result looked skinny and tall, so they refashioned the whole front end of the car, raising the hood and lowering the fenders to create a more or less horizontal plane. The step-down in the belt line was now superfluous, so they ran that line straight for the entire length of the car, from headlights to taillights, except for a little triangular notch just forward of the rear roof pillar. Curved and asymmetrical, the notch created the illusion of a small rise over the car's rear quarter. The effect was dynamite.

Now came the question of what to do about the grille. Earl was in the habit of spending a few weeks each year in Europe, studying the cars that automakers there unveiled at the continent's auto shows, and he returned from his 1953 trip excited. A new Ferrari he'd seen boasted a simple but stunning egg-crate grille, and he suggested—decreed, actually—that something similar might work on the Chevy. He took personal command of the design, overseeing the creation of a round-cornered rectangle of crisscrossing chrome blades.

At a time when front ends were crowded with heavy chrome and missile-shaped bumper guards ("Dagmars," they were nicknamed, after a busty blond TV star who recorded the novelty song "Mama Will Bark" with Frank Sinatra), the grille's forceful simplicity was almost shocking—and made more so by its marriage to a low, unadorned front bumper, wide-spaced and hooded headlights, and the car's slab-sided body. The interior was likewise uncluttered, with a dash borrowed from the '53 Corvette, a stroke aimed at younger buyers. MacKichan found the package "quite refreshing." Earl was even more pleased. "Now there's a car," he said, "that if it had a Cadillac emblem on it, I could sell as a Cadillac."

The buying public wasn't so enthusiastic. When it was introduced in late October 1954, the all-new '55 Chevy didn't move off the lot at

near the speed GM had expected. When days, then weeks, passed, and sales remained slow, the company's panicked bosses started looking for something to blame, and they fastened on Earl's grille. The car's front end was simply too radical, too austere, they said, for the mainstream, middle-class American buyer.

MacKichan was ordered to come up with a new front end for a mid-year replacement. His studio dropped everything to devise a variation on the egg crate that stretched across the entire front of the car and incorporated the turn signal lamps. It was a pleasing compromise, only a touch busier than the original—but that touch, to corporate eyes, made all the difference, for it turned the car's grimace into a smile. Then, before the switch could be accomplished, the public suddenly and overwhelmingly warmed to the egg crate: By December 1954, the unedited car was posting record sales, stunning the executives who'd denounced it just weeks before. The Plan B front end instead became the face of the 1956 Chevy.

The bosses considered another candidate for the egg crate's replacement, as well. In 1953, MacKichan's assistant chief designer, Carl Renner, had sketched a Chevy with a muscular grille-bumper assembly that more resembled a high-end car. The crash program to remake the '55 rescued that fish-mouthed grille from the studio's file of dead ideas. It was stamped into reality as the face of the '57.

By August 1954, when Earl described his work to a writer for the *Saturday Evening Post*, every detail of the car now decaying at Moyock Muscle had been decided. "Most Americans are at least a little excited over the appearance of new-model automobiles each year," read one passage of the story, which was titled "I Dream Automobiles." Earl wasn't, he said, "because, considering the share of all cars my company produces, the odds are almost even that your new car is one I designed myself and put out of my life at least twenty-seven months ago.

"It hasn't been too long ago that we settled what your 1957 car will look like."

Park them side by side, and it's not immediately apparent that the 1957 model shares much hardware with its older Chevy siblings. Their roofs, doors, and glass—their "A" body cores—might be identical, but MacKichan's studio was under heavy pressure to make something special of the last car in the design cycle, and its stylists worked magic in obscuring its origins. It was longer than the '56 car by more than two inches. It was a couple of inches lower, as well, a feat the studio pulled off by downsizing the wheels from fifteen-inchers to fourteen—a questionable "advance" in terms of performance and tire wear, but true to the most holy of Earl's commandments. The new grille-bumper arrangement not only obliterated any trace of the egg crate, it seemed to reshape the metal around it, to soften its edges. The '55 had been a handsome car. The '57 was *pretty*.

And the later model was dressed to take off from the local air force base. Its vestigial Dagmars were etched with crosshairs, unless covered with optional rubber warheads. Its hood had lost the big, stylized bird ornament that perched front and center on past Chevys, and had gained a pair of grooves cradling finned chrome darts. The company called these new decorations "scoop assemblies." The automotive press labeled them "wind splitz," and motorheads came to call them "cheese cutters." What they were clearly intended to evoke, however, were gunsights.

And not least, there were those fins.

THE CHEVY WASN'T the first American car to borrow from aircraft: The nose of Studebaker's futuristic 1950 model narrowed to a point, attached to which was a "spinner," a circular chrome gewgaw that did not actually spin, but nonetheless evoked a propeller. A team of former and moonlighting Studebaker stylists put a spinner on the nose of the '49 Ford, too. Those designs traded on America's passion for everything plane-related in the years after the country's air victory

in World War II; climb into a Studie and you could imagine yourself downing Messerschmidts and Zeros.

Over at GM, meanwhile, Earl was finding inspiration in the back end of airplanes, rather than their noses—and in the tail of one airplane, in particular. In 1941, he and a contingent of GM stylists called on the army's Selfridge Field, on the outskirts of Detroit, where they beheld the Lockheed P-38 Lightning. The new fighter was big, fast, and heavily armed, with a fifty-two-foot wingspan, twin engines and a bristle of machine guns and cannons on its nose. It was also unlike any other warplane in the sky: The pilot sat in a small pod positioned on the center of the airplane's broad wing; the engines rode in separate fuselages, off to his right and left, and these narrowed to twin tail booms ending in paddle-shaped vertical stabilizers. "We had to stand thirty feet away from it because it was still in security," Earl said of the viewing, "but even at that distance we could soak up the lines of its twin booms and twin tails." Entranced, Earl put his stylists at work incorporating the Lightning's look into GM's cars. The war intervened, halting civilian auto production, but the company was ready with its first cautious application of the P-38's style when cars again rolled off the line—the Cadillac of 1948 sported nubby rises on its rear.

Modest though they were—and they were so much so that it's a stretch to classify them as tailfins—customers didn't know what to make of these new additions, and the motoring press greeted them with mockery. But acceptance of what Earl acknowledged was a "fairly sharp departure" came soon enough. "Cadillac owners realized that it gave them an extra receipt for their money," he said, "in the form of a visible prestige marking for an expensive car."

Those early "fishtails," as Earl called them, were just earning their place as a Cadillac standard when GM unleashed its Buick LeSabre concept car of 1951, a low-riding convertible studded with Jet Age details. Its nose narrowed to an oval grille that mimicked the business end of the Air Force's new F-86 SabreJet, and its rear sported what,

back before the war, would have been called a boat tail—only here it ended in what appeared a chrome jet exhaust port flanked by high, squarish fins, each trailed by three flame-shaped taillights.

Work on the '55 cars was starting even as the LeSabre was flooring car show audiences around the country, and quieted-down versions of its fins soon found their way onto GM's production cars. The Olds and Buick sported bulges that in succeeding years would sharpen into prominent blades. The '55 Chevy, too: Its taillights were mounted on quarter panels that protruded a demure couple of inches beyond the trunk. Pontiac's proto-fins were flashier, but still only promises. Only Cadillac's top-of-the-line convertible, the Eldorado, sported bona fide scimitars on its tail: It abandoned the brand's nubs for great, triangular fins that tapered to sharp, chrome-edged points a foot behind the car proper. Nowadays, the '55 Eldorado is a rarity, but its tail remains familiar because Chevy stylists would borrow those fins, with only slight alteration, for their '57 design.

A front end passed over once before. A rear end ripped off from a two-year-old Cadillac. The '57 Chevy's designers weren't excited by the car—not at first, and not compared to the '55; it seemed a cut-and-paste job, a mash of old ideas. But that became a lonely view, especially regarding the fins, because they were executed just about flawlessly. Unlike the Caddie's, they didn't rise; rather, the car's trunk or hatch sloped downward, while its belt line—the top edge of the fins—kept going straight; they stretched rearward, not skyward. Because they extended the belt line, they helped the car appear longer; and because they were integrated so seamlessly into the car's lines, they came across as elemental, not an add-on—a point underlined by a little door hidden under the chrome of the left fin, concealing the gas filler cap.

Sure, they were silly. But they looked terrific.

6

FOR FOUR MONTHS after the county's visit, Arney assures me he's ready to start work on the Chevy, and each time he makes the promise, something happens to push the announced start date back. He's ensnared by a succession of distractions, most of them involving real estate—he has to prepare an empty storefront for an incoming customer, or clean out another property in the wake of an ended lease—or his restaurants, or the ten horses that he keeps at the Arney Compound. Being a hands-on variety of businessman, he insists on being present for each and every task, if not performing it himself.

He's rarely at Moyock Muscle when I visit. As Thanksgiving comes and goes, then Christmas, many of my visits consist of killing time, waiting to see whether he'll turn up. I sit in the Stingray convertibles in the showroom. I stroll through the Quonset's rear, behind the office, where a workshop as big as the showroom is populated by additional Corvettes under repair, along with thousands of tools and pieces of car.

More often than not, Painter Paul is the only other soul on the premises, and it's in his workspaces, in the lot's rear corner, that I waste most of these days. I inspect the odd tools he uses to bend and cut metal, the paint pots and spray guns in the paint shed. I explore the body shop's small back room, unused save for the storage of a single rusty bumper and stacks of brittle, yellowing magazines—*Hot Rod Deluxe, Car Kulture DeLuxe, American Rodder, Street Rodder, Custom Rodder*—everything sweatered in a Pompeian stratum of fine

gray dust, the by-product of sanding out in the main room. On the wall is a faded foldout poster of Miss Ginger Miller, *Penthouse* Pet of the Year for 1989, which has evidently hung in that spot for twenty-two years.

I quiz Painter Paul about his tattoos—a large, spike-collared bull-dog on his left pectoral, a horned, bone-munching ghoul on his left shoulder, and "Sabbath," his dog's name, in Old English script on the opposite arm. "My brother did them," he tells me.

"Oh," I say. "Your brother's a tattoo artist?"

"I'm not sure about that," he replies, "but he does them."

When I ask him when he expects to start work on the Chevy, he snorts. "Don't be thinking that this is going to happen quickly," he tells me. "It's going to take fucking forever." Look around, he says. He has spent the past several weeks restoring a 1965 GMC pickup, has painted it a gorgeous deep gold with ivory trim, and fitted a gleaming, varnished wood floor into its bed. It lacks an interior—not a big job on a pickup—and an engine, which Arney already owns and might take a few days, tops, to install. Those fixes would yield a truck of considerable value. In its incomplete state, it's not worth nearly as much, and on top of that, it's an investment Arney's already spent a pile of money on. Painter Paul is pessimistic about when, or if, it might be finished. "It'll sit," he says.

In one of the three sheds that constitute his work area, he points out two unfinished convertibles—a 1967 Mustang, complete but for an engine, and a 1965 Chevy Impala painted a deep red and minus an interior. Both have been there for years—in the case of the Impala, six or more. "He never fucking finishes anything," Painter Paul sighs. "Got half-finished cars all over the place."

January 2011 comes and goes, with the Chevy still slouched in the weeds outside the body shop. It's with Painter Paul's words in my head that I corner Arney one early afternoon in late February at the bar at Bootleggers and ask: What's the plan? Just when, if ever, does he plan

to get around to the Chevy? Neighboring restaurants are packed with lunch crowds, but besides the two of us, a waitress, a cook, and Slick, who's running the bar, the place is empty.

Arney eyes me impassively. "Well, to tell you the truth, it wouldn't bother me one bit to shitcan the project," he says, "because not fixing that car would save me about thirty, forty thousand dollars." Money is tight, and he's saddled with a slew of obligations that have to take precedence over the wagon. Such as, for instance, Bootleggers, which is seriously underperforming. And dozens of other properties that are sitting empty, sucking up dollars in mortgage, interest, and insurance, and for which he hasn't been able to find renters or buyers. And the banks that are breathing down his neck. And the FBI.

"The FBI?" I ask, not sure I've heard him correctly.

"Oh, yeah," he says. "They've been investigating me for a couple of years." He is suspected of having pulled some funny business in his dealings with a local lender, the Bank of the Commonwealth, the poor health of which has been the subject of numerous stories in the paper lately. He's not sure, exactly, what they think he did—he's heard varying accounts—but the bureau has assigned a couple of agents to sift through his affairs. "I don't think I've done anything wrong," he says, "but I've had people tell me, 'Tommy, once they decide to go after you, they don't like to stop.' So I don't know."

The upshot is that he has a lot to do and to think about, he says, and he doesn't have room in his days for the car. We sit, staring at each other. I'm confused by the news, because until this moment, Arney has spoken with unbridled enthusiasm about the project. I haven't said anything in reply when, without explanation, he suddenly plucks his cell phone from the bar, flips it open, and dials Painter Paul. "Paul, how much do you have to do, still, on that pickup you're working on?"

A pause. "Oh, really?" Another, longer pause. He turns to me. "He says he'll be done with it in four or five days." The wheels turn for a few

seconds. "All right," he finally tells Paul. "Finish that motherfucker, and don't start on anything else. I want to start that '57."

SID POLLARD WAS a child of the new postwar suburbs—which is to say, he was a product of the automobile age. His father, Sidney Pollard Jr., was an electronics engineer and mechanical wizard who, like the Thornhills, worked at the Norfolk Naval Shipyard during the war. At the yard the senior Pollard met Sid's mother, Sarah Pretlow Darden, who was part of an old Virginia family; her first cousin was then the state's governor.

Married during the war, the Pollards lived for a few years in a Norfolk apartment a few blocks from Colonial Chevrolet, then built a house on Portsmouth's sparsely developed fringe, five miles away—a two-story brick bungalow on more than an acre of land, in a new Portsmouth subdivision called Green Acres. Old-timers still called the place the Wright B. Carney farm, and it looked the part: When the Pollards moved into their new place, just before Sid was born in 1950, the neighborhood was an island of fescue and azalea amid rows of soybeans, corn, and tomatoes, and abounding woods, and fields busy with deer, raccoons, skunks. The biggest highway in that part of town, U.S. 17, was two lanes wide. Most of its traffic was farm trucks.

Young Sid learned how to use a peashooter and a slingshot, and to hunt snakes with a BB gun. He built tree houses and forts and underground hideouts roofed in plywood. Books did not come easily to him, but some things did: He could handle tools and machines instinctively, and by the time he was ten he could fix anything broken on a bike. He took after his father in that respect. His short, quick-tempered old man retreated most nights to his basement workshop, where he worked wonders on anything with wires. Sid often borrowed his dad's gear to repair bikes in the yard, and on unhappy occasion the old man ran over his own tools with the lawn mower. Eventually, Sid the elder stopped letting Sid the younger use his stuff.

Sid passed through junior high as the woods around the bungalow fell, and shadeless subdivisions of split-levels and ranchers and two-story colonials coiled around Green Acres and filled the farmland across U.S. 17. Construction started on a new high school for all the kids moving into these new houses, whose families were part of an exodus of whites from Portsmouth's center. When the school opened, Sid was in attendance.

After class, he honed his mechanical skills. He bought two junk Renaults for ninety dollars and, with his dad's help, cobbled a single decent car out of their parts. He tinkered with other castoffs, but acquired a morbid fascination with Renaults, a French make with a reputation for idiosyncrasies—to put it charitably—in design, engineering and performance, and pushed himself to solve ever more complex and vexing problems. Before long his father was telling him, Son, you're a better mechanic than I ever hope to be, and paying Sid to work on the family's cars.

Just about here, his path veered from the middle-class ideal. He was still in high school when he married for the first time. It didn't last long. After graduating in 1970, he took classes at a junior college for a couple of years and held a succession of jobs that didn't last, either: delivering appliances, driving a forklift, running a bike shop, fixing machinery at an iron and metal firm, molding the plastic backs of nineteen-inch TVs on a General Electric assembly line. He went into air-conditioning and refrigeration work, and in 1974 landed a post at the shipyard. A year later he married his second wife, Sheila, a secretary at the yard. They were living in a duplex not far from Nicholas Thornhill's little cottage on the western end of town—now, thanks to the spreading suburbs, the middle of town—when in 1976 he bought the wagon.

Pollard got to work. He had a Portsmouth machine shop bore out the Chevy's engine. Another shop turned the crankshaft. He rebuilt the transmission himself. He used baling wire to tie down the errant spring in the front seat, then contact-cemented a piece of matching

vinyl over the hole. He replaced the dashboard clock. His father fixed the old tube radio.

He tackled the rust by taking the car to a friend, Frank DeSimone, who ran a body shop out of his mother's garage. He and DeSimone had met a half dozen years before, when both worked for the appliance place; they'd hit it off the day they met, and had spent a lot of time together, on the clock and off—they and their wives had done some nightclubbing together in nearby Virginia Beach. DeSimone filled the Chevy's holes, then sanded and repainted the whole car. Pollard finished the overhaul with a new set of radials and Bel Air hub caps. The bill topped $1,500, a sizable sum for the time, but the car was now as sharp-looking as the day it came off the line: chrome gleaming, metallic paint fresh, interior pristine.

The wagon became his daily driver to the shipyard, a commute that took him through Portsmouth's middle. It was a bleak passage. The central business district, like those of many older American cities in the late seventies, seemed to dribble away a little more each month—stores closing, movie theaters shutting down, shoppers fleeing to the new malls in the hinterlands, which now pushed beyond his parents' place in Green Acres. The older neighborhoods near downtown were blighted eyesores.

But he only had to endure the depressing views for a few minutes each week: In 1977, he and Sheila bought a house out on the new suburban frontier, and weekends took them the other way. Pollard, keen for waterskiing, added a trailer hitch to the Chevy and used it to haul a ski boat to the rivers and lakes in the countryside to the west and south. He and Sheila didn't need a motel room. When they folded down the Chevy's backseat, its cargo bay was the size of a double bed.

LIKE NICHOLAS THORNHILL, Sid Pollard built a garage behind his house for the Chevy. He stayed true to the car's maintenance

schedule. The lust he'd felt on acquiring the car, and the love he'd had for it over the succeeding couple of years, had settled into abiding affection by now. The wagon was a trusted companion and, after his second marriage ended in 1979, his sidekick on solo weekend adventures. Some days he'd steer it onto the expressway and mash the accelerator until the speedometer needle lay hard to the right. He'd take it onto the old ditch-lined roads that wound through the swamps down by the Carolina line, skinny farm lanes not yet outrun by the subdivisions of stapled-together houses spilling from the city, and take the curves hard enough to make the tires squeal.

He was, in other words, entering the third stage of ownership, as had Bruce Thornhill before him—a point at which some owners refer to their cars by nicknames, dress their interiors in custom and often funky touches (seat covers, replacement floor mats), paper their tails in bumper stickers. It's the most comfortable stage, in that one's car is not so pristine and hallowed that a nick prompts tears, or overnight parking on a city street causes an interruption of sleep, but the vehicle in question is still sufficiently youthful and solid that its reliability is no cause for doubt. It's a time for relaxation. You might let the dog ride in the back without first covering the seats. You let your kids eat and drink without making a fuss about it. It's not a disaster to drive around with a little grime showing.

And because it's trusted, because the relationship between owner and machine is so intimate in this stage, one's car can become a sanctuary, and a tabernacle of hopes, dreams, beliefs. Exhibit One: I find a 1964 Nova parked on the apron outside the paint and body sheds at Moyock Muscle. It's a bitter day, windy and overcast, and I check the Nova's doors more to escape the weather than to explore the car. It's open. I slip into the front passenger seat.

The interior smells of mildew. The upholstered door panels have been ruined by moisture. The driver's has rotted away completely; the others are curled and stained and soggy. I glance overhead. The head-

liner, the Nova's fabric ceiling, is missing. Rusty steel struts that once held it in place still span the underside of the roof. Wedged beneath one of them, directly over the middle of the front bench seat, is a little bundle of paper.

I pry it loose, unfold it. It is composed of four slips of rough white stationery, on each of them one or more words rendered in blue ball-point, in a woman's hand, vintage unknown.

"god," the first reads.

"be sleepy," the next.

"become silent."

Last, "moneo, monere, monui, monitus"—various forms of the Latin for warn, advise, remind.

Words to live by? A small shrine of important life lessons, placed in this ravaged old sedan by a past owner? I can only guess. I can't de-cide whether that owner slipped the bundle under the strut while the headliner was undergoing some long-ago repair—so that these magic words were sealed, invisible, inside the car, like a time capsule—or drove the beater without the fabric covering, and with the car's rusted steel exposed.

Either way, I marvel, she vested her car with these mantras. She made a temple of it, a spiritual refuge.

I'm about to leave the Nova when I notice a second tiny packet of paper under a ceiling strut behind me, over the backseat. I carefully ease it out, fold it flat. It's a Chinese takeout menu, and evidently it's not that old: Chicken with broccoli is priced at $4.75. A two-liter bottle of Pepsi is $1.99.

So, okay, I think: This suggests that Ms. Spiritual Past Owner drove a beater with a bare metal ceiling—the headliner's fabric wouldn't have rotted away in the few years since this menu was printed. She hadn't secreted her bundle of inspiration beyond view, after all; she'd jammed it under a metal strut that hovered just overhead every time she drove. And Chinese food, it seems, was important to her—given its place-

ment, only a little less important than the seemingly deeper "god" and "become silent" stuff.

But I decide, as I climb out, that I'll stick with my first interpretation of the mantras. Some people really like Chinese food.

SID POLLARD DATED now and then during the year following his divorce, but it wasn't until December 1980 that he found new love. He was at a New Year's Eve party where the host, lacking fireworks, pulled out a gun and started firing it into the air. Pollard decided at the same moment that it was time to leave. He drove to a nightclub on the Portsmouth waterfront and inside met a Baptist minister's daughter named Sherrye Sheffield.

They dated for fourteen months before marrying in March 1982. Both were youth directors of their church, and they'd use the wagon to haul the congregation's youngsters on trips to the bowling alley and such. The kids, who loved riding in the car, called it the "Green Hornet."

Then, nine months after the Pollards married, Sherrye gave birth to the first of their three daughters. Mary Beth's arrival presented her father with a quandary, for the wagon was not the vehicle of choice for hauling around an infant. It lacked air-conditioning, for one thing. Worse, it failed to make any concession to passenger safety. The dash was unpadded steel; all that separated the car's occupants from their metal surroundings were a few microns of green paint. Metal knobs jutted from the instrument panel, poised to snag, rip, and puncture skin. The steering column was an unyielding lance aimed at the driver's breastbone; in a head-on wreck, he'd be a kebab.

Seat belts were entirely absent. Though Nash had made them standard on its cars in 1949, and Ford had introduced them as an option in 1956—to great fanfare, if not great sales success—GM hadn't been moved to follow suit. "GM declares that when its engineers are con-

vinced that something should be added as a safety feature, the feature is made standard, not optional, equipment," *Fortune* explained in June 1956, adding that in the case of belts, the company had "misgivings about their value."

Value, that is, in exciting the customer: Ford found that only 10 percent of its buyers shelled out extra for its seat belts. Not surprisingly, GM was cool to investing in vehicle features that "the vast majority of motorists" would neither buy nor use, as an independent study found was still the case in 1958.

Pollard had not seen fit to second-guess the automaker's decision to skip belts. He could have added them now, but even then, the car's safety would have fallen short of what he demanded in any vehicle carrying his new baby. This might seem counterintuitive: Nowadays, cars of the fifties seem to be built like tanks. But the truth is that the Chevy's size and heft and thick steel armor did not protect its occupants at all well. Tank or no, the wagon wasn't designed to absorb impacts, as modern cars are; it was built to outmuscle any obstacle it met, to retain its shape and integrity while winning the showdown with telephone poles, light standards, bridge abutments, and other vehicles. Today's cars are accordions. This was a battering ram.

This approach had romantic appeal, but suffered from two shortcomings. Instead of being absorbed, the forces generated by a collision were transferred through the Chevy, and into and through its passengers. And because it was not designed to collapse in a predictable, rational fashion, it deformed in surprising and often disastrous ways when the stresses of an accident proved too severe for its beefy constitution.

There's no better demonstration of this than an experiment conducted a few years ago by the Insurance Institute for Highway Safety, the nonprofit outfit that conducts the crash tests that yield safety ratings for all cars sold in the United States. In 2009, the institute rolled a 1959 Chevy Bel Air four-door sedan into its test facility in Ruckersville, Virginia, at the foot of the Blue Ridge north of Charlottesville, and

pointed it at a smaller, seemingly anemic 2009 Chevy Malibu. Each car was then sent speeding head-on at the other at forty miles per hour.

Unless you were a physicist, materials expert, or civil engineer, you might have watched the distance closing between the cars confident that the Malibu was about to be creamed. The '59 Bel Air was a behemoth: The cast of *Riverdance* could jig across its hood without leaving a dent. By comparison, the new car seemed built of little more than foil, and weighed a full two hundred pounds less than its forebear. But the test, which was conducted as part of the partying that marked the institute's fiftieth anniversary, yielded some major surprises. The damage to the passenger compartment of the older Bel Air was horrific: The steering wheel was thrown back and up at the dummy in the driver's seat, striking its head; the A pillars instantly collapsed, slamming the roof down on the dummy's skull and throwing it into the unpadded dash; the windshield blew out; the driver's door flew open; the front seat tore loose from its moorings and flew forward, wadding the dummy like paper; the space below the dash crunched shut on the dummy's legs.

The Malibu's passenger compartment, meanwhile, remained intact. Its airbag deployed, cushioning the dummy at the controls. The doors and windshield stayed put. Video cameras inside both cars made clear that the Bel Air's driver would have been gravely injured in half a dozen ways, if not killed on the spot. The Malibu's occupants might have recalled the collision as a truly rotten experience, but they likely would have limped away from it.

So Pollard was right to worry. And he had a second pressing concern about the Chevy, that being that seven years after his initial restoration of the car, rust had reappeared around the top of its roof. Battling it would mean pulling out the headliner, now more than a quarter century old and as fragile as gossamer. Pollard decided he didn't have the will to launch another overhaul.

He decided it was time to buy a family car. He'd sell the wagon and an automotive trifle, a '77 MG roadster that shared its garage, and

buy a new Renault Alliance, a subcompact sedan that *Motor Trend* had named its Car of the Year. Pollard's old buddy Frank DeSimone was over at the house one day and happened to ask about the Chevy, and Pollard allowed as to how he was looking to unload it. The price: five hundred dollars.

And like that, DeSimone became the Chevy's fourth owner.

OVER IN NORFOLK, Tommy Arney, back out of jail, spent his days rebuilding generators and starters at an electric shop, and earning just enough to pay the rent, buy soup, and set aside a few dollars each week for a car. He was dissatisfied by this meager existence, eager for change. When opportunity presented itself, he was ready.

Every day, junk dealers came into the shop with ruined starters and generators, and in conversations with these older men he learned, to his astonishment, that for each piece of junk they moved they were paid twice. One customer paid them to remove junk from a property. Another paid them for that junk—recycling outfits bought scrap metal, glass, plastic; salvage yards bought old cars; and businesses such as electric shops bought spent components that they might rebuild at a profit.

Arney recognized his future. He traded one hundred dollars and a 1960 Chevy Biscayne wagon for a used pickup, and started hauling junk. He had hustle, worked constantly. In short order he bought an old GMC wrecker that he had to crank by hand; hoisting loads required so much muscle that after a few months his right arm was visibly bigger than his left.

He earned extra money by moonlighting as a bouncer at a disco called the Oar House, catercorner from the old Sunoco station. He proved to be an accomplished dancer, and popular with the young women who patronized the club. One night he chatted up a cute, dark-haired girl, just out of high school, who appeared at the door in search of a friend inside. "When are we going out?" he asked her.

"Never," she replied. She reappeared a week later, and again he asked her out. She said no. When he asked a third time, she assured him that she would not change her mind, because she could see that he was the very picture of trouble.

Chalk one up for young Krista Ridenour's instincts, because it was while working the club's door that Arney perfected the use of his hands. He'd toss a troublemaker into the parking lot, the ejectee would throw a punch, and Arney would lay him out. A customer would speak insolently to him, or at too high a volume at too close a distance, and Arney would reset the parameters of the exchange with a flurry of strikes. He gained valuable practice at other nightspots, too. He'd go out with friends who were not fighters, and step in if any trouble came their way—which it almost surely would, because pretty soon, he found himself enjoying the mix-ups. Pretty soon, he came to expect them. Pretty soon, a day seemed idly spent if it didn't end with a fistfight.

Conduct yourself in such fashion, and it isn't long before you no longer have to seek trouble; it comes calling on its own. It happened so predictably that Arney grew bored with one opponent; he'd take on three, four, a half dozen at once. He made a game of it: He'd go into a bar with a friend, and the friend might get hassled—or, if not, a hassle might be prodded to life—and Arney would sidle up to the purported antagonist and say, with a warm smile, no hint of menace: Hey, what seems to be the problem? Are you giving my friend trouble? Some back-and-forth might follow, often culminating with the antagonist assuring Arney that he was going to whale on Arney's friend, to which Arney would say: No, sir. No, that's not going to happen, because he's with *me*, and if you're going to be whipping any ass tonight, friend, it's going to belong to yours truly.

Tell you what, he'd say: Let me buy you and your friends a beer. Drink the beer, think about things for a while. And if, after you finish that beer, you still want to fight, bring your friends along and we'll go outside and have some fun. It amazed him that so many guys drank the beer he'd bought them, then came back and said, Okay, let's go

outside. Without fail, they regretted it: After a couple of punches, Arney slipped into an altered state, much as he had in that grade school coatroom down in Rocky Mount—a feral place, in which he was blind and deaf to everything but the task at hand, in which he felt no pain, held nothing back. Time slowed, taking everyone else's punches and reaction times with it, while his own hands and feet became blurs. His blows were fearsomely hard and accurate; he knocked out most opponents with one. Even fights in which he was significantly outnumbered usually ended in seconds.

He did not always leave the field unscathed. At twenty or twenty-one he fought a six-foot-five opponent in the parking lot of a foosball parlor, and as he tells it, the man jammed his thumb into Arney's left eye socket and worked the digit in past the first joint. Arney had never felt such pain, and realized that if he didn't act fast the man would use the thumb as a lever to pop out his eye. Bent over at the waist, held fast by the neck, he grabbed the only thing he could reach, grabbed it hard, and with a roar, tore it free. His opponent immediately collapsed, his scrotum opened, testicles spilling loose.

Arney collapsed onto the man's chest, punched him several times in the face, then vomited on him. He heard sirens, and had just enough time to stagger to his feet and punch one of the man's friends before fleeing the scene.

On rare occasions he was defeated outright, such as when he was bludgeoned with a plank and knocked out cold. Even in that case, he didn't stay beaten. He spent months afterward asking around at bars about the responsible party. When he found him, they talked. "We kind of became friends, really, for a couple of minutes," Arney tells me. "I said to him, 'You remember cracking a motherfucker over the head with a board?' He said, 'Yeah, I sure do.' I said, 'Well, I'm that motherfucker. And I'm going to fuck you up.'" Arney beat him "next to death," he says: He broke the man's ribs, his nose, and his jaw, and "tried to break one of his legs, but I couldn't. I hurt my ankle trying."

He felt good for a little while after such a victory. The bad hand he'd been dealt seemed to hurt a little less. The rage subsided. But not for long. "I was a dangerous motherfucker," he says. "It was that anger controlling me. That anger took over. I was capable of delivering punches so hard and so fast that people didn't know what hit them, and I'd just keep doing it. When that switch got turned on, it was just like turning over a 427 Chevy big-block engine."

Despite that, he returned to the Oar House from a weeks-long stay in the Norfolk jail to find that the dark-haired young woman he'd pursued now agreed to dance with him. She had a great smile, a nice figure, and a wholesomeness that he found powerfully attractive: She was the nice girl he'd never been able to get. Arney and Krista Ridenour became a couple.

He hauled a lot of derelict cars, and in the effort to flip them, to fix them just enough that somebody would take them off his hands at a profit, he got handy with engines and transmissions and body work. He bought a gas station on a busy Norfolk corner. His mechanical skills sharpened.

Arney found peace under the hood: An engine followed hard-and-fast rules, its parts working in a predictable choreography; bolt its components together properly, fine-tune a few variables, and it was sure to fire up. No guesswork. No gray areas. Working on cars, he enjoyed some small measure of control over his environment. No matter how out of control the rest of his life might be, he could depend on a repair job to center things.

Which was good. Because the rest of his life was almost completely out of control.

PART 2 *Going Down Slow*

7

IT'S ONE THING to sell a fine old car and replace it with something reliable and long-lasting. It's another thing to sell a fine old car, one that draws admiring glances and comment wherever it goes, and replace it with a charmless pile of automotive scat. Sid Pollard's decision to swap the Chevy for a Renault Alliance was one of those another things.

The best that can be said about his choice is that it was a new car, and presumably safer. But it's also true that human nature drives us to seek complication when our lives become ordered and comfortable, and the Renault may have appealed on this count, for the Franco-American contrivance was nothing if not complicated—poorly designed, badly built, underpowered, and outclassed by its Japanese competitors.

It looked like a winner on its introduction in 1983, with a price tag of $5,595, dirt cheap even then, and styling that was uncluttered, if not exciting. It fused European pedigree and American jobs: The Alliance was assembled by Renault-controlled American Motors in Wisconsin. "Nearly 1½ million hours of development and testing and over $200 million invested in American Motors' Kenosha assembly plant have produced a sophisticated small sedan of European breeding and American manufacture," Renault/AMC boasted.

It covered thirty-seven miles on a gallon of gas, which remains impressive thirty years later, in the age of gas-electric hybrids. And there was the *Motor Trend* honor: The Alliance was "the best blend of innovation, economy, and fun-to-drive we have seen in almost a decade,"

gushed one of the magazine's editors in the "Car of the Year" issue. *Car and Driver*, only a little less enthusiastic, named the Alliance to its own "10Best" list for 1983.

Yet for all its attributes, Sid Pollard's new purchase was a bad one—sufficiently so that *Car and Driver* formally apologized to its readers twenty-six years later, admitting: "The car was trash." A glacier could outrun it. The engine would have been outgunned by a weed whacker. Within a couple of years, by which time its various reliability and quality issues were obvious, its sales were nosediving, and the car had earned a secure place in history's long roster of automotive mediocrity—comprising, unfortunately, all too many of the vehicles offered to the public over the 120 years of the horseless carriage.

It was almost, but not quite, flawed enough to earn a spot among the diabolically bad, those rare offerings that get absolutely everything wrong and so win a certain perverse admiration among collectors. The Trabant, East Germany's smoking, squealing, eighteen-horsepower admission that, okay, maybe the West was onto something. Older Fiats of any model before the automaker's retreat from the American market in 1984, just ahead of torch-bearing mobs. The Lada, which combined Fiat engineering and that famed Soviet attention to fit and finish. The Triumphs, MGs, Austins, and Rovers of the late sixties and seventies—Dickensian in their glorification of hardship, pot metal, and decay, with wiring so notoriously vexed that its supplier, Lucas Electrics, was known industry-wide as "the Prince of Darkness." (Several websites are devoted even today to Lucas humor. Examples: What's the Lucas motto? "Get home before dark." And "Lucas: inventor of the intermittent wiper.")

Any such list is incomplete without the explosively bad Ford Pinto, or Chevy's much-ballyhooed and universally reviled Vega, a subcompact that drew its looks from its sexy big sister, the Camaro, but otherwise seemed a GM experiment in just how flimsy, rust-prone, ineptly designed, and casually built a car could be. Or American Motors'

uncompromisingly ugly and shoddily engineered mid-seventies show-pieces, the Matador, Hornet, Pacer, and Gremlin: "Where's the rest of your *brain*, toots?" And let's not overlook the Yugo, a cheapie subcompact so dreadful that it sullied the reputation of an Eastern European dictatorship.

One thing the Alliance had going for it: It didn't torment its buyers for long. Within a very few years, almost all had rusted through, failed mechanically, and vanished from the American road. Even in junkyards, they're rare sights today. Poor Sid Pollard regretted selling the Chevy almost immediately. A couple of years later he saw his old wagon in traffic, a pretty blonde behind the wheel. Sitting in his Alliance, he was almost moved to tears.

As for Frank DeSimone: In the years since he first painted the car, he'd moved his business out of his mother's garage and into a shop in an industrial corner of Portsmouth, where he did high-dollar restorations, patched up exotic wrecks, and handled insurance repairs for big law firms. He parked the '57 in the shop's fenced yard, tinkering with it between other jobs.

Like everyone associated with the car to this point, DeSimone was a Portsmouth boy. At about the time he'd met Sid Pollard, a friend had asked him to help ready his car for painting, and the work had come so naturally to DeSimone, and had been so much fun, that he'd decided to take it up full-time. He and a buddy had gone into business together, DeSimone handling bodywork, the friend playing mechanic. When the partnership split, DeSimone had a reputation for quality repairs. He started doing fancy paint schemes and custom modifications—he built a car for the country-rock band .38 Special—and hired some top-notch body men to work with him.

One of his guys had a friend who now and then would drop by the shop, a fellow named Picot Savage. Sometimes Savage would bring his wife, Debbie, with him, and from the moment the two laid eyes on the wagon, they wanted it. DeSimone wasn't sentimental about the car;

to him, it was a machine—a nice machine, and a stylish one, but ultimately replaceable. So, just a few months after acquiring the Chevy, he obliged them. He sold it for $1,500.

FOR ALL OF its modernist flair, the wagon was in many respects decidedly old-school. It relied on cast iron and thick steel, anemic paints and primers. Its moving parts were quick to wear, and it had a lot of them. A host of mechanical devices—prone to inexactitude in the best of circumstances, and poised for catastrophic failure in the worst—performed tasks now handled by computers and solid-state gear. Rust feasted on its doors, fenders, its frame and floor. And though Chevrolet did not advertise the fact, parts of the wagon—the rear of the backseat and part of the cargo bay's floor immediately come to mind—were made of wood.

So by 1984, when Picot and Debbie Savage bought the wagon, it was aging rapidly beneath its deceptively fresh-looking skin. Its odometer had ticked into six figures. Chunks of its roof and body had been replaced with putty—automotive silicon, spackled on then, as now, to smooth imperfections in its metal. Road salt and coastal rains had chewed its floor pans thin, and in places, almost translucently so. Most troubling of all, its mechanical heart was about to fail.

The Savages lived in Suffolk, a southeastern Virginia town made famous by the peanut—Planters, of Mr. Peanut fame, was headquartered there, and the legume dominated local agriculture and factory jobs. When the Chevy was new, the burg still retained some of the character of a rural southern outpost, with a compact and self-sufficient downtown of mom-and-pop stores, and sharply segregated neighborhoods (black and white parts of town were literally separated by railroad tracks), and a population that earned its keep with its hands. The wicked city centers of Norfolk and Portsmouth, twenty-odd miles to the northeast, had seemed much farther away; indeed, either was considered a punishingly long morning commute.

In 1984, however, America was a land transformed by the previous quarter century's explosion in car ownership. Two-thirds of U.S. households had owned one car in 1957; now, more than two-thirds had two. Suburbia had advanced in ever-greater rings from the central city, had nosed up against Suffolk's edges a decade back, and was now swallowing the town like an amoeba; the once-distinctive community was fast becoming part of a greater metropolitan whole, indistinguishable from its neighbors and bound to them by a web of high-speed roads.

Picot Savage had seen a similar transformation firsthand. Born in 1953, he was the fourth generation of his family to live in Churchland, a farming village not far from where Sid Pollard's subdivision sprang up outside Portsmouth in the fifties. His great-grandfather, the son of a North Carolina preacher, had been pastor himself of the Churchland Baptist Church. His grandfather, a World War I veteran and the county surveyor for decades, had named many of the area's roads. He evidently favored birds and bird dogs, though one subdivision, carved out of an aunt's property, was crisscrossed by family names, including a Picot Court. Picot—rhymes with "hike it"—was the recycled surname of a distant cousin in North Carolina. It always confounded people. When a teacher called the roll for the first time each year, Savage knew that a long pause was his signal to say, "Here."

When he was a youngster, Churchland's center consisted of a few buildings clustered around two-lane U.S. 17 at its meeting with tracks of the Norfolk & Western Railway: grocery, drugstore, gas station; a restaurant and a little beer joint; and (here's how rural it remained) a grain storage silo and a blacksmith shop. Savage's grandmother lived right in the middle of this knot. A room added to her house served as post office.

The village didn't last long past the time Savage was old enough to remember it. After his mother died, just shy of his seventh birthday, he and his father and his father's new wife moved into a brick rambler in one of the new housing developments fast colonizing the area's truck

farms. The blacksmith shop disappeared. A strip shopping center replaced many of the buildings at the old village's heart. The state widened U.S. 17, the remaining truck farms became schools and parks and neighborhoods of curving streets and cul-de-sacs, and pretty soon it all looked like everywhere else.

Picot spent most of his childhood in the brick rambler. Physically, the new Churchland probably wasn't much different from the suburban picture offered up in *Leave It to Beaver*, but his boyhood ended with a sharp turn from the TV script: His parents separated, and he moved first into the homes of some school friends, then into his own apartment. He was a junior in high school.

Every day he walked to his classes, and from school to an afternoon job at a gas station, and he kept doing it until he graduated in 1973. His grades were not good enough for college—his attendance had been steady, but his efforts had been directed toward having as much fun as possible—so he went to work as a pipefitter. And did well: Three years out of high school, he built a house a few miles to the west in Suffolk, in a little knot of suburbia still ringed by cropland and nurseries.

The same year, he married Deborah Jo Brantley, the pretty daughter of a prominent Portsmouth community leader. He'd met her through a friend of his who lived across the street from her, and had been smitten on the spot: She was two years older than he was, fun-loving and adventurous. It was a solid pairing. He had a good sense of humor, was quick to laugh, wasn't one for sitting around. They took up residence in the house, Savage's father in an apartment that Picot built into the place.

Debbie was a civil servant at the Norfolk Naval Air Station when they met, then moved to a civilian job at a big naval medical complex on the Portsmouth waterfront. In time she left government service for work as a florist at a nursery near Sid Pollard's boyhood home in Green Acres. The Chevy became her daily driver on the commute into town. It was Debbie whom Pollard saw in the car after selling it. He didn't

realize it at the time, but he knew her: The two had attended the same grade school and junior high, when she was still a brunette.

The Savages were unaware that the Chevy's power plant was soon to give up the ghost. Though nearly thirty years had passed since it was bolted onto the wagon's frame in Baltimore, that model of engine had proved itself a Chevrolet mainstay—one could still buy it new and, in fact, can still do so today. It was rumbling under the hoods of millions of cars. It was simple, tough, and seemingly indestructible.

Like the rest of the car, the engine traced its lineage to the decision to make over Chevrolet's dowdy image with the all-new 1955 model. The company's old-man reputation had snuck up on it: While Ford and Studebaker dropped V8s into their cars, Chevy had been content to limp along on its ancient six, its sales goosed along by Harley Earl's ever-changing styles.

GM officials woke up to the cost of this conservatism as Ford's share of the low-end car market crept upward in the early fifties. To inject new fire into Chevy's running gear, GM recruited an engineer who'd overseen creation of a new V8 for Cadillac a few years before—an engine revolutionary for its power, light weight, and zesty performance. Ed Cole was his name. In early 1952, he was running GM's tank plant in Cleveland, cranking out armament for the fight in Korea. The bosses offered him a ride back to autos as Chevy's chief engineer. He arrived that May.

So began a two-year race to reengineer the Chevy in time for the 1955 model. Cole junked all the work that had been done on the car and marshaled his people to conceive of a small V8 that didn't know it was small, an engine that would fit into a tighter space—and thus, a sportier car—but still snap heads with a stomp on the gas.

He and his team succeeded beyond all expectations, because just as groundbreaking as the '55 model's styling was the engine he built for it: a 265-cubic-inch V8 squeezed into a snug package, and lighter, stronger, and more efficient than other eight-cylinders. This was the

famed "small-block" V8 that would prove the wellspring for Chevy engines of various displacements until the nineties, which was produced ninety million times over, and which inspired those that still power GM cars today.*

Cast with a thinner husk than its contemporaries, the 265 weighed forty-one pounds less than Chevy's old six-cylinder engine, was structurally stiffer and stronger, and turned out 162 horsepower in its most basic form to the old motor's 136. Chevrolet called its '55 car "the Hot One" in its advertising, and that was a pretty fair assessment. Its engine delivered. And the small-block propelled Cole, along with the car: He became general manager of Chevrolet in 1956, and eventually rose to the presidency of GM.

By the time Nicholas Thornhill bought the wagon, he had more of Cole's handiwork to choose from. The company still offered the six-cylinder, as well as the 265. For the 1957 model year, however, it added a variant to the V8, the same small block rebored to 283 cubic inches of displacement. Like the 265, the Turbo-Fire 283 came with a choice of carburetors; with a standard two-barrel, it cranked out 185 horses, and with the high-performance and gas-guzzling four-barrel (dubbed the *Super* Turbo-Fire), 220. With two four-barrels, it posted an impressive 270.

And you could do better still. Underlining the company's drive to snare younger buyers, Chevy supplied that one especially forward-

*For those readers who feel lost amid automotive specs, let me step in here. An engine's size is measured not by its outer dimensions, but by what's inside. Most engines have within them four, six, or eight cylinders, which are smooth-walled spaces in which a snug-fitting piston slides back and forth. It's in these cylinders that a mix of gasoline and air is pressurized and touched off by a spark to create an explosion, and it's such explosions that blow the pistons down their cylinders and, through linkages called connecting rods, cause the engine's crankshaft to spin; that spinning shaft connects to other components to move the car. The portion of a cylinder through which the piston sweeps is called its *displacement*. Take that volume, multiply it by the number of cylinders, and you get the engine's size in cubic inches (265, 283, 350, and so on), liters (e.g., 1.4, 1.8, and 2.5), or cubic centimeters, which nowadays are mostly used to describe motorcycle engines (e.g., 750, 1000, 1200, etc.).

thinking option: fuel injection. The mechanical contraption was glitchy and expensive—it added five hundred dollars to the car's price—but it boosted horsepower to 283, achieving an automotive Holy Grail: a unit of horsepower for each cubic inch of displacement.

Nicholas Thornhill hadn't needed fuel injection. He probably hadn't needed a V8 for the puttering around town that accounted for most of his driving. But it was 1957's hearty and hallowed 283 two-barrel that resided under the hood of the Savages' wagon in 1987.

Homebound from a weekend NASCAR Winston Cup race in Richmond, with Picot Savage at the wheel, the Chevy overheated. Savage, who'd had a few beers at the track, wasn't in the mood to stop. The couple made it home, and over the next few days Savage narrowed the problem to a leak in the cooling system, though he didn't pinpoint its exact location; he kept the car on the road by frequently watering the radiator. But within a few days, Debbie and a friend took the wagon across town to the beach, and on the way back the engine exploded. It was clear to Savage that he'd be unable to fix it: When he popped the hood he found a broken connecting rod jutting from a hole in the oil pan.

The car sat outside the house for several months before he pulled the ruined power plant and dropped a bigger motor, a used Chevy 327, in its place. The replacement was a small block, as well, a descendant of the same engine that Ed Cole had introduced in the '55.

For a while, everything worked. But little things started to go wrong with the car, annoying things. The gas tank sprang a leak. Savage, now using the Chevy to commute to a new job across town, found that it drained dry while he worked. He'd have to carry a few spare gallons in a can every day, and replenish the tank before setting off for home. The Savages' relationship with the wagon thus ventured from the third stage of automotive ownership, companionable reliance, to the initial substage of automotive heartache—doubt, in which a car exhibits its first, seemingly minor betrayals of strength and endurance, and its owner is left to wonder whether his machine will perform as expected.

Savage epoxied the leaky gas tank, but then a wire in the starter pulled loose, so that nothing happened when he turned the key. He discovered that when he delivered several hard stomps to the floorboards, he jostled the wiring just enough to make a difference, and the car would fire up. You have to kick-start it, he joked to his coworkers, but it runs good. Just the same, the Chevy was now approaching 140,000 miles, and it chugged gas like a frat boy. The couple took to driving other cars.

The wagon sat unused in the yard for months. Its plates expired. The Savages' place wasn't junky, by any means—the couple took care of the yard and kept the house in good repair. Still, some of the neighbors were irritated by the sight of a derelict vehicle on the premises, and complained to the city. Suffolk officials gave the Savages a choice: License it, garage it, or move it. Savage was working at a private shipyard near the navy yard, so he drove the wagon there and left it in a parking lot.

Weeks passed. Somebody mistook the car for abandoned and came close to driving it away. After three years of ownership, the Savages concluded that their once-prized classic Chevy might be more trouble than it was worth.

STILL HAULING JUNK, Tommy Arney decided running a filling station wasn't for him. He opened a second business next door that seemed a better fit—a used-car lot, which dovetailed nicely with his junk trade. It went so well that with brothers Billy and Mike he opened a second lot, Arney Brothers Wholesale, in a declining part of town, and a garage, Arney Brothers Auto Repair, a few miles away. He leased and sublet a necklace of buildings to either side of the shop.

By the early eighties, Arney Brothers Wholesale had an arrangement with several new-car dealers to sell off their trade-ins. The brothers didn't make much per sale, but they sold a *lot* of cars—fifty, sixty, even

seventy on some days, most often to the many independent used-car dealers that catered to Norfolk's huge population of enlisted sailors. A few cars came onto the lot that Arney decided to keep for himself. So began his study of the classics. The restlessness that had spelled such trouble in his schooling manifested itself now in more positive ways, at least some of the time. The brothers worked deep into most nights, augmenting their auto trade with anything that would bring a dollar. They did some roofing, sold tires and rims, and started a business training guard dogs; they needed the animals themselves to patrol their car lot at night.

In his few hours of leisure, Arney found time for romance. His relationship with Krista deepened, even as he pursued trysts with a number of other women—a number that, by his account, was very large indeed. Krista sussed out his infidelity in 1980, broke off contact, and moved to Tampa, Florida, where her father lived. Arney turned up there and convinced her not only to take him back, but to marry him, which she did on November 21, 1980, afterward returning with him to Virginia.

He found time for more violence, too. One day in the office at Moyock Muscle, I notice that he's staring into space, a vague sadness in his expression. I ask him what's the matter. "I was just sitting here, thinking about my mama," he says, his tone dreamy. "I was thinking about this one time I was supposed to go to lunch with her—me and Billy and my brother Mike. We were going to Greater Grinders to have subs, and I had to whip somebody's ass."

This was a few months after he sold his service station to a man named Mike. Arney had agreed to leave the business's electrical account in his name to spare Mike the hefty deposit required of new commercial customers. He stressed that Mike couldn't be late with payments, as his own $3,500 deposit was on the line. Months later, Arney received notice from the utility that the bill had gone unpaid, and that his deposit would be used to cover the shortfall. Livid, he decided to pay Mike a visit. He told his mother that it couldn't wait.

I thought we were going to eat, Fern complained. We will, Arney promised, just as soon as I'm done. Okay, his mother said. Take Billy with you, in case there are more than a couple of them. And hurry. I want lunch.

A few minutes later, he and Billy pulled up outside the station, which Mike was operating as a used-car lot. Arney walked in. Mike walked toward him, waving some paper. Arney punched him in the face, knocking him into his office, then followed him into the back room and beat him so fiercely that Billy, worried he'd kill him, pulled his brother off the man twice. Arney shook Billy off, climbed onto the arm of a sofa, and jumped with all of his boot-clad 190 pounds onto the unconscious Mike's back. Then the brothers revived Mike, propped him into a sitting position in his desk chair, got the money to cover the overdue bill, and walked out. Mike declined to press charges.

"We got back, I guess, in about thirty minutes," Arney tells me. "Mama said, 'Are you ready to eat? I'm *hungry.*' I said, 'Sure.' I washed my hands and we ate a sub that day.

"Yeah." He pauses, looks into the distance. "Sometimes a guy will think about his mama."

Was it nature or nurture that made Tommy Arney the violent thug he'd become by his late twenties? Some of both, no doubt: When he was five or six, he says, he got his first inkling that whatever Fern's shortcomings, his family tree was a tangle of twisted branches and strange fruit. While spending the day with an uncle in Lenoir, Tommy failed to eat every potato chip in a bag he'd opened. Offended, the uncle pulled out his signature weapon, a bullwhip, with which he could pluck a cigarette from a pretty girl's lips without leaving a mark, if he so chose. In this instance, he intended to leave a mark. He made contact with Tommy's fleeing torso three or four times. The leather cracked like pistol shots.

Tommy spent the rest of the day a safe distance off, waiting for his mother to fetch him back to Lenoir. He was so angry and bewildered that while picking at the rubber sole of his sneaker, he accidentally

ripped it off. When Fern saw that, she overlooked the fact that her brother had bullwhipped her son. She beat Tommy, instead.

That was, it turns out, a rather low-key episode in family history, compared to many, many others. Some fifty years later I drive down to Lenoir, where I meet Arney's cousin Billie Ruth Bryant, daughter of Fern's older sister, Pauline. Billie Ruth and her husband, Steve, a twice-wounded Vietnam vet who's witnessed plenty of violence up close—but even so, is awed by his in-laws—offer an executive summary of the clan's congenital yen for bedlam. Such as the time aunt Ruby, according to family legend, disarmed a Lenoir cop and menaced the officer with his own sidearm. And the time two of Ruby's children soaked her in kerosene, resolved to setting her on fire, then lost their nerve and instead threw her from a second-floor balcony, breaking her leg. Or the fusillades Ruby exchanged with her children, visitors, and Arney's uncle Clyde—who's well into his eighties, Billie Ruth says, but still "carries a pistol in every orifice he has."

Such were the family values into which Arney was born, and this accounting deals the subject only the most glancing of blows. I've skipped the stabbings. A stand-alone book could be written about Ruby's husband, Colden Crump, who installed half a dozen locks on his bedroom door so that he could barricade himself inside when Ruby took to drinking white liquor straight from a mason jar, a reliable predictor of coming gunplay. A thousand lesser family disputes earn a chuckle from the survivors, such as the time Clyde slapped Ruby so hard she wet herself, and Ruby ran him down with her car in reply.

Roughhousing wasn't restricted to the maternal line of Arney's ancestry. When he was twenty-seven, a few years after Fern told him that Fred Arney wasn't his father, that the responsible party was really one Earl Thomas Green, Arney went down to Carolina to visit his dad. Green asked him for a loan so that he could pay a lawyer who was defending him against charges that he'd shot a man.

Given his kin's fondness for the scent of cordite, it shouldn't surprise that Arney relied on firearms from time to time. There was the night he

fired a revolver into the air to break up a roadside rumble that he and a buddy were losing against four marines (though not before he swung a heavy steel tow hook through one of the servicemen's cheeks); the time he signaled his displeasure at a malfunctioning jukebox by putting five bullets through the machine, then borrowing a customer's pistol and shooting it six more times in front of a horrified repair man—an act for which he received a two-month suspended jail sentence. A November 1984 parking lot hassle morphed into a chase through Norfolk's streets, during which the pursuing Arney put a few bullets into the other car. He received a misdemeanor conviction for that.

He came close to shooting a man who owed him money, too, a used-car dealer who'd shown no signs of paying up. Not long after Krista gave birth to their first child, Ryan, in 1982, Arney "woke up and I decided: 'I'm going to kill that motherfucker.' So I took a gun"—a .357 Magnum—"and I stuck it in the back of my pants." Krista saw the weapon and intercepted him as he crossed the front yard. Please come back inside, she begged him. Don't take that gun. She was crying. She held Ryan. Arney looked at her, looked at the baby, and "something just clicked in me," he says, "and said: 'Go back inside.'" He called the man, told him what he'd almost done. The fellow hurried to settle his debt.

Arney stopped carrying a gun for good in 1989, he says, after Bill Taliaferro warned him that as a felon, he was pushing his luck. He didn't much miss it. Violence was a means to an end for him, a salve to the anger that still roiled in his head and chest, and the relief and satisfaction he gleaned with his fists and feet dwarfed that which he might have experienced with the assistance of tools.

IN 1985, ARNEY again expanded his business empire: He bought a go-go bar called Elmo's, which occupied a low-slung cinder-block pile on Norfolk's west side, not far from the naval base. He joked to friends that he bought it because he'd been banned from every other tavern in town, and "was tired of drinking at the damn car lot," and

true enough, his fighting has made him unwelcome in many such establishments. But more to the point, he had contemplated owning his own joint since his days cooking at the Shamrock Inn, and he had frequented go-go bars even longer: In November 1971, while still holed up in the Sunoco, not yet seventeen, he'd strolled into a club with a fake draft card and a yarn about having pulled a tour flying helicopters in Vietnam. A girl was up onstage, wearing tasseled pasties. A glance her way made him a lifelong aficionado.

Part of the attraction was obvious. "I really liked go-go dancers," he explains to me. "These fucking girls wanted attention. They had to have people tell them they had pretty hair, and a nice ass. Needed people to tell 'em. But, I mean, I *did* love their asses."

So there was that. And, in addition, this: Most go-go bars rarely saw violence. They were among the safest drinking spots around, in fact, because their patrons were united in a common purpose. "If I went to a disco bar, I'd get into a fight, every single time," Arney tells me. "You're looking at a girl. She's got a nice, sweet ass on her. She smiles at you. You smile at her. Next thing you know, her boyfriend's coming over and saying, 'What are you doing, looking at my girlfriend?' And I'd say, 'I'm looking at her because she's got a sweet ass on her and a pretty face—what the fuck do you *think*?' And then he's throwing a punch.

"Won't happen at a go-go bar. I was comfortable in a go-go bar. I could relax there."

Arney renamed the place the Body Shop. He shut it down for a few days, scoured the interior, put in a new bar, hung signs, dressed it up. He built a menu around the titanic, one-pound Body Burger, and wired in a sound system loud enough to splinter kidney stones. He hadn't yet reopened the bar when one early afternoon a wiry laborer in his early thirties wandered in off the street and asked for a beer. Arney gave him one, and John Nelson McQuillen, a maintenance man at a downtown Norfolk bank, pretty much never left. He loved the Body Shop to the detriment of his job, which he lost, and his marriage, which

was already in trouble but soon fractured completely. Arney gave him a job as a doorman, then taught him how to cook.

McQuillen would prove an intriguing paradox—a high school dropout and a well-read autodidact with a headful of history, literature, and the scriptures; a biker whose forearms were engulfed in tattoo flames, but who could hold his own in polite conversation with just about anyone, on a surprising range of topics; a shrewd fellow, in most respects, with a weakness for dangerous women; and a man of uncompromising loyalty who rarely saw the numerous children of his past marriages and liaisons.

He was neither a neo-Nazi nor bald nor cut his hair especially close—in fact, he wore it in a mullet at the time—but one night at the Body Shop he asked Arney to buy him a beer, to which the boss replied: "Fuck you. Buy *me* one, you skinhead motherfucker." The impromptu label stuck, in part because Arney threatened to fire anyone in his employ who addressed McQuillen by his real name.

When Skinhead was reduced to living with his mother for a while, Arney phoned the house and asked for him by his new moniker, to which Mrs. McQuillen said: "His name is Johnny. I ought to know. I named him."

"Well, ma'am," Arney replied, "*I* named him Skinhead."

The two became inseparable. Along with a couple of sidekicks, they cruised around town in a blue limousine Arney bought, wore matching, floor-length fur coats, went dining and shopping with carloads of dancers, and spent long nights at the club and venturing out to after-hours joints when the Body Shop closed. It wasn't unusual for the pair to down a case of beer in an evening, as well as a couple of bottles of hundred-proof Rumple Minze. Sometimes they slept on the go-go bar's pool tables; Arney eventually built an efficiency apartment on the club's second floor, where he crashed by himself or with members of the staff.

Often as not, the latter was the case: He was a big guy with huge biceps, an aura of friendly menace, and an electric smile, and his dancers

were drawn to him as surely as he was to them. "I would just take my pick," he says. "There were some days I was a little slack—I was with two. But most days I was with four, five, six different women.

"When I walked into a room anywhere, the women seemed to be attracted to me. I was fun. I was funny. I was wild as a motherfucker. I was crazy as a bitch. I was a fun motherfucker. I'd slap a guy and knock his teeth out, then go out in the parking lot and get a blow job."

He and Krista had been a couple for almost ten years when he bought the Body Shop, and he owed much of what was good about his life to her. Their son was nearing the age when he'd be ready for kindergarten, and they'd had a daughter, Ashlee, in 1984. His wife had proved a faithful business partner: Because he'd stolen that safe, Arney had a felony conviction on his record, and the commonwealth of Virginia was therefore disinclined to grant him a liquor license; the Body Shop's paperwork was in Krista's name. Just the same, Arney stayed away for days at a time, leaving her to care alone for the kids. On those days he did make it home, he spent most of his time sleeping. Twenty years later, Ryan's sharpest childhood memories of his father have him crashed out on the sofa.

Finally, things between Arney and Krista came to a head, and he told her that he couldn't help his behavior—he hoped she understood, he recalls telling her, but he had to be with other women. He didn't understand it himself. Krista replied that if he couldn't control these urges of his, he'd have to leave. She came by the Arney Brothers car lot with his clothes.

NOWADAYS, ARNEY TALKS about that period as "the olden days," and his behavior at the time as "the old Tommy Arney." The old Tommy Arney didn't brook any challenge, any sass, the slightest whiff of discord—or, for that matter, a wayward glance, a dancer touched, or a laugh too loud. He never fought in his own bar; the Body Shop's

parking lot thus saw a lot of scores, real or imagined, settled in the quick and brutal style for which he was renowned. After closing, when he and Skinhead ventured to other bars, he'd fight indoors, with resulting damage to property.

Each member of the crew has his or her own "greatest hits" list of Arney's mayhem. Virginia Klemstine, who was twenty-one when she started dancing at the Body Shop in 1986, recalls the night Arney faced off with a man outside, punched him into a daze, then announced he was going to give the "motherfucker" something to "remember me by"—and grabbing him by the head, bit deep into the man's neck, ripping away a divot of flesh and muscle. After he'd chewed and swallowed it, he asked Klemstine for a toothpick.

That was the only time he actually metabolized an opponent, though he bit several—he incised the tip from one unfortunate man's nose, gouged a second neck, latched on to ears. But he preferred sharp blows. He was generous with concussions.

Skinhead was present for one storied rumble at an after-hours club, sparked when a patron assaulted a Body Shop manager with a folding metal chair and Arney launched a counterattack on the dance floor. His adversary had backup; in seconds, it was Arney versus an army, which he dispatched, one by one, with kicks and punches. The club's staffers tried to intervene, but he'd entered that lizard state that tracked any movement as hostile, and he laid them out, too. Skinhead says that at one point, twenty-three of his opponents were down. Arney testifies that at least a dozen were knocked out cold.

Skinhead was on hand the night a Body Shop manager got into a fistfight with a lightning-fast navy boxer, and was on his way to defeat when Arney took over with the drawled announcement: "Let me show you how this is done." He beat the boxer with his fists, knocked him senseless against a standpipe, then ground out a cigarette on the man's head. On another night, Skinhead watched Arney beat a man over the head with a motorcycle helmet until it broke.

And both Klemstine and Skinhead were witness to the infamous power drill incident. Klemstine was working behind the bar when Arney asked a Body Shop regular named Jimmy to gas up her Trans Am at an Exxon station across the street—Klemstine had volunteered to run an errand for Arney, but had no gas. He gave Jimmy the keys and twenty bucks, and watched as the man left with a buddy.

Time passed—forty-five minutes or better—before Arney realized that Jimmy hadn't reported back. He found him skulking in the back of the bar. Jimmy, he said, why didn't you tell me you'd returned? Well, Tommy, look, Jimmy said, there's been an accident—I was at the Exxon station when a driver lost control of his car as he passed the place, and his car jumped the curb and ran right into the Trans Am while I was standing there, filling the tank.

Let's go look at the car, Arney said. He followed Jimmy into the parking lot. The Trans Am's left quarter panel was crumpled in such a manner that Arney knew instantly it hadn't been hit by another car: The damage ran vertically, as if caused by a pole. Jimmy, he said, do you want to tell me what really happened to the car?

I'm telling the truth, Jimmy insisted.

Arney sat Jimmy in the bar's back room and dispatched Skinhead to the Exxon station; he returned a few minutes later to report that no one had seen an accident on the premises. Jimmy stuck to his story. Arney, growing impatient, sought out Jimmy's friend and suggested that telling the truth was the healthiest option available to him. The man agreed. Jimmy, he said, had been attempting to spin doughnuts in a nearby parking lot when he'd lost control and smacked the rear end into a light standard. Arney bought the man a beer and returned to the office. I'll give you one more chance, he told Jimmy. What happened to the Trans Am?

Tommy, he replied, I swear on my mother's life that it happened the way I said.

At those words, Arney lost his temper. He slapped Jimmy uncon-

scious, woke him up, again asked him for the truth—and when he didn't get it, knocked him out and scanned the room for a tool to better hurt him with. His eyes fell on a Black & Decker cordless drill, bought earlier that day and charging in its cradle. The bit kept grabbing Jimmy's blue jeans as he drilled into the man's kneecap, so Arney abandoned the knee for Jimmy's skull. Fortunately for all involved, the bit wasn't up to the task.

Arney relates such stories with a mixture of wonder and regret. He does not miss the old Tommy Arney: "My dumb ass thought that if a motherfucker disrespected me in any way, I had to fuck him up," he tells me. "If you talked about Tommy Arney and I found out about it, I was coming. I'd break your nose or knock you out.

"Whatever bar I walked into, I don't care where it was, people moved out of the way," he says. "I thought people respected me and liked me." He shakes his head. "They didn't like me. They were scared to death of me."

Perhaps the most troubling facet of the old Tommy Arney was what he didn't do, rather than anything he did. He was a generous father, lavish in his celebration of Christmas and birthdays, and he spoke on the phone with his wife, Ryan, and Ashlee almost every day. He was not nearly so consistent in his physical presence, however. Ryan would wait for him out in front of the family's town house, which sat on a suburban cul-de-sac; a street sign stood at the mouth of the street, and he'd turn circles on the pole while maintaining a lookout for approaching cars. Sometimes Arney would arrive and bundle the kids off to see *Disney on Ice*, or a tractor pull, or pro wrestling. Sometimes they'd go stuff themselves at Piccadilly Cafeteria, see a movie.

Sometimes Ryan would stand out at that street sign for hours, wondering where his big, loud, two-fisted dad was, until Arney showed up hours late, contrite and eager to please.

Sometimes, Ryan says, his father wouldn't show at all.

ANY AGING MACHINERY requires maintenance of steadily in-
creasing breadth and intensity; parts wear out, protective coatings
break down, rubber gaskets oxidize and crack. This happens no mat-
ter how diligent, how devoted the upkeep; an old car will require a
steadily increasing quantity of work, and a similar increase of money,
simply to maintain its current condition, however lacking that condi-
tion might be.

Let the attention slip, and decay asserts itself with mathematical
surety, its vigor at first proportional to the duration of neglect, but
compounded as that duration proceeds, so that a car's disintegration
becomes an exponential proposition, accelerating as it goes. Charted,
decay is parabolic, the downward slope of the line steepening as it
moves to the right, eventually turning vertical—at which point, the
damage is complete.

So at thirty years old, the Chevy had arrived at a critical juncture,
for it required a sixth owner equipped to meet its mounting needs.
Enter Mary Elizabeth Byrum Ricketts, a thirty-six-year-old divorced
mother and coworker of Debbie Savage. When Debbie mentioned
that she and Picot were thinking about selling the wagon, Ricketts
knew next to nothing about cars except that she'd be thrilled to have
that one. What's more, she lacked the wherewithal to retain expertise
elsewhere: She teetered close to the financial abyss, and traveled a far
wider orbit from the cultural center—that easygoing, no-worries, spic-

and-span ideal that the wagon had once represented—than any of her predecessors.

Ricketts knew the Chevy was a dicey choice of vehicle for the daily commute to and from her home, which was miles farther out in the sticks than the Savages' place. She knew the $1,500 asking price would stretch her. She knew that she'd have trouble meeting the inevitable repair and maintenance bills. But Ricketts was not a slave to conventional thinking, careful decision making, or, truth be told, good judgment. She was a hippie chick, a rock-and-roller, an eccentric, a free spirit who dyed her hair maroon and laughed louder than was polite and collected bowling shirts, who wore cat-eye glasses and flamingo earrings decades after they were popular and long before they cycled back around. She had no desire for the suburban ideal of old, of her parents. Screw middle-class respectability and perfect lawns: She adored the car because to her it represented the opposite, the pursuit of fun. The Chevy was cool not because of what it did, or the image it conveyed, but because it just *was.*

And oh, it was beautiful, and outsized in every respect—the exuberance of its chrome, the billowing hood that rose as high as her chest, the acres of curving glass. The rearview mirror offered a study in one-point perspective, the sides and ceiling of the car narrowing to a back window an impossible distance away. It would be handy, she reckoned, to have a backyard storage shed she could take wherever she went.

So it came to pass that early in December 1987, Ricketts sat in the Savages' kitchen, writing them a check. She left their place feeling that she and the machine were meant to be together. On the way home, she noticed that every guy she passed in traffic looked her way. "Damn," she thought. "You must look really good today."

A quick CV of the car's new owner: Born in September 1951, the third and final child of North Carolinians Roy Britton Byrum, career employee of a Budweiser distributorship, and deeply religious Sara Chappell Byrum, homemaker. From all indications, an unexpected

baby—her sister, Sandy, was six and a half years her senior, and brother Don, eight. Raised in a house-proud, working-class neighborhood in Norfolk. Father had a yen for stylish suits and cars, the latter of which he traded in for new models every year or two; an early snapshot shows first grader Mary standing at the front bumper of a gleaming '57 Plymouth.

Church camp each summer. Smart, musical, and artistically gifted in school. Learned guitar. Lovely singing voice. Closest childhood friend: Mary Jo Rothgery, aka Joey, who lived across the street. In junior high, the two were entranced by the Beatles. Mary was taken with John Lennon, and baked a cake every year on his birthday; Joey preferred Paul McCartney. They drifted apart while attending different high schools.

New best friend: Marianne Holmes, fellow member of Norview High School's class of 1969. She and Mary often skipped class to smoke joints on the school grounds, with the expected effect on their grades. Mary had a sharp eye for design, fashion, and color, however, and planned to pursue an education in the arts. She advertised her creativity with her clothes—bell-bottoms, jeans she embroidered herself, fringed jackets. With her long, straight hair parted down the middle, her high cheekbones and strong chin, she looked like an almost-too-pretty Hollywood take on the counterculture.

In 1967, Mary's father died. For the next two years, she and her mother shared the family home. It was a stressful existence for both. Seeking escape, Mary spent much of her time in the company of musicians—in particular, one Wellington I. Clements III, nicknamed "Wic," a prodigy who taught himself to play piano in an afternoon and within a month was tackling difficult Chopin pieces. Clements played guitar, too; he and Mary wound up in the same band.

In the spring of 1969, Mary learned she was pregnant. Her mother, horrified, booted her out of the house. Mary and Marianne Holmes moved in with another girl, sharing a crumbling Norfolk apartment a couple of blocks from the old Colonial Chevrolet showroom. All three

slept in the same bed. They ate cereal at every meal. Cockroaches were so abundant that the girls discovered them inside the handset of the telephone.

That summer, Wic Clements asked a close friend's fiancée, Charmaine Bryant, whether she might have room in her two-bedroom apartment for his pregnant girlfriend. Bryant refused to consider it. A few weeks later, Clements appeared unannounced at her door, Mary beside him. The girl told her that she planned to put her baby into foster care shortly after its birth, and to reclaim the child after she built enough of a life for herself to support it. Bryant doubted that she could pull it off, but was so moved by Mary's sincerity that she agreed to put her up.

Mary shared the impending birth with her childhood friend Joey in an early November letter, backing into the news with a brief discussion of Paul McCartney's rumored death. "I been wanting to tell you something for quite a while but it's an awkward thing," she wrote in green ink. "Remember Wic the guy I used to sing with. Well, I'm gonna have a kid in 3 weeks. By the way are you sitting down??!" Her baby boy arrived right on schedule: December 3. Mary named him Britton Wellington Byrum. She and Marianne Holmes thought the name romantic, like that of an English poet.

As planned, she put Britton in a foster home. She landed a job making subs at a takeout place, to which she commuted by bus. After several months, she brought the baby home; she cared for him by day, and Bryant, who pulled a nine-to-five shift as a civilian at the Norfolk Naval Station, took over when Mary left for work. Wic Clements visited Britton once or twice, but was not transformed by the experience; in short order, he eloped with a sixteen-year-old girl from Mississippi. Mary was bereft.

Fast-forward to an evening a few months later, when Billy Ricketts, high school senior and member of an acoustic quartet, was transfixed by a striking young woman singing and playing guitar in a Portsmouth coffee shop, her repertoire a fusion of folk and blues. He returned with

his bandmates, who were likewise impressed. They invited her to join them. They added a bass player, traded their acoustic instruments for electric, and called themselves Britton.

The band played outdoor festivals, clubs on the naval base, and coffee shops, most of its set consisting of Crosby, Stills, Nash & Young covers. One of its guitarists, Barry Scott, would later gain some fame with a national act called the States. But it was the other guitarist, Billy Ricketts, who made a bigger impression on Mary; when she left the band after a year, they were a couple.

Impressions of the maturing Mary Byrum, courtesy of her friends and family: Fearless. Foul-mouthed. Outspoken. Outrageously funny. Willfully foolish. Unfazed by stares. (A favorite saying: "What are they going to do, take away your birthday? What's the worst that can happen?") Spectacularly creative—when she moved out of Bryant's apartment and into her own in the fall of 1971, she took command of the space, made it remarkable, a feat she'd pull off everywhere she lived.

She answered an ad seeking a "groovy" person to work at a vintage clothing boutique in downtown Norfolk. Got the job. A snapshot from the period depicts a willowy Mary, hair in braided pigtails, strolling past the shop while wearing overalls fashioned from empty burlap sacks of Jim Dandy brand hominy grits. Years later her boss recalled, "She was certainly groovy."

Next door to the boutique, and owned by the same couple, was a florist shop, the Sunflower, to which Mary eventually moved. She would make her living from flowers for the next thirty-five years. She and Billy Ricketts married in December 1973. Billy adopted Britton, and they changed the boy's name from Britton Wellington Byrum to Britton Byrum Ricketts. The family moved into a house in Norfolk and, when Billy's aunt died, bought her place across the river in Portsmouth.

Still working at the Sunflower, Mary opened a vintage fashion store of her own, Ole Time Clothiers, in a working-class neighborhood not far from where she grew up.

It didn't last long. On its demise, she sold her stock to one Carrie Ziegfeld, who had her own shop on Colley Avenue, within a few yards of the Sunoco station where Tommy Arney lived a few years before, and facing the Oar House, where he still moonlighted as a bouncer. The women became fast friends. To Ziegfeld, Mary was "Mur," and Ziegfeld became "Cur." She joined Mary at the Sunflower, then opened her own flower store; the two later bounced among several Norfolk floral companies. They danced often at the Oar House, and for a while Ziegfeld waited tables there—so it's no stretch to imagine that Ricketts and Arney might have met long before either bought the car.

As Mary entered her thirties, the challenges of her youth had grown distant and hazy. She and her family lived in a comfortable home. She enjoyed her work with flowers. Her son had inherited her creative streak, and was blossoming as an artist. Billy relished his role as stepfather, and stayed in shape by playing in a night baseball league.

If it wasn't the suburban ideal, it wasn't far from it.

THE FIRST TIME Mary Ricketts's friends saw her behind the Chevy's wheel, they reacted much as she had on her drive home from the Savages' place: She and the car seemed a natural partnership. Here was a woman who decorated her home in bobbleheads, who'd long incorporated retro touches in her wardrobe, who played Roy Rogers yodeling tapes over the PA at work. Who, when stress caused her hair to thin, fastened a fake eye to her scalp and asked a friend to check her head for the source of an itch back there.

And who could be impetuous, sometimes to the point of brinkmanship. She had demonstrated as much in the foregoing two years, because by the time Ricketts bought the Chevy her life had again seen dramatic change: With little warning, she had bolted her Portsmouth home—and Billy and Britton—for quarters in Eclipse, a fishing hamlet on the James River, ten miles to the west. Her impetus was a young

man she'd come to know on weekend visits to the village—a good-looking fellow, lean and muscled, with a Tom Selleck mustache and, more important to Ricketts, a quick and comic wit. She'd fallen hard for him. "Cur," she'd told Ziegfeld shortly after leaving her husband, "you know how it is when you realize you're not with your soul mate."

Ricketts rented a converted garage not far from the water, and in time moved into her beau's riverfront rambler. She immersed herself in Eclipse's insulated, hard-partying culture, and her boyfriend's circle of friends embraced her with equal gusto: Queen Mur became central to boozy, laugh-filled weekends of play on and near the water, of blue crab and cold Coronas and Bob Marley on the box.

The wagon seemed Detroit's ode to beach parties, so it, too, earned a key role in sun-soaked Eclipse afternoons, and—no surprise—was the most obvious vehicle in the village from the first day she drove it in; the Chevy didn't exactly recede into the background, there or anywhere else. It was missing its clock (which had been replaced with a cheap plastic digital model, affixed to the dash with an adhesive strip) and one of the chrome strips down its flanks (which the Savages included, unattached, on selling the car), but was otherwise intact and smart-looking at thirty. Strangers waved, nodded, smiled as she passed.

Ricketts adored it. And despite all the minor annoyances the Savages had suffered with the Chevy, it didn't give her any reason to feel otherwise, at first. It proved a reliable ticket to and from work. It was so fast that when Ricketts dared to floor the gas, the roar and thrust of the powerful 327 under the hood and the sensation of so much hurtling bare metal thrilled and terrified her, and she never did it again. It gulped down gasoline but in other respects was ideal for road trips, including memorable journeys down windswept two-laners and a rough-water ferry to Ocracoke, an island on Carolina's Outer Banks. She'd materialize at Ziegfeld's place to take her on "mystery rides," their destination unknown to both of them.

Britton, who eventually joined her in Eclipse, called the wagon "Godzilla." Her friends called it "Dinosaur" and "Sweet Pickle." Ricketts tended to talk about it as if it were alive, akin to a pet; in a snapshot taken in Eclipse, she lies, smiling, on her side across the car's hood, head supported on a fist, a couple of dogs cavorting around the front bumper—Mary with friends.

Ricketts imagined the Chevy would be a fixture in her life right up to her death: When depressed, she and Ziegfeld talked about ending it all in the wagon, in the style of Thelma and Louise, the movie heroines who committed onscreen suicide by launching a 1966 Thunderbird convertible into the Grand Canyon. They worried that the '57 was too stoutly constructed, however, and that they'd end up alive but crippled.

That was an illusion, as Ricketts came to see. The Chevy hadn't been garaged for four years when she bought it, and now spent another five-plus in Eclipse without protection from the weather, and without the sort of slavish maintenance any car of its age required. Rust again bloomed along its sills, around its rear hatch, behind the wheel wells. It sprang up on the rocker panels, first as innocuous sprinkles, then gnawed hungrily into the passenger compartment's metal floor, its progress obscured by carpet and seats.

Decay wasn't the only force working against the wagon. Ricketts and Britton were crossing the long U.S. 17 bridge over the Nansemond River one day when the hood suddenly flew open and crashed against the windshield, scaring the wits out of both of them. The hood was ruined; Ricketts scavenged a replacement from a six-cylinder '57, which lacked the wide, chrome V that advertised a V8. Other mishaps came along: As big and heavy as the wagon was, it was a chore to maneuver at low speed, and Ricketts backed it into a telephone pole on one occasion, and banged into equally stout objects on others, so that it acquired dents and a crinkled left fin.

Then, round about 1992, the running gear began to announce its age with surprising and inconvenient failures, and Ricketts's relationship

with the Chevy departed the third stage of ownership (companionable reliance) and reentered the fourth (heartache), and its first substage, doubt—which, you'll recall, the Savages had experienced in the closing days of their tenure with the car. It was still a reliable means to get to work and other nearby destinations, but Ricketts could no longer trust it for impromptu ventures out of town.

Worse, her long relationship with her boyfriend betrayed some mechanical flaws of its own. No need to belabor them here; suffice to say that Ricketts moved out of Eclipse and into a big house in Norfolk owned by a close friend, Julie Hill. A few months later, her boyfriend begged her back and she went, only to leave again. She was heartbroken by the split. Never bashful around the bottle, she now drank with ambition. On one occasion, a drunk Ricketts took a spill and blackened her eye.

Her return to Julie Hill's home brought the car to within a quarter mile of Colonial Chevrolet's old corner, which was now occupied by an Exxon filling station. Hill nursed Ricketts's wounds for several months, until the patient decided she was ready for her own apartment and found a place about a mile away.

It made for a far shorter commute to the discount floral supply company where she worked, which was fortunate, because once she'd settled in, the Chevy seemed to require attention continuously. She took it to a family-run garage on Colley Avenue, on a stretch a little south of Tommy Arney's old stomping grounds—a shopping district of funky boutiques and restaurants clustered around a repertory cinema. The wagon was there so often that it became something of a landmark as it awaited repair on the lot. In fact, it got so that the car sat there more than it didn't.

Her relationship with the Chevy thus entered the second substage of automotive heartache—disappointment, at which point a vehicle's owner feels a growing sense of dread at the outset of every task to which she subjects it, because said vehicle all too often fails to meet the

demands of said tasks, and at about which point an owner launches a committed search for a replacement.

Unfortunately, there wasn't much that Ricketts could do about her situation. She couldn't afford a new car, and had little money to devote to the wagon: Her best year in the flower business yielded $33,000, and most others saw her earn well under $25,000. She scrounged together enough to make stopgap repairs, the minimum necessary to keep the car mobile, and sometimes not even that. The car spent many days on the garage lot, awaiting her next paycheck.

In the space of two short years, her beloved wagon had gone from her most prized possession, a rolling embodiment of her style and personality, to a source of anguish. Ricketts and the Chevy now teetered at the third and final substage of automotive heartache, that being disgust, from which all but a tiny few such relationships never recover. An alternate label for the substage might be "abandonment," for it's at this point that a vehicle amasses so many blemishes, so many hurdles to its continued viability, that its functional value is dwarfed by the outlay necessary to achieve its function, and it thus attains greater value as scrap than transport. Automobiles that have reached this substage outnumber those in any other stage, if not those in all the others combined. Our curbs, yards, and farm fields are busy with rusted-out automotive fossils. Our cities are dotted with junkyards piled with their remains.

One day in April 1994, when the garage again had the Chevy for repairs, its owner, an old-timer named Joe Scalco, called Ricketts to say that a fellow he knew had a car for sale, a 1979 Buick LeSabre—not an inspirational piece of engineering, but a spacious sedan in good condition, running strong. You might want to check out this car, he told her. It might be time to quit fooling around with the Chevy.

Ricketts went over for a look and drove the LeSabre home. Scalco parked the '57 at the edge of his lot, its nose pointed toward traffic, its turquoise hull visible to theatergoers, window-shoppers, and dog-

walkers. That's where it was when Alan Wilson and Al Seely came rolling down Colley Avenue and Seely announced: "We *have* to get that car."

TOMMY ARNEY WAS doing well. The Body Shop treated its military customers with particular appreciation, cultivated students from the college up the street, earned a large cadre of regulars, and he packed the place most every night. He did so well that some of his dancers—whom he shared with other clubs, for an exotic dancer never got sufficient stage time at any one venue to earn her keep—had been told by his competitors that if they continued to work at the Body Shop they'd not be welcome elsewhere.

The solution was to control more stages, so that he could keep the dancers for himself. Moving quickly, Arney opened a second club, the Body Shop II, just outside the gates of the Little Creek Naval Amphibious Base, home to thousands of sailors. In a short while he took over a third bar, a dark nook that shared a roof with a sagging duckpin bowling alley, halfway between Little Creek and the main naval base. He was Norfolk's king of go-go, with the nicest clubs and the prettiest dancers in a city stuffed with the navy's enlisted, all of whom had cash to spend.

He was surrounded by more women than ever. The old Tommy Arney loved them all, and he often commandeered the DJ's booth to profess that love over the PA: A dancer would take the stage, and Arney would sigh into the mike, "Dang, girl," or "Lawd, lawd, lawd," and exhort the sailors and students to reward the lady's charms with generous tips. He cajoled customers into buying meals for themselves and the talent.

The money rolled in and life was good. It bore no resemblance to Ozzie and Harriet's, but it suited Arney fine. Until one morning he lifted his right arm to apply deodorant and noticed a lump under the

skin of his armpit. He did nothing about it for a couple of months, during which it grew in size—and in his thoughts—until he was worried enough to mention the knot to Bill Taliaferro. The lawyer was immediately concerned; he took Arney to see his own doctor, who examined the lump and announced he'd have to run some tests, including one for AIDS.

Being busy and barely literate, Arney had not kept up with the medical literature, and was under the impression that AIDS was a disease restricted to Haitians and gays. You don't need to run no AIDS test on me, he told the doctor. I'm a goddamn cowboy.

That may be, the doctor replied, but you need the test. He explained the illness to Arney, pointed out that in terms of raw numbers, it was now most often transmitted among heterosexuals, and as he spoke Arney realized with a growing horror that he was a prime candidate. He'd been having indiscriminate sex with exotic dancers for years.

He agreed to the test and left the doctor's office in a panic. He couldn't sleep. Couldn't eat. He couldn't even fight. When, after a week, he returned for the results, it was in an almost paralyzing state of dread and fear. The doctor leaned back against his desk, folded his arms over his chest, and told him: We have a problem.

How'd that AIDS test come out? Arney blurted. Before the doc could answer, he added: Please don't tell me I have AIDS.

No, the doctor said quietly. You tested negative for AIDS. But you have cancer.

Arney was ambushed. He had not seen the blow coming, and it staggered him. When he had recovered from the shock enough to mold a coherent thought, it was of his kids: He would have to make things right with them.

But not right away. First, he went out and got drunk—drunk enough to forget, however briefly, that at thirty-two he finally faced an opponent that stood a good chance of whipping his ass. Drunk enough to get through the day, and to sleep for at least two or three hours a night.

Which is to say, very drunk, indeed—and he stayed that way for weeks, all the while ducking calls from the surgeon to whom the doctor had referred him.

But the lump kept growing, until he could feel it there, all the time, pressing against the muscles of his arm and chest, and he realized he could no longer put off doing something about it. He called the surgeon. They agreed that he'd undergo a procedure to remove whatever was growing inside him, with one proviso: Arney wanted to be awake and aware throughout the operation. No way, he told the doctors, was he going to be knocked out. He was persuasive. The surgical team strapped him to an operating table and, using only local anesthesia, cut into his armpit. They removed two tumorous lymph nodes from his chest. Each was the size of an egg.

The incision had to be left open for a couple of days while the wound drained; the doctors told him he'd be staying in the hospital for the interim. But lying in bed several hours after surgery, Arney grew restless. He had been too busy for too long to do nothing, so he got dressed and drove over to the Body Shop II for a beer and an eyeful.

And as luck would have it, he got into it with a patron and had to use his right fist to knock the man out. His incision tore wide open. A tube inserted in the wound to facilitate the draining process erupted in bloody spurts. Arney walked next door to a 7-Eleven to "find something to stuff up in the hole," as he put it, and threw the store into hysteria; the tube was firing long jets of blood from Arney's armpit with each beat of his heart, and it was running down his side, his arm, getting all over the floor. In minutes, cops and an ambulance screeched to a halt in the parking lot. Arney stepped outside as a cop approached with the words: Sir, you've been shot. We need to get you some help.

What? Arney said.

We're here to take you to the hospital, the cop said. You're in shock. Just stay calm.

What the hell? Arney said.

Sir, pay attention, the cop told him. You've been shot.

No, no, no, goddamn it, Arney said. I haven't been shot. I had a god-damn operation this morning.

THE BIOPSY CAME back: Arney had Hodgkin's disease. He and Krista went to see an oncologist, who told them it was an aggressive variety of the cancer—very aggressive—and that he'd need to operate immediately to determine what stage it was in. Arney was against an-other surgery and said so. The oncologist replied that it was vital: He had to extract Arney's spleen, an examination of which would reveal much about the disease's progress; that would determine the levels of chemotherapy and radiation necessary to combat it.

What would you do, Arney asked, if you went in there and it was just the scariest shit you've ever seen? What would you do then?

The doctor replied that he'd embark on a Stage Four regimen of chemo and radiation.

Tell you what, Arney said. You just pretend that I have Stage Four cancer, and give me the treatment for that.

You don't want Stage Four chemo if you don't need it, the oncologist said. Please, believe me.

That's what I want, Arney told him.

Okay, cowboy, the doctor replied. And so Arney underwent an ex-treme chemotherapy regimen. It was evil business: Its name, MOPP, was an acronym of four agents—mechlorethamine, Oncovin, predni-sone, and procarbazine, each nasty in its own right, i.e., mechloreth-amine, a "nitrogen mustard," a variant of the stuff that blinded and blistered thousands of soldiers in World War I. For forty-five minutes every two weeks, Arney would watch the drugs drip into his arm from an IV bag, and the second the mixture made contact he could feel his insides tingle; twenty minutes later, he'd start vomiting and he wouldn't stop for a full day, sometimes two. His hair, which had tum-

bled to his shoulders, started falling out by the fistful after the second treatment.

He didn't want anyone to see him sick or vulnerable, so he checked into a Holiday Inn for a few days after each session. He worked out a routine with the housekeeping staff: He'd take a cab over from the hospital and they'd be waiting with the door open and a room ready, and the second he reached it, he'd be heaving. He slept on the bathroom floor. He could smell the chemicals leach from his pores as he lay beside the toilet.

It was down on that tile, he says, that the old Tommy Arney died, and the new was born in his place. "I had not realized what pain and hardship I'd brought to other people. Chemo was my wake-up," he tells me. "I just wanted people to respect me, but I went about it the wrong way."

The transformation was not instantaneous, however. Observe the periods between his chemo sessions, when a new Tommy Arney might have sought plenty of rest, good nutrition, and a safe, nurturing environment. No, sir: That did not occur. He was at the Body Shop one night and a fellow required some course correcting, so Arney walked him outside and punched him in the face. He cut a knuckle on the man's tooth. The next day he was in to see his doctor, who saw the cut and asked what he'd done to his hand. Arney told him about the fight.

See here, the doctor said, you can't do that. You're undergoing chemo. Your immune system is completely suppressed. You get an infection, and it might kill you.

So, what do you want me to do? Arney asked him. Not fight?

You don't have a choice, the doctor said. It is a matter of life and death.

So if somebody fucks with me, I have to walk away? Arney said. I can't do that.

The doc peered at him for several seconds before offering: What if you were to slap instead of punch?

Slap, Arney said. Like, with an open hand. Seriously.

You'd be less likely to cut yourself, the doctor said. Do you think you could slap somebody and still get your point across?

The answer, as demonstrated on dozens of occasions in the months that followed, was yes. Arney so perfected his technique that he could knock out an opponent with a single, terrible slap to the temple. He was charged with ten counts of assault after a 1988 barroom fracas in which he beat a man in the head with a billiard ball, judo-flipped the man's girlfriend, and, per the doctor's orders, slapped eight or nine other people to the floor with his open hand.* In a memorable show-down at an after-hours joint, Arney advised a belligerent bodybuilder that he planned to slap him not only out of lucid thought, but out of the flip-flops he wore. The man replied that he'd like to see Arney try. He woke up barefooted.

Meanwhile, Arney came to feel so ravaged after weeks of chemo, so depleted and poisoned, that new or not, he abandoned the treatments. He got drunk and stayed that way for several weeks, until Bill Taliaferro came to see him, said he'd heard that Arney had quit the regimen. His old friend convinced him to go back to the hospital, where his oncologist urged him to take another treatment immediately. Arney replied that he didn't think he could do it. Well, son, you have to, the doctor said. Because if you don't, you're going to die.

Arney continued to waffle, until the doctor asked: Do you have a gun at home?

No, Arney replied, which may or may not have been true.

Because you do not want to die of Hodgkin's disease, the doctor said. It is a grotesque death.

Arney changed his mind.

* In court on September 14, 1988, an opposing attorney suggested Arney was lying when he said he'd slapped his adversaries unconscious, that surely it couldn't have happened that way. "How about I slap you," an annoyed Arney growled, "and show you how it's done?" The judge warned Bill Taliaferro that if he didn't control his client, he'd hold both of them in contempt.

9

ONE SATURDAY MORNING Arney telephones me to ask whether
I'll be stopping by Moyock Muscle. He adds that it might be worth my
while because he'll be there himself, "handling" an "interesting situ-
ation" involving a Navy SEAL who has called him a "fucking pussy."

For all his talk of being much changed from the olden days and the
old Tommy Arney, he can't let such a transgression go unaddressed, es-
pecially seeing as how this is his fifty-fifth birthday. "At first, I was go-
ing to let Skinhead deal with it and not get involved," he tells me, "but
then I got to thinking about it and I thought: No, I don't think I like
the idea of this guy calling me a fucking pussy. Not on my birthday.

"I'm going to be the new Tommy Arney in dealing with him," he
adds, "but I'm going to incorporate some of the old Tommy Arney in
those dealings."

I drive to Moyock Muscle.

While we wait for the SEAL to arrive, Arney shares his side of what's
provoked the coming confrontation. The SEAL, a fellow named Rick,
purchased an electric blue, metal-flake '58 Chevy pickup from the lot.
The sale was contingent on Arney's getting the truck running, which
he did. As a friendly gesture, he says, he further offered to replace the
truck's brakes and thermostat, and to pressure-test the radiator to en-
sure its integrity—all for the cost of parts; no labor.

A day after the sale, Arney got a call from Slick, who told him that
Rick's check was no good: He'd written it for $8,645—the purchase

price plus applicable taxes—in the little box, but for "*one* thousand six hundred forty-five" on the accompanying line. Arney called Rick. The SEAL apologized profusely, agreed to meet Slick to make it right, and did so with a new check. But then, Arney said, something odd happened: Rick called him back and said: We have a problem. Arney said, What, partner? And Rick said: You have nine thousand dollars of mine, and I don't have a title.

This was true enough. Arney was in the process of getting the title, either from the former owner or in duplicate from the state Department of Motor Vehicles. He didn't expect it to be an issue. But this standard approach, which Arney had followed on scores of past occasions, didn't suit Rick, who announced: If you don't get me the title by tomorrow, I'm stopping payment on my check. Arney decided on the spot that he wanted nothing further to do with the guy. Fine, he said, stop payment, and he hung up on him.

Rick went to the bank to cancel his second check, but found that unknown to Arney, Slick had already cashed it. He called Arney, who didn't answer. He was able to reach Skinhead, but that didn't satisfy him, so the navy commando left Arney a succession of increasingly aggressive voice mails. Arney has saved them, and plays them back for Skinhead, Painter Paul, and me. "You need to call me, brother," Rick said in one. "We'll take this thing to the next level," he promised in another. Then, on that very morning, Arney's birthday, he said he'd googled Arney's name and had learned of his past tussles with authority, and that if he'd known what kind of man Arney was before he drove onto the lot, well, he'd never have done it. He concluded this monologue with "I guess you're just a fucking pussy."

Arney looks both tickled and mystified. "He don't have a fucking clue who he's dealing with," he says. "I have to help him understand."

On hearing this morning's message, he called his son and told the twenty-nine-year-old Ryan he was "uncomfortable" being called a fucking pussy on his birthday, that he felt a meeting was in order. Krista

overheard the conversation and implored Arney not to seek trouble. Please, she said, it's your birthday. Don't go to jail today.

Arney is vague on what he said in reply, beyond reminding Krista that he's the new Tommy Arney. For my benefit, he clarifies how the new differs from the old: "In the olden days, I would have told him to fuck himself on the telephone, and we would have met somewhere and I would have whipped his ass," he says. "But I don't do that anymore. If I do whip this motherfucker's ass today, it'll be *his* decision."

Skinhead, bent over some paperwork, says quietly, "You have to do what you have to do."

Arney nods. "In the olden days, Skin, I'd have kicked his fucking ass, wouldn't I?"

Skinhead, not looking up: "Absolutely."

"Without a moment's hesitation, isn't that right, Skinhead?"

Skinhead: "That's right."

"How far would he have gotten into calling me a pussy before I beat the fuck out of him?"

Skinhead: "Oh, maybe to 'puh—' "

We're laughing at this when Rick arrives. The SEAL is compact, muscular, serious. He's with a pretty blonde. "What's happening?" he asks. No friendliness.

"I tried to talk to you reasonably," Arney says, turning to face him. "I've tried to be a nice guy to you, and you've responded by calling me a fucking pussy. You've called me a fucking pussy on my birthday. I'm fifty-five years old *today*."

"When am I going to get my truck?" Rick asks.

"Well, we're trying to get it ready for you," Arney says. "We've *been* trying."

"Forget it," Rick spits. "I'm calling the police." He and the blonde head for the door.

"Come on back, and let's talk," Arney says.

"I'm calling the police!" Rick hollers.

"Well, go ahead and call the police. But the thing is, when the police get here, you won't be *able* to talk to me. They won't let you." Rick keeps walking. "It appears to me," Arney yells, "that *I'm* no longer the pussy."

Rick returns. He takes up a position three feet from Arney, arms at his side, every fiber twisted tight, ready for battle. If Arney is even remotely concerned that the man before him has been trained to dispatch the nation's enemies with his bare hands, he doesn't show it. He's loose, relaxed. Contemplative. "I'm no pussy, my friend," he says, his tone almost avuncular.

"Yeah," Rick whispers, the muscles of his neck hardened into ropes, "you are."

Arney smiles. "You think so?"

The blonde intercedes. "Look," she says, "just give us the merchandise for which we've paid, and we'll be on our way."

"Let's just talk about how we got to this point," Arney says. He launches into a recounting of the entire transaction. When he gets to the part about Rick threatening to stop payment on his check, Rick interjects that he couldn't, because the check had been cashed. Arney says he didn't know that was the case when he encouraged Rick to halt payment.

"You've got nine thousand dollars of my money!" Rick exclaims.

"No, I don't," Arney says. "I have $8,645. I don't have nine thousand. You keep saying I have nine thousand, and I've never had nine thousand. You're getting emotional."

Rick hands his sunglasses to the blonde and asks her to hold them.

Arney removes his own reading glasses, folds them closed, and places them on the counter. His movements are preternaturally deliberate, which gives them an odd air of menace. I step away. The showdown has reached a fail-safe. Blows seem imminent, unavoidable; frankly, I'm surprised Arney hasn't already launched a full frontal assault—I don't know how he restrained himself when Rick insisted he was, indeed, a pussy.

But the blonde throws an arm across the SEAL's chest, and the movement carries the power of law; he makes no move. And Arney, seeing this, checks his own attack. "Fuck it," Rick says. "We'll have the truck towed out of here."

"If that's what you want to do, fine," Arney says. "Though we're happy to do the work. It took until two days ago to get the master cylinder from California, to do the brakes."

"I don't want to have anything more to do with you," Rick says. He again makes for the door.

"Call your wrecker, then!" Arney yells after him. He adds the name of a towing company that he says will respond quickly. Once the pair is outside, Arney turns to the crew. "Well," he says, "I think I handled that just about fucking perfect."

Skinhead, who's been studiously attending to paperwork throughout the faceoff, turns to Arney and nods. "You did good."

"Real good," Painter Paul says.

The boss grins. The new Tommy Arney has prevailed. "I didn't want Ryan to be here today—I asked him not to come down," he says. "But if he had been here, I think he would have been pretty fucking proud of me."

I mention that I figured a fight was sure to happen when Arney took off his glasses. Arney nods, smiles, savors the memory of the moment. "When he asked his wife to hold his glasses, I thought: Well, shit, I better put these motherfuckers aside, because this stupid motherfucker just might be crazy enough to throw a punch at me.

"And then," he says, "I would have *had* to whip his ass."

EXACTLY WHAT SPURRED the old Tommy Arney to step aside for the new is the subject of some debate among those who know him well, because his cancer, though it probably started the process, didn't end it: The old Tommy Arney manifested himself on numerous

occasions during and after his illness, mostly in the form of brutal slap-downs.

Virginia Klemstine figures that his children were the impetus for his transformation. His behavior no longer went unnoticed by Ryan and Ashlee, who were growing up watchful and starved for his attention. Krista played a role, too—if he stood any chance of repairing his relationship with his wife, he'd have to adjust his lifestyle. His tangles with the law stood to land him in real trouble—as in prison—if they continued, because it was only through the near-miraculous work of Bill Taliaferro and his other lawyers that he hadn't been labeled a habitual criminal and prosecuted accordingly.

And another development might have played a role in the advent of the new Tommy Arney. After finishing the chemo he underwent radiation treatments, and as one might expect, they were not a by-the-book experience. He received a heavy dose five days a week for four weeks, at which point his radiologist told him that she was leaving on vacation; he needed a break from the daily bombardment, anyway, lest the radiation burn away too much healthy tissue. Come on, he told her, I want this over. I want to beat this thing. She insisted he needed time off. They'd resume the treatments in a month.

Arney wasn't content to wait. After the doctor left town, he showed up at the hospital at his usual time, and when the nurse told him he wasn't scheduled for a session he told her that oh, the doctor was going to be so upset, because she'd been adamant that he stay true to the schedule in her absence. The bluff worked. When the doctor returned, she was mortified. She asked him what he'd been thinking.

About killing the cancer, he said.

Well, what you've done is destroy all the muscle and cartilage in your chest, she told him.

Arney didn't mind the news. "If I have no muscle there, and I have no cartilage there, I ain't got no cancer there," he reasoned. "As far as I'm concerned, I'm cured."

Sure enough, the cancer was gone. But with the cure came a distressing side effect that caused much dismay to a cowboy of prominence, that being that he was rendered impotent. His eyes were as hungry as ever, but his equipment seemed to be switched off.

It came to pain him to be around women, especially the gorgeous, near-naked women with whom he'd surrounded himself. His years with new and eager partners every night? Over. Done. He found himself so shaken by this physical betrayal that he steered clear of women altogether. He went, he says, into hibernation.

He took time to reflect, over the two years that the condition persisted, on why it was that he'd become such a horndog in the first place. He found what seemed a likely answer. When he'd been little—four, six, eight years old—he'd been his mother's favorite. Fern had doted on him as much as she doted on anyone, excepting strangers at the bar. She'd treated him to far more love and attention than she gave her other kids. That might have been a low bar, but he hadn't known it.

The day she'd cut him from her life, that day in court in Rocky Mount, had left a wound that never healed, and since then he'd sought the love and attention of women as a substitute for that withheld by Fern. He'd been wild to please them, in hopes that they'd reciprocate with love affirming and sure, and when he didn't find it with one, he'd move on to another. He sought to satisfy them in every way—sexually, financially, you name it. He bought them clothes, furniture, even cars. It wasn't until years after the cancer that he recognized it had all been a waste.

Bottom line: Whatever the cause, a mellowed Tommy Arney emerged from his cancer treatment, and in the time it took his hair to grow back and again cascade over his shoulders, he seemed to acquire a greater patience—a desire to better understand, rather than simply cripple, his fellow man. He counseled his friends and colleagues to follow his example. "Relax your mind," he told them, so often that it became his de facto motto. "Life is beautiful."

The evolution was bumpy and studded with backslides, but by 1992,

four years after he discovered the lump, the new Tommy Arney had replaced most of his predecessor. Evidence to support that assertion: Slick, who arrived at the Body Shop that November, says she has never seen Arney throw a punch—and she spends a significant share of each day with the boss, second only to Skinhead.

More such evidence might be Slick herself, who was in a lot of trouble when she met the new Tommy Arney. Victoria Hammond was the proverbial farm girl who'd come to the city and succumbed to its dangers. Raised in rural Spotsylvania County, Virginia, she had taken up go-go dancing for one of Arney's competitors after dropping out of an Atlanta fashion college and moving to Norfolk. She fell in love with an enlisted sailor she met while dancing. Their breakup pitched her into a personal abyss.

She arrived at the Body Shop after the other club fired her. When she failed to show up for a shift a few days later, Arney called her into his office. The woman who sat before him was gorgeous—Slick had a lovely face, perfect teeth, flawless skin, and a body straight out of a comic book—but fidgety, unfocused, and haggard. She looked as if she hadn't slept in days. He asked why she'd missed work, warning: "Don't fucking lie to me."

She burst into tears and admitted that she was a prisoner to drink and drugs. He asked whether she wanted a better life. She said yes. He asked whether she wanted to quit cocaine. She said yes. He asked whether she had family in town. An aunt, she said, in Virginia Beach. Get on the phone, he told her, and ask your aunt whether you can stay with her. Slick did so. Her aunt was willing to put her up.

All right, Arney said, I'll help you. But we're going to do this my way: You will work for me seven days a week, sixteen hours a day. I will bank the money you earn in tips, and give you an allowance of twenty dollars per day. I will have you picked up from your aunt's house every morning, and I'll have you driven back there every night. You'll go nowhere else. You'll eat all your meals at the Body Shop. If I catch you drinking, I'll fine you five hundred dollars. If you do drugs, you're gone.

This prescription, which bore more than a passing resemblance to Arney's own apprenticeship under Jim O'Neil, lasted a year, during which Slick proved so ambitious and hardworking that the boss promoted her to bartender, then named her one of his managers. By the time he released the money he'd been setting aside, she had enough to buy a Cadillac, and he had a lieutenant whose loyalty was bulletproof. "I'd found someone who wanted to help me," she tells me one evening while she's tending bar. "I was saved."

The loyalty worked both ways. She was en route to see her family early Christmas morning, 1993, when she fell asleep at the wheel and crashed on Interstate 95 north of Richmond. Arney interrupted his own holiday with Krista and the kids, driving a wrecker 130 miles across Virginia to rescue her and her car.

That same week, I walked into the Body Shop and met the man.

FOUR MONTHS PAST that Christmas, Alan Wilson and Al Seely, inspecting the Chevy at Joe Scalco's garage on Colley Avenue, decided to make what they recognized as an iffy investment. The wagon's mechanical failings were minor but many. Its body was dented, gouged, and succumbing to rust. Its paint, unshielded from the sun during Mary Ricketts's seven years of stewardship, was faded and cracking, and one quarter panel—the left, which Ricketts had crunched, then patched with a cheap repair—was mismatched, a slightly lighter shade of turquoise. The interior was ragged. Wilson judged it "a very questionable vehicle."

But Ricketts was asking just seven hundred dollars, and the men were in the market for an old car: Wilson and Seely had fallen in with an antique car club, had forged friendships with its members, and had developed a yen for a car of their own.

The pair represented the rare fifth stage of car ownership—appreciation. A scant few automobiles surmount the effects of time and changing fashion to earn such a place in their owners' hearts. Few

merit the expense and hassle the relationship almost always requires. A machine that's endured to this point is usually, though not always, considered a classic, rather than just an old car—a classic being a paragon of styling and/or engineering that both captures the era in which it was constructed and transcends the public's fickle tastes to achieve a kind of timelessness.

The wagon certainly met that standard. Even in its neglected state, the Chevy inspired optimism, even glee: To Wilson and Seely, it promised a party wherever it went. It was getting to be a rarity, too. Fixed up, it would be a keeper.

So they cast their lot with VB57B239191. They did so as a couple; it was merely to satisfy the Department of Motor Vehicles' requirement that the title bear one name that Dr. Alan D. Wilson, M.D., became the Chevy's seventh official owner on April 28, 1994.

With that, for the first time in its long history the car came into the hands of owners who didn't depend on it for their transportation, who valued it solely for its style. The wagon's status thus changed from daily driver to weekend plaything, from beast of burden to accessory.

That Wilson and Seely were so charmed by the Chevy isn't much of a surprise, in retrospect, because most of Detroit's fare had devolved into miserable junk in the decades since the car rolled off the assembly line. The exciting future promised by the wagon's styling hadn't panned out. *BusinessWeek*'s prediction that sixty thousand jet-powered cars would be on U.S. roads by 1960 was wrong. Cars driven by solar power or tiny nuclear reactors hadn't been built. Instead, Harvey Earl's genius for repackaging musty and slow-to-change technology had become standard operating procedure not only at Chevrolet, not only at General Motors, but among their American competitors, as well.

GM executive John DeLorean quit the corporation's front office in the seventies complaining that "there hadn't been an important product innovation in the industry since the automatic transmission and power steering in 1949," and that in place of honest advancement, the

industry had gone "on a two-decade marketing binge which generally offered up the same product under the guise of something new and useful.

"There really was nothing essentially new," DeLorean advised in 1979's *On a Clear Day You Can See General Motors.* "But year in and year out we were urging Americans to sell their cars and buy new ones because the styling had changed." Each new model, he said, was "a supper warmed over."

Perhaps worse, the workmanship of American cars had gone to hell—an inevitable by-product of the industry mind-set that a car need only last a few years before the consumer working hard to pay for it was convinced to trade it in. Whatever: Through the sixties, seventies, and eighties they'd declined into leaky, cheaply appointed, slushy-handling buckets of rattle and rust, on which all manner of little things broke not long after the dealership had faded from the rearview mirror—and major things followed soon after.

The few advances Detroit managed were of dubious worth. DeLorean, who later earned fame producing his own stainless-steel sports car—and infamy trying to broker a cocaine deal to finance it—is generally credited with having popularized the muscle car. Seven years after joining Pontiac as an engineer, he dropped a big V8 into a midsized Tempest, which until then was an underpowered old lady's car, and created a screamer called the GTO. Other automakers responded with their own high performance, big-engine machines—GM with Chevy's Chevelle SS and the Olds 442; Chrysler with the Dodge Charger RT and Plymouth Road Runner; and Ford with the Torino and Mercury Cyclone CJ.

But fondly remembered and collectible though they are today, the muscle cars of the sixties weren't all that good. Their steering and suspensions were sloppy, their frames and bodies heavy; they could smoke tires and tear ass down a straightaway, but show them an S-curve and they were hopeless. In any real-world comparison with a European

high-performance car, they weren't even in the running. Besides which, the engineering beneath their pretty skins was every bit as Stone Age as the rest of Detroit's lineup.

Even the good American cars hadn't stayed that way. No example better demonstrates this sad fact than Ford's once-vaunted Thunderbird. Hurried into production as Ford's answer to Chevy's Corvette, the T-Bird was a sprightly, beautifully understated two-seat convertible at its unveiling in 1955. It blended an elegant body, a snug, 102-inch wheelbase, and V8 power into—well, not a sports car, exactly, what with the skirts over its rear wheels and the design's restraint; "personal car" was the dignified label Ford came up with. It resonated, apparently—16,155 T-Birds sold that year, twenty-three times the number of Corvettes that dribbled out of Chevy showrooms.

Over the next couple of years it got more powerful engines and a few cosmetic tweaks but didn't stray far from the original. Then, for the 1958 model year, came a fundamental thematic shift. Ford bosses surmised that two seats limited the T-Bird's sales. Double the seating and the car would fly. The suits were right—the four-seat second generation was wildly popular. But it was a very different car, almost a thousand pounds heavier than its parent and bigger in every respect. Its wheelbase was eleven inches longer. Its doors were nearly forty-nine inches wide.

Three years later came a makeover that seemed an improvement, at least from a distance: The T-Bird of 1961 was bullet-nosed, sleeker, sportier; open to the sky, the convertible was dazzling. Sidle up next to the car, however, and it dawned on you it was no closer to the nimble original than the last iteration; the car was more than seventeen feet long—five inches longer than the '57 Chevy wagon—and in its most popular trim weighed 4,200 pounds, a tonnage that even a three-hundred-horsepower engine couldn't propel with much urgency.

The car's fourth generation, introduced in 1964, traded the bullet nose for a blockier body that was even bigger: It was longer than a

modern Cadillac Escalade, and every version topped 4,500 pounds, a full ton more than today's Honda Civic. And that was nothing compared to what came next, because Ford realized that its popular new Mustang occupied a similar niche at a lower price, and chose to reinvent the T-Bird as an even vaster, full-on luxury car. The convertible was dropped. A four-door option was added, on a bargelike 117-inch wheelbase. Over at Chevy, the Corvette had gone through a few changes but remained a two-seat paean to testosterone. The T-Bird, it seemed, had lost its way and damn near ballooned into a Lincoln.

Come 1972, the transition was complete: Now it stretched 214 inches, bumper to bumper, more than three feet longer than the '55 T-Bird and fourteen inches longer than the '57 Chevy wagon. And here's the really crazy thing: Ford stopped offering the four-door; you could buy this tectonic plate of a car only as a "sporty" two-door hardtop. The company equipped it with gargantuan engines—a 429-cubic-inch V8 and a 460-incher, both with four-barrel carbs—but for all their size, they were anemic, robbed of muscle by primitive antipollution gear: The 460 managed only 224 horsepower, a fraction of what was needed in a craft of this magnitude to achieve what you could call acceleration with a straight face.

It was at this juncture—when the T-Bird was at its most bloated, when with three average passengers, a set of golf clubs, and a bag of dog food aboard it topped five thousand pounds, when it limped along on some of the biggest engines ever put into American cars—that the Arab oil embargo of 1973 arrived.

And the '73 T-Bird did not do well in the gas mileage department.

Change was coming, forced on the industry not only by the oil crises of the seventies, but by challengers that played the tortoise to Detroit's hare. In 1957, when Chevy sold more than 1.5 million cars, an automaker unknown to most Americans was struggling to gain a toehold in the U.S. market. It had a single stateside dealership in Los Angeles,

from which it sold 288 cars that year. Its showpiece was called the Toyopet, which might partly explain its poor showing. It didn't help that the car was Japanese, which at the time was listed in most Americans' mental dictionaries as a synonym for *cheap*.

That'd be Toyota.

A few years before, the slow, noisy, and cramped Volkswagen Type 1, soon to be known the world over as the Beetle, had enjoyed an American debut even less auspicious: The company sold only two cars in its first year on these shores. Two cars. Two.

But the fattening American auto left many buyers cold, and seeking a sensible alternative to the overweight, overdecorated, and technologically ancient offerings from Detroit, they soon turned in shocking numbers to imports. VW's U.S. sales went from a paltry 390 in 1951 to 177,308 vehicles a decade later, then shot sky-high from there, to half a million cars a year in the United States by the time of the embargo. Lowly Toyota surged in the sixties; by 1970 its U.S. sales were topping 300,000 vehicles a year. The first Honda microcars chipped further at Detroit's sales and appeal. By 1989, the company's Accord was the bestselling car in the country.

The initial American response wasn't stellar. Ford offered up the Pinto, of which the less is said the better. Chevrolet produced the Vega, which proved itself a nightmare faster than it covered a quarter mile. American Motors unveiled the half-baked Gremlin, its name—also a manufacturing term for an elusive flaw in a piece of machinery—all too prophetic.

Otherwise, the Big Four kept cranking out outsized and sloppily constructed junk: the Mustang II; the Ford Granada; the Chevy Caprice, Monte Carlo, and Lumina; Chrysler's lumbering LeBaron, New Yorker, and Cordoba (with its seats of "rich Corinthian leather"). It took more than a decade for the industry to come to its senses, and to recognize that it could not hope to attract buyers solely on the strength of homegrown provenance or the suavity of Ricardo Montalban. It

took years more before those buyers again viewed Detroit's products with anything resembling trust.

The turnaround was still under way when Alan Wilson and Al Seely rolled up on the wagon that first time. It grabbed their attention even before they understood what they were looking at. Among the econoboxes and rusting land yachts that crowded Norfolk's streets, its styling and sheer size set it apart, but its appeal went deeper than good looks or attitude. Here was a throwback to an America that had been a world leader in quality goods. An America that kept its promises, in which hard work and diligence paid off. That was as solid and dependable and honest as the heavy-gauge steel that girded the Chevy's flanks.

IN MOST RESPECTS, the new owners hewed close to the *Ozzie and Harriet* model. They lived in one of the region's trendiest homes. They threw smart parties. Seely's teenage daughter, Amanda, a high school student, lived with them. They figured prominently in newspaper stories about family values and Father's Day. Only the fact that they were gay set them apart from the model American family of the Chevy's infancy.

In fact, it was family values that had brought the men together. Wilson had passed most of his childhood in Chattanooga, Tennessee, where his father helped manage a textiles company and his mother oversaw a noisy, active household in the middle-class suburb of Brainerd. Keith and Madge Wilson had been attentive, encouraging parents, and the third of their five children enjoyed a successful youth. Smart, funny, and sweet-natured, Alan did well in his classes, attracted a succession of cute girlfriends, took a date to the prom. Brainerd High School's Class of 1972 voted him its wittiest member.

Privately, however, he'd been tormented: At fifteen or sixteen he'd realized, in what was less a revelation than a culmination, that he found boys more attractive than girls. The knowledge had alarmed him. He'd

had no thoughts on how he might act on it; rather, he'd wondered how to survive it. Few answers had come to him at the University of Tennessee, where he majored in biology. Fewer still had come on his return to Chattanooga, where, while applying to medical schools, he earned a second bachelor's degree, in chemistry. Lonely, depressed, he'd kept his sexuality a secret while pondering what the future might look like without marriage and a family.

His first visits to gay bars had filled him with panic; they were smoky, loud, decidedly blue-collar, and didn't square a bit with the Marcus Welby role he'd imagined for himself. In 1983, he'd finished his classroom training and moved to Norfolk to begin his residency in family practice. He immersed himself in his work and managed to achieve a wistful contentment.

Then, in February 1988, a friend had invited him to a Valentine's Day brunch at a home in Portsmouth. Wilson didn't know the host, who was two years his senior and a fellow transplant from the Deep South, but on a trip to the bathroom he found much to like about the man: The walls were covered with pictures of children, of family, of the middle-class ideal.

The host was Seely. He was from Albany, Georgia, a factory town 170 miles south of Atlanta, where his family ran an office supply business started by his grandfather. He, too, had realized he was gay as a youngster, but from there his experience diverged from Wilson's: His parents had committed him to a psychiatric hospital at sixteen to "cure" him of his homosexuality. Unaltered and well aware of it, he'd married young, had a daughter and a son, and attended art school in Florida before joining the family business as an office designer. He'd eventually shifted to residential work. In the early eighties, a client's brother, impressed by Seely's designs in Albany, had enlisted him to tackle a job in Norfolk, and the acclaim that greeted the project had encouraged Seely to move his family there. His new business had thrived.

His marriage had not. Over the next several years, the children had

spent summers and alternating holidays with their father. Seely had eventually opened a design store on Colley Avenue, just across the street from Joe Scalco's garage, and it was there that Wilson left his business card a few days after the party. A few months later, Seely had moved into the doctor's house on the beach.

Wilson was already earning a name for himself in the medical community by then. The family practice at which he completed his residency was a free HIV testing site in the first years after scientists isolated the virus that causes AIDS, and before an effective treatment regimen had been developed to keep it in check; to be diagnosed with HIV at the time was tantamount to a death sentence. Wilson recognized that the disease's young victims too often went without follow-up care after learning they were sick. Doctors might not be able to afford much hope to them, but he believed they could at least help them die well. So he'd started attending to AIDS patients. He was not out of the closet himself, but he was able to offer his patients a shoulder. He'd tell them: Tell me how you want to die. Fantasize about how it would be, if it were the best it could be. And he'd tell them: I'll make sure it happens.

Shortly after he and Seely became a couple, he opened a solo practice dedicated primarily to AIDS patients, a venture that both he and Seely knew would not pay as much as general medicine. He'd get up early each morning, grab a shower and some coffee, and head to his office in a Norfolk high-rise, where he saw patients in such numbers that he often skipped lunch. He'd get home late. He and Seely might share a meal together, might not; he was on call every night. So much, they joked, for the hedonistic gay lifestyle.

The harder he worked, and the more fully immersed he became in the issues surrounding AIDS, the more frustrated he became with the community at large, with what he viewed as his neighbors' apathy about his patients and their plight. He responded by diving even deeper: He and Seely found their already scarce leisure time increasingly devoted

to volunteer work at the city's oldest AIDS hospice. Wilson became board chairman of the region's best-known AIDS treatment and education group. He fought insurance companies that balked at awarding benefits to those with AIDS. He battled hospitals and other doctors, some of whom wore surgical masks and gowns while meeting AIDS patients. As time passed, he grew ever more isolated from the medical community. He came to see himself as independent of it.

Disconnection from colleagues, overwhelming workload, community obligations, the financial pressures of his solo practice—together, they might partly explain why, when his certification by the American Board of Family Practice expired, Wilson didn't immediately reapply. There were other reasons: The renewal stipulated that he complete one hundred hours of continuing education, some of which would have required time out of town that he felt he could not spare.

Board certification had no bearing on his ability to practice medicine, but it was a credential the doctor needed to do business with hospitals and insurance companies. He kept putting the paperwork off. It gnawed at him: He'd remind himself, now and then, that he had to get it done. But the time to do so didn't present itself. He didn't get around to it.

In such a pair of crowded and stress-filled lives, the Chevy was a rare self-indulgence. Wilson and Seely tooled it through downtown on weekends and took it to a few meetings of their antique auto club, but it was clear that as beautiful as the wagon remained from a distance, it was becoming unsafe for travel; ignorant though both were on subjects mechanical, they recognized danger when they sensed it, and the Chevy treated them to healthy doses. They could feel the floor give beneath their feet. The brakes lacked urgency, the steering was vague, the body creaky—and that was while they backed it from its parking space outside the swanky, two-story downtown loft they'd bought in the early nineties. On the move the wagon felt as if it might fall to pieces at any second.

Fixing it themselves was out of the question; this was a project for which they'd have to rely on outside experts. They found one in a friend who owned a Norfolk Chevrolet dealership, who agreed to have his shop give the car a once-over and devise a plan for its restoration. But the commitment necessary for such a venture was driven home to them when he called with the results. The job would run into the tens of thousands of dollars.

The two took the opposite tack. They did nothing at all.

They left the Chevy where it was.

It spent much of the next two years sitting on the dealership's back lot.

10

OVERWORKED AND BROKE, Alan Wilson quit his solo practice for the Eastern Virginia Medical School, where he was named an assistant professor of internal medicine. He did not abandon his patients or his passions, however—in the summer of 1996, he was instrumental in bringing an experimental AIDS vaccine to Norfolk for testing. The effort earned headlines. Wilson's work was widely recognized as heroic. He was at the forefront of the fight against the disease.

That fall, Sentara Health System, a corporation that owned the hospital with which the medical school shared a campus and with which Wilson's work was inextricably bound, asked the doctor for evidence that he was board-certified. It was an entirely routine request, akin to being asked for ID when cashing a check. Except that in Wilson's case, it didn't seem routine at all.

He panicked. He took his old certificate, fudged the date on it, copied it, and sent in the copy. Unknown to him, the old document had been signed by a board official who'd since died—had been dead, in fact, for six years, which did not escape the attention of the American Board of Family Practice. The organization sued Wilson for forging his credentials, charging that by so doing he'd endangered its credibility. It sought $200,000 in damages. That, too, earned headlines.

The press attention erased any chance of doctor and board achieving a private solution to the problem. Wilson quit his post at the medical school. He continued to see patients, but his diminished practice

wasn't sufficient to maintain his flamboyant guppie lifestyle. He and Seely sold their posh downtown loft. They moved first to a more modest neighborhood across town, then retreated to Parrott, a tiny burg (population 160) in southwest Georgia, where Seely continued his design practice and Wilson commuted to Atlanta to teach.

They all but forgot the Chevy. It remained on a back lot at Bay Chevrolet in Norfolk, exposed to the elements, crumbling. And so a relationship between car and owner that in 1994 had achieved that rare fifth stage now backslid to the third and final substage of the fourth: The wagon was abandoned.

I've only once thrown up my hands and walked away from a car—though, as the past owner of too many pieces of junk, I might have done so as a matter of habit. The one instance involved the demonic Triumph roadster I bought in college, which for all of its good looks refused to operate as expected, especially its brakes, and nearly got me killed every time I took it out—and which thus rendered practically no service in exchange for its purchase price of $2,450, a goodly sum at the time, not to mention all the hundreds I sank into trying to fix the damn thing.

It is a dramatic moment, indeed, when a driver unscrews the license plates from a car's bumper, gives the hood a fond farewell pat, and leaves a lifeless carcass on the side of the road—or, in the case of that Triumph, in the garage of my mother's house just prior to my moving three thousand miles away. It's a conscious breach of a strong emotional bond. It's a surrender of responsibility. It feels a little like taking a pet to the vet to have it put down.

The wagon sat derelict for additional months, taking up space on the lot, until finally the dealer notified Wilson that he'd have to move it. The doctor had no use for the wagon now, and no place to keep it. But it so happened that one of the dealership's workers knew a fellow who had a soft spot for old cars, and who might be able to solve Wilson's dilemma. Contact was made, a deal struck. And so, for the grand price

of two hundred dollars, the Chevy became the property of Jack's Classic Pawn, a sideline interest of Jack Reed Sr., the patriarch of a family-owned plumbing supply business.

Some types of enterprise have long done well in military towns. Drive off of any big base, and you're almost sure to encounter a clot of (a) payday lenders offering soldiers and sailors a way to cover emergency expenses between their twice-monthly paychecks, sometimes at triple-digit interest rates; (b), rent-to-own furniture showrooms, computer shops and independent car lots willing to extend credit—again, at less than competitive terms—to low-ranking service members too young, poor, or otherwise risky to qualify for a note from the bank; and (c), pawnshops, where a nineteen-year-old E-2 can get a loan against the stuff he bought from (b) to pay the fast-mounting debt he's accrued at (a).

Jack's Classic occupied a particularly auspicious location on a main drag halfway between the huge Norfolk Naval Station and the Little Creek Naval Amphibious Base, within sight of one of Arney's go-go bars. Reed augmented the usual pawnshop fare—jewelry, stereo equipment, cameras, and the like—with a personal passion, vintage cars. He didn't often grow attached to his inventory, as the business required that he spruce up a car and flip it without a lot of fuss. Even so, he barely had time to prepare this car for sale. No sooner had the dealership towed it to the pawnshop and Reed washed it and vacuumed its interior, than Navy Petty Officer 1st Class Jeffrey H. Simmons happened to drive past, fall in love with it even before he'd come to a stop, and agree to pay five hundred dollars for it.

The Chevy's ninth owner had joined the navy a day after finishing high school in Buffalo, New York, and had spent his entire military career in Norfolk. Aside from a stint as a guard at the brig, he'd always pulled sea duty—on a destroyer tender, with landing craft, and now on the salvage ship *Grasp*, aboard which he'd recently helped raise the wreckage of TWA flight 800 from the floor of the Atlantic.

Vintage cars had always excited him. Born in May 1964, Simmons had grown up among old photographs of his father in the company of

stylish, long-vanished machines, and had been heartsick over the explanations he heard as to what became of them: I cracked it up. I sold it. I traded it for something practical.

Here was an opportunity to call such a car his own, and he was not about to let it pass, even if it came at an inconvenient moment, between paychecks; he cobbled together loans from friends to meet Reed's price. Simmons's wife, Patricia, whom he'd met while moonlighting as a bouncer, laughed when she saw him pull up to their house in the wagon. The front seat had so decayed that he all but sat on the floor. He could barely see over the dash.

Simmons wasn't put off by the Chevy's decrepit condition. It represented potential to him, achievable beauty: He need only devise a plan for its restoration, stick to that plan, and in time he'd have a classic that would wow his shipmates and turn heads wherever he took it. That he had the mechanical wherewithal to complete the project was never in doubt: The *Grasp* had seven diesel engines bolted into its hull, four to drive the ship and three to run its salvage gear, and Simmons repaired and maintained all of them in the engine room. He knew how to turn a wrench.

He got to work. He knew he'd have to replace the right front fender, which was not only dented but ripped, its metal turned back on itself; he tracked down a supplier in Arizona that had a replacement front end, and started saving toward it. He made phone calls to local shops that redipped chrome, an expensive undertaking but necessary if he were to restore the rust-flecked bumpers to their original glory. The couple's three children joined in when he worked on the car in the yard. The youngest, Tamara, handed him tools as he labored under the hood. His son Joshua spent hours trying to rub the cloudy trim back to a shine. The car excited the whole family.

But no one more than Simmons, who on some evenings would take a beer outside and climb into the Chevy, sit with his hands wrapped around its big, skinny steering wheel, and picture its curves rust-free and sheathed in candy-apple red paint, its seats reupholstered, the carpeting fresh. He imagined its engine smooth and powerful, its brakes

reliable. The car thus returned to a fifth stage of ownership. It was in the hands of a savior.

Or so it seemed. Except that three kids and a mortgage will devour every cent of an enlisted sailor's pay and then some. Simmons's savings for the new body panels never grew into much. He didn't send the bumpers off for new chrome. After a year, he had the car running but far short of roadworthy. It spent all but a few hours of that period under a tarp beside the house.

One day a paper materialized on the tarp, announcing that an inspector from the city of Norfolk had stopped by and found an unlicensed junker on the premises. Simmons had never bothered to transfer the title into his name, let alone buy plates for the Chevy; now, he learned, he had seventy-two hours to rectify this oversight or his beloved classic would be towed away and impounded. Ultimately, it might be auctioned off.

Like others on their cul-de-sac, the Simmonses were within sight of the middle-class ideal, if not actually in its embrace. They lived in a comfortable house. They had good kids who attended reasonably decent public schools. They worked. No one went hungry. But in one respect they differed from most of their neighbors: They'd received such a notice from City Hall before. A few years back, while Jeff was at sea, the city had towed away a '63 Ford pickup that had been sitting in the yard. The episode had enraged Simmons, who saw it as a case of government thievery committed while he was serving the country. He resolved that he'd not repeat the experience.

Simmons briefly considered erecting a six-foot wooden privacy fence around the Chevy—that would stick it to the city, wouldn't it?—but only briefly, because just then a fellow named Dave Simon, having made a wrong turn on his way to a nearby restaurant, saw the wagon and stopped to ask whether Simmons wanted to sell it. He did not, most emphatically, but he didn't want to lose it to officialdom, either. He told Simon that yes, he might consider parting with the car, if Simon had $1,500 to spend.

Simon replied that he did not. He could afford $900.

Simmons wasn't thrilled by the offer, but he felt cornered.

They shook on it.

HERE BEGINS SOME very strange business, that being the world of auto fanatics, of compulsive collection and mind-bending fixation on details. Here appears a species of automotive ownership far pricier and more time-consuming and more generally ruinous than we have so far encountered. Because Dave Simon wasn't just some guy who got lost on his way to get a cheesesteak, and who happened to have nine hundred bucks in his pocket. He was a lost, hungry guy who happened to be obsessed—completely, utterly obsessed—with the exact make and vintage of car that Simmons offered. To wit: Dave Simon had owned, by his count, 284 Chevrolets of the 1957 model year.

That bears repeating: *284.* Thirteen ancient Chevys had been lined up outside the family's house at one juncture, and there were four or five as a matter of course. Dave's wife, Dianne, called the curb bordering their lot "Battleship Row."

Simon's earliest memories included a '57. He had a snapshot of himself at age five, playing with friends outside his family's house in a Cleveland suburb, and visible in the garage behind him, rendered in grainy black-and-white, was his dad's year-old 210 four-door sedan.

In his teens, a stormy relationship with his stepfather spurred him to move out of the house and into the back of a 1960 Ford Galaxie, then into the navy. He'd arrived in Norfolk as a seventeen-year-old radioman, his high school sweetheart in tow. In 1977, he and Dianne, the new parents of a baby girl, decided they needed to swap their Dodge muscle car for some safe, sturdy transportation. Simon chose a '57 Chevy two-door, a black 210 with a 265 V8 under the hood.

So began the collection. He started amassing parts for the car. They filled the garage, then the house—family photos show baby Carolyn in her crib, and bumpers piled under it, chrome pieces hanging from

the walls. Soon enough, he was gathering entire Chevys. He bought a four-door sedan at a police auction for $110, then a two-door sedan, then a two-door hardtop from another sailor. He traded his first '57 for a four-door sedan that he set about restoring. Bought others, dozens of others, many wrecked or ruined, for their engines or hard-to-find components, junking or selling whatever remained.

He found one car in a farmer's field, axle-deep in mud, open to the seasons, its insides shot. The farmer told him he could have it if he could move it, so Simon had it towed out of its hole while he steered, sitting on a milk crate so he could see over the wheel. He owned that car three times. Once home from the farm, he took its doors and fenders, sold the remainder, and a month later got a call from the buyer asking: Want it back at no charge? The man had taken the trunk lid and stripped the dash. Simon sold it a second time to a man who needed its quarter panels and rear glass, and who gave the rest—not much more than the frame and roof—back to him. He sold that again, too.

He embarked on restorations in his dirt-floored garage—on four-doors, mostly, because those were the least appealing to collectors, and thus the easiest and cheapest to find—and sold most before he'd finished. When he bought the wagon, he and Dianne were down to a permanent collection of just two Chevys, a bright red coupe and a yellow two-door sedan. But at one time or other they'd possessed all of the model year's various incarnations—two-door hardtops, four-door hardtops, two- and four-door sedans, Bel Air convertibles, Nomad wagons, two-door wagons, four-door wagons. When their son, Christopher, was born, in November 1979, the Simons had taken him home from the hospital in a white Bel Air.

Such a fixation, though unusual, was not unique. Scattered around the country were others of similar bent. A farmer named Leroy Walker in Beulah, North Dakota, traded for a used Edsel with a bad clutch in 1961, and grew so fond of the famously unsuccessful Ford that he started buying others; soon, thirty-seven acres of his spread were covered with 266 Edsels, about a hundred of which ran, and thousands of other der-

elict vehicles that he parted out or sold whole to finance his Edsel habit. He parked his collection in widely spaced clusters so that if a tornado should tear through the property, it wouldn't take out his whole crop.

Another Edsel fan, Hugh Lesley, had 160 of the cars scattered in the woods around his house in Oxford, Pennsylvania, through the eighties and nineties. New trees grew so close around some of them that the cars could be moved only with the deployment of chain saws. Other aficionados have fastened their attention on old Lincolns, Studebakers, Cadillacs. Dennis Albaugh, a billionaire pesticide manufacturer in suburban Des Moines, bought a '57 Chevy Bel Air convertible from a golf buddy in 1998, and got the bug to keep buying; inside of fifteen years he'd built a collection of Chevy ragtops representing every year they were built between 1912 and 1975, plus a smattering of rare Chevy muscle cars—147 vehicles in all.

Bruce Weiner, a former chief of the bubble-gum brand Dubble Bubble, collected some two hundred microcars—tiny one- and two-seat BMW Isettas and Messerschmitts and the like, next to which a modern Smart car seems a limousine, but which played a big role in getting a ravaged Europe back on the road after World War II—then opened a museum in Madison, Georgia, for a few years to show them off.

So Dave Simon had company. By dint of sheer numbers, however, he was in the first rank of automotive obsessives. This, ladies and gentlemen, was a car nut.

SIMON INTENDED THE wagon as a gift. Christopher was due to graduate from high school in a year and deserved a '57, his father reckoned, to mark the accomplishment. Could there be any better gift, any greater emblem of Dave Simon's love and pride, than to welcome his son into his weird and passionate fraternity? Probably not. But the Fates did not smile on his generosity. As he drove the two miles home from Jeff Simmons's house, the Chevy's brakes went out.

Simon kept his cool. He initiated the seasoned driver's checklist of

responses to such an emergency. First he pumped the brake pedal. No luck. It slapped against the floor like a beached fish. He pumped it again. Nothing. He stomped on the parking brake. That failed, as well. Still rolling, he resorted to a drastic third countermeasure: He grabbed the shift lever on the Chevy's steering column and slammed the transmission into park. The car slowed, shuddering as the gears ground to powder, but it didn't stop.

His options exhausted, Simon aimed the nearly two tons of rolling steel over the curb and across his lawn and into the chain-link fence beside his house. The fence buckled, but a van parked beyond it did not. With that, his seventeen-year-old son walked outside to find that he owned a not-so-gently used classic.

Its interior was littered with boxes and papers. Its right front door was dented, and its right front fender still torn. Its tailgate was bent. Its entire body seemed twisted—when the younger Simon stood at the front bumper and looked toward the rear, the driver's side seemed to bulge a little toward the stern, while the far side ran straight. The exhaust and rear-end bearings were shot, a consequence of motionless exposure to the weather. A creeping, milky haze fouled the curving safety glass at the wagon's rear corners. The back bumper was dented. The front seat was worn through. The sun visors had split and their foam-rubber innards turned to saffron powder that snowed onto the dash. Reversing all this decay now rested in the hands of an eleventh grader. The car was twenty-three years older than he was.

Chris Simon was undaunted. He'd always been mechanically gifted: As a youngster, he'd ride his bike until it wore him out, then tear it down to its frame and put it back together. As he grew older, he watched for hours as his father worked in the garage. He was surrounded in every room of the house by Dave Simon's growing collection of '57 Chevy memorabilia. No surprise that he'd inherited a romance for the vintage. In third grade, he'd shown off toy '57s to his classmates. Later, he'd built them of Lego blocks, from scratch—no kit, no instructions, just his exposure to the real thing as guide. One,

rendered in red, was wonderfully detailed, surprisingly realistic, with a hood that opened to reveal a V8 engine fashioned from the snap-together plastic.

Now Chris finally had the genuine article, and he dove into the wagon on afternoons after school. He repaired the transmission, rebuilt the carburetor, and got the motor running as smooth and quiet as a sewing machine. He repacked the bearings, fixed the brakes, replaced much of the front suspension. He tried to beat back the worst of the rust that now devoured the body, cutting away a lesion that penetrated the right rear corner of the roof and patching the hole with fiberglass. The patch sagged before it set, creating a small concavity, but it beat having rain pour into the cargo hold.

He didn't have time to redo it, anyway. When he pulled up the Chevy's carpeting, he discovered that rust had obliterated large sections of the floor. It was so bad that if he drove through a puddle, water would splash into the cockpit, soaking the rear seat and doors. So bad that on the road, the wagon filled with the sound of whooshing air and the rumble of the tires. He and his friends sang the *Flintstones* theme when he drove the Chevy. That's how bad it was.

Which is why he didn't drive it much. He never took it to school, never drove it on the interstate. He braved a journey the six or seven miles across Norfolk only once. Most of his time in the '57 was spent close to home, on brief weekend joy rides through the neighborhood.

Faced with an extra semester in high school, Chris Simon left without graduating and got a job in demolition. Like his dad, he grew his hair until it coursed past his shoulder blades. He moved out of the house and into a buddy's condominium, taking the wagon with him. He longed to restore it, talked about how sweet it would be when he did. In those early days of his relationship with the Chevy, he talked about that a lot.

But demo work didn't pay much. Money was too tight for the basic repairs necessary to make the car safe, let alone expensive chrome, paint, and upholstery. So months passed with the wagon parked at the

curb a block from the Chesapeake Bay, salt air and weather countering whatever small progress he made on its salvation.

The months became years. He and a girlfriend got an apartment together in a complex just outside the gates of the naval base. It was a modest place with linoleum floors and hand-me-down furniture, decorated with model airplanes that Chris built and hung on thread from the ceiling, model battleships and cars on the bookcases, a rebel flag tacked to the living room wall. It little resembled the fantasy suburban home of the mid-fifties. The Chevy sat out on the street, along with a beat-to-hell Oldsmobile Cutlass that Simon used as his daily driver.

He was approaching his mid-twenties now, but in economic terms was not much better off than he'd been when he left home. The jobs he landed paid little. He didn't have a telephone of his own: He used his girlfriend's cell when she wasn't at work. His budget was tested by maintenance on the Olds, which he had to keep healthy before he could consider any further investment in the wagon.

Simon did hunt down replacement floor pans—only to decide, once he had them in hand, that the installation was beyond his abilities. He couldn't find anyone who would do the necessary welding at a decent price. So the car sat all but immobile through its forty-fourth year, its forty-fifth, and its forty-sixth.

His father got on him about it. That car's sliding fast, he told Chris. Fix it or sell it. Put it in the hands of someone who'll do right by it. Don't let it fall to pieces. That, son, would be sacrilege.

A FEW MILES away, the new Tommy Arney was grappling with profound change. Three years had passed, give or take, since Krista ushered him out of the house. Now, at long last, he moved back in—believing, he says, "that if I didn't go back home and focus, there would be no telling how my children would turn out."

He was an attentive parent, involved in the kids' schooling, insistent

that they strive for good grades, eager to take an active hand in their projects. Still, it took him a while to find his rhythm, especially with Ryan. Arney was accustomed to getting his way, to snuffing resistance and neutralizing trouble with preemptive force. It was a leadership style uncalibrated to the quiet life, and especially the fragile sensibilities of a pubescent son. Arney offered Ryan advice. It came across as criticism: The boy's clothes weren't different from his own, they were *wrong*; the kid's music wasn't unfamiliar, it was crap. Arney strove to be engaged. It played as overbearing. For all his postcancer mellowing, he had strong opinions on just about everything—the right things to eat and drink, the right way to tighten a bolt, the right way to treat a car or a woman or a dog.

Ryan already had ample reason to resent him; now, as he entered his teens, he retreated into silence around the old man, escaping him further by drinking on the sly. Once, liquored up, he came close to sawing down the street sign where he'd spent so many hours waiting for Arney's weekend visits, and where he'd been so often disappointed.

Arney's public life was no less dramatic. Even with insurance, the expense of his cancer treatment required him to divest many of his holdings. Some of his car collection had to go, as did most of his go-go empire: By the time I met him, he owned just the original Body Shop.

As he rebuilt his financial affairs, he considered buying a vacant church near the bar and turning it into a soda-pop joint—a gentlemen's club that served no alcohol and thus was beyond the reach of the ABC and its rules about what dancers could wear and do onstage. The Church of the Everlasting Body and Soul, he planned to call it. He'd invite his friends and the Body Shop's best customers to "services" on Sunday afternoons, presided over by the Right Reverend Skinhead, who at Arney's behest sent off for a mail-order ordination. The reverend, the product of a churchgoing youth, could cite Bible verses like a TV preacher; he would open the proceedings with a brief sermon, a female choir behind him on the altar—"and then the music would

start," Arney says, "and the girls would all rip off their robes and they'd be wearing pasties and [g-strings] underneath.

"We would have been protected by the federal government, because all they'd have to say is that Jesus told 'em to take their clothes off."

Unfortunately, the church's owner died with the sale in the works, and the deal fell apart. It wasn't long after that, as Arney tells it, that his daughter, Ashlee, nine or ten years old, was talking with her classmates about what their parents did for work, and Ashlee announced that her dad ran the Body Shop. Ah, her teacher said, Ashlee's father fixes cars. No, Ashlee said, my dad has girls dancing onstage. Krista Arney was not pleased when she heard this, Arney says. She told him that it was time to sell the bar. The demand had muscle: Krista still held the liquor license.

In 1995 Arney bought a restaurant in suburban Chesapeake, in a busy strip shopping center surrounded by an edge city of apartment complexes, office buildings, and a sprawling mall. Maxwell's would become popular with lunching office workers and neighborhood regulars for the consistent quality of its short but wide-ranging menu. And the following year, in a move that broke his heart, Arney got out of the go-go business.

He tried to keep the Body Shop in the family by selling it to Slick, but the transfer was complicated by his iffy relationship with law enforcement. A former associate—a man who'd been a close friend to the old Tommy Arney, who'd worked with him for years, who'd joined him in numerous dustups, and who had amassed a lengthy criminal record before and during their friendship—found himself a defendant one time too many and facing serious prison time. In exchange for leniency he offered up his boss and compatriot: Arney, he said, was a major player in the Norfolk drug trade, and the Body Shop a marketplace for the trafficking of cocaine and a Laundromat for drug income. Bill Taliaferro says that this accusation dovetailed with a long-standing article of faith among local law enforcement officials that Arney was a drug

kingpin, and that finding the evidence to prove it was only a matter of time. "They always thought Tommy was involved in drugs, and I can tell you that, to the best of my knowledge, never—never, ever, *ever*— was he involved," the lawyer said. "Honest to God, I'm telling you, I don't think there was any truth to it."

Arney, for his part, denied the story and insists today that it was untrue; he never had his hand in the drug business, he says. Still, a subsequent investigation into the former associate's report, along with an ABC probe into whether Arney retained a hidden interest in the Body Shop's liquor license, hamstrung the club's operation. "They were looking for any angle to get us," Slick told me. When ABC agents popped her for what she described as a bookkeeping error (and which the ABC termed "filing a report . . . which was fraudulent or contained a false representation"), she locked the doors.

In the meantime, Arney moved the family into a big rented house on a cul-de-sac not far from the restaurant, and after a year there bought a three-bedroom rancher with a pool out back in a subdivision of quiet, meandering streets, carefully trimmed lawns, tasteful shrubbery. The former ward of the state, the fifth-grade dropout, the violent young man on society's outermost margins, had achieved what looked a lot like suburban comfort and ease.

BEFORE WE BID a final farewell to the old Tommy Arney, let's review the criminal record he amassed on the long journey to his new life—a record that, although it lists dozens of arrests, bears witness to only a fraction of the assaults, batteries, and malicious woundings he describes. Why is this? Well, for one thing, a slender few of his adversaries—or victims, if you prefer—brought charges against him. The fellow he hit with the soup can? Arney says he never had to answer for that. The melee with the marines, in which he brandished a firearm and swung a steel hook through a man's cheek? No legal intervention

there, either. Same goes for the fellow he kneecapped, the man he more or less neutered, the two he stabbed, the plank wielder, the man who didn't pay his power bill, the scores of others he beat while performing his duties as a bouncer, and the scores more who were foolish enough to swing at him first.

The Norfolk of the seventies and eighties was inured to fistfights, Bill Taliaferro says, and its police were disinclined to bring charges themselves against someone answering a first punch, even if that answer was cataclysmic, and "especially if it happened in a bar." That left it up to the participants to pursue charges—and Taliaferro found that many "so-called victims" could be talked out of it. "Many of them knew they were not entirely blameless, that they didn't have entirely clean hands," he told me.

By way of example, he cited the case of two brothers, co-owners of a used-car lot, who badmouthed Arney to a prospective customer. When she passed along their comments the following day, Arney decided he needed to set the men straight. In typical fashion, he announced his intentions on arriving, then followed through—beating both brothers so badly they were all but unrecognizable; both Arney and Taliaferro told me the men's heads were swollen to the size of basketballs. "They showed pictures in court," Taliaferro said. "I'd never seen anything like it." Arney faced charges of malicious wounding, but once they were before the judge the brothers lost their will for retribution. They "just wanted to end this," the lawyer said. "They'd been hit by a tornado, and they wanted to get away from it."

Had he been arrested for every fight in which he'd hurt someone, Arney's rap sheet would run into the hundreds of offenses. That's his own assessment, and one that Taliaferro backs up: "I represented him on a *lot* of assaults," the lawyer told me. "I don't know how many times I represented him. I couldn't count how many times."

Arney's actual numbers were almost modest. An official Norfolk Police Department printout of his record, prepared in May 2005, lists

sixty-seven offenses for which he was arrested, and a 2012 federal accounting of his criminal past turned up another five, for a total of seventy-two.

Of these charges, thirty-five, or almost half, were dismissed by a judge or dropped by prosecutors—and of those, twenty-nine no longer appear in court files because in the summer of 2005, Taliaferro argued that their "continued existence and possible dissemination" could give people the wrong idea about his client, and he succeeded in getting them expunged from Arney's record. Among the expunged charges were one misdemeanor assault, one felony assault, one assault on a police officer, one brandishing of a firearm, and fifteen assault-and-batteries.

Of the thirty-seven charges for which he was found guilty, many of those adjudicated in Norfolk's General District Court—the equivalent to what some communities call the "police court"—have been purged from the files as part of the court clerk's periodic disposal of old paperwork. The surviving documents attest that his convictions—all misdemeanors except the 1974 grocery store burglary and safe heist—included seven disorderly conducts, three assaults, nine assault-and-batteries, one charge of shooting into a vehicle, one of brandishing a firearm, and one of fornicating in public.[*]

And the record shows one charge of assault on a police officer—a case that spent some weeks wending its way through the court system before Arney was convicted on or about April 15, 1988, as best as I can tell, and which addressed his most storied and mythologized moment: his reputed confrontation with, and domination of, a Norfolk police dog and its handler.

This much can be said of the incident without fear of contradiction:

* The last offense came during a 1983 Christmas party at which Arney says he "had a couple of Bloody Marys," then was approached by a young woman. "She said, 'Tommy, I have a Christmas present for you. It's out in my car.'" He followed her out. She insisted that he open the present on the spot. They were both arrested.

that on the night in question, Arney was involved in an expansive fist-fight outside Knickerbocker's, a bar and restaurant catering to sailors and working-class townies; that the lawlessness was of sufficient scope and intensity that a seasoned Norfolk police veteran would recall it in a conversation with me more than a quarter century later; that among those arrested was Arney, who was subsequently charged with assault on a police officer, a misdemeanor.

That's as far as consensus goes. Arney's own account is that he went to Knickerbocker's to discuss some business with a man running the place, and that at meeting's end he emerged from a back room to find a fight erupting in the bar. Arney says he played the good citizen, stepping into the fray to break it up. He had one of the troublemakers in a full nelson and was advising the man to calm down when a squad of bouncers materialized, assumed he was the instigator, and rushed him. He defended himself.

Taliaferro verifies the story thus far. "That's one time when he was an innocent party, I swear to God," he told me. Arney again: The bar cleared and several dozen people spilled into the parking lot, he and the bouncers among them. He was holding his own—not winning the fight, but not losing it, either—when the police arrived in force. He heard someone yell his name, looked over his shoulder, and found a K-9 cop a few yards away, holding a German shepherd by a short lead. Stand down, the cop said, or I'll put the dog on you.

Arney says he was busy at the time. Between swings he replied: Please don't put that dog on me. Then don't move, the cop said. Don't move or I'll put the dog on you. Look, you can arrest me, Arney says he told him. But don't put that dog on me, or I'll fuck up your dog. Taliaferro told me that later, in court, Arney was quoted saying "something like 'I can tell you love that dog. But if you put that dog on me, I'll hurt it.'" He added: "Those may not have been his exact words."

The cop advanced to within a few feet of him, Arney says. The dog was going crazy, barking and growling, fur on end, spittle flying. Don't

move again, the cop said, or I'll release the dog. And that, Arney says, was one warning too many. He was already annoyed that he was being treated as a lawbreaker, when he'd actually been attempting to do good. Fuck it, he thought, I'm going to jail anyway—and he reached over and thumped the cop on the chest. As he did, the cop let the shepherd go.

Arney whipped up his hands, caught the leaping dog by the throat, and held it off the ground as it kicked and snapped at him, squeezing the animal's neck, biting deeply into its ear, bellowing, *How do you like that, huh?* The cop jacked him in the jaw, knocking his head back, so Arney swung the dog at him, landing a heavy blow that staggered the officer. The cop punched him again. Arney again swung the dog, out cold by now, harder this time, and knocked the cop off his feet. As he did, he lost his own footing on the parking lot's loose gravel. Down he went, the dog's inert weight on his chest. He was charged with assaulting the dog, rather than its handler; in court, Arney says, he told the judge that he didn't realize the animal was a police officer because it wasn't wearing a uniform or a badge.[*]

Taliaferro seconds many aspects of this account. "They put the dog on him, and damn if he didn't grab it," he said. "I asked him how he did it, and he says, 'The secret is that you have to get their legs off the ground.'" Arney choked the animal until it "was about to check out," Taliaferro said. "Finally, he dropped the dog and it ran off to [a police] van."

He did "seem to remember," he added, that the dog was so traumatized by its brief acquaintance with Arney that it had to be retired from service—it "had to go to a nice family." Arney makes this claim him-

[*] Let the record show that despite this story, Arney professes to like dogs. His household now includes two Yorkshire terriers, Lexi and Levi. A few years ago, Ashlee accidentally dropped Levi on his head. The animal appeared to be dead; Arney says the dog's "pupils were dilated and fixed." He performed mouth-to-mouth on the creature and revived it.

self, and he's also corroborated by the late lawyer and substitute judge Peter G. Decker Jr., who became a close friend of Arney's and whom I asked about the incident in November 2011, shortly before his death. "He was no longer a K-9 dog," Decker said of the animal. "The police were a little upset with Tommy."

The cops I spoke with differed with many of the story's particulars. Betty Whittington, a secretary in the K-9 unit for decades, said through an intermediary that she recalled no such injury to a police dog. A seasoned police spokesman told me he remembered hearing the man-bites-dog tale as a young cop, but couldn't say it wasn't an example of the mythmaking that pervades any police department. Retired police captain Carmen Morganti, whom Arney remembers being present during his booking, and who recalls the Knickerbocker's melee and Arney's arrest himself, told me he believes the part about the dog was "probably bullshit."

Arney says not only did it happen the way he describes, but for months afterward, Norfolk K-9 cops would demonstrate their lingering displeasure over the episode by parking outside the Body Shop on their breaks and staring down those who entered and left. When he confronted one of them as he sat in his SUV, his dog in the back, Arney says the cop growled: I'd like to see you try to choke *this* dog.

Let it out of the fucking truck, Arney says he replied. I'll choke that motherfucker right now.

11

DESPITE TOMMY ARNEY'S talk of beginning work on the wagon at once, another week passes without said work beginning, because even after Painter Paul finishes the pickup, he can't move the wagon into his body shop—much of the floor is occupied by a partially restored '69 Camaro convertible lacking front wheels. Arney promises to help him move it, but he's sidetracked in Norfolk and fails to turn up.

But lo, on Friday, March 4, 2011, a combination of restlessness and frustration compels Paul to relocate the Camaro without waiting for Arney. He enlists the help of Bobby Tippit, a sun-ravaged roofer who lives in a tiny shack across Route 168 with his common-law wife and four boys; Arney pays him to weed-whack and perform odd jobs around the lot, when he isn't furloughing him for downing beers during the workday.

The Camaro is positioned longitudinally in the building. Using floor jacks, Paul and Tippit raise the front end and jockey the car back and forth and sideways on the shop's concrete floor until it's wedged crosswise along the back wall. With the move accomplished, Paul fires up a Bobcat tractor with forklift blades attached to its front end, lifts the wagon from the weeds where it's squatted for eight months, and carries it to the concrete pad in front of the shop. He and Tippit loosen the bolts holding its front fenders in place.

Tommy Arney's efforts to rescue VB57B239191 have begun. Twenty minutes of labor on this chilly Friday afternoon foretells the first stage

of the salvation to come: The car will be reduced to its elements. Nearly fifty-four years after its initial assembly, the work of Chevrolet's Baltimore plant will be undone to the last bolt.

Never before, in all the wagon's history, has it been torn down in such fashion; the closest thing to a restoration, on Sid Pollard's watch back in the late seventies, saw it patched and repainted, but the car remained intact. This time, every tiny fold of metal that might shelter rust must be exposed, sandblasted, primed, repainted. Every rusted bolt and time-hardened rubber bushing, every wire, every inch of brake and fuel line must be replaced. The process of returning the car to beauty will first render it unrecognizable. As Paul tells me: "It won't look like much."

The work begins in earnest the next morning—Saturday, March 5, 2011—when he and Tippit unbolt the fenders and lift the heavy metal panels from the car. They disconnect the hood from its hinges, disassemble the Chevy's grille, pull off the front bumper. They position the parts on the ground in a rough approximation of their arrangement on the chassis, creating an odd effect: The bulk of the wagon, with its engine, front suspension, and wheels fully exposed, looks guillotined, and this cluster of parts seems its disembodied head. The Chevy's frame juts from under the engine like naked bone.

Tippit sprays the engine compartment's bolts with penetrating oil, which transforms the rust that holds them fast into slippery brown goo. He and Paul unbolt the engine from its mounts. Then Paul wheels an engine hoist, essentially a six-foot crane, over the car's motor, and connects its hook to the power plant at two points. He pumps the hoist's handle, the boom rises, the chains pull taught, and the engine lifts, swaying, from its mounts. He wheels the hoist back. The engine stays put: The transmission, which is attached to its rear, is hung up on the metal tunnel in which it nests—a tunnel that inside the car creates the center floor hump under the dashboard.

Tippit leans into the compartment and pushes on the transmission

with both hands, trying to jiggle it loose. He can't budge it much: With two flat tires, the car is sitting so low that the transmission's tail is resting just an inch off the concrete. Paul can't adjust the boom to facilitate the extraction, because that'll tangle the engine in its own mounts, which jut from the frame. "Goddamn it," he mutters. "We're doing something wrong."

Tippit hunts down a wheel fitted with an inflated tire and swaps out one of the flats. It buys a little more wiggle room, but not enough, prompting him to suggest, "Maybe if we took off the oil filter," or something that sounds like that. He is missing some teeth, which turns his consonants to mush. Paul nods, having tuned his ear to decipher his helper's speech.

Tippit spends several minutes struggling with the filter before getting it loose, only to find that its absence doesn't make much difference—the engine's still pinned. He slides back under the car to remove one of the engine mounts, then climbs into the engine compartment and stands on the rear of the transmission, leaning back against the windshield to brace himself. Paul yanks the hoist back, and the engine finally pulls free.

An hour later they've removed the front seats and pulled up the rotted carpeting, and the damage to the floor pan is plain to see. Its edges no longer exist. We can see the ground, and quite a bit of it, in a dozen places. The flooring is buttressed with steel ribs on its underside; even beneath the patches of sheet metal that have survived, the ribs are chewed to nothing, meaning that the pan is too weak to safely support a load. The rocker panels—the slender strips of a car's skin that run beneath its doors, forming their sills and the floor's outer frame—are shot, too.

Painter Paul is glum. "It's bad," he says. "I'm not going to tell you it's not. It's real bad. I mean, you can see it." He nods at the rocker panels. "This whole structure—the floor pan, rockers—it's a mess. These rockers are going to have to be completely replaced."

He swings one of the doors on its hinges. "Lots to do, and I don't even know what we got," he says. "I haven't seen up under the doors yet. No telling what's up under there, how far gone they are." He sighs. "It's ate up."

"But fixable," I say. It's a question in the form of a statement.

He snorts. "It's gonna take fucking years."

"Years?"

He nods, fixes me with a grimace. "Tommy Arney's involved, man."

He and Tippit resume the disassembly. They slide the chrome strips from the wagon's flanks, wrap each in masking tape, label them as to right or left side, exact location—a necessary task, as there are six strips per side. They unhook the wiring from the back of the dashboard's gauges. They enlist one of Tippit's preteen sons, Anthony, to vacuum the thick sweater of rust flakes from the floor and the cargo deck. "Everything has to come off this car," Paul tells me. "It has to be a bare shell. And then once we get everything out, we'll have to brace it—brace it front to back, brace it left to right—so that it doesn't fold in on itself when I cut out the floor."

Arney strolls into the shop area. He circles the main portion of the car, then inspects the disconnected front end. "You know what?" he hollers over to us. "This front end looks great." He nods at the vent ducts that run inside the fenders, designed to carry fresh air to the passenger cabin from intake ports hidden behind the headlights. They're "just unbelievably good," he says. He eyeballs the front bumper, which is rusted and flaking on its underside, then returns to the rest of the car and peers at the floor for a long moment. "Well," he says, turning to Paul, "we don't have to replace the whole floor pan, at least."

Paul's eyes widen. "The ribs are all ate up," he sputters. "They're gone completely!"

Arney smirks. "I'm fucking with you, Paul." They'll replace all the floor, he says, and the rocker panels, too. Start fresh.

IT WAS SEVEN winters before, a Wednesday morning in January 2004, that Dave Marcincuk first saw the car. He was riding shotgun on a two-man garbage truck, trying to stay warm as he hooked cans to its side and sent them up and over the hopper, and there it was at the curb, all curves and chrome and turquoise paint. Right off, the twenty-eight-year-old Marcincuk was charmed, in part because in the dim morning light he misread the "For Sale" sign Chris Simon had hung in a window, thought the asking price was $56.25.

Getting closer, he saw he was off by two decimal points. Simon was asking more than six times what his dad had paid for the wagon, seven years before. He was asking more than twice what the car cost new. Still, it was a '57, and in the few seconds he had to gaze on it before the truck pulled away, Marcincuk thought it looked to be in pretty good shape. He drove back into the neighborhood that evening for the phone number.

When he called, the man who answered said that yes, indeed, he had a '57 Chevy. He enumerated some of his car's strengths and flaws. The red paint, he said, was fairly new. Wait a minute, Marcincuk interrupted, this car's green. Ah, Dave Simon said. That's my son's car. Chris didn't have a phone, he explained, but perhaps Marcincuk could reach him through his girlfriend.

They made contact a few days later, and met a few after that. Quite a contrast, they were—the clean-cut, whippet-thin Marcincuk and Simon, who smoked Marlboro Reds and sported muttonchops and struck his prospective buyer as "a big, long-haired, troublemaking-looking type of guy." But Simon was friendly, easygoing, and up front about the car's weaknesses. It needed some work, he admitted. He'd been unable to give it the attention it deserved.

Marcincuk could see that for himself. Now that he got a closer look, he noticed that in addition to the dents, bad paint, and rust he'd seen

from the truck, little remained of the rocker panels and wheel wells. The radio didn't work. The clock was stopped.

The floor, Simon said, had given him the most trouble. Marcincuk opened the back doors, saw the boards chewed to nothing, street where steel should be. Well, he decided, this would be the worst of it. Even so, he turned to Simon, seeking reassurance. This is a good car, right? he asked. You've been driving it, right?

Sure, Simon said, he'd driven it. He softened on the price a little, to $5,000, and Marcincuk said they had a deal. While they were attending to the details, Simon showed off his Lego renditions of the '57. Man, an amazed Marcincuk said as he inspected the toys, this car is *you*. I can't believe you're selling it.

It's not like I want to, Simon replied. But I need the money.

It took a few days to get the cash together, after which Simon delivered the Chevy to its new home, Marcincuk following him through traffic. It was clear to the new owner that while his predecessor might have driven the car, he had not done so with any frequency: Simon was ginger at the wheel, uncertain—as Marcincuk later put it, "He was *Driving Miss Daisy*, all the way."

The eleven-mile journey ended at his house, a cluttered monument to Marcincuk's soft spot for castoffs: An unrestored Craftsman cottage dating to the 1920s, it was piled with old rotary-dial telephones he'd rescued from the trash, glass insulators, discarded wooden doors, disassembled TVs, and lamps. He'd found all of his kitchen appliances on the curb: an antique refrigerator that needed only a scrubbing, and a 1960s dishwasher that he fixed with a 1980s motor, and a late-fifties Westinghouse clothes dryer that not only worked but played "How Dry I Am" when its cycle ended.

The yard was crowded, as usual, with old cars. Over the years, he'd owned two Dodge Darts, a Dodge van, five Plymouth Valiants, six Chevy IIs or Novas, an Impala wagon, four Mercurys, and a Chevy pickup, not counting cars he'd bought strictly for their parts. All but

a couple had dated from the sixties. All but one had been older than he was.

None had been a keeper; certainly, none had rivaled a '57 Chevy. His business with Simon complete, the wagon's eleventh owner parked the car beside his garage and mulled what part of it to fix first.

MARCINCUK'S PARENTS HAD seen their adult son coming. As a toddler, he unscrewed electrical outlets from the walls and picked at their insides. The elder Marcincuks, New Yorkers who'd moved to the Virginia coast two years before Dave was born, were made nervous by this potentially lethal habit, unhappy that he took apart any toy handed to him and further discomfited when he later built kinetic sculptures in the yard from bike gears, boat dollies, wagon wheels.

Chesapeake was still undergoing the metamorphosis from soybeans to suburbs that Sid Pollard and Picot Savage had seen beginning a generation earlier. A bit of a loner, Marcincuk would ride his bike out past the newest and farthest-flung of treeless subdivisions to where the roads narrowed and fields stretched flat and away, and the ruins of old farmhouses beckoned. He always found junk to drag back home. Why, his mother lamented, are you digging around in other people's trash? His father, an electrician who built buses at a Volvo plant in Chesapeake, recognized where his boy was headed and laid down a rule: I know you're going to go buy some old junk car and drag it into the yard and take it all apart, he told him, and you'll lose the parts and have me run over them with the lawn mower. So you are not allowed to bring a car onto this property until you have a license. His son was nine.

He needn't have worried. Marcincuk never bothered with a car while in high school, or as an art student at Virginia Commonwealth University in Richmond. It wasn't until he switched to an automotive repair course that he got his first. Strange, but as good as he was with his hands, as intuitive as he had always been with machines and their

parts, Marcincuk was struggling with the course—failing, in fact—when he spotted an abandoned '64 Chevy II Nova behind a local Mercedes dealership. It was a beater, but he bought it, had it towed to school, pulled the engine by himself, disassembled it, and dropped a rebuilt engine in its place. He shined, working on the Nova. He could perform tasks before he knew what to call them. The textbooks confounded him, but show him an exploded-view diagram of a component, an engine, an entire car, and he could take it apart, put it together, make it work.

He got a job at a Montgomery Ward auto shop, another at Norfolk's city garage, fixing and changing tires—not glamorous work, but enough to keep him occupied, pay the bills. Then, in 2000, his father suffered a heart attack and died three days shy of his fifty-fifth birthday. It took Marcincuk by surprise, and for months afterward he was confused and angry, and thought a lot about life and death, about what little he had to show for his time on the planet.

He was fixing and selling old cars on the side, and one day a stranger came by to see one he'd put on the market, a rusted Mercury running somewhat unevenly, an unpromising car. Marcincuk had pulled the pushrods out of the engine, laid them on the sidewalk, and beaten them straight with a hammer, an approach to an exacting task that has failed to earn endorsement from the Society of Automotive Engineers. The stranger didn't buy the Mercury, but he gave the young mechanic a gospel tract and invited him to church; the spiritually wandering Marcincuk went, found comfort there, and kept going. A short time later he applied for another city job, in solid waste disposal. He mentioned that he was praying for the job to a city worker who stopped by the garage to get a tire fixed, and the man—a carpenter, as luck would have it—offered to send a faith team over to his house to help give those prayers a boost.

Three people showed up. They opened the Bible and explained how he could be saved. He had been raised by the Golden Rule, but the

faith team said that good works or no, he was covered in the filthy rags of sin. Dave Marcincuk sat surrounded by all manner of treasures he'd rescued from the trash and accepted the Lord.

His prayers were answered: He got the job in solid waste, and over the course of the next three-plus years he crisscrossed the city on the back of a garbage truck. He often saw old cars parked on the curb, but rarely anything that qualified as a classic. Then came that morning at Chris Simon's place.

First thing, Marcincuk decided the engine had to go. Someone had given him a thrashed '65 Impala four-door, now vegetating in his yard under a veneer of moss and mushrooms and filled with all manner of rusted junk; there was actually, swear to God, a kitchen sink in its trunk. Under the hood was a ruined Chevy V8, a 283 two-barrel, the same engine Nicholas Thornhill had bought with the wagon. Marcincuk pulled the Impala's engine and traded it in on a new one—a number of companies offer new engine cores in exchange for a trade-in plus cash—and dropped the new motor into the '57 in place of the 327 that Picot Savage had installed after frying the original.

He laid sheet metal over the holes in the wagon's floor and started working on the body, racing the sundown each evening as winter turned to spring. He straightened the bent steel as well as he could, and bought a new centerpiece for the grille. He licensed the car in April 2004. He replaced the exhaust system in June.

With that, Marcincuk started driving the car every day. He'd be up before dawn and head for the industrial park where Norfolk kept its fleet of garbage trucks, and leave the Chevy there while he made his rounds, through a city much changed over the previous few years. Downtown was now crowded with upscale homes, restaurants, and traffic, and anchored by a monolithic shopping mall. The loft condominium building where Alan Wilson and Al Seely had lived, an outpost in an urban desert ten years before, was almost lost among new neighbors. The highways that had carried flight from the central cities

were clogged now, commutes to the suburbs time-consuming and frustrating, so people were moving back to town.

After work, Marcincuk would take the wagon home again. It still caused a stir. In traffic, on the move, it was easy to miss its blemishes. He was vexed by even the smallest of them, however. He pored over catalogs, pondered which pieces of the body he could salvage, which he'd need to replace. He collected vintage magazines that mentioned the Chevy. As so many had before him, he envisioned it with a restored interior, clean sheet metal, fresh paint. Which isn't to say he had a lot of time to devote to daydreaming, because that summer, Marcincuk worked on fixing and painting his cottage, and was active at church and in spreading the Word. He wasn't bashful about witnessing to strangers, handing out Bible tracts, explaining how his life had changed since March 2001, when he'd accepted the Lord as his savior.

Then, late in the summer, some bad luck visited man and car: The block of the Chevy's barely broken-in engine cracked. Marcincuk parked the wagon in the yard, pulled the motor, and lugged it back to the place where he'd obtained the trade-in. The shop gave him the runaround; it took weeks to get a replacement. When he carted a new engine back to his house, it was October.

Another car squatted beside the Chevy by then, and Marcincuk had a new obsession.

A FEW MILES to the south, the new, relatively straitlaced Tommy Arney found his energies unexhausted by his duties as proprietor of a neighborhood pub, so he diversified with a host of sideline ventures. He opened a bar in Norfolk and erected an enormous neon nameplate reading "Tommy's" on its façade. It didn't bring a timely return, so he shut it down and recycled the sign on a used-car lot, at a former Texaco station on a soggy river bottom a few blocks from Mary Ricketts's girlhood home.

At about the same time, he opened a hair salon with a woman who'd been cutting his own thinning locks, and when that didn't work out— she lacked his round-the-clock drive—he transformed the space into Pedro's, a shop devoted to the sale of Mexican pottery that he and Skinhead fetched on epic road trips to Laredo, Texas. He and the crew took on demolition jobs, house painting, roofing, hauling junk.

Arney acquired properties by the dozen, some of them down-at-heel houses and apartments that he fixed up and flipped, others small commercial spaces, cheap to buy and easy to maintain, that he gutted, modernized, and rented out. Real estate provided an almost certain route to financial independence, Arney believed. Whatever the gaps in his formal education, he understood that property, bought at the right price, was a safer place for his money than just about any other investment.

So he bought until he had close to one hundred pieces of real estate scattered through Norfolk, Chesapeake, and just across the Carolina line. He tended to deal with the same bankers for all of his land deals, men he knew and had come to trust—and who understood that Arney was a man of his word and that they had better be, too. Pretty soon, he'd acquired such a reputation as a landowner that lenders keen for his business took to lunching at Maxwell's, just for the chance to talk with him, to forge a relationship.

His passion for these wide-ranging interests was intense but seemed puny next to his unflagging zeal for the automotive trade. Nothing brought Arney the satisfaction of horse-trading for an old car, fixing it up, and reselling it at a profit. Enjoying it at his Norfolk car lot was short-lived, however: The presence of 518 vehicles on a creek-side property surrounded by homes earned the city's unhappy attention, and with that came a visit from a petite blond municipal attorney named Cynthia Hall. Their first meeting did not go well. Hall, apparently immune to Arney's charms, informed him that he'd have to remove the cars, and she wasn't much interested in negotiating. He lost his temper and called her a "crazy bitch." Hall slapped him with a court action

aimed at shutting down his rogue operation. The judge sided with the city. Arney and Skinhead hauled away the cars.

So in 2001, Arney turned his attention to acquiring property for a more ambitious car lot, and scouted locations where he might answer his calling without interference. His search took him south across the state line to Moyock, which seemed promising: It was an unincorporated dot on the map, more a wayside than a town proper, its ragtag businesses sowed loosely along Route 168 among cropland, slash pine, and dark patches of swamp. Any name recognition it enjoyed outside of Currituck County had come with the recent arrival of Blackwater USA, a private company that gained some notoriety, not all of it welcome, in the early days of the Iraq War. The outfit trained members of the military, government contractors, and police in shooting, hand-to-hand combat, and other martial skills on a seven-thousand-acre preserve west of the settlement. If the wind was blowing right, the bark of gunfire might drift from over that way.

Arney bought a lot alongside Route 168, a mile into Carolina, then added an adjoining property in 2002 and another the year after. The biggest tract, of about two acres, included the Quonset, which had seen its first service as a drugstore and later use as a lawn equipment sales and service outlet. Next door was a tract of roughly an acre that had once been home to Outer Banks Motors, a used-car lot. Its sales office, a small trailer, still stood on the property. And adjacent to its rear was the third, squarish tract, on which stood a small modular home and three large metal sheds—formerly the fabricating plant of a company that designed and built custom trailers.

So began Moyock Muscle. He filled the properties with cars he bought cheap or got for nothing and offered them at sums he judged to be reflective of their value. He, not the Blue Book, set the prices—which is to say, the figures he soaped onto the windshields tended to the high side. If a customer seemed to be good for a car, and understood its place in history and the challenges he'd face in restoring it to

factory freshness, and was eager to take on the job anyway, Arney was inclined to settle for less. He was open to barter, too: If a prospective buyer could offer construction supplies, say, or restaurant gear, or a piece of real estate in trade, Arney was ready to deal.

Then again, if he believed a car to be rare or otherwise interesting, he could be stubborn. "It might sit for a year," he's explained to me. "Might sit for two years, three years. But someday, somebody will walk in the door and say, 'I've been looking for that car right there. How much?' "

Life was about trading, and he was good at it. Nothing he owned wasn't for sale. No possession was so valuable that he wasn't willing to part with it, if the separation made financial sense, and his family and crew were reminded of that on a regular basis. Case in point: Ryan was driving a '98 Mustang convertible Arney had given him, a sharp-looking car sheathed in metallic blue paint. A girl working at Maxwell's wanted it badly, and made clear she was willing to pay for it. Ryan found himself surrendering the car.

In 2005, Arney bought a fourth piece of land, next to the former used-car lot and in front of the former trailer plant: the longtime residence of the recently deceased Julius "Pop" Jennings, consisting of a home fashioned from two fused beach bungalows centered on nearly an acre of lawn. Jennings had promised the place to Arney in the event of his demise; they'd even agreed on a price. The acquisition gave Moyock Muscle 430 feet of frontage along Route 168. The inventory spilled into Pop's front yard, which Arney covered with gravel, and his side yard, and out back of the house.

Arney made a final, essential addition to the property: He hired Paul Kitchens, whose brother had been doing some painting for Arney. While in high school, Painter Paul had apprenticed in the body shop of a local Chevrolet dealership, and had blossomed into a bona fide artist with sheet metal and paint. He'd run into some trouble, in the form of cocaine and charges that he eluded police and whatnot, and had spent four years in state prison. He hadn't had a driver's license since 1988.

But he was careful, thorough, and ingenious in his work, an expert with a welding torch and plasma cutter, a paint gun, a palette of putty—and at making the most of the rather primitive conditions in Moyock, where his paint shed was fashioned of tin and a couple of old rail cars.

While Kitchens worked his magic, Arney and Skinhead greeted their public up front. Yankee traffic to the Outer Banks was funneled through Moyock, and in the summertime it thickened to a viscous ooze. Those trapped in the snarl had time to study the cars that Arney deployed in the front ranks—the explosion of chrome on a '49 Buick Special, an old Chrysler in two-tone blue, a convertible Olds, an ancient Chevy Suburban. Arney had business cards made, reading "We Can Build Your Dream" and listing his cell phone number along with Ryan's and Skinhead's, and he'd hand one to anyone who broke from the traffic for a look around.

If he hit it off with a customer, he might hand him a second card, which Ryan had designed and given to his father as a gift. "Tommy Arney," it announced in large type, "Master Consultant." Below were his specialties—Finance, Real Estate, Auto, Liquidation—ending with: "Life Coach."

SPEAKING OF RYAN: When he was eighteen, Arney bought him his own place, a town house not far from Maxwell's, where Ryan was working full-time as a cook. He stayed there for a year, then rented a house from Slick, where he threw epic all-night parties and drank a lot of beer and for a year or two lost his way.

He emerged from this wayward chapter committed to getting an education and to whipping himself into shape. He moved into a brick rambler on a curving lane in a pocket of suburban Chesapeake that, despite rampant home building and commercial development all around it, retained a little of the rural character that just a few years before had characterized the hinterlands around Norfolk and Portsmouth. The house was surrounded by fenced pasture. A gate

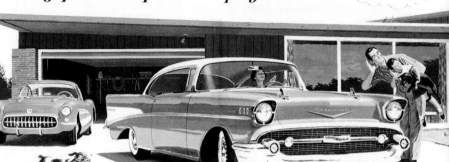

Chevy puts the _purr_ in performance !

Sweet, smooth and sassy! The dashing new Corvette (left) and the Bel Air Sport Coupe with Body by Fisher (above) two of 20 beautiful new Chevies.

Two "sweet, smooth, and sassy" Chevrolets from the company's iconic 1957 model year star in a magazine ad that pushes an image along with Detroit iron—the safe, carefree, got-it-made life of the American suburbs. The new subdivisions seemed like heaven after years of economic depression, war, and housing shortages, and made a status symbol of the station wagon, the SUV of its day.

The sales staff of Norfolk's Colonial Chevrolet admires a new '57 Bel Air convertible in the dealership's showroom a few months before Nicholas Thornhill walked onto the lot

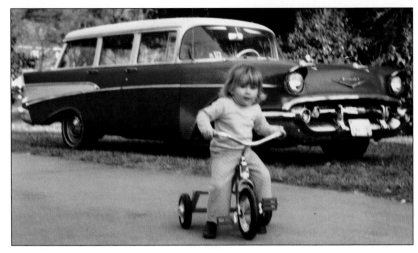

Sid Pollard's niece, Christy, rides her trike past the Chevy, not long after third owner Pollard overhauled the car and enlisted Frank DeSimone—destined to be its fourth owner—to repaint it in the late seventies. The only visible blemish is an unpainted repair behind the front wheel opening. *(Sid Pollard)*

Mary Ricketts, the wagon's funny, funky sixth owner, who loved the car but lacked the wherewithal to preserve it. *(Mary Jo Rothgery)*

Dave and Chris Simon stand with their Chevys at a Norfolk classic car gathering, c. 1998. Though still good-looking from a distance, the wagon was now rusted, dented, missing chrome, and in rapid mechanical decline. *(Chris Simon)*

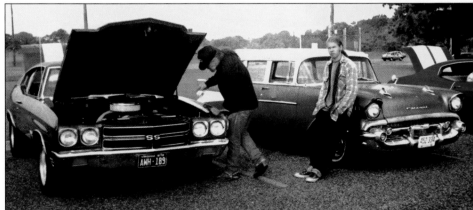

Dave Marcincuk poses in the wagon's empty engine compartment during the eleventh owner's attempt to rescue the car, December 2004. *(Bill Tiernan/ Virginian-Pilot)*

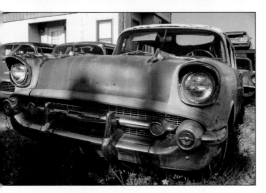

The wagon vegetates at Moyock Muscle in January 2010, a year before thirteenth owner Tommy Arney embarked on its salvation. *(Earl Swift)*

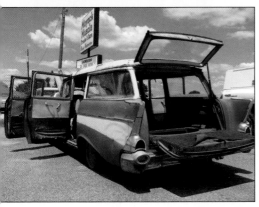

The car open to display its flaws, July 2010. *(Earl Swift)*

The wagon's ravaged interior. *(Earl Swift)*

Young Tommy Arney with his mother, Fern, in 1959. *(Tommy Arney)*

Tommy and Krista Arney during their courtship, 1970s. *(Tommy Arney)*

Victoria Hammond, who came to work for Arney as an exotic dancer at age twenty. Within a few years she managed all of his businesses and was central to his crew. *(Victoria Hammond)*

John "Skinhead" McQuillen poses with Arney at the Body Shop, the successful go-go bar Arney operated in Norfolk for a dozen years. Skinhead walked into the joint as a customer, and stuck around to become Arney's right-hand man. *(Tommy Arney)*

Arney poses at the Body Shop in December 1993. The torso on the right belongs to Victoria Hammond, then a year into her tenure. *(Martin Smith-Rodden/ Virginian-Pilot)*

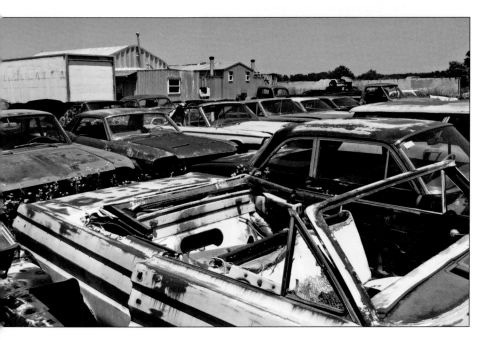

Some of the inventory at Moyock Muscle. *(Earl Swift)*

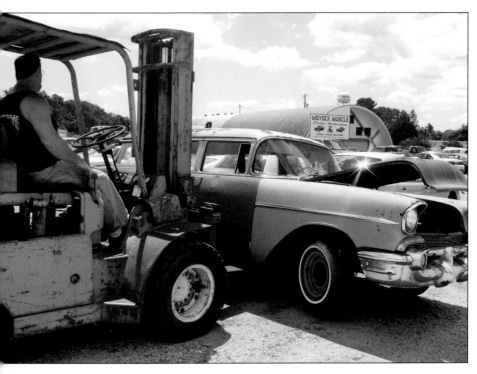

The shop area at Moyock Muscle. Arney lifts the wagon from the front lot and carries it by forklift to the body shop overseen by Painter Paul Kitchens, July 2010. *(Earl Swift)*

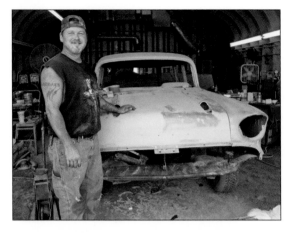

Painter Paul blocking the car, September 2011. *(Earl Swift)*

Painter Paul, right, and Bobby Tippett after dropping the new floor pan into the Chevy's core in the spring of 2011. *(Earl Swift)*

Arney examines a V8 that will power the wagon, but which is here still attached to one of several "donor cars" that he scavenged for both mechanical and body parts. Originally installed in a 1966 Nova, the engine would be the wagon's fifth. *(Earl Swift)*

Skinhead and Arney dismantle the donor car, spring 2012. *(Earl Swift)*

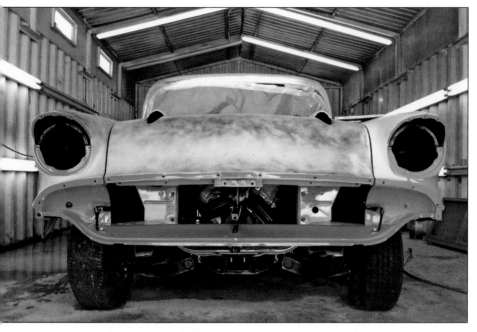

The wagon ready for paint, June 2013. *(Earl Swift)*

Paul preps the wagon for paint in the wee hours of June 28, 2013. *(Earl Swift)*

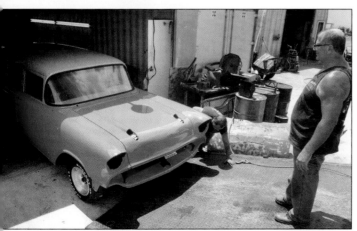

Arney and Paul roll the painted car from the paint shed. *(Earl Swift)*

A confident Arney arrives at federal court for his July 2013 sentencing. Arney's appearance ended a long-running legal drama, and one of several vexing distractions tha slowed his progress on the Chevy. (*Bill Tiernan*/Virginian-Pilot)

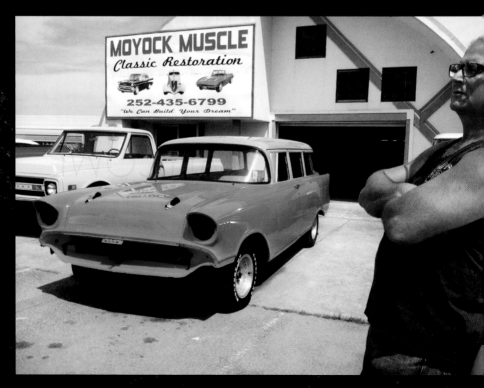

next to his driveway opened onto a barnyard and a big wooden horse stable.

Arney owned the house, as well as another rancher down the street. Over the next couple of years he bought a third house on the lane, then a fourth—the last a roomy, two-story place that had been built by a local doctor, with four bedrooms and three and a half baths and a big, bright kitchen, and into which he moved with Krista and daughter Ashlee in 2005. He filled the stable with six full-sized horses and four miniatures. As the family rarely rode them, they amounted to large pets. "All they do is shit and eat," Arney admitted, "but they're nice to talk to, and nice to look at." He put Skinhead in one of the spare ranchers, Painter Paul in the other.

Twenty-five years had passed since Arney's flight from the orphanage, and his triumph over the circumstances of his youth was at hand. He owned a town's worth of properties and lived on a small ranch. He ran a successful restaurant and pursued his life's passion in Moyock. He had a cadre of loyal followers. On paper, he was worth millions.

Little of that was liquid, but he was achieving the American Dream. He was enjoying the Middle Class Ideal. Make that Upper Middle: In the immaculate Arney home, a baby grand piano occupied a corner of the living room. No one in the house played, but still—a baby grand. It was sculpture. It was beautiful. It was immense.

If there was a note of melancholy to his success, it was that his mother didn't live to witness its highest heights. She and Strickland had married and had a couple of kids together, and for years, Arney put them up, rent-free, in Norfolk, first in a trailer and later in a house he owned. He'd worked hard to restore his relationship with Fern, picking her up every other week to take her to the beauty parlor and to lunch. They'd become as close as they could be, given her limitations in the maternal love department, before her death in 1998.

But the rest of his kin saw. He lived in a style that folks back in Meat Camp and Lenoir couldn't have imagined, that seemed another life altogether from that of the troubled boy they'd known. The new house

had a room over the garage that Arney set up with two pinball machines, an arcade game, and a stereo. One Christmas, he bought new Ford Thunderbird convertibles for his son and daughter, and when Krista mentioned that she liked them, bought one for her, too—he later reckoned he spent $145,000 on presents that year. When Ryan told him that he viewed his T-bird as "a girl's car," and wouldn't drive it, Arney sold it to his son's girlfriend for $25,000, or $17,000 less than he'd paid. The amount he *lost* is more than I've ever spent on a car.

Arney's hunger was unsated. In 2008 he bought, in Ryan's name, a pair of Cuban-themed restaurants called Havana, one in Norfolk and the other in neighboring Virginia Beach. He resold the beach location but kept the Havana on downtown Norfolk's Granby Street, at the center of the renaissance still under way in the city's long-neglected heart.

The crew was stretched tight. Slick not only put in double shifts behind the bar at Maxwell's and Havana; she collected rent from Arney's growing roster of tenants, paid his dozens of mortgages and tax bills, administered payroll and health benefits, and shepherded title transfers on his car sales and purchases. When Arney bought a property that needed cleaning, she did her share of sweeping and painting, too.

Skinhead rarely had a waking hour off the clock. He'd put a full day at Moyock Muscle or roofing or stripping the insides of a recently acquired building, then a long night in the kitchen. Painter Paul rose at dawn, fed and cleaned up after Arney's horses, put in an eight- or ten-hour day at Moyock Muscle, then tended to the horses again before calling it quits. He also cut the Arney Compound's eleven acres of grass.

By necessity, Arney was stingy with vacations and sick days. On a visit to a chiropractor, Skinhead discovered he had a bullet in his neck, a souvenir from a painful scare he'd endured in November 1977, when he was twenty-one. In the wee hours one morning he'd been held up at gunpoint, and on producing only pocket change had been tossed into the trunk of his own car and kidnapped. The robbers had driven around for several hours before announcing they would turn him

loose; they'd popped the trunk and, while Skinhead shielded his eyes against the bright light of midmorning, shot him point-blank, twice in the face and twice in the chest. They'd then closed the trunk and driven around for a while longer before heaving him off a bridge into a shallow creek.

Near death, he'd crawled up the creek's bank, earning the attention of a passing truck driver. The newspaper ran a huge photo of Skinhead splayed out on a sidewalk as paramedics worked on him. He'd spent eleven days in the hospital. The guy who shot him died in prison.

Thirty-odd years later, one of the bullets in his chest, which had been left in place, had somehow migrated into the muscles of his neck. Skinhead underwent outpatient surgery to have it plucked out, and was recovering from the procedure when Arney phoned. "You going to lie around all day?" he asked.

"I just had an operation," Skinhead replied.

"You had that bullet in you for years," the boss said. "You really going to let that little inch-and-a-half scar keep you in bed?"

"It would be nice," Skinhead said.

"It ain't happening," Arney told him. "Get your fucking ass up. We got to go to work."

THAT SAME SPRING that he acquired Havana, Arney was already busy with other business ventures. He prepared to convert the bottomland on which he'd had the rogue car lot into a twenty-seven-unit, upscale condominium development. He bought more property, some of it residential, some commercial. And his long and wistful retirement from the business of "gentlemen's entertainment" seemed to be nearing an end. He declared publicly that downtown Norfolk would benefit from the presence of what he called a "cabaret"—a place offering food and drink and stage performances by scantily clad, beautiful women—and that he'd be just the man to run it. "If you put a nice gentlemen's club in downtown Norfolk, it would say nothing but 'wel-

come' to travelers," he told a reporter. What he had in mind, he elaborated, was a classy place with valet parking, a ten-dollar cover charge, and a dress code.

His proposed venue was a recently closed bar two blocks from Havana. When the owner, who'd leased the place to Arney, caught wind of his ambitions, he took the property back. With that, Arney arranged a $2.17 million loan to buy a four-story building next door to Havana, and in the summer of 2009 launched a formal campaign for his concept among city officials and business leaders who'd have a say in any application for a liquor license on the premises—and who'd worked for decades to scrub away Norfolk's "Shit City" image.

It was a hard sell. Arney's efforts closely followed the forced closure of two waterfront bars for excessive rowdiness: the city's Bar Task Force, a squad of building inspectors, health officials, city planners, and fire marshals led by Cynthia Hall—the same city lawyer with whom Arney had tangled over his car lot a while back—had swooped in on the bars and found them loud, drunken, violence-prone, and out of step with Norfolk's emphasis on good, clean, family entertainment.

The Bar Task Force had also shut down a lounge in the very building Arney hoped to use for his cabaret; Hall and her lieutenants had cited the place for health and fire code violations. Arney nonetheless presented himself and his cabaret plans to the Downtown Norfolk Civic League, stressing that the club he had in mind would include neither private rooms nor lap dances—nor, for that matter, any physical contact between patrons and employees. He upped his proposed cover charge to twenty bucks.

The civic league president said Arney had proved a great neighbor at Havana. The mayor praised the restaurant. But the cabaret was doomed. Seven of the City Council's eight members said they would not support it. A gentlemen's club, no matter how high-end, did not mesh with the city's long struggle to make its downtown a focus of municipal pride.

Arney left his new building vacant, awaiting more receptive times, and leased the much smaller storefront on the other side of Havana. It, too, had housed a bar recently shut down by the city, a nightclub catering to a mostly black clientele. Arney figured it would be a good location for a country-western saloon that served traditional southern food—collard greens, catfish, country-fried steak.

Bootleggers, he called it. He and his crew gutted the interior, hired a muralist to decorate the walls, installed a DJ booth over the front door, and cleared space for a dance floor. It was a gamble—nothing like it had been attempted in downtown Norfolk. That only made it more of a draw. "If you don't gamble, what can you win?" he later told me. "I've been gambling all my life. If I didn't gamble, I can tell you I wouldn't be standing here right now. I've gambled with life itself."

The naysayers, the doubters—city officials, politicians, bankers—had no gumption: "If you put three dollars here and a thousand here, and you tell a banker, 'You can have the three bucks—or you can have the thousand dollars, but you might get slapped,' he'll pick up the three dollars. He don't want the risk.

"Hell, I'm going to pick up the thousand dollars," Arney said. "Go ahead and punch me in the face ahead of time. I'm going to pick it up."

12

I'D OWNED TEN cars when my path first intersected with the wagon's. On occasion I'd wonder what had become of those I'd unloaded over the years: Were they coddled by their present owners, as I had coddled them? Garaged and fresh-looking, or worn, beaten? Where had they traveled? What adventures had they seen? This musing eventually led to my contemplating a story for the newspaper built around a single old car and the otherwise unrelated people who had shared it. In the early summer of 2004, I decided to make some exploratory calls on the idea.

Right off, I got some unwelcome news: Virginia's Department of Motor Vehicles, like its counterparts in many states, destroyed its car ownership records after a few years. If I were to trace a car's history, I could rely on no official paper trail; instead, I'd have to find a chain of owners with exceptional memories. Each one would have to remember from whom he'd bought the car, and to whom he'd sold it. Were I looking for a car that had been owned by two, three, or four people, this might be reasonably easy to pull off, but to make the story work, I reckoned I needed a car that had passed through many more lives— seven seemed a reasonable minimum, spread out over thirty-five, forty years. I'd have to get lucky.

That spring I went through my newspaper's classified ads, circling cars in the "antiques and classics" columns that seemed interesting. I came away with a dozen, most dating from the late sixties and early

seventies, and called the numbers advertised with each. Within an hour, four fell off the list. One was still with its original owner; the sellers of the other three couldn't remember where they'd obtained them. So I called the previous owners of the other eight cars. Five could not recall who they'd bought from.

Two rounds of calls, and already I was down to just three cars. One was a 1965 Plymouth Satellite, which an older couple in town had just sold to a fellow in Texas. They'd bought the car from a sailor raised in Kansas and remembered his name down to the middle initial, but I could find no trace of the man in Virginia, Kansas, or anywhere else. Next up was a '65 Ford Galaxie convertible that had been owned back-to-back by navy fighter pilots—ideal for a newspaper story in a navy town. Unfortunately, the pilot who owned it first blanked on who'd sold it to him.

Last candidate: a 1970 Olds Cutlass wagon. I was encouraged about this one, because the current owner said he knew the car's history going back to the seventies. So I drove out to his little Craftsman cottage, and there met Dave Marcincuk. He was soft-spoken, clad in a T-shirt smeared with axle grease and motor oil, and eager to show off the Olds, which was in fine shape for its age: Its glove box contained the original owner's manual, and he had a build sheet for the car—a slip of paper secreted in the rear seat, on which all of the car's variations were recorded: the fabric, pattern, and color of its upholstery, the grade of carpet, the gauge package in its dash, the type of column supporting its steering wheel.

But it became clear, as Marcincuk related what he knew of the car's history, that it had passed through just four owners in its thirty-five years. We talked briefly about the decrepit Impala parked beside his garage, from which he said he'd pulled an engine; it had been abandoned on a farm for several years, and thus hadn't had many owners, either. I closed my notebook and was saying a disappointed good-bye when he offered, almost as an afterthought: Well, I do have another car that might interest you.

Yeah? What is it?

A '57 Chevy wagon, he said. It's in the shop right now, getting a new exhaust. As a matter of fact, I need to go over there to pick it up, and if you wouldn't mind giving me a lift, I'll show it to you.

I drove him to Big Al's Mufflers. The wagon was parked out front, and we circled it for a few minutes, Marcincuk describing the work he'd already completed, what he planned to do next. Rusted and crumpled and sun-bleached though it was, it was an arresting piece of machinery. Still, I couldn't imagine that I'd be able to trace the ownership of a forty-seven-year-old car, seeing as how I'd struck out on so many newer models. Mostly as a courtesy to Marcincuk I jotted its VIN into my notebook, and that evening wrote to the DMV requesting their records on VB57B239191.

A few days later, an envelope arrived from the agency with the paperwork from two title transfers. Per the state's privacy act, all the names and addresses had been blotted out; the only useful information was the dates of the transfers—or would have been, had a clerk at DMV used a decent marker to redact the documents. When I held the papers at an angle, I could make out typed names through the ink: Alan D. Wilson. Mary E. Ricketts. After that, breaks started coming my way at such a pace that I don't believe it's cutesy or coy or too poetical a flourish to say that I didn't choose this particular Chevy as the subject of my research and the story you hold in your hands.

It chose me.

I FOUND RICKETTS in the phone book. She recalled that she bought the car from Picot Savage, who now lived in Smithfield, twenty-five miles west of town. I called Savage, who remembered that he bought it from Frank DeSimone. I found DeSimone at his auto body shop. He remembered the car well, he said, but couldn't come up with a name.

"I can picture him," he told me. "Give me a couple weeks to think about it. I'll call you."

That was in August. I went on vacation and returned to find that I'd received no call. I got caught up in other assignments, and still, DeSimone did not get in touch. Convinced that I'd hit another wall, I telephoned DeSimone in early September to formally let him off the hook: "I haven't heard from you," I said, "so I'm guessing you couldn't remember."

"No, I *did* remember," he replied. "I just lost your number."

That took me to Sid Pollard, who couldn't remember the name of the man who'd sold him the car, but did recall that he was a veterinarian with an office on U.S. 17, and that his surname began with a *T*. It took only minutes to narrow the hunt to Dr. Bruce Thornhill Jr., who told me that why, yes, he had owned the car, and knew who'd owned it before him: his grandfather, the car's original owner, whom he'd accompanied to Colonial Chevrolet to buy it.

I now had the car's provenance from 1957 to 1994, and the names of two later owners. I called Chris Simon first, learning that he'd acquired the car in 1997. It took a lot longer to reach Alan Wilson, who'd all but vanished; I tracked him to Georgia through Al Seely, whose name I'd found linked to the doctor's in newspaper coverage of a 1992 political fund-raiser they'd thrown for Bill Clinton at their downtown loft.

Wilson recalled having owned the car for two or three years, and having sold it at about the time he'd had his professional troubles. That placed the sale in 1996 or 1997. *Voilà*: I figured that Wilson sold to the Simons, and that I had an unbroken chain of nine owners.

But there were details that caused me doubt. Wilson remembered selling the car for a lot less than the nine hundred dollars Dave Simon told me he'd paid. And when I pressed Simon for details of his purchase, he said it had occurred at a house in central Norfolk, nowhere near any home Wilson and Seely kept. Simon also said that the sellers

were a married couple, by which he meant a man and a woman. That was problematic.

I had Simon walk me through the purchase in further detail. He recalled that he'd been headed for dinner at a cheesesteak place, turned onto a side street assuming it would allow him entry into the parking lot, and discovered that it did not. He wound up driving the street a short ways and taking a right onto a dead-end to turn around. The wagon had been sitting in a yard on the cul-de-sac.

I asked whether he remembered anything about the seller.

Not really, he said.

Nothing? Nothing at all that stood out?

Well, there was one thing, he said. The guy drove a big red pickup, one of those tandem-axle jobs.

I headed for the newspaper's library, the shelves of which held long rows of hardbound city directories, one for each year, going back decades. These weren't the regular white pages—city directories list residents alphabetically, as expected, but often they include their occupations, along with their addresses; in addition, they feature a second section listing addresses by street and number, and a third of phone numbers in sequence. If you want to know who lives in a particular house, you can find that—along with the occupant's job and phone number—with the turn of a few pages. If you want to talk to that person's neighbors, you'll find them listed under the heading for the same street.

Companies produced the books for every major American city through the late nineteenth century and all of the twentieth. As quaint and laborious they might seem next to today's computer search engines, they remain valuable to researchers for an attribute that digital sources can't match. Because a new edition came out every year, each amounts to a snapshot of a community at a precise point in time. You can track people's movements around town by consulting consecutive directories, just as you can estimate when they switched jobs, or how long a business operated at a particular address, or when a fire wiped out a downtown block.

Dave Simon had given me the approximate location of the cheese-steak place. I found it in the 1996 city directory, along with the street onto which Simon had made his wrong turn. I used MapQuest to find the cul-de-sac where he'd encountered the car: Tyndale Court. Then it was back to the directories. Four of the people listed as living on the street in the 1996 edition were still there in the 2004 book.

None of the four was a past owner of a Chevy station wagon. None of them remembered seeing such a car in any of their neighbors' yards, either. But one recalled that a former neighbor drove a big red pickup: His name was Jeff Simmons, and he moved away a few years before, to a place called "Savages" that was somewhere near Ahoskie, North Carolina, about fifty miles to the south.

I found no such place, but I did stumble on a Savage Road a considerable ways north of Ahoskie—just across the state line, in fact, maybe twenty miles west of Moyock—and there came upon Jeff Simmons. He'd been so embittered by his experience with Norfolk officials that when he retired after twenty-two years in the navy he sold his house and moved his family to the edge of the Great Dismal Swamp, where they shared a comfortable homestead with horses, peacocks, geese, a donkey, and visiting eagles and bears.

Yes, he told me, he'd sold the car for nine hundred dollars to a fellow named Simon, and he'd bought it from Jack's Classic Pawn. I called back Alan Wilson, who when prompted remembered that indeed, he'd sold the Chevy to a pawnshop; the deal had been brokered by the people at Bay Chevrolet. The pawnshop had gone out of business, but I found its owner, Jack Reed Sr., running his plumbing supply store not far away. He remembered getting the car, cleaning it up, and selling it.

Improbably, almost unbelievably, the chain was complete.

IT TAKES FAITH to buy an old rust bucket and to embark on a quest for its lost youth—to scour junkyards and catalogs for arcane parts, to

spend extravagant sums on improvements not even visible to the eye. Faith, Dave Marcincuk had. But he was also a practical man, with a growing awareness, as we talked in the autumn of 2004, that (a), he had paid too much for the Chevy, and (b), it was going to cost a bundle to address its most desperate needs, let alone its cosmetic flaws. Worse, he would not gain a car that was worth a tremendous sum, it being a four-door station wagon, versus the far more collectible two-door sport coupe or convertible.

Just as he reached this unhappy reckoning, the Lord provided: Marcincuk got a bead on a 1955 Chevy wagon that lacked an engine but had spent forty-nine years in Southern California, and was thus entirely rust-free. It was selling for less than a third of what he'd paid for the '57. Marcincuk didn't care for the '55's egg-crate grille as much as he did the later model—its grimace made its "face" somewhat less friendly—and its nubby tail didn't compare with the '57's outlandish meat-cleaver fins. All that said, it was a more realistic proposition on a garbageman's pay, so he bought it in mid-October, rolled it into his yard, and parked it next to the '57. When the new engine arrived later in the month, he didn't drop it into VB57B239191, as planned, but into the older car. He figured he'd pull the transmission out of the '57, along with the five-hundred-dollar dual exhausts he'd just had installed at Big Al's, and he'd put those in the '55, too.

At long last, Nicholas Thornhill's wagon had reached that critical juncture at which so many old cars cease to be machines in their own right, and become mere organ donors for vehicles still on the road. Scavenged, it would testify to the impermanence of all things manmade. Parting it out would also cap membership in the fraternity of those who'd owned it, a fraternity whose members were happy and surprised, when I'd called them, to learn that the Chevy had survived the years; all voiced at least a little regret at having parted with it.

In the years since he'd done so, Bruce Thornhill had retired from his veterinary practice and was now a passionate big-game hunter. He

and his wife had raised three children; his youngest, the only boy, was named Nicholas. Sid Pollard, divorced a third time, was the father of three grown girls, and had moved back into his boyhood home to care for his ailing mother. Both were still mourning the loss of his father seventeen years after the fact: In 1987, dying of prostate cancer, the elder Pollard had run a garden hose from tailpipe to cabin of the family's '68 Plymouth Fury sedan, started the engine, and settled in the backseat with the Sunday paper. Pollard's mother found him when she came home from church.

Frank DeSimone had been busted for selling cocaine out of his auto body shop not long after selling the Chevy. Never in trouble with the law before, he'd pleaded guilty, done his penance, and gone back to work on high-dollar cars. Picot and Debbie Savage had split up in 1989. Picot was living a quiet and solitary existence in the woods near Smithfield, Virginia. His ex had remarried and moved to Florida with her new husband, who'd died in 1998 while the couple operated a motel near Marco Island. She'd married again, then died herself in December 2000.

Mary Ricketts was still working at a nursery and sharing a co-op apartment with her pet dog, though she bore only passing resemblance to the fun-loving, hard-partying woman who'd owned the wagon: In August 1998, she'd suffered a brain aneurysm that dulled her lightning-fast wit and robbed her of her zany brashness, along with her head for numbers. Now a knot of close friends with whom she met every night at a local saloon was beginning to disperse, its members moving away or dying off, and Ricketts was spending more and more time alone. She rarely saw her son, who surfed and designed T-shirts year-round on North Carolina's Outer Banks.

Alan Wilson taught college part-time in Atlanta, commuting to his classes, and Al Seely continued to grow his interior design business. As for Jeff Simmons, he told me that selling the car had been "about the stupidest" thing he'd ever done.

In the right hands, restored, the car might outlast all of them, might

insinuate itself into a host of new lives, witness time's passage with a new succession of owners experiencing new cycles of lust, love, reliance, heartache. Sold for parts, its story ended here.

Marcincuk agonized over what to do. In early November he decided that he should keep the Chevy more or less intact—harvest a few items he needed for the '55, perhaps, but sell what remained as a unit, rather than piece by piece; that strategy, he figured, gave him a better shot at recovering more of the enormous sum he'd sunk into the car. Obtaining top price meant getting the wagon running and rolling. He bolted on replacement front fenders (two different colors, but unperforated by rust) and found an engine, the car's fourth. It was a 265-cubic-inch V8, not a match for the engine the factory had dropped into that vehicle, but carved from the same block, and an option Chevrolet offered in 1957. Close enough.

He was looking for a buyer at year's end, when my newspaper story finally ran. I moved on to others. My assignments sometimes took me out his way, and as I neared his cottage I'd scan his backyard for the wagon. It was there, damn near as big as his garage, all through 2005, looking no better or worse than before, always in the same spot alongside the ruined Impala.

I'd look for Marcincuk, too, planning to stop for a chat if he was out in the yard, ask him how it was going. I didn't see him, however, and one day, I didn't see the car, either. It was still missing from its spot the next time I passed, and the next.

Then, in the spring of 2007, a friend who taught a college journalism class was called out of town and asked me to sub for him. The subject of my lecture was sourcing—how to use readily available documents, library resources, and such to get information—so I brought along a volume of the city directory, and by way of describing how useful it was I related how I'd used it to close the chain of ownership on the Chevy. As I packed my papers after class, up walked a student, a fit-looking guy in his mid-twenties with a day's worth of beard. He somewhat hesitantly said: "You know that car you were talking about?"

Yeah, I replied.

"Well, my dad owns it now," he told me. "And he knows you."

"He does?" I asked. "He owns the Chevy? Who is he?"

And he said: "His name is Tommy Arney."

More than thirteen years had passed since I'd spoken with Arney at the Body Shop. I promised myself to reconnect with him, to find out how he and the car were doing, but myriad errands and responsibilities intervened, and better than two more years passed. Then, as I drove in downtown Norfolk one morning in the fall of 2009, a pedestrian stepped into my path without so much as a glance either way. My squealing tires earned his attention; he stared me down, his scowl assuring me that hitting the horn would be a mistake. On the far sidewalk he stepped into a storefront that was piled with lumber, Sheetrock, and other construction supplies, and as I watched I realized I knew him from somewhere.

A week or so later, I was walking past the same storefront and saw that the door was propped open. I stepped inside to find the space stripped to the bricks; the floor was covered in plaster dust and littered with kitchen equipment and plywood. The same man was standing a few feet from the door. "Tommy?" I asked. "Tommy Arney?"

He shook his head. "I'm Billy," he told me. "That's Tommy." He pointed to a big fellow who stood with his back to us, speaking on a cell phone. When he turned around, slipping the phone into his pocket, I saw that aside from his mane's replacement with a thinning flattop, and a belly that had ballooned a bit from its 1993 dimensions, he hadn't changed much.

I told him my name and asked whether he remembered me. He said he certainly did. I asked what he was doing in the storefront. He said he was transforming the space into a country-western restaurant and bar. I said: "I understand you have a '57 Chevy station wagon that I wrote about a few years ago."

"Yes, I do," he replied. "As a matter of fact, we're getting ready to fix up that car."

HOW MANY PEOPLE in all the world could claim to be friendly with born-again Dave Marcincuk and with Tommy Arney, who is still wrestling with the circumstances of his first birth? I reconnected with Marcincuk, five years having passed since our last conversation, and found he could name at least one such individual—Bobby Dowdy, the owner of an electrical contracting firm in Virginia Beach.

Marcincuk had sold Dowdy his '55 Chevy wagon, and had thrown in the '57 as a parts car. Dowdy was not a sentimental man when it came to cars; at nearly sixty, he knew too much about them to care too much about any one. It's an automotive truism, counterintuitive though it might seem, that the less you know about your car, about what makes it work, the more emotionally attached to it you're likely to become. Real "car guys" might have, as Dave Simon did, a passion for a particular machine, but they don't see it as anything but that; the more you understand the mechanics of a car, its simple logic, the easier it is to see it as a concert of replaceable parts. Not a personality. Not a member of the family. Just an amalgamation of metal, plastic, rubber, and glass.

Dowdy was a car guy, through and through—a Chevy guy, to be specific. He'd been sixteen when he'd bought his first '55, and had spent the years since building and racing street rods and dragsters. He'd introduced his son to racing at age nine. He'd had his daughter racing at eight. When he looked at the '57 now, he understood that it was the hub of twelve narratives, including his own—this, he knew, was the car that had been in the paper. But mostly, he saw an inventory.

And when he'd owned the '57 for a few months and came to the realization that he wasn't going to get around to fixing up his '55 wagon anytime soon, and that the '57 took up space he couldn't spare, he

recalled that another local car guy, Tommy Arney, had opened a car lot down on the state line, and gave him a call.

He'd built his sales pitch, ironically enough, around the wagon's history. This car was in the newspaper, he told Arney. This car has provenance: Everyone who's ever owned it, all the way back to its sale at Colonial Chevrolet in Norfolk—it's all written down.

Arney had found that appealing. Whatever else the wagon lacked, and it lacked a lot, it boasted a feature that not many of his cars shared. They'd agreed on a price—three thousand dollars—and Arney had driven a tow truck into Virginia Beach and hauled the Chevy down Route 168 to Moyock. He'd planted it in the car lot's front yard, amid rusted but newer Chevys and Plymouths and Fords.

Rain had fallen on the car, and snow, and the sun had baked its ravaged paint. The tires lost their air. The interior's metal flaked like pastry. Birds nested in the bench seats.

Three years had passed.

A FEW WEEKS after encountering Arney at the storefront, I headed to Carolina. A quarter mile from the house I stopped for gas at the Exxon station that occupied the corner where Nicholas Thornhill had bought the wagon. I crossed the Elizabeth River and hugged its southern branch on Interstate 464, the sky-blue cranes of the naval shipyard looming on the water's edge, and sped into Chesapeake—once home to the truck farms and woods of Sid Pollard's boyhood, and now a loose quiltwork of subdivisions, strip shopping centers, and crowded roads. Fifteen miles from downtown Norfolk I neared the ragged edge of suburbia's advance, a frontier marked by a Wendy's and a Chik-fil-A, a Cracker Barrel, Target, and Home Depot, all brand-new and built in anticipation of houses to come.

Route 168 narrowed from expressway to four-lane blacktop just beyond. I'd never visited the car lot, but I spotted it a quarter mile before

I reached it: From that distance its trucks and cars, some piled two and three high, seemed the skyline of a far-off city. On pulling in, I had to pause for a minute to acclimate myself to the sensory overload I experienced. This was in January 2010, before the county had come down on Arney, before he'd launched his cleanup of the property, and seven-hundred-odd cars were shoehorned into its every nook. They guarded the Quonset five deep. Most of the lot could be negotiated only on foot; to sell a car from amid the crowd meant forklifting dozens of others out of the way.

I had not yet stepped from my car when my eye fell on a green '57 Chevy wagon parked in the shade of a small house trailer that at some point in the distant past must have been used as a sales office—a wind-scoured sign reading "We Finance" hung beside the door. I could make out other old Chevys around the wagon, and figured that Nicholas Thornhill's was among them.

Five wagons were clustered there—a couple of two-doors, including a completely trashed Nomad, and three four-doors. None of the latter looked to be my quarry. Two were rusted almost to powder. The third, the green car, had a hood decorated with a painted arabesque, a sort of automotive tramp stamp.

The wagon I sought had to be elsewhere. Over the next hour I explored every square yard of the lot, turning sideways to squeeze between some old hulks, climbing onto the bumpers of others for a better sense of my whereabouts, retracing my steps to ensure that I'd left no merchandise unexamined. I found no other '57 wagons.

I returned to the green car, wondering whether Arney had been mistaken; the color matched, but nothing else. No way could this be the Chevy I'd known. No car would have, could have, gone to hell so dramatically in so short a time. No car this bad off was drivable just five or six years before; to look at it, this thing hadn't moved under its own power in twenty. It was only to confirm this certainty

that I opened the driver's door, found the VIN on the jamb, and wrote it down.

An hour later, back at home, I dug through my files for my notes from five years before, and found my request to the DMV for title information. The letter included the Chevy's VIN: VB57B239191.

A match.

PART 3 *Out with the Old*

13

THE SPRING OF 2010, a few months before the county's visit to Moyock Muscle, found Tommy Arney facing crises major and minor that unrelaxed his mind and fouled his concentration. First was the conclusion of a long battle he'd waged with Old Dominion University over three of his commercial properties near the campus, including the darkened Body Shop building. ODU wanted to redevelop the area with a mix of stores, restaurants, and apartments, but its offer to Arney—$1.47 million—was less than half of what he thought he had coming. When the sides couldn't reach a deal, the city had condemned the property.

Arney had pushed the fight into court, only to lose there in February 2010. The affair gobbled up time he might have spent on the Chevy and overlapped with another time-sucking dispute: At Bootleggers, where Arney was hurrying to finish the build-out and open for business, a city inspector found that a new spiral staircase was ill-designed and lacked some necessary permits, and that a balcony railing violated safety standards. Arney told the man he'd make them right. As he remembers it, the inspector replied that he'd better, or the restaurant wouldn't be opening—said it twice, actually, which Arney judged to be too often, and which prompted him to ask the man, "Why don't you go fuck yourself?" and to suggest: "Get the fuck out of my building."

He was following his guest toward the front door, the two of them still discussing the matter, when the inspector complained that Arney

was raising his voice and should stop. Arney replied that he wasn't raising his voice, which caused the fellow to again insist that he not raise his voice. That's where it ended. The man left.

The following day Arney got a call from one of his lawyers, Pete Decker III, who said he'd just spoken with Cynthia Hall, the municipal attorney whom Arney had labeled a "crazy bitch" years before. She'd been super-angry, Decker reported. She'd told him that the inspector was a former marine and thus unaccustomed to experiencing fear, yet had felt it keenly when eye to eye with Arney. The man had believed his safety to be in jeopardy. She had thought about putting Arney in jail.

Decker insisted that Arney apologize. He and the inspector made peace, after which Arney raced to make all the changes mandated by the city, and thereafter received the all-clear to open Bootleggers for business on a provisional basis, pending final approval a few months hence. But as the evidence will show, he did not achieve anything like peace with Cynthia Hall.

At roughly the same time, Arney pushed the city's blood pressure to a new spike when he splashed a neon sign across Bootleggers' façade that Norfolk planners considered too big and bright next to those of its neighbors, the nearest being Havana and a Subway sandwich shop. He was called before the Planning Commission, the vice chairwoman of which declared the electric blue lettering "out of line."

Arney responded with a surprise tack. The problem wasn't that the Bootleggers sign was too big, he said, but that the neighbors' signs were too small. "We're actually going to change the Havana sign as well," he testified, "because as soon as Captain Skinhead—he's worked for me for twenty-five years—as soon as Captain Skinhead saw the Bootleggers sign up, he loved it so much he said: 'Tommy, we need to take and do Havana's sign big as well.' So we're going to do that."

"Oh, you are?" the vice chairwoman asked.

"Yes, ma'am," Arney told her.

The vice chairwoman intimated that Arney would have done well

to seek permission before erecting the sign. "When you were a child," she suggested, "there were many times that you played a game called 'Mother, May I?'"

"Not me, ma'am," Arney said. "Didn't have a mother."

The meeting raced downhill from there, with Arney assuring the panel that he'd sue if he didn't get his way. "It's like y'all are telling me," he said, "[that] if you come into my business and you don't like our chicken, you can come in and tell me I've got to change my menu."

The Planning Commission disagreed, voting six to zero to force the sign's removal, which required Arney to appeal to the City Council. He prevailed there, but not before spending a lot of time in preparation with his lawyer—which, again, was time he couldn't devote to the wagon.

No sooner was Bootleggers settling into a routine than the Bar Task Force swooped in on the saloon. Arney wasn't working that Saturday night, but Ryan and Slick were, and called to say that Cynthia Hall and a squadron of officials had just filed in, were snooping around, and had asked to see some of the restaurant's paperwork. Arney, in his truck at the time, asked Slick to hand the phone to Hall. The lawyer refused to speak with him. Now of profoundly unrelaxed mind, Arney left a raging voice-mail message for the city's liaison with downtown business owners, during which he called Hall a "stupid motherfucking cunt."

Another man might have been more circumspect with his feelings, as Bootleggers was still operating on a provisional license to serve alcohol, but as Arney explained to me: "I wasn't born kissing ass, and I wasn't raised to kiss ass, and if you tell me I have to kiss your ass, well, fuck you—I'm going to fight you." The next day, he got another call from Pete Decker III. All hell's breaking loose, the lawyer advised. I just got a call from Cynthia Hall. She said you called her an MFC.

MFC? Arney said. What the fuck is an "MFC"?

A motherfucking cunt, Decker replied.

Pete, Arney said, I did not call Cynthia Hall a motherfucking cunt.

Tommy, there's a recording, Decker told him. They have it on tape.

I promise you that I did not call her a motherfucking cunt, Arney said. (Reader, you can see where this is going, can't you?) I called her a *stupid* motherfucking cunt.

Decker insisted that he apologize, so at a meeting the following week, Arney did so: Angry though he remained over what he regarded as the task force's harassment, he told Hall he was sorry he'd called her a stupid motherfucking cunt, explaining that he'd lost his temper and said things he didn't mean. As the men remember it—and this is a point on which their recollection differs with the municipal attorney's—Hall said that she did not accept his apology and walked away.

That further incensed him, Arney says. In the following weeks he couldn't help stewing about the way Hall had marched into Bootleggers like Eliot Ness leading the Untouchables, about the disrespect the city had shown to the owner of a million-dollar restaurant who every year contributed fat sacks of tax money to that very city. He decided to take his grievances public, and that he wouldn't wait.

Arney's appearance before the City Council came just two days before Norfolk was to decide Bootleggers' long-term fate. He wasted no time getting to his point. If he'd been working when Hall and company showed up, he told Norfolk's eight top officials, "I honestly would have gone to jail."

"I'd like for somebody to tell me: Who gave them this power?" he said. "They're horrifying. They're ridiculous"—what with their "badges on chains around their necks, guns on them," and their "Gestapo-like tactics," and that leader of theirs, whom he called a "little Hitler." The following day, the newspaper carried a story saying he'd "declared war on the Bar Task Force." The mayor was quoted calling Arney's remarks "completely inappropriate," and Hall said she found them "offensive and inaccurate."

He got his license from the city—the Planning Commission found

that he'd met all of its demands, and approved his continued operation without discussion. But Bootleggers remained the wellspring of a million worries. Arney sold Maxwell's in June 2010, a few weeks after he opened the downtown saloon—that being a logistical decision as well as a financial one, because his tiny crew could not run three restaurants, especially with one of them twenty miles away—and then, to his great chagrin, saw his new venture fail to thrive. Bootleggers boasted the same home-style southern menu that had proved so popular at Maxwell's, along with a full bar, a pleasant and unique atmosphere, and lower prices than those next door at Havana, which was doing quite well. Still, it was as airy as a hangar on nights you could barely squeeze into neighboring places.

He shut it down after nine months.

ARNEY MIGHT HAVE been able to weather the vagaries of the restaurant trade if it hadn't been for a much greater distraction, his most pressing, next to which Cynthia Hall and the Bar Task Force and the Chevy's fate seemed piddling concerns. He was in financial trouble, big trouble, and his situation was getting worse by the day.

America's real estate collapse, which had loomed large as far back as 2006, was in full effect two years later, and it had cleaved deeply into Arney's wealth. He was in hock to several banks for most of his roughly one hundred properties, and though most of his loans required interest-only payments, he was finding it increasingly difficult to keep up with them.

His biggest creditor was the Bank of the Commonwealth, based in downtown Norfolk and led by people Arney held in high esteem. Its chief lending officer, Stephen G. Fields, had been among the bankers who lunched at Maxwell's, and by January 2008 had arranged loans to Arney totaling more than $7 million. Arney considered him a friend and a key to his success.

Through Fields he'd come to know Edward J. Woodard Jr., the bank's CEO and chairman, whose bullish enthusiasm for downtown Norfolk had helped spark its resurrection. Portly, bald, and avuncular, the Portsmouth native had held his post since 1973, when at thirty he'd become the youngest bank president in Virginia history. Arney revered him, telling me once: "When I think about Mr. Woodard I get real emotional. There's nothing negative I could ever say about Mr. Woodard." In his home office Arney had big, framed photographs of himself with both men. The bank even gave him an office in its headquarters building, a five minutes' walk from the restaurants.

In 2008, behind on paying down his existing debts, Arney pulled a trick akin to using one credit card to pay down another—he borrowed more money to cover his delinquencies. With the bank's blessing, if not at its behest, he took out new loans totaling $514,000, and late in the year, an additional $150,000 line of credit through a "nominee borrower," a third party who assumed the note on Arney's behalf. He fell behind again, and the bank gave him more money, anyway—a $5.72 million loan to complete his condo project on the site of the old rogue car lot, and another big pile of cash to buy a condo that Woodard owned and wanted to unload.

In October 2009, the Federal Reserve found the bank's lending practices unsound and forced its officers to create a reserve account of nearly a million dollars to cover losses likely to result from their many loans to Arney. That didn't stop them from making more: They fronted him $2.17 million to buy the vacant four-story, bank-owned building next door to Havana where he hoped to put his gentlemen's club, and two months after that they okayed a $100,000 line of credit through straw borrowers so he could get square on past-due mortgages—including the one on the building he'd just bought.

In two years, Arney's loans from Bank of the Commonwealth had doubled, and he was falling faster and deeper into a financial whirlpool. And it seemed that he wasn't the only customer in such straits, because now the feds and state regulators took an active hand in the bank's af-

fairs. Woodard was forced to step down as chairman, and in July 2010 he and his fellow officers promised in writing that they'd not loan any more money to certain troubled borrowers, Arney among them.

Damned if the very next month the bank didn't ask Arney to buy a pair of vacant buildings it owned, and offer him another $325,000, again through nominee borrowers, to finance the purchase and to pay down some delinquent bills. But now a reckoning was at hand. The bank had been bled out, and by the fall of 2010 failed to meet the industry's standards for capitalization. Its book value dropped by nearly seventy cents on the dollar. Woodard was forced to retire. Fields was fired. The FBI moved in. Its agents seized Arney's loan papers and checking account records.

This distraction promised to linger.

In the midst of his sharpening panic for cash, Arney decided to sell much of what he owned. He had a wee-hours epiphany that he owned too much, had become slave to his possessions, he told me—that if he died in bed at that moment, as he lay there thinking, it would take his family years to sort out his estate, assuming they could do it at all. So he decided to get out from under the most troubled of his real estate, and a great many of his cars. Maybe especially the cars: He owned cars stashed in garages and warehouses all over town, cars he'd bought on a whim and hadn't thought about since, even some he didn't particularly like. "I don't even know how to tell you how much shit I've got," he told me. "I was addicted to buying car stuff. I mean *addicted*."

His paradigm shift, as he called it, extended to Moyock Muscle, which was still crammed to its edges and where he faced a mandate to thin out his herd anyway. Early in the year, Currituck County had put Arney on notice that when he opened the car lot nine years before, he'd failed to obtain a conditional use permit, a document required of all such enterprises, and was thus operating illegally. Getting such a permit required expensive and time-consuming labor to bring the lot into compliance with the county's ordinances.

Arney appealed the decision, and was summoned to a July 2010

meeting of the Currituck Board of Adjustment. No way it was right that he should get such a notice after doing business for so long, he told the board. The county itself had been unaware of his breach. He should be left as he was.

The Board of Adjustment disagreed. He'd not be granted an exemption. That decided, the panel turned to the question of whether he qualified for a permit. Presenting the case against him was Brad Schuler, a slightly built and youthful county planner. Moyock Muscle was endangering the public health and/or safety, he told the adjusters. It lacked handicapped parking and fire lanes. And it injured the value of nearby property, because Schuler and his colleagues felt it met "the definition of a junkyard or salvage yard." Arney was annoyed by few things more than the characterization of his car lot—his celebration of Detroit's genius, his salute to American history, his *patriotism*—as a junkyard. He took a strong and instant dislike to Schuler.

The board denied him the permit. To stay in business, he'd have to back his cars away from the property's edges, move them off the septic tanks scattered underground, open fire lanes through the inventory. Plant shrubbery. Establish order. Another distraction was the last thing he needed, but Arney threw himself into meeting the county's demands. Which takes us back to where we began: Two months later, Schuler and his boss showed up at Moyock Muscle.

A WINDY, OVERCAST morning in mid-March 2011 at the car lot's northeast corner, where the wagon sits on the concrete pad outside the body shop. It is stripped bare: Painter Paul and Bobby Tippit have pulled off the doors, tailgate, and hatch, removed or knocked out the glass, yanked the steering column, slipped the gauges from their homes in the dash. Paul has reinforced the remaining core, which is light enough to roll with one hand, with one-inch steel pipe—four pieces across the door openings and two crosswise across the cabin,

one under the dash, the other linking the B pillars. Even so, the Chevy is frail: Paul leads me to the car's rear, where he points, glaring, to two spots, newly exposed, where the tailgate hinges attach; all that remains is a feeble web of wet-looking rust. Below the lacework I can make out a pair of steel braces that bolster the floor and helped support the tailgate's weight. They've disintegrated, too. "It's bad," he mutters. "It's terrible."

But with a lot of effort, replaceable, if not fixable, and the boss is willing to make the effort. Paul wheels a plasma cutter, his own piece of equipment, onto the pad beside the car. The device blasts compressed gas through an electric arc, creating an extremely hot—well, not a flame exactly, but a crackling, blue-white glob that's neither gas nor liquid nor solid, the sort of stuff that makes up the sun. It can cut through steel with greater ease than a blade without the noise and mess.

Paul trips the arc, and a bright cone erupts from the torch's nozzle, sputtering in the wind that sweeps across the lot. Crouching outside the right rear door opening, he touches the cone to the floor pan near one of the attachment points for the rear seat, the contact throwing off evil electric snaps and pops and sprays of tiny, smoke-trailing fireballs, and slowly inches across the rotten metal. The torch leaves a molten gash in its wake, smoldering with the reek of overheated wiring and burnt toast.

He cuts a fifteen-by-fifteen-inch square, interrupted once during the twenty-minute task when the plasma ignites some coating or debris on the floor pan's underside, and he has to whip off his welding helmet and extinguish the fire, and several times when sharp westerly gusts snuff the torch. It is slow work, wordless, wearying. He finishes the square, shifts forward to the right front of the floor, and carves out a larger rectangle, a foot by two; afterward he runs a handheld cutting tool called a whiz wheel along the blistered wound to slice away the few burrs that here and there hold the piece in place, then pries the rectangle free with a crowbar. In places the metal rips like paper.

Back to the plasma torch, Paul cuts out the strip between the existing holes, another square that climbs halfway up the hump, then a triangle beside the front door sill. Once they're out of the way, he redeploys the whiz wheel to cut through the front door sill. He continues the cut all the way through the rocker panel, sparks and powdered rust shooting from the small, fast-spinning wheel, then does the same to the rear door sill, then runs the wheel through the base of the B pillar between the front and back doors. Several blows with a sledge knock the rocker to the concrete. The right B pillar now dangles from the roof, held stiff by the bracing Paul installed.

He climbs into the cabin, pulling the plasma torch in with him, and squatting on ground that just a few minutes ago was invisible under steel flooring, starts on the left side. The plasma torch whooshes and cracks. The whiz wheel squeals, throwing shrapnel. Metal groans as Paul pulls, bends, and pries it free. A green-brown cloud hangs over the car. On the ground beneath it is a carpet of rust, metal shavings, and ripped felt insulation more than an inch thick. Most of the old floor pan is a stack of ragged sheet metal.

LATER IN THE week I watch as Paul uses the whiz wheel to cut away the bottom five or six inches of skin from three doors, to which he'll graft new steel—a sheet of it now leaning, raw and unblemished, against a wall in the body shop, eighteen-gauge in thickness, far heftier than the tinny stuff shrouding a new car—or, for that matter, most modern vehicles not intended for battlefield duty. His actual patching of the doors will wait until later. He's cut away the portions holey with rust in preparation for the next major task, now that the floor has been completely removed: sandblasting the paint, putty, and surface rust from the Chevy's core and everything that attaches to it. Bobby Tippit and his teenage son Andrew are outside on the concrete pad, grinding and sanding the wagon's rear quarters. Blast media, as the abrasive grit

used in sandblasting is called, is expensive; they're removing some of the body's coarser blemishes in the interest of avoiding waste.

Their efforts have yielded archaeological evidence of a sad episode in the wagon's past, likely dating to Mary Ricketts's ownership. Sanding on the left rear quarter, out on the fin, has descended through the paint to expose silicone body putty, aka "mud," used to hide imperfections in the metal—goes on wet, can be smoothed to match its surroundings, dries as hard as cement. There's a lot of it, which appears as beige patches beside the steel's dull silver. This fin was crinkled in a collision, Paul says, and evidently a hard one. He points out little round points of beige, betraying holes where a dent puller was slipped through the creased skin, hooked inside, and yanked outward, undoing the bends. Not an especially good repair job, but typical, he says: The shop in question achieved only a rough approximation of smoothness before leaving the metal as it was and troweling the mud on thick.

While we're standing at the end of the fin, he notices that in addition to being filled with silicone, the left rear of the car bulges. It's slight, something a casual glance would miss, but when he shows me how to use the top of the fin to draw a bead down the car's side, there's no question that something odd is going on with that quarter panel. It occurs to me that this is the same strange twist that Chris Simon noticed in the car back in the nineties.

The blasting commences a couple of days later. The tool for the job is a strange contraption the size of a lawn mower, with a gasoline-powered air compressor mated to a tall cylindrical tank, in the top of which is a hole for the media. A hose fitted with a nozzle branches from the device. Auto restorers employ varying grits depending on their objective—one can spray ground walnut shells, cornstarch, or fine glass beads to remove paint, or a "soda blast" of baking soda for finer work on smooth or delicate surfaces, or various weights of sand— from the last of which Paul has chosen a middling grade, suited to the Chevy's oxidized, pitted skin.

We roll the wagon twenty yards from the shop, to keep Paul's work area free of windblown sand. Bobby Tippit fires up the blaster's motor and gets to work on the firewall, the nozzle issuing a deafening whoosh when he's a foot from his target, a rising shriek as he pushes closer. The nozzle carves a surprisingly narrow path through the old green paint—roughly a quarter inch wide—so stripping requires a steady back-and-forth in short sweeps; you clear a block of two square inches, then another, and so on, so that your rate of progress is about equal to coloring a car with a crayon.

Paul and I look on as Tippit is enveloped in a caul of airborne sand. He's wearing safety glasses, but no other protective gear, as he leans face-first to within a foot of the blast and receives a brutal exfoliation from its ricochet. It has to hurt—his face is scoured a bright pink in minutes—but he works all day and doesn't seem the least bit fazed.

It takes several afternoons to blast the core and the body's detached components; after Tippit has thoroughly stripped a piece to bare metal, its rust holes gouged free of even a micron of decay, Painter Paul sprays on a coat of light green, bare-metal primer; left unprotected, the raw steel would don a sweater of rust overnight.

A TIDEWATER SPRING is an unpredictable affair, with dark and chilly days followed by swampy warmth—midday temperatures topping ninety degrees, the relative humidity climbing until it achieves a level at or very near cruelty. The weather now turns. The tin roof and sides of Moyock Muscle's body shop amplify the sudden heat's discomforts: In its airless chamber, even the lightest shirt soaks through in minutes; socks and underwear dampen and bunch; cascading sweat stings the eyes, slickens the grip, drops sizzling into fresh welds, and on the skin it combines with pulverized rust and whatever flies off the whiz wheel to form a grimy poultice. A couple of ancient floor fans produce a noisy breeze, but little relief.

Such are the conditions as Paul dons a welding helmet to perform the initial repairs to the wagon's battered husk. Bare-chested, sheathed in sweat, he cuts rectangles of rusted-through steel from the rear wheel wells, which arc along the sides of the cargo hold, then welds fresh metal in their place. Welding is intrinsically dangerous, in that it involves heat, a lot of heat—enough to transform the two edges being joined to a red-hot goop, and to fuse them with a third molten metal, which is produced by a wire fed into the middle of the conflagration by the torch itself. The process creates dangerous gases and blinding light, which are problematic as well, but to a shirtless welder, burns pose the greatest hazards. Paul's torch throws fat, fiery sparks back at his bare skin as he carefully seals the edges of each patch. Shouted obscenities greet those that make it through the sweat. He shouts a lot. Still, he doesn't pause; he keeps his head down, gaze fast through the helmet's smoked glass, his torch's business end inching slowly along the seams. When he's used a pneumatic grinder to clean up the new joints, the repairs are so smoothly integrated that I can't detect them with a hand swept over the wells.

Next, he inspects the roof, where Chris Simon's ancient fiberglass patch has given way, leaving a rust-edged, two-by-three-inch hole. It's at a point in the right rear corner where the roof slopes in two directions, to side and rear. Fashioning a patch from new metal, he decides, would take a lot of time and trouble—unnecessary, as he has an alternative.

He and Bobby Tippit roll another '57 Chevy wagon from Moyock Muscle's front lot to the concrete pad outside the shop. It's a 210 four-door assembled in Los Angeles. Despite its birthplace, where rock salt isn't needed to melt snow that never comes, and car bodies thus tend to hang on to their good looks, it seems to be in far worse shape than our wagon. Its paint, ivory on cola brown, is invisible for the rust that cakes its every exposed surface, and most of its unexposed ones, as well. It's only by checking the doorjambs that I discover it was brown.

A vestigial corona of the ivory survives around the gauges, though the rest of the dash is as bad off as the exterior.

Happily, some of the California car is solid beneath the rust, including the right rear corner of its roof. Paul uses the whiz wheel to resect a foot-square chunk. He cuts a matching hole in the roof of VB57B239191, trims the graft to fit, then positions it with tack welds—small, widely spaced links that enable him to arrange its exact placement before embarking on the long, laborious task of filling the seams around the entire wound. When he's finished grinding the welds smooth and covers the patch with a spray of primer, I'm again unable to tell old metal from new; it's so perfect a repair that I have to duck my head inside the wagon and look to the ceiling, which is not yet primed, to reassure myself that yes, he really did patch a hole there.

The California car yields little else of use. Paul cuts a section of rain trough from the roof's right side and welds it to our wagon. He finds that its subfloor braces for the tailgate are good, too. He scavenges both, sandblasts them, primes them, and sets them aside for later. Bobby Tippit removes the car's chrome trim and labels it, on the off chance that it's needed, and uses a screwdriver and hammer to chisel loose the chrome retaining rings around the windshield wiper hubs. Otherwise, the California wagon is ready for the crusher.

While this work's under way, the new floor pan arrives, boxed in cardboard and strapped to a pallet. It gleams shiny black inside its box, which I notice bears the stamp of Golden Star Classic Auto Parts of Lewisville, Texas.

Were Painter Paul to rebuild the floor as Fisher Body fashioned the original fifty-four years ago, he'd do it with several separate pieces of sheet metal, reinforced with separate braces that he'd have to weld to their undersides. The Golden Star Classic pan is a single, huge piece, including the central hump down its middle, the braces already attached. It's an improvement over the original, far stronger than the quiltwork arrangement—and it's much easier and quicker to install.

Paul cuts the bolts holding the rear end of the wagon's body to the chassis, then jacks up the body's rear with a floor jack that's five feet long, not counting its handle, and looks more like medieval siege equipment than an automotive tool. When the wagon's shell hovers more than two feet in the air, he and Tippit carry over the pan, grunting, and slide it between body and frame from the driver's side. Paul climbs into the car to pull it across. It hangs up on one of the A pillars, but when they grasp the pan's rear edge and give it a tug, the whole sheet seats itself with a clatter.

For the first time in thirty years, the wagon's floor offers no view to the ground. "There, it's in. We got the son of a bitch in," Paul says. "Ain't nobody can say we didn't." He and Tippit exchange a high-five.

I notice a little sticker on the powder-coated floor pan, read its message. I find the same words stamped on the cardboard box: "Made in Taiwan."

14

IF YOU WERE so inclined, you might be able to build an entire '57 Chevy from scratch, with brand-new parts that have never seen the inside of a GM factory. One American outfit makes beefed-up frames of its own design. A couple of suppliers offer complete convertible bodies, at least one sells a clone of the two-door hardtop, and several peddle doors, trunk lids, hoods, fenders, and complete interiors, all of them fashioned from new materials. Finding a fresh version of virtually every mechanical component is a snap.

Many of these reproduction parts are built in the States, and a few big pieces are assembled here from steel components produced elsewhere. But a lot of them are Chinese—so many that a hobbyist with a tight budget, political message, or perverse sense of humor could bolt together a reproduction of this American classic that's more Asian than homegrown. It wouldn't be real, needless to say, but it would certainly look it. You'd really have to know your vintage Chevys to call it out.

Odds are, some of the old cars you've admired have new muscle and bone beneath their skin, some of it foreign. So Tommy Arney has plenty of company in putting a little bit of Taiwan into his otherwise aged and American car.

This raises worthwhile questions about what constitutes authenticity in the automotive world, questions such as: How much of an old car can be swapped out for new parts before the whole is no longer old? Strictly speaking, will the wagon still be a vintage Chevy when Arney's

restoration is complete? And: Assuming it's okay to replace certain worn pieces of an old car, are there particular pieces that must not be replaced, lest the car's integrity be forever compromised?

Answering such questions requires a quick look at the factors that influence a classic car's monetary value, a loose grasp of that subject being necessary to what follows. Stripped to its basics, assigning value to an old car comes down to how you answer four questions about it, of which the first is: Is the car desirable? If you want to get decent money for it, the answer must be yes. That doesn't mean it has to be a good car, necessarily, just that it be one people want. Mid-fifties Chevys and sixties muscle cars are always sure bets. Ford's disastrous Edsel now enjoys a contrarian appeal among collectors. A Chevy Vega, on the other hand, won't ever be worth a dime.

Question two: Is the car original? Is it just as it was when it left the factory? Does it include all of its original components—the genuine articles, not replacements? An original is more prized than one laced with modern parts or pieces scavenged from other cars, for two reasons. First, it offers an unadulterated view of the past, and thus a lesson on the state of technology and the car culture and America in whatever year it was built. It gives testimony. It has archaeological value.

The second reason, perhaps more compelling, is the improbability of an old original's very existence. "Use is the road to destruction in a car," points out Richard Todd, author of *The Thing Itself*, a wonderful rumination on authenticity published in 2008. "It starts falling apart the minute you get it. The idea that it's mechanical means that everything— every action, every bit of use—is threatening to its integrity."

Question three: Is the car correct? Does it feature only gear that was available on that make and model, in that year? This is not a repeat of the last question, for while an all-original car is by definition correct, a correct car is not necessarily original—a '57 Chevy that has replacement fenders from another '57, for instance, might be correct, but it isn't exactly as it was when new.

This was demonstrated to an extreme degree in January 2013, when a 1971 Plymouth Hemi 'Cuda convertible rolled onto an auction block in Scottsdale, Arizona, with a history that included the car's theft in the seventies, its disassembly and the scattering of its parts, and the abandonment of the biggest chunk on a weedy field in British Columbia, where it reportedly came within days of being taken to the scrapper.

An American car enthusiast rescued this piece, which consisted of the firewall, inner front fenders, and radiator support strut, in 2001. It bore a numbered tag, proving its pedigree, and from that acorn grew a complete car, fashioned from original pieces tracked down with the help of detectives and others scavenged from another Plymouth. The result was only fractionally original, but because the Hemi 'Cuda is prized among muscle cars, and because only eleven Hemi 'Cuda convertibles were produced in 1971, and because only this one bore Plymouth's Plum Crazy purple paint that year, its correctness proved to be worth $1.2 million.

Final question: What is the car's condition? Is it pristine, ready for show, a museum piece? A good-looking daily driver with the light wear and muddy floor mats that suggests? A rusted-out beater?

The answer to each question blends fact and opinion. Some cars are more desirable than others, at least to most people, but not so to the exceptions. Some originals are in such compromised shape that their originality might not matter so much. But as a rule of thumb, the highest monetary value is assigned to cars that are extremely desirable, original, and in great condition.

Again, that's monetary value, which is not the only measure of worth, for old cars always involve trade-offs. An entirely correct showpiece—its mechanical guts polished to a gloss brighter than the factory's imagining, its interior spotless, its paint shielded from ultraviolet rays and extremes of humidity—might serve as impressive art, but you can't take it for a spin, as driving will destroy what sets it apart. An original car with "fair wear and tear," as Todd put it, must be used gently if its

originality is to prove long-term. On the other hand, a car that falls well short of original and isn't correct in every respect might get you to work and back every day, and there's obvious value in that. We're talking about automobiles, after all, machines designed to provide transportation, and as the conventional wisdom goes, the worst thing you can do to a car is not drive it.

Point being, any restoration has to start with a clear objective as to what kind of car it'll produce, and that decision will inform hundreds of smaller decisions that follow. In the case of VB57B239191, Arney had no hope of achieving an original car. The wagon was already on its fourth engine and second set of fenders when he bought it. The floor was unsalvageable. The interior was chewed to bits.

His next option was to attempt a correct restoration. Much of the Chevy will qualify—it will have an engine identical to that which sent Nicholas Thornhill on his way in 1957. Its exterior will be restored to its good factory looks with replacement panels, as needed, from other '57s. Its seats will be rebuilt using the original frames or those from another Chevy of the same year. If he wished, he could go all the way and hunt down genuine Fisher Body floor pans for the wagon, either from a wreck or from the factory in the form of "new old stock," or NOS— parts produced in 1957 but never used, and available at a premium today, often in their original boxes and bearing their original tags.

But Arney is not gunning for a show car: He intends to return the wagon to the street, in keeping with the philosophy that a car undriven has ceased to be a car at all—and if modern technology offers a better way to achieve that aim, he's not averse to tapping it. He'd have no qualms about trading the drum brakes for disks, though in this case he won't, or updating the car's electrical components, which he will. He plans to swap out the brake and fuel lines for modern incarnations. He'll trade the old windows for up-to-date safety glass. He'll have Paul sheath the body in incorrect but durable modern paint. And a one-piece floor pan seems to make good sense, in that it's stronger than the

original patchwork arrangement, and certainly easier to install—and its Chinese origin makes it affordable.

Outside the automotive world we're surrounded by such hybrids of old and new, some of them celebrated around the globe. I give you the Statue of Liberty, which beneath its skin has few parts in common with the colossus dedicated at the mouth of New York Harbor in October 1886. Supporting the statue's copper cladding is an armature of some 1,800 ribbonlike bars, originally made of iron, many of which were swapped out for steel in the late thirties and virtually all of which were again replaced, this time with stainless steel, in the mid-eighties.

A visit to Independence Hall would be a gloomy, uncomfortable affair without lights and climate control. Frank Lloyd Wright's Fallingwater might be *in* the water, if it hadn't been reinforced in 2002. Some overseas landmarks revered for their age sometimes aren't what they seem: St. Mark's Campanile, the most familiar feature of Venice's skyline, dates back centuries—or did, before the original collapsed in 1902; the current tower is a clone. Milan's La Scala opera house was bomb-damaged in World War II; it's a reconstruction. On the Athenian Acropolis, one of the Erechtheion's six maiden-shaped columns was looted and another broken by a British nobleman in the nineteenth century. When I visited the temple as a kid, in the late sixties, unconvincing concrete statues had replaced them. The other four have been removed and replaced with concrete since.

Finally, the famous Hollywood sign in Los Angeles dates not from 1923, when its first incarnation appeared as a billboard for a nearby housing development ("Hollywoodland"), but from 1978—when the original, rusted and broken, its third O toppled, was removed from its mountainside perch and rebuilt from scratch with new concrete and steel.

It remains beloved because it succeeds as a visual reminder of the movie capital's past; its spirit is true to the original, even if its metal is not. Likewise, to a buyer seeking practical transportation dressed in high fashion, the wagon will be a good fit—a far more suitable choice

than a car restored with slavish devotion to originality or correctness. And Arney's restoration will be truer to the wagon's spirit than a perfect show car, because it'll keep the Chevy doing what Chevys are built to do.

A RELATED LINE of inquiry presents itself in mid-July 2011, when Arney tows a '57 Bel Air four-door hardtop onto the lot and deposits it outside Painter Paul's body shop. It's not in terrible shape; fact is, it's in better condition than the wagon in virtually every respect. The body is fairly straight and rust-free. The seats are intact. The engine is clean, its exhaust manifolds freshly painted, its valve covers and air cleaner plated in bright chrome.

Even so, the hardtop is to be sacrificed. It's to serve as a donor car, a rolling inventory of parts that'll be put to use in the wagon. In the name of saving one car with a known history, Arney will destroy another with a past of equal length, but of unknown shape and texture; the only part of its resume that can be related with certainty is stamped into its tags—that its body was built at the Fisher Body plant in Flint, that the car was assembled in the same town, and that it was originally painted Inca Silver.

Arney plans to harvest the car's front fenders, which are rust-free and very nearly perfect. He'll take the engine and transmission, for sure. Its seats, almost certainly. Its suspension, its brakes—any number of components might prove useful. As I circle the doomed hardtop, I find myself wondering how many pieces of the wagon Arney can replace before it's no longer this particular wagon. Is there a limit?

As debates associated with restoration go, this might be the oldest, because it predates the first horseless carriage by thousands of years. The Greek historian Plutarch wrote that a ship used by Theseus, the fellow credited with killing the dreaded Minotaur, was preserved as a memorial for centuries after, during which its curators "took away the old planks as they decayed, putting in new and stronger timber in their

place," until so much of it had been replaced that it "became a standing example among the philosophers," one side "holding that the ship remained the same, and the other contending that it was not the same."

The frigate USS *Constitution,* or "Old Ironsides"—the oldest commissioned warship afloat, and a big tourist draw in Boston Harbor—was the subject of similar musing by architect Edward Ford in a 1997 article in *Harvard Design Magazine*: The ship, "launched in 1798, still officially exists," he wrote, "but after the rebuildings of 1840, 1905, 1931, 1976, and 1996—the last of which replaced all of its rigging and sails, ninety percent of its masts and spars, seventy-five percent of the upper deck, and forty percent of its internal knee bracing—how much of the original can be said to remain?"

The more I ponder the question, the more muddled my thinking becomes. I suspect that intent is important—that the *Constitution* remains the *Constitution* because the ship's identity and purpose have never changed, and new planking does nothing to alter that fact; that likewise, the newer wood in Theseus's ship simply became part of that ship, his ship, and over centuries of use the distinction between original and replacement became moot.

In the same vein, I figure you can swap out much of a car as its condition demands—you crunch a fender in an accident, so you get a new one; the other fender rusts out, so you replace that; the bumper gets bent against a lamppost, so another takes its place. You can make repairs in such manner, à la Theseus's ship, and not compromise the car's identity. It remains not only that make and model of car, but that individual example.

But what of that Hemi 'Cuda, its elements scattered and almost entirely lost, its identity reduced to a small portion of skeleton left to rust outside for untold years? Can its essence be said to survive in a re-creation that is 80 or 90 percent new, and that was performed all at once? When I put the question to Patrick Krook, a nationally respected muscle car expert in Illinois, he was of the opinion that yes,

it can: "It's not like the car is a clone, a car that was never a '71 Hemi 'Cuda," he said.

So what makes it *that* Hemi 'Cuda? The chunk of front end? Does that suffice?

No, Krook told me. The firewall and inner fenders did not establish the car's identity; by itself, the sheet metal was practically worthless. What did the trick was the little metal tag on the wreckage. That's all—a few numbers stamped on a plate that was riveted into the metal. Had the car's rescuer found the same remains but lacking the tag, he wouldn't have bothered. The numbers were worth seven figures.

Tags are everything. Theoretically, Tommy Arney could replace all of the Chevy but those parts bearing identification tags—the driver's doorjamb, where the VIN is attached, and the firewall, where the Fisher Body cowl tag identifies the vehicle as a four-door wagon and details its paint colors and interior trim—and there'd be no harm done; the fact that it has acquired a Chinese floor pan, new metal in a multitude of patches large and small, and fenders from a Chevy built a thousand miles from Baltimore—as well as modern primers that safeguard it from rust to a degree unimagined by its original builders—doesn't count for nearly as much as its alphanumerical tag codes, especially the VIN, which is akin to a birth certificate. The Department of Motor Vehicles and much of the automotive world would consider it one and the same car that Nicholas Thornhill bought in 1957.

Maybe that's as it should be. The advantage of any mass-produced machine is its interchangeable parts. They were all designed to be replaced.

A FEW DAYS after the donor car's arrival, Painter Paul takes delivery of two new steel rocker panels, which he points out were made in the United States. Before he can weld them to the floor and the B pillars, he has to rehang the doors, so that he can be sure all these parts fit with

the appropriate snugness. He temporarily screws the rockers in place, then removes the one-inch steel pipe he's braced the body with, and which the floor's replacement has rendered unnecessary.

Paul uses the whiz wheel to slice the pipe from the right rear door opening, then a pneumatic grinder to smooth away the welds. Sparks fly as he takes on the cross brace under the dash. They pose little hazard to bare skin today: Paul, shirtless, is so soaked in sweat that the sparks simply drown on contact. The heat index, according to the scratchy FM signal of the shop's dust-caked boom box, is 106 degrees Fahrenheit, and it's considerably higher within the all-metal building; the humidity hovers just below 100 percent, so that the air feels thick and uncomfortably warm in the throat, like a hit from a foreign cigarette. The floor is littered with sodden paper towels with which he's wiped himself down.

Bobby Tippit enters the shop in tiny steps, woozy from an hour's weed-whacking. Together they lift the right front door and slide it onto its hinges, Paul sitting on the car's floor to guide steel tongues into slots, then bolt them fast. Once hung, the door hangs low, overlapping the rocker panel by a quarter inch, so Paul takes a foot-long section of four-by-four and with it, cushions the blows of a hammer he wields in his other hand to drive the rocker downward. It budges a little, but not enough to permit the door to close.

Okay, Paul says, fine. He loosens the screws binding the rocker to the B pillar until it shifts with a shove from above, then gives it a few good whacks with the hammer and wood block. Still, the door overhangs, and when he loosens the rocker further it falls to the concrete with a clatter. Cussing, he enlists Tippit to hold the rocker hard against the edge of the floor pan while he adjusts its position to accommodate the door and rescrews it to the floor. A couple of tack welds restore its union to the B pillar.

Still, the door won't close. It isn't the body that needs adjusting, Paul decides, it's the door—so he opens it wide, slides a jack under its

trailing edge, then raises the jack, bending the hinges into compliance. "These motherfuckers are a pain in the ass," he tells me as he and Tippit smoke cigarettes and give the metal a few minutes to adjust. "It ain't like a new car, where you can adjust the hinge every way. These old sons of bitches, you have to play with them."

When he lowers the jack, he faces a new and opposite problem— now the door sits high or the rocker low; the gap between them is a quarter inch too wide. "It just takes time," Paul says, shaking his head. "I mean, I got a USA rocker and I got a Chinese aftermarket floor pan, so you have to kind of fiddle-fuck with it."

The next day, having triumphed over all four doors, Painter Paul spends several hours welding new metal into places where the right rocker panel meets the body—its fore and aft ends, its triangular connection with the B pillar—and making the whole assembly seamless. He's just starting on welds to the left rocker when Arney and Skinhead stroll into the shop. A couple of days, Paul tells the boss, and he'll have the body complete, free of rust and patched with new metal. Everywhere, that is, but in the tail. Arney nods. The back ends of old Chevy wagons tend to be the first sections to rust, and their replacement is a chore, the parts hard to find, none of them cheap. In recent days, Paul and Arney have scavenged a ruined '56 wagon on the front lot for a few minor elements of the cargo hold, and the mail has brought new replacement panels for the jamb surrounding the hatch and tailgate. Paul plans to rebuild the hatch itself, which is holed through with rust but salvageable.

The original tailgate is beyond repair, however, and a replacement has been elusive.

"I've exhausted all my resources," Arney tells me. "I've called everybody I know, looking for a tailgate. Looked all over the Internet, me and Victoria. You look at all the pictures, and they're all rusted.

"I found one for $450 that once you fixed the rust, which was fixable, it would cost so much that fuck it, I'd just as soon buy a whole car and

cut it up." He doesn't much trust online deals, anyway: "You can't *feel* that motherfucker. You can't touch it. Just about the first thing people have told me about buying a car on the Internet is, 'It didn't look like this in the pictures.'"

But maybe, just maybe, his luck is about to change, Arney says. Just this week, he's learned of a man in Gloucester County, Virginia, about sixty miles north of Norfolk, who has a '57 wagon for sale. This fellow, name of Dixon Smith, wants $2,500 for the car, which he reports is in good shape. When they talked by phone, Arney says, he asked about the tailgate. It's strong, came the reply. Straight. Arney told him he'd be by.

He'll go up there, he tells Paul and me, and maybe the car will have not only a tailgate, but also other stuff Paul can use. There's the strange bulge in the left fin, smaller than before, thanks to Paul's efforts, but detectable still—it could be that it'll be easier to cut a fin from this Gloucester car, rather than try to warp the original into shape.

Get the tail's issues addressed, and it won't be long before this car's ready for paint, Arney observes. And though he isn't 100 percent decided on it, he's thinking that he probably won't return the car to its original color scheme. The two-tone green doesn't pack enough of a wow factor. It lacks sex appeal. You wouldn't see the car coming and think: *Holy shit.*

I suggest that burgundy and cream would look sharp. Arney nixes the idea. "I don't care for a burgundy car," he grumbles. "I don't care for any kind of burgundy or red."

"That's true," Paul says. "He doesn't."

"Let me tell you why," Arney says. "Because whenever somebody fixes up an old car, what color do they paint it? Red. Every motherfucking time."

I ask what color he's considering. He doesn't know. I ask whether he'll stick with a combination available in 1957. "Maybe. But maybe it should be a 2011 color," he replies. "I've been thinking about this a

lot. Over the past seven weeks I've had maybe six chances to relax my mind, and on four of those, I've thought about this."

ON A SUNDAY late in the month Arney, Skinhead, and I climb into Arney's rollback—a large flatbed truck, the bed of which tilts and extends hydraulically to accommodate cars, two or three to a load—and we head to Gloucester. Arney has three stops planned, culminating with the '57 he hopes to buy. First up: The home of Charlie Apperson, retired telephone lineman and active car collector, in a pine forest near the town of Croaker, Virginia. Arney is interested in a '65 Chevy short-bed pickup that Apperson owns; our host, clad in T-shirt, shorts, and sandals, shows the truck to him, then leads us on a tour of his property, which features cars parked under two carports, in two freestanding garages, and scattered all about the yard under a blanket of pine needles.

When Apperson lifts the door to one of the garages, we're confronted by a squadron of baby birds cheeping on the concrete floor. As they hop for cover, Arney mentions that we're headed up to Gloucester to see about a wagon. He asks Apperson if he knows the car. Apperson nods. He's walked around it, he says, though he didn't look close. "I'm planning to cut it up for another wagon," Arney tells him.

Apperson frowns. "It might be too good to cut up," he says. "It's a good car."

Arney shakes his head. "It's not too good for *me* to cut up."

We visit the other garage, where Apperson is restoring a '56 Chevy convertible, then cut back across the yard. "That truck," Arney says, "if you decide to sell it to me—"

"I'll sell it to you," Apperson interrupts. "We just have to come up with a price."

"Well, Charlie, I think we have a price. I think twelve hundred is a good price," Arney tells him. "You owe me six hundred. I'll give you another six hundred, and we'll take it out of here today."

"Let me think about that," Apperson replies, "because I'm not sure I want to sell it for twelve hundred."

"I've got the rollback right here, and I'd really like to put two vehicles on it," Arney says.

"I want to think about that," Apperson says again.

"I'm just trying to help you out," Arney says. "That twelve hundred could come in handy. You could use it on that '56 convertible."

Apperson chuckles. "Yes, I could."

They reach an accord. Arney will take the pickup today and pay the balance when he returns for the truck's bed in a couple of weeks. He's happy with the purchase as we pull back onto the road. "In this economy, you have to watch every fucking penny," he tells me. "That fucking paradigm shift, it changed my fucking life. I've walked away from a lot of real estate, a lot of cars, a lot of deals I never would have walked away from."

We head to the northwest, turn off a state four-laner and onto a skinny farm road, and after a mile or so pull up in front of a shed in a cornfield: Chris Byrd's shop. "Charlie Apperson and Chris Byrd are both buddies with the guy who owns the wagon," Arney tells me. "All these ol' guys who live up here are buddies. You do a deal with one of them, and they all know all about it within an hour."

Skinhead, from the truck's backseat: "Charlie's probably on the phone with Chris right now."

While Arney negotiates with Byrd for another old pickup, Skinhead and I talk with Byrd's son, Ben, a meaty fellow with a Brother Ezekiel beard and the tic of saying "I ain't mad at you" when he means "I understand." Skinhead mentions that he doesn't have a car at the moment. "I ain't mad at you," Ben says. "I know how it is."

"I'm riding a bike full-time these days," Skinhead says.

"I ain't mad at you," Ben replies.

Skinhead says he likes the paint job on Ben's truck: It's matte black, to hide dings.

"I ain't mad at you," Ben agrees.

We join the others in the shed, which is piled with ancient factory-issue car radios and crawling with cats. Byrd says he wants five hundred dollars for the truck. Arney offers four hundred. "Well," Chris says, "what do you say we split the difference, say four-fifty?"

Arney shakes his head. "Nah. I don't really need it. I'll take it down and put it on the lot and it might be a long time that it sits." The men jaw for a while before Byrd caves. Okay, he says—four hundred will do. As we pull away, Arney is energized. "That truck was well worth four hundred. *Well* worth it. We bought and we bought well." He happens to know, he says, that Byrd paid two hundred for the truck. "So he made two hundred. Everybody did well."

He's in a fine mood as we arrive at Dixon Smith's place, which is at the end of a narrow dirt drive that wriggles this way and that through swampy forest before diving deep into a vine-draped hollow. Our quarry, a dark blue 210 wagon speckled with rust, sits high on a trailer in front of Smith's modular home.

As Arney and I stride toward it, Skinhead jockeys the rollback into position. Close up, the car is crusted with bird droppings, sun-bleached, and smells of hot metal and mildewed carpet. Arney opens the tailgate. The inspection lasts less than a second. "Skinhead," he hollers, "you're all right."

"What?"

"You're good."

The whole tail of the car is rusted out. The frame around the gate, as well as the bottom of the gate itself, contains a lot more oxygen than iron. "This won't work." Arney sighs. He's muted as he and Smith walk around the property, looking at other stuff Smith might want to sell. When they return to the rollback, Smith tells Arney he'd really like to part with the wagon. "The car, it's got a lot of usable parts on it," he says.

"It's got some good stuff on it," Arney allows, "but at that price, it's a

little heavy. At most, that's a thousand-dollar car." Smith says nothing. Arney waits.

Smith remains silent.

The negotiation is over.

"I don't know what the fuck," Arney fumes as we thump back up the drive. "Chris Byrd said it was nice. Charlie Apperson said it was too nice to cut up. And when I talked to Dixon on the phone, I asked him if the tailgate was in good shape. He said it was real good."

Darkness falls as we head back into town on the interstate, Arney wondering aloud where he might find a tailgate. Skinhead reminds him of a fellow in Norfolk who, several years back, had a warehouse filled with '57 Chevy parts, a good many of them wagon components. I glean from the conversation that Arney did something to anger the man, who swore off doing further business with him; he later died and left the warehouse and its contents to his girlfriend. "She won't deal with me," Arney guessed. "She knows he wouldn't have wanted her to. You'll have to talk to her, Skin."

Skinhead says he'll make the call first thing in the morning. Arney seems satisfied, but as the city rises around us he has a new idea—we could stop by the house of a Chevy collector who lives off Little Creek Road. It's on the way, and we just might get lucky. He asks Skinhead if he has Dave Simon's number stored in his cell phone.

He does not, so we pull up unannounced outside the home of the Chevy's tenth buyer. Simon answers Arney's knock, recognizes him right off, and joins us in the driveway as lightning flashes and thunder booms with growing menace overhead. The two discuss Arney's predicament. Simon sympathizes: A good tailgate, he says, can be tricky to find, even more so at a good price. Unfortunately, he has none, and offhand doesn't know anybody else who has one, either.

While they're talking, Chris Simon steps out of the house. It's been seven years since I saw him last, but he hasn't changed much—he's still a "long-haired, troublemaking-looking kind of guy," as Dave

Marcincuk put it, and still quiet and friendly. He seems pleased that the wagon's salvation is under way. "I still have a couple parts for that car," he tells me. "I still have the Colonial Chevrolet tag that I took off the back of it." His tone suggests that he might not have fully recovered from having to sell.

Over the next few days, Skinhead tracks down the girlfriend with the warehouse, but obtains no tailgate. He and Arney chase other local leads, one after another, to dead ends. When a week's passed since the trip to Gloucester, Arney orders Paul to scavenge the fairly straight tailgate from a '56 two-door wagon on the Moyock lot. It's an option Arney would normally be loath to choose, as a two-door wagon is far rarer than a four-door, and is thus a strong candidate for a future restoration, and which he makes now only because the current project is otherwise at an impasse.

Paul gets to work on the tail.

15

LATE ONE BREEZELESS and stifling summer night I meet Arney at a vacant double storefront he owns at the edge of downtown Norfolk, five blocks from Havana. When I step inside, I find the place gutted, its walls bare brick. A skinny fellow with shaved head and neck tattoos rides a jackhammer, fracturing the concrete underfoot, and Arney uses a crowbar to uproot the broken floor behind him. He is covered in sweat and pulverized cement, which floats around him in choking suspension.

This is one of the buildings his lenders at the Bank of the Commonwealth convinced him to buy from them last year, as the bank teetered toward collapse. Now he's racing to put it in shape to rent or sell it, to get out from under its mortgage. It doesn't look to be a fast job, as the century-old building is both overbuilt and undermaintained. The cracked and uneven concrete floor, which has to go, is seven inches thick.

"If I'd ever known it was going to be so tough owning so much motherfucking shit, I'd never have done it," Arney wheezes, dropping the crowbar. "You just have to work so hard."

His relationship with the bank is high in his mind, and for good reason. The institution's declining health has been the subject of accelerating press coverage since April, when the bank disclosed that a federal grand jury is investigating its practices, and its bosses have denied him any additional cash, which has put him in an ironic bind. As a young man, he's told me, he performed collections for loan sharks. "I borrowed thirty million from banks, and now here it is, thirty years

later, and I'm having to borrow from a loan shark," he said. Without the loan he got from this private citizen, he wouldn't have made payroll at the restaurant, so he viewed it as a necessary evil. But its price was high—12 percent a month. A *month*. Besides which, in his experience loan sharks tend to be "completely sick motherfuckers."

On the relative cool of the sidewalk, Arney tells me that the feds have pulled Virginia Klemstine before the grand jury, and agents have spoken to his real estate agent, as well as a lawyer with whom he's done some business. It's clear to him that they want to put him in jail, though he doesn't see how it could happen. The bank offered him loans. He took them. Who wouldn't? "When they're done," he predicts, "I'll be able to tell everybody that the FBI investigated me, and I'm squeaky-clean. So it's kind of nice, really. Sort of like getting a colonoscopy."

Within days of this conversation, Arney cuts a deal that enables him to hand several of his troubled properties back to the Bank of the Commonwealth in lieu of foreclosure, a maneuver that reduces his debt to $2.4 million—the bulk of which is tied up in the tracts containing Moyock Muscle. He is visibly lighter on his feet.

Days later the bank announces that its shareholder equity is lost, and soon after that the state shuts it down. The feds estimate that the failure will cost taxpayers more than $260 million.

Arney betrays little concern at these developments. When I see him at Havana, he reports that he's been giving nearly unbroken thought to the wagon's color scheme, and he thinks he's hit on a winning combination: titanium gray with bright silver accents. He painted a 1955 Chevy pickup in such manner a few years ago, and was pleased with the results. With that, he produces a snapshot, and we spend the next fifteen minutes discussing how sharp that old truck looks.

FOR THE TIME being, the wagon is sheathed in ghostly gray primer as it squats, mostly assembled, at Moyock Muscle. The front clip from the donor car is bolted in place, the hood attached, all the doors hung;

Painter Paul now turns his attention to the first step in rebuilding the tail, which is to install the heavy steel braces that will support the hinge assembly for the tailgate. He slithers under the car with the torch.

Outside, Bobby Tippit uses a sledge and a pry rod to disconnect the two-door wagon's tailgate. He's already drilled out the bolts; only rust and habit are binding the parts now, but they're tenacious, and by the time he's finished, Paul has completed the welds and is grinding them smooth. Shotgun sprays of white-orange sparks ricochet crazily around the wagon's bare interior.

Paul reaches for one of three pieces of new aftermarket steel that will together form the tailgate's jamb. It doesn't fit. He attempts to finesse it into position a half-dozen different ways, but concludes that there's simply not enough room—not, at least, with the body bolted to the frame, which is so stiff an arrangement that there's no flex to the space the piece is supposed to slip into. A possible solution: lift the body off the frame, position the new metal, and lower the body back down. He slides back under the car, unscrews all the bolts holding the body to the chassis, then rolls a huge floor jack under the body. The jack has little room to do its job—with a rise of three or four inches, it bumps into the frame, and can rise no more—so Paul balances a one-foot cube of wood on its cup, and tops that with another thick block standing on end, and with this extension wedged hard against the body's belly with the jack at its lowest position, again pumps the handle. It's a lethally unsteady solution, but the body rises the needed few inches clear of its seat.

Unfortunately, even now the piece won't fit, so Paul resorts to trimming with the whiz wheel. He widens the opening at the car's rear by a half inch, slips the brace into place, forces it home with a sharp pull and a grunt. Hammers the brace a quarter inch to the left. Clamps the assembly in place.

Before welding the brace to the body, he has to be sure everything fits, so he and Tippit now carry the two-door wagon's heavy tailgate into the shop. Paul lacks bolts with which to attach it—Arney says

he's ordered a bolt kit, but it has yet to arrive—which provokes a stream of muttering about the "fucking bullshit" Paul has to endure before he stalks back out to the two-door and scavenges bolts from its door hinges.

It all fits perfectly. In fact, within a few hours, Paul welds in the brace, installs the other two sections of jamb, and wipes, sands, and primes the whole rear end. When I venture into the shop the next morning, the results exceed the craftsmanship achieved by Fisher Body on its best days.

Tippit has spent two hours sandblasting the hatch and donated tailgate, which are now the dull, gunmetal gray of bare steel. Paul decides to first repair the hatch, which is perforated with tiny rust holes, too many to fill, on its bottom and inside surfaces. Tippit gives him a ride to the drugstore, where he buys a sheet of blue poster board, cuts it to fit the exact shape of the hatch's damaged bottom, and, using a permanent marker, traces around this template on a fresh sheet of eighteen-gauge steel. Now he takes his whiz wheel and carves the sheet slowly, carefully, along the line. The shop fills with an asbestos stink, like overheated brakes, as the wheel advances. Sparks gush over Paul's oil-streaked jeans and Lynyrd Skynyrd T-shirt.

He grinds the surface rust from the finished piece and primes it gray from a spray can. While it dries, he takes the whiz wheel to the hatch, cutting away the matching bottom panel, then tack-welds the new metal panel over the hole. He grinds the edge of the new metal and pounds it round and smooth with a hammer, then goes back over the seams with spot welds, the steel glowing orange. By afternoon's end, the hatch looks new.

Over the next few days, Paul rehabilitates the tailgate in like fashion, and welds steel sheeting into the sides of the cargo hold, and cuts and shapes and installs a new windowsill for the car's right rear corner, and replaces a piece of the left fin in an attempt to correct the bulge, and patches a hole in the right rear wheel well, then grinds it smooth.

The restoration is racing along now. It's easy to forget Arney's reputation for foot-dragging. Painter Paul's prediction that the work would take years seems not only wrong, but maybe a little unkind.

LATE IN AUGUST 2011, Hurricane Irene sweeps past the Carolina coast not far east of Moyock. Its eighty-knot winds peel the big sign on the front of the Quonset from its plywood backing, but otherwise the close brush with disaster does wonders for the car lot—when I pull onto the property two days later, it looks as if it's been swept and mopped. The pad outside Painter Paul's shops is pristine. I walk the bug-infested moor behind the Quonset, which before Irene was littered with trash and small debris. There's not so much as a gum wrapper on the ground.

Arney has Skinhead repair the sign and, sensing pressure from Currituck County to get started on the improvements he has yet to make—or even think much about—devotes the next ten days to augmenting the storm's work. The crew cuts the grass, chops up a walk-in cooler and carts it off, hauls away cars. They pull back the Jersey wall that runs along the lot's frontage. Painter Paul has no time for the wagon.

But that changes. I arrive at Moyock on an early September Saturday just ahead of a fellow in a Ford Ranger, on the door of which is painted "Bobby Chapman's Glass & Upholstery," along with a phone number. Chapman, a compact fellow in his fifties, steps from his truck and shakes hands with Arney. They've known each other since the eighties, when Chapman did upholstery work for other men's shops in Norfolk, before he opened his own. He's been Arney's go-to man for automotive interiors for much of the time since.

The two walk back to the body shop to look over the Chevy, and afterward stop to eyeball the rusted California wagon parked outside. Chapman is excited by its seats. "This looks good," he tells Arney. They walk to a house a few yards from the shops, a modular place that serves

as a storage shed for the wagon's disassembled pieces. The original seats lean against a wall in the living room. Not bad, Chapman says, though at a light touch, dried foam geysers from the holes where the birds nested. The others are better, but these will work—the metal frames are intact, which is all he needs.

Okay, Arney says, here's what he'll do: When Painter Paul is close to finishing the bodywork, he'll move four cars out of the showroom so that Chapman has room to set up an upholstery operation. Winter's coming. That'll give Chapman a place to work, no matter the weather.

Ordered back to the wagon, Paul muds the right quarter panel with silicone putty and smooths it with a handheld sanding block while it's still damp. The block is wrapped in coarse sandpaper that produces a shower of stringy beige shavings, dead ringers for sawdust, and Paul pauses now and then to clean its grit with a wire brush. Once the putty dries, he replaces the block with a pneumatic sander. Roiling clouds of dust erupt from the car's fins to burn the eyes, inflame the throat.

He stops every couple of minutes to run a hand over the car's skin, checking for invisible bulges and declivities—the sort of imperfections that are masked by the gray primer's matte finish but will be all too apparent under highly reflective paint. He returns to hand-sanding, this time with finer sandpaper wrapped around a thick wooden dowel, with which he's able to navigate the curving flare of the cutout for the rear wheel.

He blows the dust from the quarter panel with the hose from his air compressor, then sprays a light "guide coat" of black paint over the metal. When he hand-sands over it, dark patches remain, advertising low spots on the skin. I watch as he prepares another batch of putty, mixing gold filler and deep orange-red hardener on a steel palette, and slaps it onto the quarter panel—then again sands it, blocks it, paints it with guide coat, and blocks it some more, while the radio squawks out static-distorted Bad Company, Heart, and Van Halen. Then he does it again.

Four rounds of mudding, sanding, and blocking takes all of a morning and afternoon, and leaves Paul physically spent. He takes a half-hour break before finishing the quarter with a top layer of finishing putty, or "icing"—a fine glaze that will fill pinholes remaining in the Chevy's skin, along with any subtle striations left by his sanding. Paul trowels the runny, light gray goop over the already smooth body. It dries as hard as glass. He sprays on a guide coat, loads even finer sandpaper to his pneumatic sander, and achieves what seems a flawless smoothness to the Chevy's right fin.

We break for lunch at close to suppertime, and I drive him down Route 168 to a Subway sandwich shop. He's a regular customer, and friendly with the stooped old-timer who runs the place. "What are you working on?" the manager asks.

"I'm still working on that '57," Paul replies.

The manager looks surprised. "Shit," he says, "you gonna retire on that car?"

I realize to my own surprise that it's been six months since Paul started the restoration.

"Man," Paul says, "you have no idea how much there was to do."

FOR THE NEXT ten days, Paul smooths successive parts of the car. It is slow, tedious, and hard on every part of his body—he spends hours kneeling on the shop's concrete, mudding and blocking the wagon's flanks. I'm driving down to the car lot to watch him work on the left fender when I get a call from Arney announcing that the *Daily Advance*, a newspaper serving Elizabeth City, the biggest Carolina town in these parts, a half hour's drive from Moyock, has published a story about him on its front page—Currituck County is suing him for $78,800, the story says, for failing to satisfy its many demands at Moyock Muscle. This, despite the cleanup he and the crew accomplished in recent days—it's low-down, he tells me, and chickenshit, to pull such a stunt when it's

obvious he's making efforts to comply with the county's stupid rules. "I didn't even know they were making the fucking fines official until I heard there was this story in the newspaper," he snarls into the phone. "It's just a pain in the fucking ass. It fucks up a good morning." He promises to put on his "ass-kicking shoes" for a "battle at the Moyock Muscle Corral."

But within a few hours, such a rush of customers descends on the lot that Arney calls Paul to the front to help him handle the influx. Two days later, it's still going strong, and I find Arney in high spirits in the Quonset office. "I wish the fucking county sued me every week," he says. "We've had people coming in here all day yesterday and all this morning. Seriously: This has been fucking unbelievably good for business."

Over lunch, Arney assures me that the bodywork won't take much longer. He's eager to paint. "We're what—no more than thirty days, Paul?"

"Oh, yeah," Paul says.

Arney nods, folds his hands behind his head. "Inside of thirty days, we'll throw some paint on it." What color it'll be—well, that remains a question. Arney tells us that yesterday, as he admired the bright paint on his cars in the warehouse across the highway, he became worried that the gray and silver scheme would "diminish" the wagon, would fail to announce itself with sufficient volume. "Some color of yellow would look good," he muses. "Orange would look good."

He leans back in his chair, thinking. "Orange would look fucking *great*," he murmurs. He looks over at me. "I had an orange wagon when I was young, and I should never have sold that fucking car. That was a beautiful motherfucking car, and my dumb ass sold it so I could buy my first wrecker."

Five of those thirty days later, Painter Paul finishes mudding and sanding the wagon's sides. He welds new metal into the rust-eaten slots of the gunsights on the hood, grinds the additions, muds and sands. I

watch him clean up the gutter he welded weeks ago to the right rear corner of the roof, after borrowing it from the California wagon. He subjects it to the same exhaustive cycle of smoothing, using a thinner dowel wrapped in sandpaper to block its rain channel, running a finger in the hollow every few minutes to check for burrs or wrinkles.

Nearly seven months after he started, he's fitted the wagon with new fenders, a new floor pan, rebuilt doors, new rockers and rear jambs, and a rebuilt tailgate and hatch. It has been purged of rust, and its holes patched or filled with fresh metal. The whole has been sanded smooth and sheathed in pale gray primer. In fit and finish, in the strength of its body panels, in the armor provided by its undercoatings, it is a much finer car than rolled out of Baltimore fifty-four years ago.

Now it's time to break it in two.

IF YOU'RE DRIVING an automobile made in the last thirty years, odds are that it doesn't have a frame—that is, a heavy steel spine to which the engine is mounted, the body is fastened, and the suspension and axles are attached. Rather, its foundation likely is incorporated into its body, in the form of stiffening spines stamped into its floor pan, so that body and frame are inseparable partners in a single welded steel box. This is commonly called unibody or unitary construction, and because it is lighter, more fuel efficient, and absorbs more energy in accidents, has become the standard in passenger cars since the seventies.

An older American car, on the other hand, has two distinct pieces—its body, and the chassis to which that body is bolted. In the Chevy's case, the frame consists of four beefy steel girders welded into a rectangle; this skeleton provides the car with the structural muscle to resist flex when trundling over railroad crossings or making fast turns, and to bear the vehicle's many weighty components. The arrangement is called body-on-frame construction, and while it has fallen out of favor with automobile manufacturers, it remains the standard in pickups, large SUVs, and heavy trucks.

Most automotive restorations restrict themselves to freshening the parts of a car that its owner directly experiences, namely the body, paint, interior, and running gear. But anyone committed to achieving like-new results takes the process further—he undoes its birth on the assembly line, that critical moment when, in the wagon's case, the body from Cleveland was dropped onto its chassis in Baltimore. He separates the car's halves in a "body-off" restoration.

This is an obsessive undertaking by definition, for it bespeaks a level of effort that likely will go unwitnessed and underappreciated; once the body is returned to its chassis, the triumphs of the work will be rendered invisible. It also requires time, special equipment, and a pile of money that often dwarfs any prospect of recovery through a vehicle's sale. But it is the only way, when restoring a body-on-frame vehicle, to achieve perfection—to sandblast and repaint the frame and arrest every last speck of its rust; to sand the body's every last nook; to leave no bolt uninspected and uncleaned. The result, in every respect but technological modernity, is a new car.

Painter Paul begins the process by removing the pieces he has so carefully mated to the car's body core. He takes off the doors, hood, hatch, tailgate, and fenders and deposits them with great care on the floor of the body shop. He unfastens all the bolts linking the new floor pan to the frame. He rolls the Chevy onto the apron outside, where he spends close to an hour grunting and cussing before he successfully disengages the steering column, which threads through a hole in the firewall, from the assembly that steers the front wheels.

Now he faces a thorny challenge: how to get the body off. "I've been thinking about that," he tells me as we eye the car. "Thought about it all night." The lot is short of helpers today—Arney's away, and Skinhead's busy moving cars around up front, dragging them farther from the highway to mollify the county; Bobby Tippit has been absent for days, having been furloughed by Arney for unspecified failings. I'm the only assistance he's going to have, except for the lot's small Bobcat tractor.

And it's unclear how he can use the Bobcat. He can fit the tractor with forklift blades, but to hoist the body from underneath might crease it. We're discussing the difficulty of the situation when Skinhead happens by in the wrecker. "You ain't got that thing off of there yet?" he asks from behind the wheel.

Painter Paul explains the problem. Skinhead considers the matter for maybe two seconds. "Why don't you get some nylon straps," he suggests, "and lift it by its top?"

"Hey, son—that might work," Paul cries. "I'm glad I had you around today."

"The top will take the weight?" I ask.

Paul shrugs. "Hope so." He assesses the wagon's roof and the eight slender pillars, four to a side, on which it rests. "It should," he says. If he places the straps close to the B and C pillars, which run vertically and close to the car's middle—the B pillar runs between the doors, and the C just behind the backseat—he should have the strongest part of the roof supporting the body's weight. "The thing ain't *that* heavy," he says, more to himself than to me.

He attaches forklift blades to the Bobcat, drives the tractor onto the pad, and sits in the cab for a moment, squinting at the wagon; then, forgoing the nylon straps Skinhead prescribed, he eases the blades through the car's empty door openings, tilts them until they're parallel with the roof, and slowly raises them until they make gentle contact. He shifts a lever and the body rises smoothly off the frame; Paul lifts it eight feet in the air, jumps out of the Bobcat, and rolls the chassis out of the way with a shove.

In its place we position a wheeled steel contraption that resembles a combat-ready tea trolley. It lacks a tabletop; instead, its legs are welded to crossbars, which form parallel rails across the trolley's top. It looks as if it might have been designed to transport plywood or glass panes, but whatever its original purpose, it's less than an ideal tool for the task at hand. Atop the trolley's rails are a pair of four-by-fours, held fast

with turn after turn of duct tape. Paul intends to rest the car on these short sections of lumber. The car's welfare, and months of work, will rely on the strength of this rather shaky-looking assembly. As he tells me: "We're gonna see how strong that duct tape is."

To complicate matters, if he simply lowers the Chevy onto the trolley, it will come to rest with its rear foot wells, which bulge lower than the rest of the floor pan's bottom, on the four-by-fours. The bulges will almost surely be crushed under the body's weight. Paul devises a typically Moyock Muscle solution: He scrounges several planks of wood from his shops and the weedy ground outside the buildings, lays three heavy planks across the top of the trolley, then positions stacked four-by-fours on top of these crosswise planks and outside the foot wells.

He lowers the body onto the stacks, and the wood succeeds in sparing the floor's weakest points. But the load is tail-heavy, so we spend twenty minutes stacking four-by-fours under the wagon's rear end, trying to get it level. The wood is warped, the pile unsteady; it takes several attempts before we hit on the correct combination of planks and blocks to bear the tail's weight.

Paul backs the Bobcat away. A light breeze is sighing in from the west, and with each of its breaths, the car rocks gently on the trolley and its wooden cushions. Moving with an almost wide-eyed urgency, Paul loops nylon straps through the door openings and under the trolley's rails, ratchets them tight. We both breathe easier. "This ain't going nowhere," he says, performing a quick walk-around inspection, "as long as I can get this bitch inside."

We ease the Chevy across the pad, careful to apply our hands to the trolley, rather than the car itself, lest we shove the load out of balance. We face a moment of dread at the threshold to the body shop, where the building's floor is an inch higher than the concrete outside; I pull, Paul pushes, and with a running start we thump our cargo indoors.

I find myself lying awake that night, tormented by the possibility that the duct tape has already failed, that the Chevy has slumped sideways

on the trolley and crashed to the shop's floor, bending itself worthless. But the tape holds, the car survives, and when I next see it, a few days later, Paul has used the Bobcat to again hold it aloft while he bolts it to a rotisserie—a wheeled cage of heavy steel girders that, as the name suggests, holds the wagon like a chicken on a spit, so that it can be barrel-rolled onto its left and right sides. With the help of all available hands—Arney, Skinhead, Bobby Tippit, and one of Tippit's boys—he turns the car so that it hangs left side down, and tightens the rotisserie to hold it fast.

The restoration's second phase begins.

16

OCTOBER'S END FINDS Painter Paul, wearing a stocking cap and long johns against the damp chill that has abruptly replaced the summer's heat, welding shut the small cracks and holes on the wagon's underside, painstakingly inching his way from the car's tail to its nose as it hangs driver's side down on the rotisserie. He grinds the welds smooth with as much care as he did on the Chevy's skin and interior, despite there being little chance that anyone will ever see, let alone notice, the near perfection he attains. As he did on the visible portions of the car, he muds and sands the joints between the cargo hold and the new tailgate jamb, the floor pan and the toe boards.

Grinding without goggles one afternoon, he catches a flying sliver of steel in his right eye. It turns a solid, bright red, swells up overnight, and weeps all the following morning, until Paul reluctantly gets his mother to come by Moyock Muscle and drive him to a doc-in-the-box, where the metal is tweezed free. Inside of an hour he's back at work. He spends the balance of the afternoon grinding away blobs of dry glue on the wagon's ceiling, once anchors for the cloth headliner.

Through these weeks of labor on the suspended body, the wagon's chassis sits in the shed next door. Bobby Tippit is ready to sandblast it, after which Painter Paul will repair and paint it. But before that can happen, Paul tells me, Arney and company have to strip it down to a bare frame—minus its suspension, exhaust, all of its lines and wires. "Which'll take fucking forever," he adds.

Actually, I learn in speaking with Arney that the chassis has gone untouched not because he's distracted, but because he's mulling an idea Skinhead had shortly after Painter Paul cracked the Chevy in half—namely, that the Michigan donor car has a fine frame lurking beneath its body, and it would be a whole lot easier to use that, rather than the wagon's original chassis, because the new engine, transmission, and suspension are already bolted to it.

No one would be the wiser, what with the frames being identical in every respect. And it would save a week's work, at the least, because Plan A requires that Arney separate the donor car's body and frame, strip that chassis, then bolt much of what he's just removed onto the wagon's frame, after stripping it, too.

But Arney, who rarely gets sentimental about a car, decides against the easier course of action. He's already spent a lot of money and Paul's time on returning the wagon to its former glory, and he convinces himself that swapping out such an essential element of the Chevy for no other reason than convenience would be wrong.

Besides, the original chassis is in strong condition, which becomes clear when the crew finally relieves it of its suspension and steering gear. Only a little surface rust speckles the frame rails, which are each made of two pieces of thick steel rolled into C shapes and welded together to form a square cross-section. "I was expecting to find some holes in the motherfucker," Paul tells me. "But it's really pretty clean."

Arney is even more enthused when he stops in for a look. "I'm amazed at this motherfucker," he crows, as Paul shows it off to him on the shop's floor. "You can sandblast it if you want to, but I'm not sure you even need to. You could just power-wash it."

"Why?" Painter Paul asks. There's the slightest tinge of challenge in the question. He's spent months perfecting the wagon's body, and I can imagine that he's not inclined to recombine that handiwork with a frame that hasn't been afforded similar attention.

"Well, I mean, it's in such great fucking shape," Arney says.

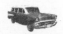

"Okay," Paul says, frowning. "I mean, I'd like to get all that rust off it."

The new Tommy Arney evidently smells an argument in the offing, and decides that Painter Paul holds the high ground. "Yeah," he says. "Okay. Sandblast it, Paul. You're right."

WITH THE BODY coming along so quickly, Arney again rethinks the paint. He, Skinhead, and I are sitting in the Quonset office one morning when he announces that he's grown disenchanted with orange, and now favors a metal-flake gold. Maybe.

"Gold would look good," Skinhead says.

"That same gold that's on the truck back there," Arney specifies, referring to the GMC pickup Paul finished just before starting work on the Chevy, and which eight months later remains engineless in a shed out back.

"That'd look real good." Skinhead nods.

"With maybe a cream color as the accent?" I ask.

"An Indian ivory," Skinhead suggests.

"Nah, not Indian ivory," Arney replies. "I don't want too bright a white. That shit's too bright. But, yeah—something like that."

We suspend further discussion. A primary task looms—to turn the car on the rotisserie, Painter Paul having completed all work possible with the wagon suspended driver's side down. We walk back to the paint shed, where we join the rest of the crew assembled for this primitive and potentially dangerous operation: Paul, Bobby Tippit, and Tippit's son Anthony, who is fourteen but big for his age. Even with so many of us crowded into the small space, we seem understaffed, for the wagon is not centered on the rotisserie; it is bolted to the spit at the points where its bumpers normally reside, so that the load's off balance. Rolled to the left, as it is now, its default tendency is to roll farther left, until its roof smacks the floor. Turning it onto its right side will require us to lift the car's weight—close to a ton—until the Chevy

sits upright, high on the spit. Then, when it's balanced at the top of its arc, we'll have to run to the rotisserie's far side and gently lower the car until it hangs perpendicular to the floor. One slip, and gravity takes over—and the car rolls unchecked, crushing anyone in its way. The prospect of crippling injury is real.

We all line up along the Chevy's roof and fasten gloved hands to the ceiling or a doorjamb, and wait, muscles tensed, as Painter Paul loosens one end of the spit, then runs past us to the other end. Skinhead says: "It's about to get real heavy." Paul undoes the last bolt.

It gets real heavy.

Four of us emit involuntary gasps.

Arney, his tone almost breezy, says: "Okay, let's lift." Each of us shoves hard against his piece of car, groaning. Somebody mutters, "God damn shit."

"Let's go," Arney orders. "Let's go. Let's go." The car slowly rises, each of us grunting and yelling, taking turns to search for handholds lower on the car's left side as it swivels toward us. "Come on!" Arney barks. The left side inches upward. Paul, watching our progress from the rotisserie's end, announces: "You need to come onto this side."

"It's gotta be on top, first," Skinhead says through clenched teeth. We keep pushing, until the load lightens all of a sudden—the car is at the top of the arc, sitting high and upright on the rotisserie. Arney booms, "*Go*," and Skinhead slips to the other side. Bobby Tippit follows. "Go," Arney says again, and young Anthony deserts us. Three pairs of hands now support the car's right side, preventing it from rolling too far. Arney lightens his grip, testing the car's balance, then leaves to join the others. I'm left alone on the car's left side, a human chock, all too mindful that if the load were to shift back my way in more than the slightest fashion, I'd be powerless to stop it. The roll would be sudden, and I wouldn't be able to outrun the roof as it swept downward like a scythe with a ton of force behind it.

As this image sharpens in my mind, the car lifts out of my grip: The

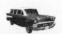

other four have pulled the body's right side toward them, have toppled it onto their hands and are now easing it toward the floor. They slow as the roof becomes vertical. Painter Paul hurries to refasten the bolts that lock the rotisserie.

Afterward, most of us have a look at the GMC pickup. It shares an outbuilding with the cars Paul offered as evidence that Arney often fails to finish what he starts—a beautifully painted but engineless 1967 Mustang, and a 1965 Impala convertible lacking an interior. The pickup's metallic gold skin twinkles in the shed's fluorescent light.

We watch as Arney circles the truck, eyeing the paint's depth, nodding. "Yeah," he says. "That color will be fine, Paul."

HALFWAY THROUGH THE second week of November, Arney and Skinhead have returned to the business of appeasing Currituck County. I find them in front of the Quonset, rebuilding the distributor on a 1962 Bel Air six-cylinder so that they can get the two-door sedan running—which will enable its easy movement in the days to come, as they jockey the inventory around the lot.

"I want to put something in so they'll leave me the fuck alone," Arney says of the county as he works under the hood. "But at the same time, this is my first experience at kissing ass, and I'm finding it really difficult to do. And I'm confused. I don't know how much of it I *can* do."

On a recent visit to the courthouse he met with Ben Woody, Currituck's top planner—the polite, bearded fellow who visited the lot fourteen months ago with Brad Schuler—and learned that getting the county off his back was going to require a great deal more work than he'd performed to date. He'd have to draw up a site plan of the property, reflecting all the changes the county demanded, and submit said document to the county's Board of Adjustment for its approval. And if and when the board granted that approval, he'd actually have to make the property conform with the plan; that is, if his drawing

depicted shrubbery planted on the property's edges, per the county's wishes, real shrubbery would have to appear in the same spots at the real Moyock Muscle.

Arney had to get busy, Woody told him. The site plan was months overdue. The inventory was still too close to Route 168; they had to be at least twenty feet from the right-of-way. He'd planted nothing. If a fire broke out on the back lot, pumpers wouldn't be able to get through the sea of cars up front to extinguish it, because Arney had cleared no fire lanes. "My goal's not to beat you up," Woody said. "My goal is to see you comply with the ordinance, so that we can call it a day and be done with it." He felt, he told Arney, "like we've been dealing with this forever."

The visit was not without good news: Arney learned that if he played nice, the county would reduce his $78,000 fine to just $5,000. Even so, he left the courthouse irritated, and he remains so as he and Skinhead work on the Bel Air. Woody, he tells Skinhead and me, is "a troublemaking whore" whom he "can't be around no more," because he doesn't "want to get so mad that I do something that I'm going to regret." He says this as he's stripping the end of a wire, in a tone that borders on the pitying. As for Brad Schuler, he says he would "like to take him and just pinch him like a little bitch."

His displeasure notwithstanding, the following Saturday he and the crew back the inventory away from the Jersey wall fronting the lot, then use the Bobcat to drag the wall's eight-foot sections away from Route 168 and reposition them exactly twenty-two feet from the highway's edge. When they're finished, the wall runs straight as a rifle shot, and the row of cars just behind it, evenly spaced on gravel swept free of litter, includes some of the best-looking merchandise on the property. He also visits a local firehouse and asks how wide its trucks are, and carves lanes a couple of feet wider through the inventory. Arney is pleased, and expects the county people to feel likewise. He's done more than they asked. How can they not?

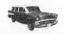

Currituck County surprises him. At a meeting with its fire, wastewater, building and planning officials, Arney learns that he's moved the inventory away from the road, rather than the right-of-way. His latest efforts have planted the Jersey wall and front rank of cars barely two feet outside that line. He has eighteen to go.

Arney accuses Woody of telling him differently—or at the least, of not setting him straight. "When I moved them, I called you on the phone" to report they were twenty-two feet from the road, he says. "I'll be honest," Woody starts to reply, but Arney interrupts: "You can't be honest with me." He's tried to do right, he says, bitterness evident in his voice. He crushed and hauled away 338 cars to satisfy the county. He spent several days creating fire lanes to satisfy the county. He's moved his front wall to satisfy the county. And months ago Woody told him there'd be no fine, he says, "and the next thing I know, I have to go to court and I have a seventy-eight-thousand-dollar fine."

Woody complains that he's being called a liar, but he fails to cool Arney's fire. The Board of Adjustment is "a joke. It's like a kangaroo court." Any suggestion that he park inoperable vehicles behind the Quonset is "impossible." When one of the officials tells Arney that based on the number of buildings on the property he'll need thirty-nine marked parking spaces, Arney, mishearing him, agrees to the demand by saying, "I'll give you thirty-six spaces." When another official corrects him—"It's thirty-nine"—he's outraged: "What—so it's thirty-*nine* now?"

So passes the hour. "I don't bother anybody," Arney tells the officials, by way of summary. "In nine years there's never been a complaint in the county about Moyock Muscle. People love Moyock Muscle. All the sudden I have to jump through a bunch of hoops when I've been doing business there for ten years."

His cars resonate with people, a lot of people, he tells them, and you'd understand that if you appreciated that among these machines are "the car that your mother drove, or your grandfather, or that you enjoyed driving years ago yourself.

"If you don't have that in your mind," he says, "then you can't under-stand classic cars—or American history."

He leaves disgusted.

At the rear of the property, Painter Paul, excused from participating in most of the improvements up front, works on the Chevy. He grinds smooth the knobby welds that bind the frame's girders, fills the cracks between the welds, sands everything smooth. He suspends the frame between the paint shed's wall and the Bobcat's forklift blades, and sprays it with two coats of shiny black acrylic enamel paint. Wearing a respirator, he passes his spray gun back and forth over the frame, his pace neither slow nor fast—swaying, heel lifting on the trailing foot as he stretches to extend the spray's reach with the opposite hand, eyes sharp for dull spots that signal sealer peaking through the enamel.

He shrouds the body in heavy paper and tape, then sprays its under-side with two coats of urethane primer and a stratum of sealer. The following morning, he lays on two coats of acrylic enamel, which takes days to dry; when the boss stops into the shed hours later, the paint still glistens as if wet.

"It'll be a long, long time before anything happens to this," Arney tells me, then points out how tight and sanded-smooth and rustproofed all the joints between the bottom's various panels are. "Look at all these seams, the way he's done it. You don't see it that nice at the fuck-ing factory." Paul acknowledges the praise with a modest nod.

Arney steps back a few feet to admire the undercarriage from afar. "If we took this car to any auction, when they roll it over the camera, this is what you'd see," he says. "I think it looks great, Paul. It looks great." Paul allows that he's satisfied with how it's turned out.

"You see," Arney says, turning back to me, "what I'm doing is teach-ing Paul to be a *restorator*. Before, Paul was a master painter. But now, I've taught him how to restore a car. A master restorator—that's what he is now." I glance at Paul, who offers no response.

While the body dries outside, car and rotisserie bagged against the

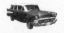

elements in plastic, Paul hangs smaller pieces of the Chevy's mechanical gear from a rope strung across the paint shed, then paints them in rustproofer—the A-arms and front coil springs, ball-joint assemblies, the brake drums. He primes the inner wheel wells and two small pieces of body that will be visible through the grille.

After six days the paint on the car's belly has cured to a hard, glossy shell. He rolls the rotisserie and its load back into the paint shed, unbags it, and sprays the car's ceiling with primer, then rust-resistant white paint.

IN MID-NOVEMBER 2011 rains arrive with such persistence and force that Paul must work for more than a week straight with the rolling doors on both the paint shed and the body shop pulled shut, and with a mountain of gear (that in the course of a sunny day typically spills onto the pad) crammed inside. In the body shop, the frame, balanced on the tea cart that a few weeks ago held the body, occupies much of the floor that isn't already cluttered with Paul's workbench and rolling tool chest, the Camaro, the sandblaster and piled bags of blast medium, leaning sheet metal, and the Chevy's fenders—and snaking over, under and around it all, Paul himself.

It's in this setting that he works on the doors, grinding and sanding them in preparation for a slathering of mud as the wind howls outside and a cold draft wafts through the building. He slips a canister of Fusor, a heavy-duty automotive seam sealer, into a dispenser resembling a caulking gun, attaches a long nose to the device, and injects a ribbon of green-gray goop into a gap in the bottom of the door, where the outer skin and interior panels meet. At its widest, the space measures an eighth of an inch, but that's a freeway for rust if left as it is. He smooths the Fusor with a finger, then plugs in what appears to be an industrial blow dryer. This heat gun is necessary because the body shop's air and the door's steel are cold, conditions that Paul tells me will cause

the sealer to "take fucking forever to dry." The heat gun's blast is hot enough to turn the air wavy a foot in front of its nozzle, and to briefly check the damp chill that's descended over the room.

He has a propane heater on hand, but its tank is empty, and a search among the discarded tanks littering the ground outside turns up no trace of gas. So with numbed fingers, his breath visible, Painter Paul passes two days finishing the doors, and with Skinhead's help, uses the Bobcat to roll the wagon so that it sits upright on the rotisserie. He spends another three days sanding the doorjambs, first the left side, then the right. It's close to finished, he says. He'll be painting the car inside of a week.

Just a few remaining details require his attention. One is the spare tire well, which ranks among the car's least visible metal: It's a round tub that hangs below the cargo hold, its bottom angled nose-down toward the bow to facilitate easy removal of the spare, its contents hidden beneath a cover and carpeting. But the tub is rusted through, and Paul decides a simple patch will sell the car short; the wagon's future owner, whoever that might be, might pull the spare one day, and would surely notice the condition of the well. How affirming to find it as perfect as the rest of the car; how disappointing to find a crude sheet-metal bandage lurking down there.

So he cuts away a rusted flange encircling the well's mouth, welds fresh steel in its place, grinds the welds smooth and shiny. He fills in tiny rust holes with the torch as the shed's walls and ceiling go crazy with blue flashes and black shadow. He hammers at one troublesome weld while holding a maul beneath it, looking every bit a modern Paul Revere.

The lowest point of the tub, its nose, has sustained the greatest damage. Paul draws a rectangle around the rust holes there with a permanent marker, then carefully slices the rectangle out with his whiz wheel. The piece is curved on two planes. He hammers it flat, then uses it as a template to cut its replacement from the new steel.

He now has to replicate the original's complicated curvature. The

tool for the job, called a planishing hammer, runs off the shop's air compressor and features a round hammerhead that beats up and down at high speed; you can manipulate sheet metal under the thing so that it beats it into a curve, or several curves at once. The downside is that this bending creates an eruption of thumps, screeches, and scrapes so loud that I suffer real and alarming pain and run outside—and from the pad it's still so insanely loud that I retreat farther across the puddled back lot.

Paul, wearing no ear protection, stays on the job, bending the rectangle along one axis, curling it along the other. It takes the restorator hours to get it perfect.

ON A LATE November Saturday, Arney and Painter Paul shuttle cars in and out of the Quonset, seeking a more efficient parking arrangement. Among the vehicles they remove from under the building's dim fluorescents and into the bright light of midday is a 1970 Nova painted an aggressive, glossy orange called "Tangerine Twist," and when Arney sees it gleaming in the sunshine he announces: God *damn*, I like that color. That's the color we're painting that '57.

Paul orders the paint. Arney has blown his thirty-day forecast for the paint job by more than a month, but now he seems impatient to get started. Paul will "cut in" the paint around the doorjambs, the rear opening, and the engine compartment while the Chevy is on the rotisserie, he tells me. Arney and Skinhead will put together the chassis, including the engine and transmission from the donor car, and the body will be lowered over it and bolted down. They'll have an auto glass specialist come in to install new windows in the car. None of these tasks is complicated, he says. None should take long. They'll "throw some color" on the car inside of four weeks. "Yes, sir, buddy," Arney says.

But now a strange series of events unfolds, starting on November 28, when I notice that while Paul is blocking the Chevy's hood in the body

shop, a new car has materialized on the concrete pad outside; Bobby Tippit is using a power sander on this interloper, a 1974 Dodge Charger that is decrepit with rust, inside and out.

The Dodge is still there late in the week, when Paul fires up his paint guns and applies two coats of Tangerine Twist, in all of its energetic glory, to the wagon's four doors. He trims the window frames in an off-white, and shows the doors to Arney on December 3. The white is too bright, Arney tells him.

And he tells him something else: He wants him to work on the Charger parked outside the shop. "It's a piece of shit," Paul mutters two days later, when I drive down to Moyock to watch him finish the last bit of sanding on the wagon, and instead find him with the Dodge. "Everything is gone. Everything." Later that week, I find him cutting out a big piece of the Charger's left quarter panel. "I should be finishing up the '57," he complains, "but Tommy's pulled me off it." Three days after that, he's still on the Charger.

That evening, I find Arney, Skinhead, and Bobby Tippit in the workshop at the Quonset's rear, performing triage on a Jeep Wagoneer flooded in saltwater during Hurricane Irene. With them is mechanical wizard Eddie Card, an octogenarian wearing two hearing aids. Everyone, and Arney in particular, seems to be in fine spirits as they examine the Jeep's exhaust and quiz Tippit on whether he performs household chores in his little shack across the highway—such as washing the dishes, for instance.

"I don't wash my ass," Tippit replies, "so why would I wash any dishes?"

Arney turns my way. "It's true," he says. "Bobby don't like to take no showers."

"I don't like water," Tippit explains.

Skinhead, to me: "His kids don't take showers, either. One of 'em was telling me he hadn't taken a shower in seven weeks." Tippit notices my stunned expression. He yells: "I worked on roofs in 160 degrees!"

"Bobby says he sweats so much, he don't need to take no showers," Arney tells me.

Tippit chatters on until Eddie Card, annoyed, tells him: "If your mouth was a fucking impact wrench, it'd take you no fucking time to do this job."

I detect nothing to suggest that Arney has lost his ardor for the Chevy project. He speaks breezily about the car. He expects Paul will be cutting in the paint on the doorjambs any day.

But the next morning, and the two after that, I phone Painter Paul to find out whether he's working on the wagon, and he tells me he's spending the day on the Charger. When I call on the fourth morning, Paul tells me he's not going into Moyock because he's been laid off.

What? I ask.

"Tommy fired me," he says.

What? I ask again.

"He fucking fired me. He accused me of doing drugs on the job."

The charge doesn't make sense to me, and I say so. I've watched Paul do the seeming impossible in saving the wagon. I've seen him do it day and night, regardless of the weather, with a drive for perfection that has amazed me. He has never seemed the least bit addled.

Painter Paul has an alternate explanation. "He's broke," he says. "He can talk about me doing drugs all he wants, but the bottom line is that he's fucking broke."

PART 4 *Pedal to the Metal*

17

MOYOCK MUSCLE SITS dormant, the Quonset and body shop dark, the Chevy split between the buildings. Weeks pass. The holidays come and go. The gate out front remains padlocked when, early in the new year, Arney faces a climax in his long and frustrating intercourse with Currituck County: The Board of Adjustment will weigh his ongoing breach of its zoning ordinances on January 12, and unless he takes dramatic action, the results will be ugly.

So Arney has his surveyor draw up a new site plan for the car lot, depicting the changes the county has demanded, and two days before the reckoning drives to the county courthouse with Slick to meet with Ben Woody. The planner seems relieved that his tussle with Moyock Muscle may be nearing an end. "I'll be happy to set this behind me," he tells Arney from behind his desk. "This has not been pleasant."

Arney replies that it's been no picnic for him, either. "This has made me so bitter that I don't think I want to continue in the car business, and that's heartbreaking to me," he says. "I am so upset by the way that I have been treated for doing nothing wrong. Now, if I'd killed somebody or robbed somebody, I could understand completely."

In fact, he'd love to sell the property to the county right now, if Woody's interested. Right this minute. He's not joking. "I'll offer to sell it to you for exactly what I owe the bank, which is $1,821,000," he says. "Give me six months to get out of there."

That's something Arney will have to take up with the county manager,

Woody says, and turns the conversation to the site plan that Arney has unrolled on the desk. He notes, approvingly, the trees around the lot's periphery. He applauds the fire lanes. But there are a few adjustments that still need to be made to the drawing and to Moyock Muscle itself. Those portions of the lot used for public display and sales have to be paved. Arney will have to build a lagoon to collect stormwater run-off. And any inoperable cars will have to be invisible from Route 168. Woody draws a line on the site plan where Arney might build a fence to screen them. Fine, Arney says, he'll build the fence.

The county manager, Dan Scanlon, sticks his head in the room and seems pleased that an accord is at hand. Arney seizes the moment. "Sir," he says, "would you like to buy that property?" He's planning to shrink his business, he explains, "to the point that I can move everything across the street and abandon that property. Do you all need any?"

Scanlon is noncommittal. Woody steers the conversation back to the site plan. So, he asks Arney, you understand that once all these changes have been made to the site plan, and the Board of Adjustment approves it, you have to make the property match the drawing, right? "I will do everything I've told you I will do," Arney assures him. "I'm a man of my word."

The next day, Arney and his surveyor are back at Woody's office to deliver the revised plan, and Arney has a suggestion. He could build additional fences, he says, fences the county hasn't demanded, along Moyock Muscle's sides and back—and if he were to do that, perhaps the county could forgive the five-thousand-dollar fine. Woody is not authorized to make such a deal, but he passes along the request to his boss in an email.

Comes now the day of the Board of Adjustment meeting, and Arney and Slick arrive girded for battle. She sits before the all-male committee in a blouse that exposes a dramatic expanse of décolletage. Arney is exceedingly polite as he addresses the panel, most of his comments sounding a single theme: "I've done everything that they asked me to

do, and more." He goes on long enough that a board member finally tells him: "I don't want to cut you off, but I don't want you to get a sore throat."

The discussion that follows is friendly. Generous, even. The board appears moved by Arney's cooperation. It votes to grant him the permit he needs to operate with one condition, and that is that he meets with the county's technical people within two weeks to decide how to address stormwater runoff on the property. It almost lets him slide on that, but the staff insists that the gravel Arney put down in front of Pop's house is "impervious," and thus requires environmental remedy.

Arney is buoyant as he leaves the meeting. The county is off his back. His bureaucratic nightmare is over. He so relaxes his mind that he doesn't give Currituck and its demands another thought for months.

IN EARLY FEBRUARY Arney reveals that he's contemplating a change in who will do the wagon's interior. Bobby Chapman does fine work, he tells me, but he can be stubborn, "and if he doesn't get his way and doesn't get the long end of the stick, he pouts." In Chapman's place, he might hire a fellow known as Crazy Junior, who brings some baggage of his own: "He drinks twenty-four/seven, he's as big around as a fucking toothpick, and he has a fifties hairstyle," Arney says. "But he can do some fucking upholstery." As for the chassis: He vows that he and Skinhead will jump on it in less than a week.

Once again, he finds his time demanded elsewhere. A prospective renter materializes for a long-vacant, two-story building Arney owns on a sketchy corner in Norfolk, last occupied by a unisex hairstyling business downstairs and a couple of apartments up. Arney spends most of the next two weeks on-site. The tenant wants the ground floor emptied; Arney buttonholes men as they saunter by on the sidewalk and offers them cash to sweep, bag rubbish, wipe the walls. The tenant also wants the ground floor to be windowless, so Arney has Skinhead

board the big picture windows out front, then nail siding over the entire façade. The result is jarring. It might pass for a blockhouse, were Arney to add a few slits here and there for rifle barrels. Soon, a rumor circulates that explains the tenant's desire for privacy—said tenant is the Hells Angels, who will use the ground floor as a local clubhouse. I call Arney. He confirms the rumor, hastening to add that the club's members aren't the monsters they're thought to be, that "they're real nice guys" who want only to be left alone.

Nice or not, the Angels receive a cool reception from Norfolk officials, who suspect that Arney and/or his tenants have performed work on the building without the necessary permits, and deploy a squadron of code officials, fire marshals, and building inspectors to have a look. Arney arranges to meet the inspectors there. On the way, he calls to invite me, too.

I note several unmarked Crown Vics parked outside the building and a couple more across the street as I approach the front door. My knock is answered by two men with comprehensive neck tattoos. I ask whether Arney is on the premises. Not yet, one replies. I thank them. The door shuts.

A few minutes later it reopens, and out file several inspectors. They're chatting among themselves on the sidewalk when Arney roars up in the rollback and pulls to a squealing stop in a neighboring parking lot. He jumps from the cab and strides toward the building, stepping off the curb and into busy Granby Street without so much as a glance at approaching traffic. One car, its nose diving as it brakes, comes within a foot of hitting him. He doesn't seem to notice.

One of the city's men steps forward, hand extended—the same inspector Arney allegedly menaced at Bootleggers eighteen months back. He and Arney speak quietly for a couple of minutes, after which Arney powwows with the tattooed men I met at the door. They're agitated. The inspectors are going to force them to make all manner of changes, one tells Arney, adding: "It's going to cost us twenty grand just to be able to

move in." Arney advises him to relax his mind. If the Angels are mindful of the fine print of city code when installing electrical lines and plumbing, and true to Norfolk's fire regulations, and careful not to change the residential character of the upper floor, they should be just fine.

Which might be reasonable advice, except that Arney fails to grasp just how stridently Norfolk officials reject the prospect of Hells Angels in the neighborhood, and how steadfast is their insistence that the city's building codes and zoning ordinances be followed to the letter. When Arney tries to cajole, bluster, and strong-arm a path through the red tape, he finds himself in a meeting with his old nemesis, Cynthia Hall, to whom he makes the mistake of saying that he doesn't much care if the Hells Angels are "murderers, rapists, drug dealers, or if they screw donkeys," as long as they pay rent.

Hall asserts in a letter to Bill Taliaferro that that might be the least of Arney's mistakes. "Mr. Arney has been harassing and intimidating city staff and his actions must cease," she writes. "Following city staff to their vehicles in an attempt to intimidate them will not be tolerated. Additionally, threats made by Mr. Arney to me regarding me being careful because I was 'pissing off powerful and important people' will likewise not be tolerated. I will assume for now that Mr. Arney was not authorized by the Hells Angels Motorcycle Club . . . to threaten a city attorney." Norfolk, she writes, is "governed by the rule of law, not by thuggery tactics."

In mid-March, by which point it's clear that "persons continued to go into the building at all hours," as Hall puts it, and that "Hells Angels 'probies' were seen standing guard at 'parade rest' outside," inspectors descend on the building and paper its exterior with notices that it has failed to meet various city codes and is thus unfit for habitation.

Arney figures that the only thing that makes the building unfit for habitation is that it's the Hells Angels who want to inhabit it. He says he hears as much in several meetings with city officials, who assure him that no matter what he does to the place, the Angels won't be partying

there, period. He mulls whether to take the officials to court or let the bikers look after themselves. "It's not really my fight," he tells me at Havana one night, "but I hate to see the motherfuckers get away with something like this."

A few days later his lawyers convince him to end his role as middleman, and he calls the leader of the local Angels to let him know. The city "hates Tommy Arney, period," he tells the biker. "They should never have put those stickers on that building. But they put them on the building because they don't like you and they don't like me. And I think it would be better for you to fight one fight than to have both of us try to fight two."

The upshot is that days pass, a lot of days, during which Arney is not only not working on the chassis, he's not even visiting the lot. The gate is padlocked through late February and most of March. It isn't until the twenty-sixth that Arney and Skinhead return to the office at Moyock Muscle, where they find dozens of messages left on the answering machine.

A woman's voice: "Just wondering when and if you guys are ever open. Could you call me?" She leaves a number. "I already talked to that crazy bitch," Arney growls. Another call: "I don't know how you intend to make any money if you never answer the—" Arney halts the machine, deletes the message, moves on to the next. "Hi, I'm calling after hours. I'm at the lot, and I just wanted to walk around without getting shot—take a look around, look at some cars, pick something out and come back and talk to you about it." Arney writes down his number. A new voice, asking about parts. Skinhead records the details. Another, long-distance, seeking some arcane component. Arney jots. Several callers ask about cars they've seen on the website. Arney and Skinhead divide up the list.

Skinhead notes that another call came in that morning, before Arney's arrival—a guy looking for a price on the 1969 Pontiac Trans Am on the lot. "There's no such thing," Arney says.

"Sure there is," Skinhead replies. "It's right outside."

"No, you dumb motherfucker, there ain't no such thing as a '69 Trans Am," Arney tells him. "Never *was* a '69 Trans Am. There was a '69 *Firebird*."

"Okay," Skinhead says. "Whatever. How much do you want for that Pontiac?"

"We have no '69 Trans Am. We have a '69 Firebird."

Skinhead nods. "Okay. How much do you want for it?"

"The one out there—the Firebird—is silver."

"Right. Okay. How much do you want for it?"

"I'll take thirty-five hundred," Arney says.

Skinhead dials a number, and while awaiting an answer murmurs: "I'm sure I've seen, in one of these books, a '69 Trans Am. It was white with blue stripes."

Arney scowls at him. "So you're saying it had one paint scheme?" he asks, his tone incredulous. "God *damn*, Skinhead, you really are a stupid motherfucker. You think they made a Trans Am with just one paint color?"

Skinhead points to a pile of manuals, parts catalogs, and muscle car magazines on the desk between them. "I saw it in one of these books."

Hold on, Arney says. He flips open his cell and speed-dials a number. "Hey, Slick, look up on the goddamn Internet for me and see what year they introduced the Trans Am for me, will you?" He hangs up.

A couple of minutes later, she calls back with the news that the Trans Am was introduced in the 1970 model year, which appeared in late 1969. Arney immediately takes to the Internet himself, and reads aloud from a website: "The Trans Am package appeared in the spring of 1969." It was a midyear offering. He sighs and peers across the desk. "Well, Skinhead, you're *not* a stupid motherfucker."

"Thank you," Skinhead says softly.

"Be glad about that: You're not a stupid motherfucker," Arney counsels. A pause. "Well, you *are* a stupid motherfucker, but not about this."

BEFORE HE CAN get back to the Chevy, Arney must first clear enough space in the showroom for the chassis and the donor car, meaning that he'll have to relocate several of the cars parked there. Three or four can be shoehorned into a large garage at the rear of Pop Jennings's house, but only after that room—now piled with brake shoes, mufflers, fan belts, old signs, and pails of nuts and bolts—is itself cleaned up and rearranged.

So the pair spends the rest of the day at Pop's. Skinhead backs a pickup to the garage door, and he and Arney use it as a Dumpster as they sift through the room's jumbled contents. "We've gotten way ahead of ourselves and now we've got to get back to the basics," Arney says as they work, as much to himself as to Skinhead. "The basics are not buying any more properties—go back to enjoying life, instead of being in a race to get somewhere where it's no fucking fun being there. I got caught up in what everybody else got caught up in, and it led to me being in a place where everything got out of control."

They bolt together a trio of six-foot metal shelving units. "You get addicted to the deal, you know what I mean?" Arney says. "I got addicted to the deal. I got addicted to making that deal. And the fucking banks were giving away all the fucking money you wanted, and I was like so many other people—if you're giving it away, I'll take it. I'll try to make some money with it."

Skinhead nods. Arney sighs. "I guess in all fucking reality you get lost in trying to make money. The more money you can get, the more properties you own, the more you want to keep making those deals."

"You're amassing all this shit that you think is wealth," Skinhead offers, "and it turns out it isn't wealth at all."

Arney grunts agreement. "All my life, I was under the impression that if I bought property, I couldn't go wrong," he says. "Well, guess what? I found out that I certainly *could* go wrong." They screw the shelving units to the wall, Arney lowering a shoulder against their

frames, Skinhead wielding the power driver. "I'm out of the real estate business," Arney vows. "I just want to own me some cars, and if a motherfucker wants to buy one, they can give me some money and I can go on down the road."

They take a break to show a customer a '67 Camaro with a "Carolina quarter panel"—sheet metal has been patched to the car with rivets, which are unevenly spaced as well as ugly in their own right—but otherwise, the two labor without pause into the evening, bickering all the while like an unhappy couple. Arney accuses Skinhead of soiling himself. Skinhead replies, evenly, that he has not. They argue about it. Arney complains that Skinhead is a weakling. Skinhead counters that he's as strong as he needs to be. They differ on this at length. Slick calls to report that she's on her way, and will stop at a hot dog joint en route; the men wrangle over how many hot dogs Skinhead should order.

They select the first car they'll move to Pop's: a 1959 Mercedes 190 SL convertible, its silver paint pristine under a quarter inch of fluffy gray dust, its engine unturned for more than twenty years. Its left front tire is flat; the engine's belly is resting on the Quonset's concrete floor. Skinhead jacks up the front end, and under each wheel positions a GoJak, a steel cradle on casters with a foot-operated jack attached; the devices enable him to raise the Mercedes off the floor, inch it onto the rollback, then ease it into Pop's garage.

He and Arney start several other cars in the Quonset, most of which fire up eagerly, and drive them onto the lot. With half the showroom empty, they take the rollback to the property's north side, where the donor car waits between Paul's paint shed and the body shop. The old sedan's left side is locked up; neither wheel turns. Arney, impatient, hooks it to the rollback's winch and drags it shuddering and groaning onto the truck's bed.

Thirty minutes later, the donor car is positioned on the showroom's hydraulic lift. Arney raises it overhead. Pine needles sprout from the undercarriage like hair from an old man's ears. The frame is studded with mud daubers' nests. Yet the car's running gear appears straight,

and many a part is ripe for salvage: The exhaust and muffler look new, as does the gas tank. The last won't fit the wagon—the arrangement of its rear-end components differs from that of Chevys with trunks—but it's worth keeping just the same.

Skinhead uses a reciprocating saw to cut away the straps cradling the exhaust pipe, then unbolts the pipe from the engine's manifold. Arney pulls the cotter pins holding the parking brake cables. They hunt down the bolts joining the body to the frame, unsure of how many there are. Sixteen? Eighteen? Twenty? They unscrew nine, break two others, saw the heads off three more that are stripped beyond turning. They find empty holes where four more ought to be.

The bolts measure nine-sixteenths of an inch in diameter—not an especially beefy girth, and a reminder that even old-school, heavy-metal beasts like the wagon have weaknesses: Their integrity depends on their bodies remaining bound to their frames, and that enterprise comes down to these bolts. The car is only as strong as they are.

At eighteen bolts they figure they've found them all, but no—two others turn up, tucked away in folds of the metal, in crannies formed by the frame. They're nestled too deep to turn with a socket wrench; Skinhead opts to cut them. Smoke curls from a thick rubber washer cushioning one of the bolts as he forces the saw's dulling blade through.

Arney next unbolts the shock absorbers from the frame, and Skinhead uses a pry bar to force them free. As they come loose the rear axle drops a foot, dangles by the leaf springs. They unfasten the steel straps hugging the gas tank to the car's underside, then lower the lift so that Skinhead can disconnect the shock absorbers from the floor of the trunk, where they're connected to the body. The shocks drop, clattering, to the floor.

They move to the front end, where Arney unhooks the ignition, feeding the wires through holes in the firewall. They pull the steering wheel. Skinhead disconnects the cable linking the floor shifter to the transmission. They have to enlarge a hole in the floorboard so that

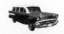

the cable will slip through; Arney uses two crossed pry bars, one as fulcrum for the other, to tear the floor while protecting the cable. "I've been doing this a long time," he tells me. "I used to do this in the middle of the night when I was a young man."

"Yeah," Skinhead says, "in people's driveways." They both laugh. A few final disconnections—carburetor linkage, master cylinder linkage—and Arney adjusts the arms of the hydraulic lift so that they're positioned under the car's body, rather than its frame, and raises it. The body snags on the steering gear.

They drop the lift, reposition its arms under the frame, raise the whole car so they can reach the steering box from beneath. When Skinhead fails to move with sufficient speed to suit Arney, the boss snatches a wrench from him. "Dum-dum, what the fuck are you doing?"

Skinhead narrows his eyes. "You talking to a dog or cat or something?"

"I don't think so," Arney says.

"You don't have enough money anymore, to be talking to me like that."

Arney half laughs, says, "Yeah, I do," but there's not much mirth to it. The man who for years has lorded with impunity over Skinhead and the rest of the crew, licensed by providing their sustenance, shelter, and place in the world, now shrinks before their eyes. The dynamic between boss and bossed is shifting. "No," Skinhead presses, "you don't."

Arney, turning a wrench, resorts to a singsong taunt: "Dum-dum." Skinhead answers in kind: "Fatty." Arney straightens and glares at him. "Where do you see any fat on me?"

"That belly of yours," Skinhead replies.

They finish dismantling the steering assembly, and Arney brings the Bobcat into the Quonset, then runs its forklift blades through the donor car's windshield opening and out the back window. When he raises the blades, the body's front end lifts, but not its rear. The Bobcat rolls back out. The lift rises. The men pore over the rear end, searching

for body bolts they might have overlooked. It takes a while to find one, just behind the back bumper. Skinhead spends several minutes trying to maneuver a wrench to it, but can't find an angle that works, before an exasperated Arney shoves a chisel against the bolt, gives it a sharp pull, and snaps the head clean off the shaft. "See?" he says. "See how it's done? And you said I was fat."

"You *are* fat," Skinhead says.

"Motherfucker, I'm solid as steel. You're the fat one."

Skinhead squints at him. "I weigh 166 pounds."

"I weigh 230," Arney concedes. "But I can probably lift five times the weight you can." He steps away from the car, waits for Skinhead to clear the broken bolt. "You're like a woman, actually," he says. "That's why even though I'm always saying I'm going to kick your ass, you know I'm not really going to do it. Because I don't believe in hitting women."

Now, finally, comes a moment of both promise and melancholy, as Arney climbs back into the Bobcat and lifts the donor car's body away from its frame—promise, because the act exposes the drivetrain that soon will be harvested for the wagon, a key to keeping the Chevy viable for years to come, and melancholy because the wagon gains this future at a price. The donor car is a goner. Its frame may, in time, end up the invisible spine to another restored Chevy; what remains of its body will be sold off a piece at a time, and should find its way into other cars. But as an individual it dies here and now.

Arney dumps the donor body outside. He lowers the lift to the floor, steps onto the donor frame, stares down at the engine. Its cast-iron block, painted Chevy orange, is stamped with numbers at several places. They indicate that the block was created at or about 4 P.M. on July 7, 1966, and that it was assembled into an engine at GM's Flint plant on August 30 of the same year. In other words, this motor is not original to the donor car; it's a decade too new.

Confirmation comes in another stamped code: The original recipient

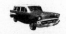

of this engine was a Chevy II, aka Nova. The same number indicates that the motor was originally paired with Chevrolet's two-speed Powerglide automatic transmission—which has been swapped, in the years since, for a model even newer than the engine, a three-speed Turbo-Hydramatic 350.

The Turbo 350, as motorheads call it, is probably no heavier—it has an aluminum housing, versus the Powerglide's cast iron—but it's bigger around and longer, which might have prompted a modification that Arney spies under the transmission's rear: A past owner has augmented the engine and transmission mounts with a homemade metal sling. Arney identifies it, with a glance, as a cross member from a mid-sixties Chevy Impala, hammered flat, bent, and wedged between the transmission housing and the car's frame. "I can't figure out why they did this," Arney says. "But it's shade-tree, backyard mechanic bullshit, for sure."

He eyeballs the engine mounts, decides that even an official Chevy brace would have been unnecessary, then tests the theory: He steps onto the transmission's bell housing with one foot, then both. "I'll put that 230 on there," he says. "Look—that motherfucker ain't going anywhere." He bounces up and down on it. The transmission doesn't budge.

"So that brace served no purpose whatsoever," Skinhead says.

Arney shakes his head. "Whoever did it," he says, "didn't know what the fuck he was doing."

They roll the donor car's chassis out of the Quonset. They haul the wagon's sealed and painted frame over from Paul's body shop on the duct-tape dolly. They strap the restored frame to the showroom's hydraulic lift. The engine dangles from a wheeled hoist a few feet away, ready for installation.

AND THERE IT stays. Two months pass.

A few of the many occurrences in the interim—

One: Arney orders the parts necessary to rebuild the chassis. They arrive from Oldedays Classic Car Parts of Waterville, Washington, through which one can obtain most any part for a classic mid-fifties Chevy, albeit at a price—the wagon's new gas tank and associated gear tops $300, a "front-end rebuild kit, deluxe" costs $239.99, and the brake lines come to just shy of $110. It adds up quickly, and this isn't the expensive stuff—when the time comes to replace dashboard gauges and chrome, look out.

Arney or a member of the crew misplaces some of the ordered parts, namely a box containing the little clips with which the brake and fuel lines are attached to the frame. Rather than reorder the clips, Arney berates Skinhead about the loss for several days on end.

Though Arney swears several times that he's set to order new leaf springs—without which the chassis cannot be completed, but which cost $120 apiece, minus shipping—he doesn't do it through April and most of May. Skinhead eventually discovers a used but clean set in the Quonset's loft storage space, buried under a mountain of parts, supplies, and papers.

Two: Whatever Paul did or didn't do to get laid off is apparently forgiven. He is rehired full-time, but is put to work on an income-producing job, restoring an El Camino. The undertaking appears simple at first, but turns epic when Paul discovers hidden rust, and lots of it, where an El Camino does well to have none. Arney several times promises that Paul is about to get back to the Chevy; each time, it seems, another complication arises. "I can't afford to leave my house," the El Camino's owner frets to Arney as the job explodes. "I might have to sell my house to pay for my car. I might have to live in the car. I might be living in an El Camino."

Three: Money, already tight, gets more so. A rainy spring scares diners away from Havana. Sales are slow at the lot. "We had a lot of folks come in this weekend, but none of them wanted to give me any money," Arney complains to Fat Joe, the owner of a Norfolk tire and rims busi-

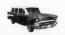

ness and a longtime acquaintance. "I don't believe we could sell any pussy down here, if we had any to sell. That's how bad it is."*

Four: Arney has not yet fulfilled his commitments to Currituck County. He has been slow about getting a revised site plan to Ben Woody, and hasn't even started rearranging Moyock Muscle to reflect the document. He hasn't paid his fine, either: Ben Woody has not given him an answer about whether the county would waive the five thousand dollars, and Arney has chosen to hold on to his cash until he hears.

*Arney isn't inclined to relax his prices, despite the worsening situation. Consider a scene typical of the period, in which two young men in crew cuts enter the showroom on a Friday in mid-May to ask about a 1965 Volkswagen Beetle outside.

Arney: "It's four thousand."

Young man, disenchanted: "Oooh."

Arney: "Runs great. It's in great shape."

Young man, looking doubtful: "It's been sitting there awhile."

Arney: "And it's going to be sitting there until somebody gives me four thousand dollars." (Laughter.)

"Let me tell you, I've had a lot of people try to give me thirty-five hundred for that car, [or] three thousand. But the fucked-up thing is that bitch is paid for, so it can sit there from now until—look, let me tell you a story. There was a guy who'd come in here and look at a car every year. The car was four thousand dollars. He'd come in here every year and offer me thirty-five hundred. I'd say, 'No. It's four thousand.' He'd say, 'Sell it to me for thirty-five hundred.'

" 'No. It's four thousand.' This guy even had other people call for him, offering thirty-five hundred. He'd come with his wife. His wife would sit in their truck, a little Ford Ranger, while he walked the lot. And she asked him: 'Why don't you just pay the man what he wants? Because what's going to happen is somebody else is going to buy that car, and then you'll be all upset.'

"Well, somebody bought the car. The guy shows up and he says, 'What have you done with my car?' And I said to him: 'It ain't your car. You never agreed to pay me the four thousand dollars.' " (Pause.) "You fellows in the navy?"

Young man: "Coast guard."

Arney: "Oh, you are? Where? In Portsmouth?"

Young man: "Elizabeth City." A huge installation a half hour to the southwest.

Arney, getting back to the VW: "Well, you can drive that motherfucker right to fucking Elizabeth City."

Young man: "Yeah." (Laughs.) "You can."

In late May, however, Arney wakes in the middle of the night with a strong sense that he's waited too long, and that the county is poised to smite him. He calls Woody, asks what's going on with the fine. Woody is circumspect; he says he never got an answer from his bosses when he asked them about the waiver, and wonders what's up, himself. Arney's foreboding continues.

And finally, one May morning Skinhead steps from his house, headed across the street to feed the horses, when a voice calls: "John?" He turns. A stranger shoves a sheaf of papers at him. The federal investigation into the Bank of the Commonwealth's collapse has continued to percolate.

Not long after, Skinhead finds himself on the witness stand before a federal grand jury in Norfolk, being quizzed by prosecutors about Arney's past and present business dealings, his habits, his proclivities. He tells me later that he's asked whether he has any knowledge of Arney having made money in the drug trade. No, he replies. He is asked whether Arney has a safe containing a million dollars in drug money. No, he says. He is asked whether Arney has sex with his employees. What on earth, he wonders, does any of this have to do with a bank failure?

As Skinhead's testimony winds down, he says, a prosecutor—Assistant U.S. Attorney Uzo E. Asonye, out of Alexandria, Virginia—reminds him that the proceedings are secret. So when we're finished here, Asonye says, are you going to talk to Mr. Arney?

Yes, Skinhead replies. I am.

Asonye asks: Are you going to tell Mr. Arney what we asked you and what you answered?

Yes, Skinhead tells him.

Asonye asks: Why would you do that? It's secret.

If somebody's trying to do harm to your friend, Skinhead says, wouldn't you tell him about it?

Asonye asks: Is that what you think we're doing—trying to harm Mr. Arney?

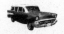

To which Skinhead says: It sure looks that way to me.

The grand jury laughs.

"They laughed?" I ask Skinhead when he relates this story.

Skinhead nods. "They laughed like I'd said something hilarious."

WE NOW RETURN to the wagon, June 2012 upon us. The month opens with Arney and Skinhead fitting the restored frame with pieces of the front end—overhauled control arms and ball joints, which have just had their fifty-five-year-old rubber bushings removed and new ones pressed into place at a local machine shop.

Later that day, the crew moseys outside, strips the donor car frame of its rims and tires, and bolts them to the wagon's chassis. "We're going to have this motherfucker sitting on the floor for the first time in a *long* time," Arney crows as he lowers the lift. The tires come to rest on the showroom floor, and everyone takes a moment to savor the sight.

But only a moment. They wheel the engine, dangling from its hoist since late March, over the frame and slowly lower it into place. I'm struck again by the degree to which the strength of the Chevy relies on skinny bolts. A single bolt connects the engine to each rear engine mount, which is in turn attached to the frame with two more bolts. Two long, fragile-looking bolts keep the engine's front end in place. No wonder, I reflect, that in a head-on wreck, the engine of a fifties car was known to plop into the driver's lap like a red-hot medicine ball.

Skinhead examines the long front bolts, which are supposed to have a series of washers and bushings arranged along their shafts. The arrangement is crucial, and while he's familiar with the 283 and engines in general, Skinhead wonders aloud: "How the fuck do these go?" Arney proposes that they consult the readiest authority. He leads the way outside and across the lot to a cluster of rusting Chevys parked among the weeds. One is the shell of a '56 Nomad, minus its doors, its back glass and most of its paint, its trademark scored roof sagging around a clumsy sunroof installation. It's missing its engine, but the

front mounts are in place, and the men study how the bolts are arranged. In the name of thoroughness, they study a '56 wagon and a '57, too. "You got the knowledge you need, Skin?" Arney asks.

"I do," Skinhead says.

"Then let's get the fuck out of here."

They return to the showroom and bolt down the engine. "The neatest thing is that now we've got a rolling chassis," Arney says as they finish. "We're rocking and rolling. Next week we'll get to work on some of the precision shit we need to do." He nods at the chassis. "You won't even recognize that motherfucker."

For once, Arney's not alone in his optimism. "Didn't think you'd see it get to this point, did you?" Skinhead asks me when Arney heads to the bathroom. "If we can keep the boss focused, we can have this bitch done in a week or two."

18

TRUE TO HIS word, Arney devotes considerable attention to the wagon over the next several days. He and Skinhead rebuild and install the front suspension; lacking a compressor to squeeze the coil springs, they rig a floor jack to some nylon webbing and somehow manage to compress the springs and bolt them in place without maiming themselves. They install the cleaned and repainted rear axle and differential. Skinhead undertakes the tedious business of hand-scrubbing the engine and transmission housing. With two or three days' labor, Arney figures, they'll have the chassis ready for the body drop. They have only to run the brake and fuel lines, install a new radiator, and swap out the leaf springs.

But he decides not to rush into those tasks. It makes no sense to get too far ahead of Painter Paul, who's still mired in the El Camino project; even when that's finished, he still faces a day or two of sanding and painting the wagon before he'll have the car's top ready to mate with its bottom. If he and Skinhead wait, Arney says, everyone will be working on the Chevy at the same time, which he views as the right way to tackle the job. He's confident that Paul will complete the El Camino within the week.

Early one morning a week later, a fellow in an SUV stops in front of Arney's house, raps on the door, and receiving no answer, hollers over to Paul, who is fiddling with a lawn mower in his yard: Do you know if Tommy's up? Paul detects something in the man's appearance and

manner that advertises *cop*. He answers that he has no idea. After the stranger leaves, he describes him to Skinhead, who recognizes in the description the same fed who served his subpoena to the grand jury—Andrew C. Bowers, a criminal investigator with the Internal Revenue Service. Skinhead calls Bowers to ask whether he's looking for Tommy. Bowers confirms that he is, and later in the day hands Arney a letter signed by Assistant U.S. Attorney Melissa E. O'Boyle.

It is what lawyers call a "target letter," and amounts to a declaration of war in any federal criminal case; it's in such documents that the "subject" of a federal probe is notified that he's about to become a "defendant." O'Boyle wastes few words: "As a result of information gathered by the Federal Bureau of Investigation" and others, her letter opens, "this office has sufficient evidence to present a multi-count indictment to a grand jury charging you with violations of federal criminal law including, but not limited to conspiracy to commit bank fraud in violation of 18 U.S.C. 1349 and bank fraud in violation of 18 U.S.C. 1344."

O'Boyle then offers to discuss a plea deal with Arney, should a "pre-indictment resolution of these charges" interest him. He has a few days to think it over; if she doesn't hear from him, "we will assume that you have no interest," she writes, "and will proceed accordingly."

Arney has no interest, as he makes plain when he gets a call from a fed a couple of days later. Arney's recollection of the exchange: "He says, 'Mr. Arney, this is Special Agent Whatever-the-fuck-his-name-was, and I saw that you gave Agent Bowers your business card. I viewed that as maybe you reaching out to us.' And I said: 'No, I don't think so.' So he says, 'Well, we wanted to reach out to you. It would be good for you to talk with us.' And I told him: 'I don't have anything to say.' And when I hung up I said: 'Thank you. Have a great day.' "

He's somewhat more emphatic than that in his conversations with me. "I wouldn't talk to those motherfuckers if they called my lawyer and promised that every one of them was going to give me a blow job and a million dollars," he says a few days after the deadline has passed.

"I would rather die than speak to those motherfuckers." Receiving a target letter isn't the same as actually being indicted, he points out. Why on earth would he want to plead guilty to something with which he hasn't even been charged? And an indictment isn't the same as a conviction. "I'll take my chance with a jury," he says.

Later that same afternoon he haggles with a customer over the price of a 1963 Pontiac Catalina,* loses the sale, then strolls north across the lot. An apocalyptic storm is sweeping our way from across the state line, bolts of ice-white strobing against a mountainous black thunderhead, but for the moment, Moyock is sunny, hot, and still; I join him in the lot's one dab of shade, on the rusty back bumper of a 1957 Chevy Suburban.

He'll do nothing to help the feds, he vows again. They're immoral. They're willing to twist the truth and bend the facts until they're about to break in pursuit of what they have the nerve to call justice. "They're the lowest form of human beings on earth, simply because they manipulate," he says. "They take what people say and turn it around so they make the jury think whatever they want it to think."

He will offer variations on this complaint any number of times in the coming weeks. And on this one: "A grand jury is set up so they eat with the prosecutors, hang around with the prosecutors, talk and joke with the prosecutors," he says. "If I could go in there and eat lunch with the jurors and shoot the shit with them, they'd fucking fall in love with *me*."

I watch, uneasy, as the storm swallows the sun. The lot plunges into twilight with a low snarl of thunder. Wind materializes, its gusts

*Arney to customer, as they step out of the Quonset: "Let me walk outside with you, and I'll help you understand."

Customer: "I don't need to understand, really."

Arney: "Really, I think you do. Because otherwise, when I said, 'It's twenty-five hundred dollars,' you'd have said, 'I'll take it.'"

strong and surprisingly cold. Arney seems oblivious. He makes a final point to which he'll often return. He can't see how he's done anything wrong—or, rather, he certainly didn't know he was doing wrong, if he did.

Now dust devils whirl in the lot. Nylon tarps draped over open engine compartments snap like bullwhips. At last Arney stands, and we make a slow retreat across the lot toward the Quonset. The waiting, the wondering about what happens next—that's a new experience, he says; typically, he's confronted trouble before it arrived, preempted any attack he sensed was imminent. He tells me a story, by way of illustration: Back when he was barely out of his teens, he was gassing up his wrecker when he was approached by a panhandler. Arney told the man he couldn't help him. The fellow remained a couple of feet away.

Partner, Arney told him, I said I can't help you. You can move along now.

Still, the man didn't move. Instead, he looked Arney in the eye and smiled.

Arney whipped the pump nozzle from the wrecker and doused him head to foot with gasoline. The man bolted, shrieking.

"I was going to set him on fire," he tells me. "I mean it. If he hadn't run off screaming, I was going to set the motherfucker on fire. I thought he had a gun. When he smiled, I really thought he was going to pull a gun on me.

"I was going to set him on fire. Does that make me crazy?"

The morning after this conversation—June 26, 2012—Skinhead is alone at Moyock Muscle, moving cars around the lot with the wrecker, when a Crown Vic pulls onto the property. A bald fellow in sunglasses steps out and strides toward him. Damn, Skinhead mutters. It's the sheriff.

The lawman is not entirely unexpected. Despite Arney's growing unease over the disposition of his fine, he has failed to write a five-

thousand-dollar check to Currituck County; he's opted, instead, to wait until someone in officialdom explicitly grants or refuses his request, now more than five months old, that the fine be forgiven.

Here comes his answer. The sheriff carries a paper holding him accountable not for $5,000, but for the original fine of $78,800, plus $120 in court costs—and placing a levy against certain of his real estate until the debt is paid, to wit: 373 and 383 Caratoke Highway, the southernmost two of the four tracts that make up Moyock Muscle, and including the Quonset. If he fails to produce the cash, the sheriff could be back to padlock the gate.

When word of the levy reaches Arney, he is spurred, at long last, to confront all he must do to satisfy the county. His deadline for making the improvements is Friday, July 13, less than three weeks away—and those improvements include rearranging hundreds of cars, removing the Jersey barrier from most of the lot's Route 168 frontage, erecting several hundred feet of chain-link fence, and excavating a large drainage pond on the property's eastern edge, back by the railroad track. In that he's made few friends at the courthouse, it's safe to assume that he'll get no breaks if he blows the deadline.

So within hours of the sheriff's visit, all other business at the lot is dropped. Skinhead races around the property in a wrecker, moving the inoperable cars away from the highway. Paul leaves the El Camino to build fences, which will shield the inoperable inventory from view. Arney recruits his brother Billy and Bobby Tippit's teenage sons, Bob Jr. and Anthony, as additional muscle, and hires a fellow with a dump truck to help create the thirty-by-120-foot lagoon.

Stifling, triple-digit temperatures settle over the borderlands. Thunderstorms rake the lot several afternoons straight but offer no relief; they only provoke an explosion in the mosquito population. The new hole out back fills with muddy water; the ground around it turns to stinking, slippery bog. The crew works through whatever discomfort the days bring, from early mornings to well after the late midsummer

sunsets; its members take few breaks, even for water; working shirtless, they turn deep and salt-caked brown.

Arney spends an increasing amount of his time elsewhere, talking to lawyers and accountants about his situation with the feds, and with another lawyer about Currituck County. The meetings seem to pay off: The county softens its position. If he meets the deadline, he'll have to pay only the five thousand dollars, after all. He's pretty confident he can make it.

Then, early on Thursday, July 12, Skinhead steps out his back door and into the yard, just in time to see a caravan of late-model sedans and SUVs speed up the street and stop in front of Painter Paul's house. A phalanx of men approaches the front door. Several wear guns.

Oh shit, Skinhead mutters. Here it comes.

ACROSS TOWN LATER that morning, reporters gather on the steps of the Walter E. Hoffman U.S. Courthouse to hear federal investigators announce that four Bank of the Commonwealth officers and two "friends of the bank" are in custody and will be prosecuted for their roles in a massive fraud that toppled the bank and contributed to the lingering U.S. economic crisis.

Arney's part in the scheme, according to the fifty-one-page indictment, was to repeatedly take loans from the bank that he used to pay down earlier loans on which he'd fallen behind; in so doing, he helped the bank hide the fact that it was carrying millions of dollars in bad debt—and helped keep the secret until the debt grew so big and heavy that it pulled the whole operation under. He also obtained loans to buy bank-owned properties, which enabled the bank to convert inert real estate into interest income, at least in theory; the purchases further obscured the bank's shaky health, and Arney took out additional loans to cover his resulting payments.

The feds also charge that when he no longer qualified for loans himself, Arney asked others to borrow money in his place—then used the

proceeds to make good on his other debts. These "nominee borrowers" include two whom the indictment identifies only by their initials—"R.A." and "A.A."

While the lawmen host their news conference, agents are going room by room through each of the Arney Compound's four houses, cataloging their contents—because should Arney be convicted, said houses and contents are likely to become the property of the United States. Agents descend on Moyock Muscle, too: By the time Skinhead arrives, fresh from showing investigators through the compound, a dozen or more of them are on the lot. They eyeball the stock. They throw ladders against the buildings and climb to their roofs to take photographs of the cars. They shoot video.

They choose, from among the 308 vehicles on the property, thirty-three that will be forfeited to the government, no question about it, if Arney is convicted. They hand Skinhead a restraining order informing him and other employees that they are "RESTRAINED, ENJOINED AND PROHIBITED" from any action that would affect the availability or value of the vehicles.

The implication is that they judge these thirty-three the most valuable on the premises. If that's the case, the feds don't know much about cars. How else to explain the presence on that list of an electrically crippled '98 Trans Am, a worn Cadillac limousine, or a Chrysler PT Cruiser? A wrecked '02 Thunderbird? A Ford Focus? "Just random," Skinhead says as he shows me the roster. "Trucks with blown head gaskets and bad transmissions." He shakes his head.

They make some choices that are impossible to miss—e.g., the unfinished '69 Camaro convertible that remains under a tarp in Painter Paul's body shop. It lacks an engine, interior, and top, but its body is flawless, its paint fresh. A fifth grader would recognize its worth. But a fifth grader might be more savvy in assigning a value to the car. The feds lowball the Camaro at $10,000. It's worth twice, if not three times, as much. They do the same with a 1981 Excalibur, a big, fast, faux-thirties roadster that's modern under its hand-built fiberglass skin; the

agents judge the car worth $8,000 to $10,000, which Skinhead reckons is something like twenty cents on the dollar. You fellows might want to do some research, he tells them.

That afternoon, Arney and his five codefendants make their first appearance in court. One at a time, they're asked to stand with their lawyers while Magistrate Judge Tommy Miller instructs them on the conditions of their bond: They're to restrict their travel to Virginia, open no new lines of credit, commit no criminal acts, and so on.

When Arney's turn comes, the lead prosecutor—slim, dark-haired, and pretty, her manner crisp—notes that he stands apart from the other defendants: He has a "substantial criminal history, including a history of violence," Katherine Lee Martin tells the judge, noting that he also works across the state line. "We have no objection, your honor, to his going to his business," she says. "That's his means of employment. But we'd ask that electronic monitoring be imposed." Judge Miller waves off the suggestion. "Moyock is a lot closer to here than Richmond" and most of Virginia, he observes. He won't make Arney wear an ankle bracelet.

Arney leaves the courthouse and walks to Havana. It will be weeks before he tells me what he thought about as he stood in the courtroom, peering at Katherine Lee Martin and, sitting behind her, prosecutor Melissa E. O'Boyle, and at the FBI agents in the gallery, many of them women: that for the first time in his life, his fate was "in the hands of females," and that these particular females were "going to fuck me," and not in the manner to which he was accustomed; that the females were "digging it," too, "because they were trained to have no emotion, to not trust anyone, and to destroy motherfuckers' lives." That he was one of the motherfuckers in question. That some terrible karmic leveling might be afoot.

But on the day of his indictment, he's not so downbeat. It's been as good a day as it could possibly be, he tells me at the restaurant. Everyone at the courthouse was kind to him.

And truly, the day is not without positive turns. When Slick calls Ben Woody and explains that Arney and the crew have been dealing with the feds all day, and thus won't make the next day's deadline for improving the car lot, Woody is understanding and extends it to the following week.

There's this sliver of luck, too: The Chevy is safe, at least for the moment. Had the restoration not been stalled by one frustrating distraction after another—were the wagon's body bolted back to its frame, as should have happened months ago—the federal agents, whatever their shortcomings as automotive appraisers, would have tagged it for forfeiture.

But the frame is in the Quonset, the body still on the rotisserie one hundred yards away, and the fenders, hood, and doors in another building still. The agents, it seems, don't even recognize it as a car.

FOUR DAYS LATER, a Tuesday, the car lot has been transformed. The gravel in front of Pop's house is empty, the Jersey wall removed. New wire fence, wrapped in black fabric, corrals most of the inventory. The spoils from the lagoon excavation have been trucked away. Dragonflies and lethal-looking red wasps zigzag over the hole's now-greenish water. The county has given Arney until midweek to put the place in order, and as he eats lunch in the office with his brother Billy, Skinhead, and Paul, it appears he'll pull it off.

Though it hasn't been easy. The crew raised fences through the weekend and well into the last three nights, despite relentless heat, hunger, and a collective shortage of cash for lunch, snacks, and cigarettes: At one point, I witnessed Billy Arney, age fifty-four, bum a smoke from Bobby Tippit's fourteen-year-old son, Anthony. "The fucking boss man is fucking broke," Paul lamented to me one afternoon. "Working for a motherfucker who's broke: We're some stupid motherfuckers."

Arney reports as he eats that "teeny" Brad Schuler called this morning to say he'll be inspecting the place at eleven the next morning;

Arney says he told him that he won't be around—he has to be in court. You don't have to be there, Schuler told him.

"So I said, 'Skinhead will be there,'" Arney tells the crew. "'If you have any concerns or need us to make any changes, we'll do it in a day or two.'"

"What did he say to that?" Skinhead wants to know.

"He didn't fucking say anything," Arney says. "He hung up on me."

"He did?" Skinhead asks, incredulous.

Arney chews for a moment. "I guess he had said what he needed to say," he offers, in a tone so mild it seems that it couldn't possibly be coming from Tommy Arney. He adds, as if to explain himself: "They have been very nice to me, I have to say. Which surprises me."

"You have to watch out," Skinhead warns. "Whenever they're nice, it means they have something up their sleeves."

"You might be right, Skinhead," Arney says. "They know I'm going to be in court tomorrow." A customer approaches the office to ask about a '62 Pontiac Tempest outside. "Yes, sir," Arney says, leaning back in his chair. "A nice car. I bought that from the original owner. He was a Filipino man." The price: $4,500.

The man asks about two GTOs on the lot. Arney says he'll part with one for $5,000, and the other for $4,500. The man stands there blinking at the numbers for a second, then asks about another Pontiac parked out near the highway, "a '68 or '69."

"A '70," Arney corrects him. "That's a '70. I'd take four thousand for it."

The man thanks him and leaves. Arney clasps his hands on top of his head. "I think they're going to love that fence," he says of the county. "Don't you, Skinhead?"

"They better fucking love it."

Painter Paul agrees: "They better love it."

Skinhead: "They'll either love it or they can lump it."

"It ain't bad," Billy grunts, "for a junkyard fence."

He barely gets the sentence out before Skinhead pounces: "It ain't a fucking junkyard." By then, Arney is spinning in his chair to face his brother, a fearsome scowl on his face. "Don't ever use that term again," he says, his volume rising with each word. "Do you hear me, you fucking piece of shit?"

Everyone else in the room seems to hold his breath, half expecting Billy to make a smart-aleck remark—which, given the pressure the boss has been under, and the irritation the "junkyard" label provokes in him, might spark a stern fraternal pounding. But Billy hangs his head and doesn't so much as smirk as Arney adds: "This isn't a junkyard. It's a classic car lot."

Billy nods. Arney peers at him for a moment, ensuring that the point's taken, then turns back to Skinhead and the coming inspection. "I don't think they're going to be fucking dickheads," he predicts. "But if they are, you be fucking nice to them."

Paul voices doubt: "You expect Skinhead to be *nice*?"

"Skinhead knows how to be nice to dickheads," Arney assures him. "Don't you, Skin?"

Skinhead looks Arney in the eye. "I certainly do."

IN COURT THE next morning, prosecutors announce that all of their evidence has been made available to the defendants—including more than a half-million documents that have been digitized and stored in a government database. Each of the accused is called before the judge. All plead not guilty. All ask for trial by jury. Arney is the last. The judge asks him, as he has the others, how old he is. "Fifty-six years old," Arney replies.

"And how much schooling have you completed?" the judge asks. Another standard question. "Fifth grade," Arney says.

The judge's head jerks up. "Fifth grade?" he repeats, clearly surprised.

"Yes, sir," Arney says.

The session ends a minute later, having taken a total of seventeen.

Twenty-six miles to the south, the crew is slouched in the office, drained by a three-hour push to finish the back fence under an already-blistering sun, when a white Ford pickup pulls into the lot. Out step Brad Schuler and two other county officials. Schuler walks the property, snapping pictures with a small digital camera and every so often consulting a folded copy of the site plan. He roams past the lagoon, out by the paint shed, along the newly fenced northern property line, back to the Quonset. His one remark to the crew comes as he finishes: "All right. We'll give Tom a call." The visit has taken about as long as the court session.

Most of Arney's waking hours for the next five weeks are outgrowths of these brief proceedings. The county gets back to him to say that it's generally pleased with the progress he's made, but requires a fence on the south property line and a few additional refinements. The crew thus extends its long string of days spent in the high grass, brutal heat, and swarming mosquitoes along the fence line. Spirits sink even further. No one knows how Arney's indictment will affect his little company, but all can guess the fallout won't be good. No one has money. On some afternoons, Skinhead has to haul scrap metal to a local junkyard just for the cash to feed everyone lunch.

Arney, scrambling to keep his little empire from collapse, isn't around much—and when he is, he does little to bolster the crew's mood. Of the conditions under which he must live as a defendant, one of the most noxious is that he can involve himself in no transaction in which one thousand dollars or more changes hands, without first notifying (and, by implication, receiving permission from) his federal probation officer. This all but freezes his assets, including the accounts from which he pays his employees; he negotiates over several days for the latitude he needs to keep his waitstaff at Havana. But no tweaking of the conditions will alter the overriding reality of his new existence: For

the first time in his adult life, Tommy Arney has to answer to someone. He is no longer his own boss.

Gone is his freewheeling style. Gone are the days of thumbing a fat wad of cash girded in a rubber band and pulled from the pocket of his jeans. Scores of times I've seen him slip off the band, open the folded cash, peel away bills to pay for hay, auto parts, lunch at Subway. After his indictment, I no longer see the wad.

And as if his finances weren't in sufficient distress, he learns that the Hells Angels are taking him to court. The club's bosses are seeking $25,000 in damages for his renting them an uninhabitable building. I learn this from Skinhead, who is utterly disgusted, if not insulted, by the development: "The Hells Angels, fucking suing somebody," he mutters, shaking his head. "Can you believe that Mickey Mouse shit?

"Whatever happened to firebombings?" he asks me. "What is this world coming to?"

For all of this, whenever I see him Arney talks about finishing the Chevy. With the fence finished, Paul is going to jump back on the El Camino, he tells me, and as soon as he's done—and he doesn't have much left to do—he'll be getting the wagon ready for the body drop. Not much to that, either: a day's sanding, a day's painting the interior, a third day's "cutting in" the paint on the door sills, dashboard, firewall, and around the rear hatch. Then the reunion of body and frame, after which Paul can get to the rest of the paint.

He can't afford not to get the car squared away. He has, by his own estimate, between $38,000 and $40,000 in the car at this point; that includes his initial payment to Bobby Dowdy, maybe $16,000 in parts and materials, and Paul's pay for seven months of full-time attention. If he tries to sell the car as is, he'll get only a fraction of that, and the entire project will have been a voracious suck of time and money. If he leaves the car unfinished and the feds seize it, it'll auction for even less.

Mind you, getting more for the car will mean spending more. Six thousand for new carpeting, headliner, upholstery, door panels. An-

other three thousand to have the chrome redipped and replaced. New glass all around, including the expensive, curved windows that wrap around the cargo bay—yet another three; and three more to cover odds and ends—lights, lenses, tires, rims, and whatnot. Throw in Paul's additional time and paint, and Arney's investment in a fully restored wagon will approach $55,000.

But he'll spend what he needs to spend, he promises, and he'll do it soon, because time is short. He's scheduled to stand trial in six months. He seems resolved to finish the job. "I'm going to drive this motherfucker," he tells me.

Over the same period, Arney's understanding of just how much trouble he's in seems to sharpen. "It's tough to work all your life, and to work sixteen- to eighteen-hour days, and to find that these motherfuckers can come along and take it all away," he tells me one night as we stand on the sidewalk outside Havana. "And they're going to do it. They're going to take everything.

"Cancer doesn't compare to these motherfuckers. I did Stage Four chemo and two months of radiation, and I'd take both of them again instead of dealing with these people," he says. "Cancer, in all reality, changed my life to make me a better person. This won't do that."

He also seems to develop an ever-clearer view of his bank codefendants, whom he so long viewed as his friends, even mentors. "You become friends with the community bank, and you get comfortable," he tells me. "And they're able to use you in ways you don't realize they're using you." Did he take the loans the feds say he did? Yes, I hear him tell a friend on the phone one afternoon, but he did not know the loans were illegal; no one at the bank ever told him so, even as they were encouraging him to take them. "If they had called me and told me: 'Tommy, we want to loan you money so you can get current, but it's illegal,' I would have said, 'Fuck you. Forget about it. I'll let the payments go overdue,'" he says.

By late August, an air of inevitability has crept into his discussion of

the case. "They have unlimited resources. They have power that's just unreal," he says of the feds. All the time and money they need. Mountains of evidence. When he hires a monolithic refrigeration specialist nicknamed "Tiny" to repair a restaurant cooler, and notices that the fellow (who, quite talkative, informs me that he holds "a master's in five areas of expertise" and can "propagate the words with the best of them") has bandaged lower legs covering childhood burns that have never properly healed, Arney takes me aside. "You see his feet? That's some fucked-up shit, there," he says. "It reminds me of how lucky I am to have been indicted, instead of having to deal with something like that every day.

"Hell," he says, "I'll just go away for a little while."

One more thing: His promises that he'll never talk to the feds, never cooperate? He stops making them. Instead, in mid-August, comes this: "If I were younger I would fight this motherfucker, and do it to the end, because I don't think I'm wrong.

"But if you're in a fight with a giant," he tells me, "sometimes it makes sense to let him take a slap at you and not get up."

19

TOMMY ARNEY PRIDES himself on being no snitch, on having never consorted with snitches, on having held snitches in the deepest contempt all his life. He isn't so much resolved to tell the government nothing as he is biologically incapable of doing otherwise.

But then comes a meeting with federal prosecutors at which they play a card he doesn't anticipate. If you don't cooperate, they tell him, we can't guarantee that we won't pursue charges against the nominee borrowers you enlisted to get loans from the bank. If you don't talk to us, "R.A." and "A.A." could be facing indictments of their own.

Arney is aware that he's done his son and daughter no favors by involving them in his financial misadventures, but until that moment he has not recognized that their actions might be criminal. After all, they didn't even know what they were signing. They put their names on the loans because he told them to. Clearly, it was all on him.

But the feds characterize his children's roles differently. Their signatures enabled Arney to defraud the bank's shareholders, and by extension the American taxpayers. Witting or not, the kids were players in a criminal conspiracy. Arney has a choice: cooperate, in which case the government will agree not to prosecute Ryan and Ashlee—or don't, and court incarceration as the new family business.

And so it comes to pass that Arney agrees to plead guilty to three of the charges against him, and in so doing becomes a witness for the prosecution in *United States v. Edward Woodard, et al.* He admits to

conspiracy to commit bank fraud, to participating in an unlawful monetary transaction, and to making false statements. In all, he faces up to twenty years in the penitentiary, $750,000 in fines, and restitution that could exceed $2 million.

The written agreement he hammers out with prosecutors calls on him to forfeit to the government all properties he derived through his criminal acts, including Moyock Muscle and the Arney Compound, plus the contents of twenty-three bank accounts. He must provide "full, complete, and truthful cooperation" to Katherine Lee Martin, Melissa O'Boyle, and the FBI.

If he does so, the government's lawyers may petition the court for leniency, though they make no promises about the sentence he'll receive; federal guidelines suggest that as things stand, he's looking at sixty-three to seventy-eight months. More important, so far as Arney is concerned, the agreement states that they "will not criminally prosecute the defendants' children, R.A. and A.A., in the Eastern District of Virginia."

Still, his mind is not entirely settled when the agreement is signed. Slick has received a target letter in recent days. She, too, should receive immunity from prosecution, he tells the prosecutors, because the blame for anything she did in connection to the bank lay with him or his codefendants—she was his employee and simply did what she was told to do. By his account, he tells the feds that he's willing to plead guilty to an additional charge, if that's what it takes to clear Slick's name. The feds opt to stick with the three charges he has already agreed to.

On Friday, August 25, Arney presents himself before U.S. District Judge Raymond A. Jackson to make the pact official. The judge questions him at length to establish that Arney's guilty plea has not been influenced by drugs, alcohol, mental illness, threats. He notes that Arney will forfeit a lot of property, not necessarily limited to that listed in the plea agreement. Arney, who is the picture of law-abiding conservatism in a pinstripe gray suit and muted olive and gray tie, says he understands.

Jackson asks whether Arney has ever been convicted of a felony. Once, the defendant replies, back when he was a teenager. The judge peers at him from the bench. "You appear to have done well, notwithstanding that previous conviction," he says. He asks Arney how he pleads. Arney answers "Guilty, your honor" to each charge.

"The court accepts your plea and hereby finds you guilty," the judge says. "You're now a convicted felon waiting to be sentenced."

Arney walks out. Ryan and I meet him in the courthouse lobby. He cannot leave the building, he informs us; the feds want him to provide a urine sample, so he'll have to catch up with us later. We watch him enter an elevator with prosecutors and federal agents.

HIS FATE IS now assured. Arney will be sentenced within a few months, and go off to the penitentiary a short time later. He has a great many pieces of business to resolve in the interim, and a month after his plea, he focuses on one of the longest-running: He and Slick pick out an accent color for the Chevy, a companion to the Tangerine Twist, and buy the selection in quantity. It's called Timor Beige, and it's a deep tan, almost a café au lait—a far darker shade than one might expect to partner with bright orange.

Painter Paul is vocal in his dislike for the choice after applying the paint to the car's dashboard. It looks like shit, he tells the boss—the contrast between main color and accent is insufficiently pronounced. Arney, who alternates between calling his selection "golden" and "cocoa," encourages Paul to accept the selection, because "that's the color it's going to be."

I see it myself a few days later. The wagon, sitting high and upright on the rotisserie, has been "cut in" with paint on its doorjambs, hatch, and engine compartment—orange below the beltline, the Timor Beige above. The combination does, indeed, take some getting used to—at first inspection, the beige seems too brown, too murky. Arney is cer-

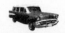

tain of his own taste, however. "Once the chrome's on it," he assures me, "it's going to look fucking great."

My visit is prompted by a milestone in the Chevy's restoration: the reunion of body and chassis, which Arney has assured me will happen by day's end. That seems unlikely at noon, when I enter the Quonset to find half the showroom occupied by a chest-high heap of machinery and junk Arney has removed from a building he's rented out. Included in the pile are battered weed whackers, a couple of industrial safes, several bucket seats, a broken wheel-balancing machine, a pallet stacked high with Ryan's childhood toys, hundreds of bad electronic dance music CDs, and a five-foot, soft-bodied Big Bird statue chewed by mice and bleeding desiccated foam rubber from its wounds.

It takes the crew more than three hours to relocate the stuff. Some of it winds up in a truck bound for one of Arney's vacant buildings and some of it is thrown away; a few large pieces are simply pushed against the showroom's walls. The boss seems stressed throughout the operation, betraying his nerves with frequent harangues at Skinhead, who seems deeply aggrieved by the attention. When Skinhead returns one salvo with a muttered crack, Arney erupts. "You smart-mouthed motherfucker," he booms, then adds to the room: "Every day he tries to do something to piss me off. Every day he wakes up thinking, 'Today I'm going to fuck with Tommy Arney.'"

Skinhead sinks into wordless gloom, and I'm reminded of conversations I've had with each man about the other in recent days. Arney has hinted that Skinhead must have said something to the feds or the grand jury that he shouldn't have, though he isn't specific about what that something might have been. Skinhead has voiced dismay that Arney seems angry with him but won't say why, or much of anything else.

That Arney's rage might spray wide and messy is understandable. The bank's leadership took advantage of him. The feds "didn't care about my life. They didn't care that they destroyed me," he'll complain. He has a lot to be angry about, and a lot of people to be angry with.

But it's distressing to witness a rift widening between him and Skinhead, of all people—his constant companion, his loyal friend and lieutenant, whom he's told me he regards as "more of a brother to me than any of my real brothers." Who, Arney's cousin Billie Ruth says, "loves Tommy and would do anything for him." To whom Arney gave a new Harley-Davidson a few Christmases ago, and whom Arney has defended against all comers. "My brother Billy told me one day that he was going to whip Skinhead's ass," Arney confided to me a while back, "and I told him: 'I don't think so. You try to whip Skinhead's ass, you're going to have to whip mine, too.'" The silences and blowups of the last month haven't been the bitchy but harmless back-and-forth that typically characterizes their conversation. This new style of exchange has prompted Skinhead to consider the unthinkable—leaving.

"He won't talk to me," Skinhead told me at Havana a few nights ago. "I ask him what's happening, and all he says is that everything is going to be all right. Well, everything *isn't* all right. You've seen what's on the list of shit they want to take. The car lot is on it.

"What I don't want to happen is for him to say, 'Everything's going to be all right' up to the day it all shuts down."

"So what do you do?"

"I don't know," he said. "I'm not too old to start over, doing something else."

Now, as Skinhead sorts through a pile of old tools, Arney snatches up a light plastic hammer and raps him twice on the head with it. The blows make loud knocks. Skinhead stares at him in shock. "Have you lost your fucking mind?"

"What?" Arney says, smiling.

"Have you lost your fucking mind?" Skinhead says again. "That *hurt*."

"It ain't nothing but a little plastic hammer," Arney says. "Feel how light it is." He offers it handle-first, but Skinhead, glaring, refuses to take it. Arney gives himself a couple of light taps on the skull. His eyes widen. "God *damn*. That thing *does* hurt."

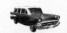

It's not an apology, but it's close enough to usher a truce as the day's main event arrives: We troop over to the body shop and push the rotisserie and Chevy out of the building and across the concrete pad and down a dirt drive to the front lot. The new fences prevent our crossing the property to the Quonset, so instead the team steers the rotisserie onto Route 168, rolling south against the northbound traffic, appointing me to serve as flagman to wave away oncoming cars during the brisk, hundred-yard transit to the lot's main entrance.

Once outside the Quonset, we make a discovery that seems par for the afternoon: The Chevy sits too high on the rotisserie to pass through the building's garage door—to eyeball it, about eight inches too high. The load can be lowered by almost exactly that distance, so it promises to be close. If it still doesn't fit, we might buy an inch more clearance by deflating the rotisserie's tires, but beyond that, we're out of luck.

Lowering the rotisserie is not a casual undertaking, because the spit must be unbolted as it was when we rolled the car several months back, with all the attendant hazards that involves. Three of us now line up on each side of the wagon to keep it from flipping or from dropping too far, too fast. As we clasp the wagon by its rockers, Painter Paul unbolts the spit and we ease the car's tail down a few inches—just a few, lest we twist the body, bend its metal, or crack the putty in its flawless skin. He retightens the bolts, runs to the car's front, and loosens that end, and we drop it by an equal amount.

It's not as much work as rolling the body was, but the Chevy hasn't gotten lighter since then, and we do a lot of grunting and yelling as Paul refastens the bolts. It takes two more loosenings at each end to hit bottom, after which we very slowly edge the contraption to the Quonset's door. The wagon sneaks through with an inch to spare. The showroom fills with whoops.

The afternoon is almost spent by the time the crew transfers the Chevy from the rotisserie to the showroom's hydraulic lift. Skinhead and Painter Paul roll the chassis below and jockey it a foot this way, a few inches that, to properly align the engine and transmission, the

frame rails, the bolt holes, as Arney works the lift's switch to lower the body, raise it again to enable adjustments on the floor, bring it back down. They finally get it right after half an hour, and for the first time in almost a year, on this Saturday late afternoon—September 29, 2012—what rests on the Quonset's concrete floor is recognizable as a '57 Chevy.

Arney is optimistic about the speed and ease of the restoration from here. "I'd like to get it operable and drivable by the end of November," he announces. "I'd like to do some driving in it."

IS HIS OPTIMISM well-placed? Well, over the succeeding eight weeks, Arney and Skinhead rebuild the brakes, hang a new master cylinder on the firewall, and paint the engine block in Chevrolet orange. They install new brake lines and fuel lines. They bolt new inner wheel wells and a freshly painted radiator support to the front end. They strap dual exhaust pipes and the new gas tank to the wagon's belly, and attach a sound-deadening firewall pad on the toe boards under the dash. They rebuild the steering box.

In other words, they achieve significant progress on the Chevy's salvation. But come Thanksgiving, the car is nowhere near ready for the street, and that remains the case for a long while, because Arney's legal and financial woes dominate his time through December and January. The feds release their freeze on his real estate, which opens the way for his creditors to pursue foreclosures on his loans that have fallen into delinquency. One by one, his properties are wrested from his hands until just a few remain, Moyock Muscle among them. Only a lifeline from a well-heeled friend saves his house and the rest of the Arney Compound.

The properties he stubbornly holds on to include the erstwhile Hells Angels clubhouse, which is still plastered with stickers applied by Norfolk inspectors. Arney's plan is to finish its plumbing and electrical

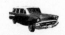

work, then have those inspectors back to sign off on the improvements, which will enable him to rent to a new tenant. But the inspectors won't do it: Municipal attorney Cynthia Hall has assumed oversight of all official action regarding the building, and she puts the kibosh on any inspections or approvals. Arney's feud with the lawyer becomes a consuming fixation. "I have never, ever in my life had anyone dislike me as much as that fucking cunt," he tells me. "And I can't figure out why she doesn't like me."

He orders parts for the Chevy and has Painter Paul install the spare tire well, but it's early February 2013, four months after the reunion of body and frame, before Arney returns to the car himself. I pull into Moyock Muscle one Saturday morning to find Skinhead and Paul laboring to reattach the wagon's right fender. They've placed thick rubber pads and anti-squeak gaskets between the big steel panel and wheel well, which tightens the fit and complicates the already difficult task of mating the unwieldy fender to several parts of the car at once—to the grille, the firewall, the ductwork for the fresh air vent, and a brace that backstops the front bumper.

They manage to connect it to the grille and bumper, but struggle to force it back far enough to bolt to the firewall. Both take up positions on the fender and shove. "Push it!" Paul grunts. "Push it! Harder!"

"Goddamn," Skinhead croaks. "It's like a fat girl."

"You need to know how to handle those grizzlies," Paul says. The fender and firewall meet, but Paul sees that their bolt holes don't align. He enlarges the attachment point on the fender with a die grinder, a pneumatic tool with a spinning cylindrical head slim enough to fit into the bolt hole, until the opening's edge matches that on the firewall. He threads a nine-sixteenths bolt through both and tightens it halfway.

He slips under the car to fasten a second bolt low on the firewall. I can hear him muttering, "Come on, motherfucker," as I chat with Skinhead, who sounds as if he has barbed wire for vocal cords. "I aspirated my right lung," he explains. He went out to dinner a few nights ago,

went to bed with indigestion, and "threw up in my sleep, and choked on it."

"Damn," I say.

"Happens to Tommy all the time," he shrugs. "He's nearly died twice. First time it ever happened to me."

Painter Paul scrambles to his feet, having threaded the lower bolt halfway, and examines the alignment of the fender and cowl. The fender sits a quarter inch low, so he taps a stack of three slender metal shims onto the upper bolt. Most cars hide these space-makers at their attachment points, he tells me; without them, even modern models fail to achieve the proper fit.

The shims overcorrect the problem, so he pulls one of the three back out and ratchets the bolt down. The panels comes into line until he further tightens the lower bolt, which shifts the fender high. Paul trades one of the shims for one half as wide. Everything lines up. "Okay," he announces. "The fender's on."

Arney arrives then, as Skinhead prepares to install the wiring harness, a bundle of color-coded cords that supply juice to a car's electrical devices—its lights, horn, gauges, radio, and not least, the components under the hood that make the whole business move. It's simple and straightforward compared to the harnesses of modern cars, in that the Chevy lacks the computer modules that control today's engines, their airbags and overamped stereos. Even so, diagrams of the wagon's electrical system cover a four-by-eight-foot worktable, and Skinhead eyes them carefully before crawling into the car with a shop light and a drill to install the fuse box.

Arney, clad in his standard black wifebeater despite the February chill—it's sixty degrees, tops, in the Quonset—is in a quiet mood this morning. He stands for a long minute at the Chevy's nose, gazing at the engine, before murmuring that he'll have a radiator installed within three days, and "the motherfucker running next week." He asks Skinhead, who is sprawled on the car's floor, drilling holes in the kick plate,

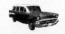

whether he needs help. Space under the dash is tight, Skinhead complains, but no, he's fine. Arney wanders over to Painter Paul, who has encountered a problem hanging the right rear door: New rubber trim on its edges has made it too big for its frame; when he shuts it, the door wedges metal-on-metal against the C pillar.

Okay, Arney says, get inside the car and loosen the hinges, and I'll hold the door in the proper position while you screw them back down. Paul points out that the adjustments have to be made with the door open wide, so that he can get to the hinges, so Arney centers the loosened door in its frame, then tries to keep it from shifting as they slowly swing it open. Paul fiddles with the bolts. When Arney closes the door, it's centered, but its lower rear corner juts out.

Paul loosens some bolts, tightens others. Now the door's lower edge is flush, but the window frame tilts a half inch outboard. More fiddling. The top is in line, the gaps between door and frame are perfect, but the bottom rear corner again sticks out.

Over the next hour they experiment with a dozen different hinge adjustments, each of them failures—either that one corner doesn't align, or their attempts to bring it flush knock the rest of the door out of true. "Well, fuck," Arney finally says. "We're never going to be able to get this motherfucker to hang right, because the problem ain't the fucking hinges, it's the fucking door."

They pull it off the car and set it on a shopping cart parked a few feet away. "That's what it is," Arney confirms, pointing to the door's bottom edge. When Paul replaced the steel in its skin he used lip welds, the new metal overlapping the old, rather than butt welds, which would have fused the pieces edge to edge. In mudding the door to smooth the joint, he made its bottom a quarter inch too thick. Chances are, they'll encounter the same problem on one or more of the other doors, which Paul repaired the same way.

"So we can either get a new door, or two doors," Arney says, "or we can take these quarters off the bottom of the doors and replace those."

Paul favors the latter option, and begins the unhappy task of grinding his carefully applied and lovingly sanded finish from the door. The Quonset fills with the earthen smell of ground putty. Paul and the door are enveloped in a beige cloud.

The missteps will take two weeks, maybe more, to correct. And before Paul is far into the job, Arney decrees that the left quarter panel—the bulging fin that mystified Chris Simon fifteen years ago, and which still looks slightly swollen despite Paul's past efforts to straighten it—has to be replaced, too.

When I hear about all this, it occurs to me—for perhaps the hundredth time—that the wagon's restoration might never end.

IF THERE'S A happy sidebar to this latest setback, it comes one Saturday when I'm hanging around in the workshop at the rear of the Quonset, chatting with Arney and Skinhead as they work on a '71 Corvette convertible that belongs to Slick. Arney's sister Freda is visiting, too, and we talk about their Carolina hometown, which gets us onto their kin thereabouts, which narrows to a discussion about their cousin Billie Ruth, which prompts me to repeat an observation Billie Ruth made when I visited her in Lenoir: She never fails to end her phone calls to Arney with "I love you, Tommy," to which he usually responds, "You're crazy as shit, Billie Ruth."

"That's true," Arney says. "I like Billie Ruth probably best of all my cousins. I think Billie Ruth's a good person. But I don't understand why some people say they love people they don't know. Billie Ruth knows me, but she doesn't know me well enough to say she loves me."

He looks at his hands as he wipes grease from between his fingers with a paper towel. "I tell my children that I love them every day. And I know they love me, because I'm their daddy," he says. "I don't remember the last time I told my wife that I love her, but she knows that I do, and I know she loves me because she's tolerated all the crazy bullshit

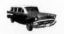

I've done over the years." Skinhead, bent over the Corvette's engine compartment, looks up and nods.

"I used to think Skinhead loved me," Arney says, glancing at me, rather than him, "but lately I'm confused. I don't know. I think he probably does."

"You're like a brother to me," Skinhead tells him.

Freda chuckles and says, "That's not necessarily a good thing."

"No," Arney allows, "but I think he looks to me as somewhat of a brother figure, and maybe as something of a father figure."

"You *do* remind me of my dad," Skinhead says. "He was always calling me a stupid motherfucker, too. And he was fat." He adds quietly: "Although he had hair."

"I've been giving this a lot of thought lately," Arney says, still wiping his hands with great concentration. "I think Skinhead appreciates the fact that I can get things done. And I think that Skinhead knows from experience that I will take care of him, no matter what happens—that I will protect him, that I would never let anything bad happen to him." He looks my way again. "And I think that's important to him."

"That's true," Skinhead says, eyes on Arney. "Loyalty is very important to me."

"He knows," the boss says, "that as long as Tommy Arney is alive, Tommy Arney will take care of him. And I think that's kind of a nice thing. That's why I worked so vigorously—is that the right word?—to try to get Skinhead to quit smoking for twenty-two years. Because I did not want to see him die of that nature, because as we got older, I thought we'd have some fun together."

Skinhead: "But now you don't have fun no more."

"That's true." Arney sighs, still not looking at him. "But I do like to see Skinhead have fun. I like to see Skinhead enjoying himself. I like to see him with his prostitutes, his whores."

Freda, shocked, turns to Skinhead. "Is that what you do?"

Skinhead, still sprawled across the Corvette's engine, says matter-of-

factly: "Yes, it is. I don't have much time for relationships, Freda. But I do have needs."

"So I don't know," Arney says, "why Billie Ruth goes on about all that 'I love you' shit."

I point out that his cousin is religious. Arney shrugs. "I think all religious people are pretty fucking weird, because they believe in something that isn't there," he tells me. "I believe in food, money, pussy—something I can put my hands on."

The exchange seems to recalibrate the interplay between Arney and Skinhead. When I ask Arney about it, he says he's done a lot of reflecting of late, and has come to see that he's in debt to a few people for "assisting me in creating Tommy Arney." And "part of the mechanics of me," he says, "is to be loyal to the people who have been good to me."

So things seem back on somewhat sturdier footing when, in early March, I receive an unsigned text that reads: *Tues is Tommy's birthday and I'm having a lil get together at Havana around 7. Would love to have you there. May be last one for a couple years. :(*

I don't recognize the number. I figure it's from Arney's wife, so I text back: *Krista?*

The reply: *No. Victoria. :)*

Slick's party proves to be an upbeat affair attended by a wide range of Arney's friends, family, and business associates—including Norfolk patrol cops in civvies—and distinguished by enthusiastic alcohol consumption. Arney closes his fifty-seventh year in fine spirits, regaling us with tales of his youthful indiscretions late into the night. "They weren't fast, and they didn't know where to hit," he says of some college football players he took on as a teenager, "but they were so fucking powerful. When they hit you, it was more like they were pushing you, know what I mean? Only they were pushing you in the fucking face, with their fists."

It's a good party.

The trial starts a few days later.

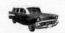

WE'LL NOT GET bogged down with all the details of Arney's testimony, which occupies a day and a half of the court's time. Suffice to say that under the direct questioning of prosecutor Katherine Martin, he says he had a "lending relationship" with the bank for eight or nine years and got "monies any time I needed them." That he "got special treatment," explaining: "You did things for them, they'd do things for you." That he didn't prepare the loan documents he signed—"I never really looked at these things"—and thus didn't know that his purported buddies at the bank arranged for terms that were not to his advantage, financial or otherwise.

On cross-examination, he testifies that he alone, of his family and crew, is guilty of any wrongdoing. His children signed documents because he told them to. Slick served as a nominee borrower after a banker suggested the arrangement. It was he, Tommy Arney, who needed and got the money. It was all his doing.

He tangles with one of the defense lawyers, a brusque fellow out of Chicago named Vincent "Trace" Schmeltz III, whose aggressive approach is precisely the wrong one to take with this particular witness. Schmeltz's first words to him are "Mr. Arney, my name is Trace Schmeltz. Can you hear me?"

To which a serene-looking Arney, outsized for the snug witness booth, replies: "I can hear you just fine. What did you say your name was—*Smells*?"

In his subsequent parries with the lawyer, he remains so cool and friendly that it almost seems he's enjoying himself. In summary, it's a bravura performance. It will prove key to the multiple convictions that crash down on Stephen Fields and Ed Woodard several weeks later.

And it will reverberate beyond that, because he testifies that he bribed a Norfolk city councilman, paying the man's girlfriend twenty-five thousand dollars in exchange for his promise to deliver the votes

Arney needed to open his gentlemen's club. Arney paid the money, he says, but the votes never materialized. The revelation appears on the front page of the newspaper.

That is not, it turns out, the most sensational part of the trial for Arney or those closest to him. The first hint of what's coming occurs during Katherine Martin's direct examination, when she asks about Slick's role in Arney's businesses. "She did everything," he replies. "She paid the bills. She did all the paperwork."

Martin asks whether they've had a personal relationship. "Yes," Arney says.

An intimate relationship? "Yes," Arney says.

That doesn't make the newspaper, but late the following morning the prosecution calls its next witness—Slick herself, who is testifying in exchange for the immunity Arney insisted she get. She tells the court that she and Arney had an on-and-off affair that lasted nineteen years. That *does* make the paper.

As Arney tells it, he and Ryan are having lunch that day when his son, surfing the Web on his cell phone, comes upon coverage of the morning's testimony. "Ryan turned his phone to me and he said, 'You had a nineteen-year affair with Victoria?' And I said, 'I'll explain it to you later.'" Arney drives home and goes upstairs to the bedroom to relax his mind for a while, and so fortified calls the family together in the living room. It is a difficult meeting. Tears are shed.

Later, in a long, late-night phone conversation, I ask Arney how the news could come as a surprise. He and Slick spend a lavish amount of time together. She hauls around a purse stuffed with his various must-have supplies: emery boards, with which he files his nails several times a day; antiseptic wipes and hand gel; toothpicks, nail clippers, and ibuprofen; the hot sauce he applies to most everything he eats. She is his go-to source for advice and hard data. She tells him, as no one else will, when he's out of line. As Arney acknowledges, "I'm sure that anyone who ever saw Victoria and me together suspected."

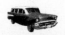

I certainly wondered, though I never witnessed anything to confirm the notion, and any circumstantial evidence I encountered was flimsy. To wit: When I spent a Sunday afternoon with the Arneys more than a month before the trial, poring through their scrapbooks and a mountain of family snapshots, Krista gave me a brief tour of the boss's home office, during which she plucked an old newspaper clipping from a pile and announced: "This is my favorite picture of him."

The clipping was the story I'd written nearly twenty years before about his tussle with the Alcoholic Beverage Control people. In the accompanying photo, Arney was seated and wearing a grin that suggested he was the luckiest man on earth. Standing just behind him were two bikini-clad, hard-bodied dancers, visible from bust to thigh. I knew that one was Slick—because she'd told me so—and pointed to her midriff. "That right there is Victoria."

Krista stared at the picture for a moment. "Oh," she said, her voice suddenly small. "I didn't realize that." She folded the clipping, returned it to the pile, and we left the room.

Suspicions or no, Arney tells me on the phone, "not a human being knew" of the affair. Yes, Skinhead thought something was afoot shortly after it began, and others caught a whiff of it later. "I just denied it," he says. "I just said, 'I don't think so.'"

Krista might have asked him point-blank about Slick a time or two, but "I'm thinking that I lied," he says. "She probably said something like 'You're probably fucking her,' and I probably told her she was crazy or just laughed. She would never press it. My children never asked me."

Ending the affair was Slick's decision, he says. Every few months she'd have an attack of conscience and tell him she couldn't continue. She loved Krista, Ryan, and Ashlee, and fretted about hurting them. Sometimes he and she went on hiatus for months. Eventually, he says, Slick decided it had to end for good.

But back to the scene in the living room, as he shared the details with the family. "I asked them not to take it out on her, because it was

my responsibility," Arney says. "I said that when she came to work for me she was twenty years old. And because of my age, and my experience, and what I knew about women, and my ability to manipulate women, she didn't stand a chance. I took advantage of her. I completely took advantage of her.

"I told them I had been with so many women it would be impossible for me to ever count them up, even with a calculator. I had become addicted to sex. I almost felt like being involved with Victoria was almost like a cure for me, because I went into a semiretirement program in my mind.

"I told them that if they were mad at me I understood," he says, "and they could stay mad at me as long as they liked. And I told them that if they had any questions I'd try to answer them. But I told them that if they had any questions they needed to ask them, because I wasn't going to keep answering questions after that day. As far as I was concerned, it was in the past. I was moving on.

"Krista asked me why. I said simply my mother was that way, my aunts were that way, my brothers and sisters were that way. I don't know if it was something in the blood. It was how we were.

"I'm not blaming it all on that, because I enjoyed myself," he says. "If I had to do it all over again, would I do it again? Yes. I told Ryan, Krista, and Ashlee that. Krista said, 'You don't have a guilty bone in your body, do you?' I said, 'No, ma'am. If I told you I did, I'd be telling you a lie, and I'd rather not tell you any more lies, if you don't mind.'

"Now I don't have any lies anymore. Everything's out in the open for the whole world to see. And I'm never going to lie again."

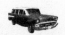

20

SO NOW COMES the crunch.

Arney's sentencing is set for July 22, leaving him less than four months to figure out how Havana might continue to operate, presumably under Slick's stewardship, when he goes away—and whether Moyock Muscle will survive, at its present site or elsewhere—and of greater import, whether all or part of the Arney Compound can be kept from his creditors and/or the government, so that his wife, children, and crew will have roofs over their heads.

None are rhetorical questions, because Arney's deal with the government requires him to surrender "any fraud related asset" and "any property that is traceable to, derived from, fungible with, or a substitute for property that constitutes the proceeds of his offense," which describes close to everything he has. Rather than seize the booty, the feds would prefer to present him with a dollar amount he has to meet through his own liquidation of his assets. It promises to be so big a number—millions on millions—that selling everything is almost certain to leave him short. The feds acknowledge as much in their paperwork, which says that after forfeiture, his net worth will sink from $1.58 million to a negative half million.

Then there's the matter of restitution—of repaying the money his admitted crimes cost the taxpayers. He has no cash on hand to meet this obligation. To the contrary, he's struggling to pay his bills: The government's own assessment is that his monthly expenses already ex-

ceed his income by $3,149. It looks as if he'll go to prison in deep debt to the U.S. Treasury.

Alongside such serious business, the Chevy is a trifle. But Arney has vowed that he'll drive the wagon before his incarceration, and by God, he intends to do everything in his power to fulfill the promise. So in April, he puts Painter Paul back to work on two of the car's faulty doors, and in a search of the loft over the Quonset's workshop finds two more, in pristine condition, that will fit the car. By month's end, one of the project's recent setbacks has been eliminated.

At the same time, Arney acquires an engineless four-door sedan that for all of its flaws—and it has too many to count—boasts a perfect left fin. He has Paul and a local welder named Bubba cut out the fin's outboard panel and graft it to the inner half of the wagon's. It is a surgery that some body shops would rule impossible—the sedan and wagon have very different metalwork on their tails—but Arney conjures a technique to pull it off, and it works. For the first time since Mary Ricketts's ownership, the wagon's left side runs straight from nose to tail.

I allow myself to think: Well, maybe this thing *will* be finished.

On my next visit to Moyock Muscle, the car's doors hang straight and flush, and each closes with a reassuringly deep thud. Paul has just painted the wagon's floor in a glossy black—a detail that will be covered in jute matting and carpet, but leaves no metal unprotected—and has masked the window openings in paper and tape to protect the still-drying enamel while he sheaths the exterior in a final coat of icing and blocks it smooth.

Arney and Skinhead arrive with lunch well into the afternoon. Paul and I walk to the Quonset under a fast-moving sky reflected on hundreds of windshields—a dragonfly's view of the heavens. "You know," I tell him, "it's been more than three years that I've been hanging around here, watching you work on that Chevy."

He shakes his head and, grinning, says: "I *told* you."

It's warm in the office. As I find a chair I see that Arney has wad-

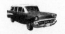

ded up several paper towels and shoved them down the front of his wifebeater. Skinhead offers us a tight-lipped smile, having misplaced a dental appliance that stands in for his AWOL upper four front teeth. "Paul, what have you done today?" Arney asks. "You look tired."

"A little," Paul says as he sits. He rubs an arm dusted with dried icing. "Blocking and blocking."

Well, Arney says, he and Skinhead have had a full day themselves. Among other tasks, they've picked up some belts for the fan that vents the hood over the stove at Havana. The fan runs thirteen hours a day, every day, and what with Skinhead being too weak to adequately tighten the belts when he installs them, they wear out quickly.

"This has nothing to do with me being weak," Skinhead objects.

"A weak motherfucker," Arney insists.

"What the fuck," Skinhead says, "does this have to do—?"

"Tell me this, motherfucker," Arney interrupts. "How the fuck does a motherfucker lose his *teeth*?" He glances my way. "He lost his teeth a week ago." It's Arney's theory, which he now shares at some length, that one or more of the five cats living in Skinhead's house took them.

"The cats didn't touch my fucking teeth," Skinhead counters.

"Well, where the fuck did they go, then?" Arney asks. "What happened is, you put them down somewhere, and the fucking cats took them. Because in all reality, there's no other explanation."

"The cats didn't do it," Skinhead says. "The cats can't even get to them. I put my teeth in the same place, every time, and the cats can't get up there."

"So where the fuck are they?"

"I don't know," Skinhead says.

"He shouldn't even have the fucking cats in there," Arney tells me. "He only has them because he thought it would get him some pussy if he looked after this bitch's cats."

"Is that true?" I ask.

Skinhead is typically forthright. "Yes."

"Did it work?"

His expression is blank. "No."

Arney clears the remains of his lunch from his desktop, then reaches for a roll of paper towels and wipes down his neck and arms. His thoughts shift to the Chevy. "Paul, the windows will be here Thursday. And the gaskets and all the other shit. And the windows are already assembled. They're all on tracks and everything."

"And the vents are already assembled?" Skinhead asks.

"Yeah. They already have chrome on them."

"All right," Paul nods.

Arney tears off a long stretch of paper towel and soaks his desktop in spray cleaner. He's brought in a new fax-copier to replace an old and broken example, and in anticipation of setting it up, directs Skinhead to clean his desk, which is back-to-back with his own and piled with manuals, keys, empty cups, assorted paperwork. "You can't let your desk get like that," he lectures as he scrubs his down. "It doesn't look good when people come in."

"It looks like I work," Skinhead replies. He leafs through a stack of papers.

"No," Arney says, "it makes it look like you're a filthy, nasty, cock-sucking motherfucker, to be truthful."

The sniping continues as they disconnect wires from the old machine, set it aside, and carefully position the new device. It peaks when Arney snatches up the outgoing copier and lobs it across the room at Skinhead, who sees it coming just in time to catch it with his gut and a backward stagger. "One of these days," Skinhead says, feigning as though he's going to toss it back.

"You wish you could kick my ass, don't you?" Arney asks him.

"I do," Skinhead says, with a gaping black scowl. "If I could, I would."

Arney, chewing on a toothpick, regards him silently for a moment. "Well," he says, "I wish you could *almost* kick my ass."

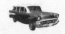

THE CHEVY'S NEW windows arrive on schedule. Arney tells me he intends to have them installed at once, and to follow that work with a new interior—upholstery, carpeting, door panels, headliner. After that, he'll have Paul paint the car. But Paul, who is finishing the last of the blocking on the car's tail, convinces him that it makes sense to paint first, to better avoid fouling the glass and new vinyl with his spray gun.

So in early June, Paul paints the interior of the car and the door-jambs above the beltline in Timor Beige. Once sheathed in the glossy paint, which tends to reveal the slightest imperfection in whatever it covers, the quality of his earlier metalwork is plain: The wheel wells in the cargo hold, once perforated with rust, are flawlessly smooth. The next day he finishes the lower portions of the jambs in Tangerine Twist, and I can't stifle my amazement at the sublimity of seams and joints that two years ago were nonexistent, having been devoured by rot.

At midmonth he begins water-blocking the car, for which he wets down the exterior and goes over it with a super-fine sandpaper. The step takes several days, during which he also clears the shed of extraneous car parts and tools and equipment not directly related to the last complicated, make-or-break task in the Chevy's restoration.

After paint, what's left of the job is quick and easy. Window installation takes a day or two. The interior, which Arney has always planned to job out to an upholsterer, should take a week or ten days, tops, and relies on patterns and precut fabric. Paint, on the other hand, is a tricky undertaking—expensive, difficult, and prone to environmental interference. Extremes of temperature or humidity play hell with drying paint. An errant insect, alighting on a freshly applied coat, can necessitate hours of repair. The paint itself must be mixed with thinners and drying agents in proportions that are as much intuition as straight-up chemistry. The process requires both skillful speed and patience, along

with physical stamina, artistic grace, and an eagle-eyed attention to detail. And it all comes down to one day's work: A good day will ratify Paul's three long years of labor to save the wagon, and a bad one will usher expensive correction.

So Paul, like all good painters, prepares for the job with an unvarying ritual born of years of practice. He wipes down the car not once, not twice, but over and over and over. He hoses down the paint shed with a power washer, removing every stray grain of dust from the car's surroundings, lest such a grain settle on his freshly painted baby. He remasks all of the openings into the car's interior with paper and tape, ensuring that the seal is complete. He bags the wheels and tires in plastic. He opens two small windows high in the paint shed's rear wall, and over the openings tapes blue furnace filters, allowing a breeze to enter, but with nothing on it.

An hour before dawn on a Friday in late June 2013, I watch as he stumbles from his house to my car, in which I'm picking him up at this unthinkable hour because Arney and Skinhead are unreliable early risers, and because success at painting the car requires an early start. The temperature and humidity will climb high by midafternoon—a problem in itself—and should the heat provoke a thunderstorm, as it has on recent days, insects will seek shelter from the rain and most likely defeat Paul's efforts to keep them out.

We beat the doughnut truck to the convenience store where we stop for coffee, and pull into Moyock Muscle at 5:20 A.M. Clouds are scudding by just a few hundred feet off the deck, obscuring a gibbous half-moon. Off in the black, ducks are quacking. Paul opens the paint shed, turns on the lights, and goes over the car with paper towels and blasts from his air hose as Pat Benatar thumps through an anthem on the boom box.

As the sun clears the trees a mile to the east, he lowers the shed's roll-up door onto a homemade contraption that resembles a ladder on its side: It's two feet tall by eleven wide, fashioned from two-by-fours, and in the gaps between its rungs are fitted five furnace filters—another

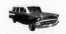

low-tech attempt to promote a little ventilation in the otherwise airless building. He soaks the shed's concrete floor with water, as much to keep the temperature down as any dust. He wipes down the car with prep solvent, which dissolves any lingering wax or grease. He shoots it with the air hose, waits a few minutes, then goes over it with a "tack cloth," which in purpose is not unlike a lint roller. Then, at long last, he mixes up a pot of paint, pulls on a respirator, and locks himself into the shed with the Chevy.

The first coat is white, to create a uniform base for the paints that follow. When he opens the door to the shed and pulls off his respirator twenty minutes later, I'm struck by how good the wagon looks in a single color. Its mottled, primered skin of the past couple of years has confused the eye as dazzle paint on warships did during World War II, obscuring the pleasing length of the car's beltline, the grace of its curves.

Paul runs a tack cloth over the car, then mixes a pot of Timor Beige and, alone in the shed, applies several coats of the paint to the Chevy's roof, pillars, and the triangular accent panels on its fins. The tan finished, he masks the triangles with tape and paper, using as his guide the holes through which the car's chrome trim will attach. Skinhead pulls into the lot, and Paul enlists his help in spreading clear plastic over the roof and anchoring it with tape carefully placed along the beltline. Paul mixes a pot of Tangerine Twist, and has finished laying down several coats by late morning.

These "base coats" are matte, not glossy; the paint job's shine and depth will come with four layers of clearcoat, which Paul now hastens to prepare as the temperature outside climbs through the eighties. He kicks me out after gingerly peeling the tape and paper from the masked portions of the car and loading his spray gun. As the drying time for clearcoat is significantly longer than that for the base colors, it'll be forty minutes before the door to the shed reopens, so I wander the lot under an intensifying sun.

The fences are down. The interior barriers, the ones the county in-

sisted Arney erect to shield his inoperable inventory, have been toppled by the wind. I look to the lot's perimeter, see that the fence along the northern edge is now just a picket line of steel posts, the wire ties binding them to the chain link having snapped in a recent storm. The metal mesh lays flat on the ground, weeds shoving their way through its gaps. I stroll toward the eastern property line, passing the lagoon en route. Eight-foot reeds erupt from its water. Algae carpets much of the rest, dimples in the slime betraying invisible life beneath. I keep an eye peeled for snakes.

The long eastern fence is standing, though much of it has been stripped of the plastic sheeting that sequestered the lot from public view. From where I stand, at the inventory's edge, I can look out over a field of low cropland to a ragged copse of pine, and beyond it, a new subdivision of big homes. A few are yet unfinished, clad in bright yellow pine and Tyvek. Off to the southeast is a house much closer than the others, maybe two hundred yards from Moyock Muscle's edge. It wasn't there when the fence went up.

I am transfixed by these early declarations of postrecession confidence, out here on the outermost ring of suburbia. Intrigued by the notion that whatever else has changed in American life since the Chevy's infancy—and what hasn't?—the suburban ideal has survived, adapting in its details to shifts in taste and technology, but in its essence remaining pretty much as it was when its first blooms appeared. Three generations on, we still demand elbow room and privacy, and we still love, rely on, and are enslaved by the automobile.

Some mock the suburban model advertised by the Cleavers and Nelsons. Some denigrate it. Some note, rightly, that in an era of declining energy and rising temperatures, it may be unsustainable. Still, it remains a part of us, a fantasy of safety, order, and independence firmly imbedded in the American psyche.

I turn away from the new houses and trudge back to the paint shed, where Painter Paul is overhauling a tattered emblem of that ideal, and making it seem new.

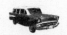

OUR STORY COULD end here.

Maybe it should, with Arney yet unsentenced, and still lording over his crew, and surrounded every day by his beloved cars and customers at Havana—and, most important, for our purposes, with the Chevy's salvation assured. Regardless of what happens to its current owner the car is safe; it will not be parted out or abandoned. At worst, it might be sold—and it will be an easy sell, because as we've already discussed, the hard work is done. The restoration is all but complete. It would be a mighty attractive buy for someone with a little bit of money.

It would be a satisfying ending, because in the hands of such a buyer the wagon would come full circle. It would return to the suburbs, most likely, to a family of means, to a place near the cultural center. It would again inspire lust. The cycles of ownership would begin anew.

Here would end a story of human ruin and redemption, of a protagonist who has himself been written off as unsalvageable, and whose struggle to rescue the Chevy from the scrap heap serves as metaphor for his own unlikely rise to pseudo-respectability. Who, in saving the car from death in a junkyard crusher, has rescued a little piece of American history, and preserved the long procession of hopes and dreams it represents. And whose down-to-the-last-bolt approach means that the car should, if provided a sensible level of care, last at least as long as it already has, which is to say well past its hundredth birthday.

But, no: We've come too far to stop now. Instead, take a minute to mull those grand, closing thoughts, and then let's get back to the action, because there are two scenes remaining to bring this story to a proper close. We'll preface them with a series of snapshots taken as Arney's sentencing looms:

Skinhead gets new teeth and a dazzling white smile. Paul sands the Chevy's thick armor of clearcoat with ever-finer paper, then buffs it to a mirror finish. Eleven days after the paint job, he rolls the wagon out

of the shed, and sunshine transforms the Tangerine Twist into a visual scream that can be seen and heard two counties away. Arney has a new windshield installed, but has to reorder the curving panes that wrap around the cargo hold—when he uncrates the pair delivered in June, he finds they're broken, and because he didn't open the crates immediately, the company that sent them will not take them back.

Along the way, I notice in some government paperwork that the feds have adjusted their appraisals of the cars they tagged at Moyock Muscle, so that now they're almost credible. The '69 Camaro convertible body under the tarp in Paul's body shop, initially lowballed at $10,000, is now said to be worth $23,100. The value of the hand-built '81 Excalibur roadster has been boosted from $10,000 to $33,895.

I notice, too, that the feds include a "1957 Chevrolet wagon" among Arney's unencumbered assets, which they presumably intend to seize. The document sets this Chevy's value at $13,950.

Arney has told me he has close to $40,000 in the wagon. Can it really be worth less than fourteen grand? Confused, I ask him whether the feds are talking about the same car. Yes, Arney says: An agent was at Moyock Muscle one day, saw the wagon, and added it to the forfeiture list. "It'll be finished," he tells me, "and if they take it, they take it. I'd like to keep it, but really, it don't matter. We'll drive it."

On July 15, a week before his sentencing, he mentions again that the wagon is on the government's hit list. This comes in the course of his telling me that his bankers are calling the note on the Moyock Muscle properties. "They wouldn't renew my loan, even though I made every payment," he says. "They said, 'We're not going to extend it.' So they'll take the property that Moyock Muscle is on.

"The feds will take all the cars—all of them. They're going to take everything—everything I've worked for, for forty years, will be gone. They'll fucking take it all.

"I'm trying to get them to let me keep the '57," he says, "but I don't know."

At the end of this conversation, it seems obvious to me that the Chevy's fourteenth owner will be the People of the United States.

But to spend time with Tommy Arney is to court the unexpected, and now comes a twist that I haven't foreseen and don't quite understand: Two days before his sentencing, he tells me that the wagon on the government list is *not* Nicholas Thornhill's Chevy, after all—it's some other car. Exactly which is unclear, but no doubt about it, it is not the car that he's had Painter Paul working on for three years. The serial numbers make that plain, he says. The car on the list is identified by a VIN that is not VB57B239191. And as we've established earlier in this story, tags are everything.

He tells me in the same conversation that he's out of money. Flat broke. He can't afford to finish the restoration. But he thinks he's found a way to make it happen. A longtime employee of his restaurants, a convivial sixty-two-year-old fellow named Al Godsey—a lifelong bachelor who keeps birds, lives in a walled-off portion of Skinhead's house, and has been with Arney since his Body Shop days—has offered to buy the car for a modest sum of cash and the cost of completing the job.

Before I'm able to process this information, Arney has an appointment to keep with Judge Raymond Jackson.

HIS ARRIVAL AT Norfolk's federal courthouse has the air of a red carpet event: Arney strolls in smiling, fist-bumping friends seated along the aisle, loose and relaxed and looking sleek in a fresh, close haircut and a sharp gray suit. He's trailed by Slick, Krista, and Ashlee, all of them wearing sunglasses and high, high heels, and by Ryan and his girlfriend, Holly. The family occupies the gallery's front bench, well-wishers crowding those behind. Slick winds up directly in front of me. "How you doing?" I ask.

"I could be better," she admits. "I need a shot."

Judge Jackson enters. The court has reviewed the papers filed by

the defendant and the United States, he intones. Among those papers is a government motion for "downward adjustment" of Mr. Arney's time behind bars, in recognition of his aid to the prosecution. Said adjustment would lower the recommended sentence by more than half—instead of looking at sixty-three to seventy-eight months, he'll face twenty-seven to thirty-three.

Prosecutor Katherine Martin steps to the microphone to present the government's argument supporting the motion. "Despite his limited education, Mr. Arney is a very smart man," she opens. "He's a very savvy man. He was exploiting, through his own fraud and deceit, a culture of corruption" at the Bank of the Commonwealth. But he is also a man "who's overcome a number of obstacles," she says, and in doing so, he has "become a devoted family man and friend."

As she says this, Arney's wife and longtime mistress are sitting maybe five feet apart on the bench in front of me.

Martin notes that the court has received eighteen letters vouching for Arney's good works, and she quotes one, from Ryan. "My father has arrived here today as a loving, generous, honest, responsible, and hard-working man," the letter reads. "He has come a long way from the abandoned and homeless teenage boy with a few cents in his pocket, living in a service station bathroom. He has never used his lack of education or poor upbringing as an excuse for any of the mistakes he has made or setbacks he has encountered.

"The day my father pled guilty and agreed to cooperate with the investigators in this case I was neither ashamed nor embarrassed," Ryan wrote. "I was filled with admiration. I knew that day that the stress and difficulty of this situation had not changed him one bit. He has always been an honest man who takes full responsibility for his actions and mistakes he has made."

Martin tells the judge that Arney is "readily distinguishable from other defendants in this trial," in part because he "did not minimize his conduct, he did not blame it on others, and he did not lie about it."

By the time she finishes, she's made a pretty convincing case that Arney ranks among Greater Norfolk's first citizens. Bill Taliaferro takes the mike and reiterates many of the same points, adding that his client "has expressed tremendous contrition for what he's done."

The judge asks Arney if he'd like to speak. He replies, "I think everything's been said, your honor."

Jackson peers at him from the bench. "The record reflects an ability to overcome and adjust," he tells the defendant, "and as counsel has noted, you have been a successful businessman and a compassionate member of the community.

"You have done well with your life," he says, which makes Arney's presence here today all the more disappointing: "How did you somehow manage, in this point in your life, to slip into this corrupt activity and jeopardize all you had done in your life?" He answers his own question: "A lot of it was just plain greed."

So while his situation might be "unique and different" from those of his fellow defendants, the judge says, "at the end of the day, Mr. Arney, there is a penalty to be paid." He imposes a sentence of twenty-seven months. Arney will get 15 percent of that, or four months, knocked off if he behaves himself in prison. He'll serve six months of it in a halfway house. In sum, he'll spend seventeen months behind bars.

He'll also do three years of supervised probation. He'll pay more than $2 million in restitution. He'll forfeit cash and property totaling $7.5 million and change. "You fail to make the restitution," Jackson warns, "you'll find yourself back in here."

Taliaferro requests that Arney be allowed to report to prison in ninety days. Martin seconds the motion: "Some of the things on the list to liquidate, down in Moyock—it would be helpful to have Mr. Arney's help," she says. The judge isn't convinced. Thirty days is plenty. "The court's confident you can get it all done," he says.

Arney's exit from the courtroom is delayed by hugs, more handshakes, hearty congratulations. When he finally gets outside, he's smil-

ing broadly. With the exception of the thirty days instead of ninety, the session went better than he expected. He unknots his tie, pulls it off, and unbuttons not just his collar, but the top four buttons of his dress shirt, which he then pulls open to reveal a thicket of silver chest hair.

"So what are you doing for the rest of the day?" I ask him, thinking that perhaps he's going to enjoy a celebratory lunch with his family.

He looks at me like I'm crazy. "I'm going to work, is what I'm doing," he says. "I've got a fuck of a lot to do in the next thirty days."

INCLUDING THIS:

On a cloudless and balmy afternoon a few days later, Paul pushes the Chevy out of the paint shed, and he and Arney hook it to the rollback and pull it onto the bed. I watch as the truck jounces over the back lot's ruts, the wagon swaying on its back, then thread my way through the Moyock inventory, planning to meet the men and their cargo over by the Quonset.

On the way I encounter a couple standing under a carport next to the building. It's Jeff Simmons, the Chevy's ninth owner, and his wife, Patricia. Simmons is wearing a black hat and T-shirt emblazoned with patriotic eagles, stars, and stripes, in keeping with his status as a navy veteran. We shake hands. "So where's the car?" he asks.

I look out to Route 168, clogged with beach-bound traffic, where the rollback is waiting to turn in to Moyock Muscle's main entrance. The Chevy hovers above the cars and pickups around it, orange paint bright enough to cause corneal damage. It's what I imagine a nuclear meltdown to look like.

Jeff Simmons's eyes widen. "Oh my God," he whispers.

"Where?" Patricia asks, looking around.

"There, on the truck," he says. His eyes are glued to the car as Arney swings the rollback into the lot. A few days ago, when I called Simmons to propose this reunion with his old friend, he told me that he missed

the wagon terribly. "I still talk about that car," he said. "I've made some stupid decisions in my life—I can rank the five stupidest decisions I've ever made. And selling that car probably ranks number one."

A few seconds later I run into Picot Savage, owner number five, who's watching as Arney backs the rollback toward the building, tilts the bed, slowly unspools the Chevy to the ground. Savage wanders around to the car's nose, where the Simmonses are taking pictures. "It's beautiful," Jeff Simmons says. He sniffles, rubs his eyes, moves a few yards off, and stands for a minute with his back to us.

"He just lost his dad," Patricia explains. "And he *loved* this car."

"I got some memories of that car, too," Savage says. "Some good, some bad." The Simmonses laugh. "Did you actually drive it?" Savage asks them.

"I got it running," Jeff Simmons says, but adds that he drove it only to get it home from the pawnshop—and at that point it was smoking, trembling, and he could barely see the road from the collapsed front seat. "But I loved it," he adds.

"When I got it, all it needed was to have the chrome strips attached," Savage says. "I had them, but they just weren't on the car. That's all that was wrong with it."

"I liked it better when it was green," Patricia says.

"Nah, I like it this way, too," Jeff counters. He shakes his head. "Beautiful. If I won the lottery right now, I'd buy it."

Up walks Nicholas Thornhill's daughter-in-law, Ruby, now ninety, with her daughter, Janet—to whom the Chevy's first owner pointed out black cows on Sunday drives fifty years ago, and claimed that they made chocolate milk. Ruby peers at the bare metal interior through the right front window opening. "I've ridden in this car a lot, let me tell you," she says.

"Oh, yes," Janet says, grinning. "Me, too."

"I like the colors," Ruby says, studying the Tangerine Twist. "It's a little bit loud, but so what?"

"Why *not* make it loud?" Janet agrees.

I introduce them to Sid Pollard, who has ridden down to Moyock with his girlfriend, Liz, on motorcycles. Janet immediately recognizes Pollard's name: "You bought the car from Bruce," she says, meaning her brother, the car's second owner, who was called out of town today.

While they're getting acquainted, Arney talks with Dave and Chris Simon, both of whom are eyeing the car with their arms folded across their chests. Chris, whose muttonchop sideburns have achieved almost feral wildness, tells me that he's living with his folks these days and restoring a four-door hardtop on the property. With three '57 Chevys parked outside, not counting a wagon that Dave has been attempting to transform into a car-pickup hybrid, the Simon place has recaptured its Battleship Row past.

I stroll among the guests, eavesdropping on conversations, sharing their excitement, gratified that everyone seems happy to be here. I knew ahead of time that some past owners wouldn't make it today. Nicholas Thornhill, obviously. Bobby Dowdy, owner number twelve, who told me he'd be out of town. Alan Wilson and Al Seely, the seventh members of the fraternity, who not only live hundreds of miles away in Albany, Georgia, but are grieving the loss, just days ago, of Seely's mother.

I'm disappointed I won't see those two, because I'd like to congratulate them: On Valentine's Day 2013, the twenty-fifth anniversary of the brunch at which they met, Wilson proposed to his longtime partner and Seely accepted. They've had their share of challenges—Seely shut down his design business in the spring of 2013, after several lean years—but they have three grandchildren, who call Wilson "Gramps" and Seely "Grumps," and they live in a modernist house that Seely admired for years before they bought it. Life is pretty good.

I also knew not to expect Mary Ricketts, with whom I spoke a few times after interviewing her back in 2004. In one such conversation, the car's sixth owner told me that she'd just seen the wagon up close,

eleven years after selling it. "It was like visiting an old friend," she said. "I had my little moment."

Most recently, I called her in May 2011 to suggest we get together. She said she'd been feeling poorly, but promised to call when she recovered. The following month, I ran across her obituary in the paper. Struggling with her stroke's aftereffects, bruised by several job losses and demotions, she'd plunged into a depression the year before and holed up in her Norfolk apartment, eating infrequently, drinking constantly. At her death, she'd dwindled to vapor.

Much of the conversation at her memorial centered on her funkiness, her love of kitsch, her appreciation for midcentury style. An urn containing her ashes occupied the middle of a table arrayed with fossils from her life—photos, books, musical instruments. Prominent among them was a framed photo of Mary with the Chevy.

I notice Dave Marcincuk standing alone at the wagon's tail, squinting at the car as if he's trying to work out a puzzle. I walk over to him. Since selling the car, Marcincuk has won the love of a Christian woman, to whom he proposed two weeks after they met. They married in 2006 and had a daughter two years later. He's still a garbageman for the city of Norfolk, and still lives in his little Craftsman cottage, which looks a lot more put-together these days. Life, he said, "is more wonderfuller than I could have imagined."

He was surprised to hear of the reunion when I called him a few days ago. "I thought that car was a total loss," he told me. "The '57 was worthless, really."

"So," I say now, nodding at the wagon, "what do you think?"

He shakes his head. "I'm just overwhelmed by the amount of work," he says. He searches the gleaming Chevy for something—anything—familiar, and shakes his head again. "There's no clue that this is the same car," he says, "other than your telling me that it is."

Indeed, the wagon's every telltale tic has been erased. The flaws that Marcincuk once obsessed over have been cut out, welded,

replaced. If I didn't witness the transformation myself, I might not buy it.

But I did.

"Believe me," I tell him. "It's the same car."

LATER IN THE day, a short while before Moyock Muscle locks up for the weekend, I find Tommy Arney alone in the Quonset, taking stock. The big neon Bootleggers sign is mounted on one wall, facing a sign across the showroom that once advertised another of his bars, Tommy's. A ceramic "No Smoking" placard from his first gas station hangs over the office. An old, smoke-stained print of Jesus that he found in a back room of the Body Shop is on display between two pieces of NASCAR memorabilia.

"I came in here yesterday, and I was just looking around at all this, thinking about all I've done in my life," he tells me. "The feds'll come in and take all of this shit." Just yesterday he surrendered the family's Mercedes. In the coming days he'll turn over his giant red pickup and a couple of Corvettes, including a rare 1963 model he gave his son for his twenty-first birthday. Any time now, an army of government agents might descend on the lot to take everything here, down to the pictures on the walls, after which he expects the bank will claim the property.

"But that's okay," he says. "I protected my family, and I protected Victoria. Everything else is just bullshit." Havana will continue to operate with Slick as the boss, and Skinhead will stay chief of the kitchen. The feds have agreed to spare the Arney Compound, so that will remain intact, assuming the mortgages are paid. His family and crew will hang together.

And once he's again a free man, they'll start over. They'll rebuild. He's done it once. He can do it again. "I can't wait to get there," he tells me. "I can't wait to go to prison. I want to get this shit started so I can get it done."

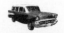

Bill Taliaferro called him a day after his sentencing with a plan to extend the time before he reports, but Arney says he stopped him. "If they'd take me today, I'd go today," he says. "I asked them, 'Can't I just go right now, and get this motherfucker started?' And they said, 'No, Mr. Arney. You have to wait.'

"I got to bail, buddy. I got to get this shit started. I've got shit to do."

As for the Chevy: It isn't seized. I've seen the government's forfeiture papers myself, and can attest that the VIN of the '57 Chevy wagon they list does not match that of the wagon. Arney signs VB57B239191 over to Al Godsey.

I've often seen the wagon's fourteenth owner at Havana, usually in the kitchen, but exactly what he does to earn his keep has eluded me. When I ask him a few days after the reunion, he's uncertain, himself. "Our situation isn't really like working for somebody. It's more like a lifestyle," he says. "It's not like we have titles or anything. We're just here, you know? I try to look out for Tommy, and he looks out for me."

He's known Arney so long that he doesn't remember how they met, but it was during a time when he frequented after-hours joints—"seven days a week," he says—and Arney did, too. He first came to work for the boss twenty-one years ago, not intending a long stay. "It isn't a career, really," he says. "It's more like just going through life."

Godsey obtained the title in exchange for two thousand dollars and the cost of all parts necessary to build out the car, he tells me, adding that the crew will perform any labor involved at no charge. Even so, "It's going to be a little while before I'll have the money to be able to complete it," he says. "We're not rich right now. But little by little, we'll turn it around. It'll get done."

Two thousand dollars, I think to myself, for a car in which Arney figures he's invested forty thousand. As the thought lingers, Godsey offers that "it's a good deal for me, and it's a good deal for him."

I ask him how that can be. "It doesn't go anywhere," he says. "It kind of stays in the family."

And then it makes sense.

"So when Tommy gets out," I say, "will you sell it back to him, if he wants it?"

"Oh, yeah," Godsey replies. "If he wanted it, I'd hand it right to him."

I'm betting he'll want it. He may not have driven the Chevy before beginning his sentence, as he's promised so many times that he would.

But just you wait: He will, once he's out. He'll take the wagon out onto the same streets where it logged its first miles, into a city and a world much changed from Nicholas Thornhill's day.

He'll drive that motherfucker.

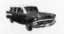

Acknowledgments

AUTO BIOGRAPHY HAS been part of my life, to one degree or another, for nine years—an admittedly crazy amount of time to devote to any project and about nine times longer than I expected to spend on this one. It has not been my burden alone: All along the way I've pestered the book's cast time and again for details of their lives, have wearied my mentors with worried musings on story structure and pacing, have exhausted the patience of friends who no doubt prayed for me to find something else, anything else, to talk about.

So, to anyone who has crossed paths with me over this book's long gestation: Thank you. And I'm sorry.

A few folks made contributions vital to the story's completion, as well as whatever merits it might enjoy. First among them is Tommy Arney, who as I write this is an inmate at the Morgantown, West Virginia, Federal Correctional Institution: Without him—and minus his candor, his enthusiasm for my questions, and his intercession on my behalf with his friends and relatives—there'd have been no story to tell. Arney understood that readers would shrink from some aspects of his past, but he never wavered in his commitment to share it. I salute him for that, and look forward to buying him a beer when he's next allowed to drink one.

Those close to him likewise endured my presence, often when they were under significant stress. Krista, Ryan, and Ashlee Arney treated me as a family friend. Victoria Hammond, John "Skinhead" McQuillen, and

Paul Kitchens helped me in uncountable ways and never failed to make me feel welcome; I likewise could rely on the good cheer of Virginia Klemstine, Al Godsey, Krystle Andrassy, and Ron Young. I'm grateful, too, to Bill Taliaferro, the late Peter G. Decker Jr., and Pete Decker III.

The twelve previous owners of the car and their families trusted me with their stories and made for varied but always gracious company. I am indebted to all of them, but especially those whom I subjected to multiple interviews. As Mary Ricketts died in 2011, I relied on the recollection of others for my reconstruction of her youth. Thank you, Charmaine Clair, Martha Clements, Don Harrison, Julie Hill, Billy Ricketts, Mary Jo "Joey" Rothgery, Kenny Rowe, Barry Scott, Marianne Vest, Sandy Wood, and Carrie Ziegfeld.

Experts filled the chasms in my knowledge about GM, Chevrolet, and automobiles in general. I thank former GM workers Leo Heid, Skip Shiflett, Henry Marshall, and Tom McDonough; Dan Reid; and folks who walked me through the discussion of authenticity in chapter 14—Loren Fossum, Patrick Krook, Ronn Ives, and Richard Todd.

I wrote this book with the support of the Virginia Foundation for the Humanities, through a fellowship at the University of Virginia. Writing at the foundation and living on the Lawn at UVa are experiences for which I will always be grateful. I especially thank Rob Vaughan, the foundation's president.

At Goucher College, I received essential counsel from four mentors on the story's overall shape, as well as the ideas lurking behind the action. I will be lifelong fans of Jacob Levenson, Suzannah Lessard, Tom French, and the same Richard Todd I mentioned before. Thanks, too, to Rebecca Markovits, Brian Mockenhaupt, and Mike Capuzzo.

At Norfolk's *Virginian-Pilot*, I received help from Tom Shean, Maureen Watts, Jakon Hays, Patrick Wilson, Larry Printz, Denis Finley, and, especially, Tim McGlone.

This story benefited immensely from the sharp mind and pencil of Maria Carrillo, my longtime editor at the *Pilot*, who has followed

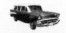

VB57B239191 for as long as I have. Maria edited the paper's December 2004 series about the car, then agreed to read the first draft of what you now hold in your hands—and it's far, far stronger for her having done so.

My dear friends Mark Mobley and Laura LaFay read early drafts and gave me suggestions that have made this a different and better book. I've subjected them to exhausting chatter about the story, far beyond the limits of friendship, but they've stayed interested and helpful and continue to take my calls.

Four other friends commented on essentially complete versions of the manuscript. Thank you Diane Tennant, Walt Jaschek, and Cindy and David Fuller.

My agent, David Black, has heard me go on about the wagon since I first met the car. No one has worked harder or longer to help me refine my thinking on this story, and he was tireless in his efforts to find a home for it. He's the best there is.

At HarperCollins, the book found a champion in Peter Hubbard, who talked it up among the company's various divisions until the like-minded Cal Morgan took it on. Peter was smart and encouraging in his every contact with me, and edited the manuscript with panache. This is his baby as much as mine.

Finally, friends and family kept me on track during the years I spent reporting and writing the story. I thank my folks, E.V. and Gerry Swift of Bedford, Texas, who were intrigued by the tale from the beginning (despite my dad's misgivings about its "rough language"); Joe "He Gets All the Facts In" Jackson of Virginia Beach; Boyd Zenner, Ros Casey, and Bill Womack, who brightened my otherwise monastic year in Charlottesville; the aforementioned Cindy and David Fuller of fair Verona, Virginia, who treated me to weekends of lavish meals and wonderful conversation; and my friend and brother Mike D'Orso, who opened his Norfolk home to me during my 2012 reporting trips back to Tidewater.

I owe special thanks to my daughter, Saylor, who has known the story's cast and followed its action for much of her teens, and who buoyed me with frequent visits to UVa; and the lovely Amy Walton, who was excited by this project from its start, so long ago, and has been its enthusiastic booster all the while, despite its demands on her fiancé's time and attention—and with whom I am thrilled, at last, to share its completion.

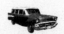

Notes

This is a work of nonfiction, which is to say that I've made none of it up. Its characters are real people, identified by their real names—though in a few cases, I've dropped last names to preserve the privacy of minor characters who haven't had contact with the story's main players in many years. I've also left the doctors who treated Tommy Arney's cancer unnamed, in the interest of keeping an already large cast at least a little easier for the reader to manage.

Whenever possible, I've sought out multiple sources for the story's various turns. I witnessed most of the scenes and conversations related here, and have based my description of those events on copious notes that as a rule I typed into my computer very soon after. In these cases, I have used quote marks around the speech of the participants, which signals my confidence that I've captured verbatim what was said. I have also placed quote marks around speech in a few scenes that I did not personally witness, but reconstructed with the help of multiple participants, and about which the participants agree. Further, if quoted speech is included in a larger quote—if, for instance, I quote a character recalling a conversation—I've punctuated the interior quote for clarity's sake.

In some instances, I have recounted speech without the use of quote marks. You should interpret these passages as reflecting the gist of what was said, rather than the exact phrasing. In some cases, I've chosen this device simply to compress a long and complex exchange into its essence; in others, I've done so because the participants did not remember their exact wording, but did remember the overall content and character of what was said; in a few spots, I've done so because corroboration was impossible, and I've thus relied on a single source—more often than not, Tommy Arney. In the last case, I've noted in the text that a scene is "as Arney recalls it," or "as Arney tells it," or something similar.

PART I: DRIVES LIKE A DREAM

5 **This particular afternoon:** I witnessed the visit of Currituck County planners Ben Woody and Brad Schuler to Moyock Muscle on Friday, September 24, 2010.

12 **Tommy Arney and I:** My 1993 conversation with Arney is quoted in "The Abdominal Showman: How Tommy Arney Turned Booze and Belly Buttons into a Constitution Issue—and Won," (Norfolk) *Virginian-Pilot*, January 20, 1994.

15 **So it defied long odds:** I witnessed and photographed this scene on July 2, 2010.

17 **Tommy Arney knows the inventory:** I heard Arney mention the tinted windows at Moyock on June 25, 2012. I was with him when he discovered the Firebird thievery on September 8, 2011.

17 **And such is the power:** I was present for this scene on Monday, August 16, 2010.

18 **His head is filled with such trivia:** I conducted the inventory on August 26, 2011.

20 **The *V* indicates:** My description of the Chevy's assembly is based on phone interviews with former GM workers Bill Bethke, Leo Heid, Henry Marshall, Tom McDonnough, and Skip Shiflett in May 2012. The Baltimore plant's size and output is from "G.M. Impact on City Told," (Baltimore) *Sun*, November 24, 1954.

21 **At the plant's "body drop":** The approximate date of the Chevy's birth is based on Baltimore plant records; the wagon was the 6,235th car built there in July 1957, among a total of 14,450—meaning that it likely rolled out of the plant late in the month's second week.

21 **His mother's people:** Tommy Arney's family history is based on numerous interviews with Arney and a January 13, 2013, interview with his cousin Billie Ruth Bryant and her husband, Steve.

33 **Back to an earlier point:** My description of Colonial Chevrolet is based on photographs in the collection of the Norfolk Public Library's Sargeant Memorial Room, and on another loaned to me by former dealership head Josh Darden in 2004.

24 **The wagon had not been on display:** My descriptions of Nicholas Thornhill and his purchase is based on interviews with Bruce Thornhill Jr.; his mother, Ruby Thornhill; his aunt Polly Parker; and his sister, Janet, in November 2004.

26 **Folks in rural Alabama:** My passage on Durant's role was informed by Eugene H. Weiss, *Chrysler, Ford, Durant and Sloan: Founding Giants of the American Automotive Industry* (Jefferson, NC: McFarland, 2003); Axel Madsen, *The Deal Maker: How William C. Durant Made General Motors* (New York: John Wiley & Sons, 1999); Arthur Pound, *The Turning Wheel: The Story of General Motors Through Twenty-Five Years, 1908–1933* (Garden City, NY: Doubleday, Doran, 1934); Robert F. Freeland, *The Struggle for Control of the Modern Corporation: Organizational Change at General Motors, 1924–1970* (Cambridge, MA: Cambridge University Press, 2001); and John Chamberlain, "The Rise of Detroit," *Fortune,* March 1962.

26 **His replacement was a man:** My section on Sloan relied on Weiss, *Chrysler, Ford, Durant and Sloan*; Pound, *The Turning Wheel*; Freeland, *The Struggle for Control of the Modern Corporation*; Peter Marsh and Peter Collett, *Driving Passion* (Winchester, MA: Faber & Faber, 1986); Alfred D. Chandler Jr., ed., *Giant Enterprise: Ford, General Motors, and the Automobile Industry* (New York: Harcourt, Brace & World, 1964); David Gartman, "Harley Earl and the Art and Color Section: The Birth of Styling at General Motors," *Design Issues* 10, no. 2 (Summer 1994); and Michael Lamm, "The Beginning of Modern Auto Design," *Journal of Decorative and Propaganda Arts* 15 (Winter–Spring 1990).

28 **Fifty-three years later:** My tour of Arney's childhood took place on October 23, 2010.

32 Arney trudges in a minute later: I witnessed the scene with the college boys on August 16, 2010. When I discussed this scene with Arney more than a year later, he insisted that the car in question was priced at $4,500, rather than $4,000. That may be—I never checked the windshield—but my notes leave no doubt that in discussing the car with the lads, Arney listed its price at four grand.

37 Likewise, it's probably safe: Thornhill's biography is based on interviews with his family—particularly his daughter, Polly, whom I interviewed on November 4, 2004.

39 Across the water: Reports of "dogs and sailors" signs have persisted not only in Norfolk but in other navy towns—i.e., San Diego; Portsmouth, New Hampshire; and Jacksonville, Florida—and aren't restricted to the World War II years. To date, no legitimate example has turned up. See http://www.snopes.com/military/keepoff.asp.

41 Midwifed by the explosion: The Texaco ad appeared in *Collier's,* September 14, 1956; that for Pendleton, in the same magazine's November 9, 1956, edition; and the Gleem ad in *Life*, August 19, 1957.

41 No dummies, Chevrolet: The Chevy ad appeared in *BusinessWeek*, January 19, 1957.

43 See, for example: The "Road Race" episode is available in several parts on YouTube, the first at http://www.youtube.com/watch?v=479bv1iseKg.

44 Real life was messy: I located the *Star* story on microfilm in the reference library of the *Virginian-Pilot*.

44 At thirty-five: The Thornhill children's response to their mother's death was described to me by the oldest child, Polly.

44 Seventeen years after: Thornhill's marriage to Mary Drew Early, and their divorce, are described in court papers filed with the Portsmouth Circuit Court clerk's office.

45 If the Thornhills fell short: Tommy Arney supplied this account of Fred Arney's departure. His mother claimed to county officials that Fred Arney deserted her in a May 13, 1969, "Social Study" conducted by Edgecombe County officials, part of a dossier related to his childhood state custody that Arney obtained from North Carolina authorities in 2010.

45 The new man of the house: My descriptions of Strickland and Fern's injury are from ibid.

45 Against this backdrop: Arney provided the descriptions of his own misbehavior and the family's flight. The May 1969 Social Study suggests his older siblings may have chosen to stay in Norfolk.

46 Some of Tommy's antics: Arney described his hatred for Strickland in a May 12, 2011, interview.

46 The five moved into: My description of the home is from the May 1969 Social Study.

48 The school expelled him: The cloakroom incident is detailed in Principal Pitt's May 30, 1969, letter to Judge Tom H. Matthews, which was part of Arney's state dossier. She makes her plea in the same document.

49 **Witness a TV ad:** The spot can be viewed at https://www.youtube.com/watch?v=FES_ cg6Zv5M.

49 **The baby boom was on:** The station wagon's market share figures are from *BusinessWeek*, November 17, 1956. The *Popular Science* quotes here and in the next paragraph are from "The Big Boom in Detroit: 14 New Station Wagons," February 1957.

50 **The aim was to excite:** Don Hammonds, "Style-Substance: Harley Earl's Design Innovations Changed the Auto Industry," *Pittsburgh Post-Gazette*, October 16, 2008.

51 **His people knew to stay true:** Francis Bello, "How Strong Is GM Research?" *Fortune*, June 1956.

51 **He ascribed to a few more:** "Another Kind of Transport: The Car as Art," *Economist*, Dec. 23, 1995.

52 **And there was Earl's:** Harley J. Earl as told to Arthur W. Baum, "I Dream Automobiles," *Saturday Evening Post*, August 7, 1954.

52 **By the mid-fifties:** My account of Earl's personal style was informed by Gartman, "Harley Earl and the Art and Color Section"; William Diem, "GM's Harley Earl 'Invented' Auto Design," *Automotive News*, June 26, 1996; Michael Lamm, "The Earl of Detroit," *Invention & Technology*, Fall 1998; and Stephen Bayley, *Harley Earl and the Dream Machine* (New York: Knopf, 1983).
Incidentally, not all of the workers Earl fired came back. The styling departments of other automakers filled with refugees from GM. Gordon Buehrig, who won fame designing the uniquely elegant Cords of the thirties, worked for Earl beforehand, as did John Tjaarda, who designed Lincolns and Packards, and Frank Hershey, who crafted the '55 Ford Thunderbird. Virgil Exner, the chief of design at Chrysler in the fifties, became a worthy rival to his old boss. Richard Teague, another alum, headed Packard's styling and eventually became a top executive at American Motors.

53 **The strategy dovetailed:** The '57 Chevy owner's manual is reproduced at http://oldcarmanualproject.com/manuals/Chevy/1957/index.htm.

56 **In North Carolina, Edgecombe County officials:** The passages describing Arney's feelings about Strickland, and his family's about him, are based on numerous interviews with Arney and the May 1969 Social Study.

57 **At first, his behavior was angelic:** The December 15, 1969, Social Diagnosis is included in Arney's state dossier. Quotes in the following paragraph are from ibid.

58 **With that, doctors prescribed:** The psychiatrist's errant diagnosis and the "wrong and harsh" remark are from an August 1971 "Social Work Study" prepared by North Carolina officials and included in Arney's state dossier.

58 **In his first six months:** Ibid.

58 **Indeed, a November 1970 evaluation:** The handwritten assessment by a "Mr. Myers" is included in the dossier.

59 **"He worked quickly and carelessly":** The quotes here and in the succeeding paragraph

are from a psychological report prepared on February 9, 1971, and included in Arney's dossier.

59 **That August, a break came:** Arney's adjustment issues are described in a February 17, 1972, "Summary Dictation" prepared by Kennedy Home officials and included in his dossier.

60 **About a month in:** Arney described his flight and return to Norfolk in a March 18, 2010, interview. Official accounts in his dossier indicate he ran on September 26, 1971.

62 **Thirty-nine years after:** Arney shared his Sunoco and Coach House experiences in our October 23, 2010, tour of his old neighborhood.

62 **Eventually, the cops caught:** Fern Strickland's handwritten letter, dated October 21, 1971, is part of Arney's dossier. A May 10, 1972, memo prepared by a Kennedy Home social worker indicates that Arney "disappeared and was not located until Mr. Roger Williams, Superintendent of Kennedy Home, received a letter from Mrs. Fern Strickland. . . ."

63 **Brokering the arrangement:** My description of Arney's stint with O'Neil is based on my March 18, 2010, interview with Arney and an April 17, 2013, interview with Bill Taliaferro.

64 **When, outside a sub shop:** Arney interview of April 1, 2011.

65 **Another example:** Arney interview of October 23, 2010.

66 **Pity, even, the biker:** Arney told me the soup can story on September 8, 2011.

67 **He was breaking the law:** Arney interview of March 18, 2010.

70 **Sid Pollard was one of those kids:** My description of Sid Pollard's childhood and his purchase and restoration of the wagon is based on my interviews with him on October 20 and 27, 2004, and December 10, 2012.

70 **The '57 Chevy inherited some:** My passages on the development of the '55 Chevy's body and the grilles of subsequent model years were informed by Pat Chappell, *The Hot One: Chevrolet, 1955–1957* (Contoocook, NH: Dragonwyck, 1977); and Michael Lamm, *Chevrolet 1955: Creating the Original* (Stockton, CA: Lamm-Morada, 1991).

73 **By August 1954:** Earl and Baum, "I Dream Automobiles."

75 **Over at GM, meanwhile:** Ibid. On fins, see also Grady Gammage Jr. and Stephen L. Jones, "Orgasm in Chrome: The Rise and Fall of the Automobile Tailfin," *Journal of Popular Culture* 8, no. 1 (Summer 1974).

82 **Like Nicholas Thornhill:** Pollard interviews of October 20 and 27, 2004, and December 10, 2012.

83 **And because it's trusted:** I had my visit with the Nova on November 23, 2011.

85 **Seat belts were entirely absent:** Ford's safety campaign of 1956 is described in "When Wrecks Sell Cars," *BusinessWeek*, December 10, 1955; and in "The Truth About Auto Seat Belts," *Changing Times*, May 1957. GM's position is described by Francis Bello in

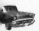

"How Strong is GM Research?", *Fortune*, June 1956. For contemporary study of seat belts, see Charles A. Chayne, "Automotive Design Contributions to Highway Safety," *Annals of the American Academy of Political and Social Science* 320 (November 1958), and for a still-impressive primer on safety failures of the cars of the day, see Ralph Nader, *Unsafe at Any Speed: The Designed-In Dangers of the American Automobile* (New York: Grossman, 1972).

86 **There's no better demonstration:** The IIHS video can be seen at http://www.youtube .com/watch?v=joMK1WZjP7g.

88 **Over in Norfolk:** Arney described his entry into the junk business in several interviews, beginning with that of March 18, 2010.

88 **He earned extra money:** Arney described meeting his future wife in a June 1, 2011, interview. Krista augmented that account in a June 6, 2013, conversation.

89 **Conduct yourself in such fashion:** Arney described his conduct in fights in several interviews, including those of March 18 and October 23, 2010, and May 12, 2011.

90 **He did not always leave the field:** Arney interviews of May 12 and September 16, 2011.

90 **On rare occasions he was defeated:** Ibid.

91 **He felt good for a little while:** Ibid.

PART II—GOING DOWN SLOW

95 **It looked like a winner:** The advertisement I mention, along with other Alliance come-ons, can be savored at http://www.productioncars.com/vintage-ads.php/Renault/ Alliance.

95 It **covered thirty-seven miles:** Ibid. The *Motor Trend* quote, from editor Tony Swan, was featured in Renault's advertising.

96 **Yet for all its attributes:** *Car and Driver* admitted its mistake in a January 2009 feature, "Dishonorable Mention: The 10 Most Embarrassing Award Winners in Automotive History," available at http://www.caranddriver.com/features/dishonorable-mention-the -10-most-embarrassing-award-winners-in-automotive-history. The story opens with the Alliance, which is saying something, seeing as how the list also includes the Vega and the 1974 Mustang II. "Here and now, in vivid HTML, *Car and Driver* formally apologizes for naming the Renault Alliance to the 1983 10Best Cars list," the piece opens. "For the past 26 years, it's been gnawing at our collective gut like a shame-induced ulcer. The car was trash. We should have known that back then, and it's taken us too long to confess our grievous mistake. Let this frank admission be the start of our penance."

97 **As for Frank DeSimone:** Interview with DeSimone of October 14, 2004.

98 **The Savages lived in Suffolk:** My description of Picot Savage's upbringing and his life with Debbie is from my interviews with Savage of September 24, 2004, and July 15, 2013.

99 Picot Savage had seen: Ibid.

101 The Savages were unaware: For more on the history of Chevy's small-block V8, see Chappell, *The Hot One*; Lamm, *Chevrolet 1955*; Gartman, "Harley Earl and the Art and Color Section"; J. P. Vettraino, "Block of Ages: Its Place in Automotive Lore Secure, the Chevy V8 Is Stronger than Ever," *Autoweek*, May 1, 1995; and "Horsepower Nation: Chevrolet's Small-Block V8 Celebrates Its 50th Birthday," *Autoweek*, June 20, 2005.

101 GM officials woke up: For more on Ed Cole and his development of the Chevy small-block V8, see From vintage-metal.blogspot.com/2009/02/1955-chevrolet.html.

104 Still hauling junk: Arney described his transition into car repair and sales in a March 31, 2010, interview.

105 He found time for more violence: Arney described the attack on Mike in a March 27, 2012, interview.

106 Was it nature or nurture: Arney described the potato chip incident in our interview of May 12, 2011. I tried to ask the uncle about it, but on hearing Arney's name he hung up on me twice on November 12, 2013, yelling both times: "He ain't no kin to me!"

107 That was, it turns out: My interview with Billie Ruth took place during my visit to Lenoir on Sunday, January 13, 2013. I followed it up with a second conversation, by phone, on November 12, 2013. For all of her storied misbehavior, aunt Ruby's criminal record in Caldwell County is short: The court clerk's office turned up only a June 1981 arrest for "Drunk & disruptive," and a July 1983 arrest for "Unsafe movement."

107 Roughhousing wasn't restricted: Arney described his first meeting with his father in our May 12, 2011, interview.

107 Given his kin's fondness: Arney told me of his rumble with the marines in a May 30, 2012, interview.

108 He came close to shooting a man: Arney interview of May 12, 2011.

108 In 1985, Arney again expanded: Arney interviews of March 31, 2010, and June 1, 2012.

109 Part of the attraction was obvious: Arney interview of June 1, 2011.

109 So there was that: Arney interview of April 27, 2010.

109 Arney renamed the place: John "Skinhead" McQuillen described meeting Arney in a September 28, 2011, interview. Arney's conversation with Mrs. McQuillen is from ibid. Arney described the meeting in our April 27, 2010, interview.

110 Often as not, the latter was the case: Arney interview of May 7, 2013.

111 He and Krista had been a couple: Ryan's recollection is from an August 31, 2010, interview.

111 Finally, things between Arney and Krista: Arney interview of April 27, 2010.

112 Skinhead was on hand: John McQuillen interview of September 28, 2011.

114 Arney relates such stories: Arney interview of May 12, 2011.

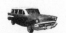

114 **Perhaps the most troubling facet:** Ryan recalled spinning on the street sign in our August 31, 2010, interview.

116 **Ricketts knew the Chevy was a dicey choice:** Interview with Mary Ricketts on September 24, 2004. Also, interviews with her sister, Sandy Wood, on April 30, 2012; Julie Hill on April 23, 2012; Carrie Ziegfeld on May 1, 2012; Mary Jo "Joey" Rothgery on May 7, 2012; Marianne Holmes Vest on May 16, 2012; Charmaine Clair on May 24, 2012; Lona McKinley on June 25, 2012; and undated notes from a telephone interview with former Ricketts coworker Kenny Rowe.

116 **A quick CV of the car's new owner:** Ricketts and Sandy Wood interviews.

117 **Church camp each summer:** Rothgery interview.

117 **New best friend:** Vest interview and numerous email exchanges in the weeks after.

117 **In 1967, Mary's father died:** Wood, Vest, Rothgery, and Clair interviews.

117 **In the spring of 1969:** Wood, Vest, and Clair interviews.

118 **That summer, Wic Clements:** Clair interview.

118 **Mary shared the impending birth:** Rothgery interview. The letter, which Rothgery shared with me, was dated Friday, November 7, 1969. The bit about the baby's name is from the Vest interview.

118 **As planned, she put Britton:** Clair interview; Facebook exchange with Martha Clements, January 13, 2013.

118 **Fast-forward to an evening:** Billy Ricketts shared his recollection of seeing Mary for the first time in a May 10, 2012, email.

119 **The band played:** Mary Ricketts interview; Billy Ricketts emails; telephone interview with Barry Scott, June 8, 2012.

119 **Impressions of the maturing Mary:** Wood, Vest, Clair, Hill, and Ziegfeld interviews.

119 **She answered an ad:** Notes from May 2012 telephone interview with Sandy Tickle, owner of the boutique; May 8, 2012, interview with Norman Goodwin, who operated a fine-fashion place next door. The photo is in the collection of Sandy Wood.

119 **Next door to the boutique:** Mary Ricketts and Wood interviews; Billy Ricketts emails.

119 **Still working at the Sunflower:** Wood and Ziegfeld interviews.

120 **The first time Mary Ricketts's friend:** Ziegfeld, Hill, and Rowe interviews.

120 **And who could be impetuous:** Billy Ricketts emails; Ziegfeld and Hill interviews.

121 **Ricketts rented a converted garage:** Ziegfeld and McKinley interviews.

121 **Ricketts adored it:** Mary Ricketts, Ziegfeld, and Hill interviews.

122 **Ricketts imagined the Chevy:** Ziegfeld interview.

122 **Decay wasn't the only force:** Mary Ricketts interview.

122 **Then, round about 1992:** Ibid.

123 Worse, her long relationship: Hill and McKinley interviews.

124 Unfortunately, there wasn't much: Mary Ricketts and Wood interviews.

124 One day in April 1994: Mary Ricketts interview; 2004 telephone interview with Joe Scalco.

124 Ricketts went over for a look: Mary Ricketts and Scalco interviews; 2004 interviews with Alan Wilson and Al Seely.

125 Tommy Arney was doing well: Arney interview of March 31, 2010.

125 He was surrounded by more: Ibid., and Klemstine interview.

125 The money rolled in: Arney's discovery of the lump, along with his subsequent doctor visits, operation, and the 7-Eleven incident, are drawn from the Arney interview of March 31, 2010.

128 The biopsy came back: The passage on Arney's chemo treatment is ibid.

129 It was down on that tile: Arney interview of May 12, 2011.

130 The answer, as demonstrated: Arney described the pool table fracas in a March 6, 2013, interview; I also found references to the charges he faced after the fight in a May 2, 2005, Norfolk police record check, prepared as part of Arney's application for his record expungement. Skinhead described the flip-flop episode in our September 29, 2011, interview.

130 Meanwhile, Arney came to feel: Arney interview of March 31, 2010.

130 In court on September 14: Arney related this story in a March 6, 2013, telephone interview.

131 One Saturday morning Arney telephones: I witnessed this scene on March 12, 2011.

136 And another development: Arney described his radiation treatment in our March 31, 2010, interview.

137 Sure enough, the cancer was gone: Arney interview of April 27, 2010.

137 He took time to reflect: Arney's self-diagnosis is from our interview of April 27, 2010.

137 The evolution was bumpy: Klemstine and Hammond interviews.

138 More such evidence: Hammond interviews of May 11 and 31, 2012; Arney interview of May 31, 2012.

139 Four months past that Christmas: Interviews with Al Seely on November 4, 2004, and Alan Wilson on November 5, 2004.

140 That Wilson and Seely were so charmed: *BusinessWeek*'s forecast is from "What to Do Until Turbine Comes," in its October 22, 1955, issue. Also worthwhile is "What Car Designers Are Planning," in the magazine's January 21, 1956, edition.

140 GM executive John DeLorean: J. Patrick Wright, *On a Clear Day You Can See General Motors* (Grosse Point, MI: Wright Enterprises, 1979).

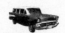

143 **Change was coming:** For more on the Toyopet's anemic beginnings in America, see Jerry Garrett, "Fifty, Finned and Fabulous," *New York Times*, May 20, 2007; and Paul Ingrassia and Joseph B. White, *Comeback: The Fall and Rise of the American Automobile Industry* (New York: Simon & Schuster, 1995).

144 **A few years before:** Paul Ingrassia, *Engines of Change: A History of the American Dream in Fifteen Cars* (New York: Simon & Schuster, 2005). See also John F. Katz, "1957 VW Beetle Cabriolet: Twice a Savior," *Autoweek*, September 30, 1996.

144 **But the fattening American auto:** Ingrassia, *Engines of Change*. See also "A Place for Small Foreign Cars," *BusinessWeek*, January 26, 1957.

145 **In most respects, the new owners:** Wilson and Seely interviews.

150 **Overworked and broke:** Wilson interview.

152 **Jack's Classic occupied:** I interviewed Jack Reed at his plumbing supply store on December 18, 2004.

152 **The Chevy's ninth owner had joined:** I interviewed Jeff Simmons at his home in North Carolina in December 2004.

155 **Here begins some very strange business:** I interviewed Dave Simon in October 2004 and March 2011.

156 **Such a fixation:** James MacPherson, "In Midwest, a Model Farm Where Failed Fords Grow," *Los Angeles Times*, November 13, 2005.

158 **Chris Simon was undaunted:** I interviewed Chris Simon on October 30, 2004.

160 **He was an attentive parent:** Ashlee Arney described her father's parenting style in a June 6, 2013, interview. Ryan's friction with his father is from our interviews of August 31 and September 8, 2010.

161 **As he rebuilt his financial affairs:** McQuillen interview of September 29, 2011; Arney interview of September 16, 2011.

162 **Unfortunately, the church's owner:** Arney related the classroom tale in an April 27, 2010, interview. Ashlee Arney said in June 2013 that she did not recall the incident; and ABC documents supplied by the agency via email in November 2013.

162 **He tried to keep the Body Shop:** Taliaferro interview of April 17, 2013; phone interview with Victoria Hammond on October 24, 2013.

164 **Arney's actual numbers:** I drew Arney's crime stats from a July 14, 2005, packet of documents related to Arney's successful application to expunge his record, and a November 2012 presentence report prepared by Senior U.S. Probation Officer Jeffrey A. Noll as part of the government's prosecution in the Bank of the Commonwealth affair.

166 **That's as far as consensus goes:** Arney discussed the police dog incident with me on several occasions, including our interviews of March 31, 2010, and March 5, 2013.

166 **Taliaferro verifies the story:** Taliaferro interview of April 17, 2013.

167 **Arney whipped up his hands:** Arney described his courtroom comment—which he

says occurred before Norfolk Circuit Court judge Lydia Taylor—in our March 5, 2013, interview.

167 **Taliaferro seconds many aspects:** Taliaferro interview of April 17, 2013.

167 **He did "seem to remember":** I interviewed Peter G. Decker Jr. at his Norfolk office on November 17, 2011.

168 **The cops I spoke with:** Betty Whittington made her contribution through retired police lieutenant Harry Twiford, in a February 1, 2013, email. I interviewed Carmen Morganti by phone a few days later.

170 **The work begins in earnest:** I witnessed the project's beginnings on March 5, 2011.

173 **It was seven winters before:** Dave Marcincuk described his first encounter with the Chevy in September 13, October 5, and October 25, 2004, interviews.

177 **First thing, Marcincuk decided:** Ibid.

181 **Then again, if he believed:** Arney's comment is from a July 1, 2010, interview.

182 **Speaking of Ryan:** Ryan Arney described his wayward period in a September 23, 2010, interview.

183 **Arney owned the house:** The quote about the horses is from my May 18, 2012, visit to Moyock.

184 **By necessity, Arney was stingy:** McQuillen interview of September 29, 2011; Arney interview of July 1, 2010. See also Walt Potter, "Man, 21, Shot, Then Tossed from Bridge," *Virginian-Pilot*, November 19, 1977, which was accompanied by the photo of Skinhead on the sidewalk; "Crime Taking No Holiday in Norfolk This Weekend," (Norfolk) *Ledger-Star*, November 19, 1977; "4 Men Shot, Robbed Him, Victim Says," *Virginian-Pilot*, November 20, 1977; Bill Burke, "Shooting Suspect Surrenders," *Ledger-Star*, November 22, 1977; "2nd Norfolk Man Charged in Abduction and Shooting, *Virginian-Pilot*, November 30, 1977; "1 Defendant Pleads Guilty to 4 Charges in Shooting," *Virginian-Pilot*, May 18, 1978; Mike Hardy, "Man, 21, Gets 51 Years in Abduction, Shooting," *Virginian-Pilot*, July 15, 1978; and Clifford Hubbard, "Plea Bargain Draws 10 Years," *Virginian-Pilot*, July 18, 1978.

187 **Bootleggers, he called it:** Arney's quote is from our interview of September 8, 2010.

189 **Last candidate: a 1970 Olds:** My first visit with Dave Marcincuk took place on September 13, 2004. My notes from that visit include this passage: "On M's front door, taped over the oval glass, pages from a Sept 15 1966 newspaper. Ad for Ajax laundry detergent shows line drawing of couple waving from a 67 Pontiac Bonneville convertible full of cash. 'Name the White Knight' contest. Veal Sale! Cutlets $1.09 lb. Shoulder roast 39¢ lb. Veal loin chop 99¢ lb. Scott toilet tissue 4 rolls 45¢ Bread 23¢ a loaf."

190 **I drove him to Big Al's Mufflers:** The car is described in great detail in my notes of September 13, 2004, and augmented by my October 5, 2004, interview with Marcincuk.

193 **It takes faith to buy an old rust bucket:** Much of the section that follows was informed by my October 25, 2004, interview with Marcincuk.

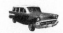

195 Frank DeSimone had been busted: Shirley Bolinaga, "Man Pleads Guilty to 5 Counts of Selling Cocaine," *Virginian-Pilot*, December 14, 1989; James L. Pate, "The 'War' on Drugs Just Costly Words," *Portsmouth Currents*, September 9, 1990; Picot Savage interviews of September 24, 2004, and July 15, 2013.

195 Mary Ricketts was still working: Mary Ricketts, Wood, and Hill interviews.

198 Marcincuk had sold Dowdy: Bobby Dowdy interview of May 13, 2010, and Dave Marcincuk interview of July 19, 2013.

199 He'd built his sales pitch: Arney provided this account.

199 Route 168 narrowed: My visit to Moyock occurred on January 29, 2010.

PART III—OUT WITH THE OLD

205 The spring of 2010, a few months: I was present in Norfolk Circuit Court on February 18, 2010, when Arney lost his case against ODU. Afterward, as we stood in the hall, Arney delivered an angry soliloquy. "Lawyers like that, they should be executed," he said. "I told [one of the opposition's lawyers] that—I said it right in that courtroom, in front of the bailiff.

"I can't stand that behind-your-back sneakiness, because I'm a man. If I don't like you, I'll walk right up to you and tell you, and if you don't like it—well, in my younger days, I'd punch you. Now that I'm older, I've come to see there are better ways, *maybe*, to do things." Emphasis his.

206 At roughly the same time: My description of Arney's appearance before the Planning Commission is from a city transcript of the panel's April 8, 2010, meeting, which I obtained through the Freedom of Information Act.

207 The Planning Commission disagreed: Harry Minium, "Western Bar Sign No Longer a Bootleg . . . It's Legit," *Virginian-Pilot*, July 26, 2010.

207 Another man might have been: Arney interview of February 10, 2011.

208 Arney's appearance before: I witnessed Arney's City Council appearance on October 26, 2010. See also Harry Minium, "Owner Takes Verbal Shots at City's Bar Task Force," *Virginian-Pilot*, October 28, 2010.

209 Arney might have been able: The Bank of the Commonwealth's faltering health, and the role that loans to Arney contributed to it, are detailed in the government's "Statement of Facts" accompanying his indictment and in his plea agreement of August 24, 2013. See also the coverage of the bank's failure by the *Virginian-Pilot*'s Tom Shean, including these stories: "As Losses Mount, Commonwealth Bankshares' Future in Doubt," April 2, 2011; "Feds Investigate Bank, Officials," April 16, 2011; "Inquiry Hurts Bank's Effort to Raise Cash," April 19, 2011; "Community Banks Feel Pressure to Raise Capital," April 24, 2011; "Commonwealth, Amid Asset Troubles, Postpones Meeting," May 24, 2011; "Fed Gives Bank of Commonwealth 30 Days to Bolster Finances, or Sell," July 8,

2011; "Commonwealth Bankshares Posts $26.22M Quarterly Loss," August 16, 2011; "Commonwealth Bankshares' Stock Price Slides 45 Percent," August 17, 2011; "Va. Seizes Bank," September 24, 2011; and "Failed Local Bank's New Owner Fields Queries on the Future," September 27, 2011.

210 Through Fields he'd come: The quote about Woodard is from my interview with Arney of April 1, 2011.

211 In the midst of his sharpening panic: Arney interview of July 1, 2010.

211 Arney appealed the decision: My description of the Board of Adjustment's July 8, 2010, meeting is based on the minutes. See also Cindy Beamon, "Currituck, Classic Car Dealer Clash over Rules," (Elizabeth City, NC) *Daily Advance*, July 12, 2010.

213 But with a lot of effort: I witnessed this scene on or about March 14, 2011.

215 The blasting commences: I was present during this scene on March 25, 2011.

217 He and Bobby Tippit roll: My account of the floor pan's installation is drawn from notes of my Moyock visit of July 6, 2011.

220 If you were so inclined: My discussion of the issues associated with restoration was informed by Stephan Wilkinson and Philip Herrera, "Restoration Drama," *Town & Country*, June 1999; Richard S. Chang, "The Motivation Is Perfection," *New York Times*, February 7, 2010; Joseph Siano, "Is It Real or a Replica? The Factory Knows All," *New York Times*, October 30, 2008; Donald Osborne, "The Art of the Restoration," *New York Times*, August 17, 2008; "Clones, Tributes, Reproductions, Recreations, Fakes," *Collector Car & Truck Market Guide*, September 2000; and Marjorie Keyishian, "Cars of Yesterday Purr like New," *New York Times*, March 24, 1991.

221 Answering such questions: Telephone interview with Patrick Krook, president and CEO of Show Your Auto Inc., of Grayslake, Illinois, on February 22, 2013.

221 The second reason: Telephone interview with Richard Todd on February 23, 2013.

222 This was demonstrated: The Hemi 'Cuda saga was related, more or less, in Paul Sontrop, "Rags to Riches," *Mopar Action*, October 2011; and by Krook in our interview of February 22, 2013.

224 Outside the automotive world: For more on Fallingwater's salvation, see Patricia Lowry, "Restoration of Drooping Fallingwater Uncovers Flaws Amid Genius," *Pittsburgh Post-Gazette*, December 8, 2001. To the list of examples I offer, I can add one more, which was hard to miss while I wrote this book at the University of Virginia: Thomas Jefferson's Academical Village at UVa is part of a UNESCO World Heritage Site, yet its centerpiece—the Rotunda, Jefferson's domed tribute to the Roman Pantheon—burned to the ground in 1895, and was rebuilt with an interior that veered substantially from the original. The changes were later undone, and Jefferson's original vision reproduced—so that what we have now is a modern rehabilitation of a century-old reconstruction of a Jeffersonian reimagining.

225 As debates associated with restoration: My discussion in this and the following paragraph relies on Edward Ford, "The Theory and Practice of Impermanence,"

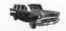

Harvard Design Magazine 3 (Fall 1997); and Howard Mansfield, *The Same Ax, Twice: Restoration and Renewal in a Throwaway Age* (Lebanon, NH: University Press of New England, 2001).

226 But what of that Hemi 'Cuda: Krook interview.

227 A few days after the donor car's: I witnessed this work on July 21, 2011.

229 The next day, having triumphed: I witnessed this work on July 22, 2011.

231 On a Sunday late in the month: I witnessed the several scenes that unfolded during the July 24, 2011, trip to Gloucester.

235 Over the next few days, Skinhead: The '56 two-door wagon that gives up its tailgate is VIN B56T194191, a 210 six-cylinder built in Tarrytown, New York.

236 Late one breezeless and stifling summer night: This scene took place in Norfolk on June 1, 2011.

236 His relationship with the bank: Interview with Tommy Arney of May 31, 2011.

237 For the time being: I witnessed this scene on August 13, 2011.

239 Tippit has spent two hours: I witnessed this scene on August 14, 2011.

239 Over the next few days, Paul: I witnessed this work on August 17 and 26, 2011.

240 Late in August 2011: My account of post-storm Moyock Muscle is based on my visit of August 29, 2011.

240 But that changes: Chapman visited on September 8, 2011.

241 Ordered back to the wagon: I witnessed Paul's mudding and sanding on my visits to Moyock of September 8, 16, and 21, 2011.

242 For the next ten days: The story I mention is "Car Dealer Faces $78K in Fines," *Daily Advance*, September 13, 2011.

243 Over lunch, Arney assures me: I witnessed this exchange on September 16, 2011.

245 Painter Paul begins the process: I was present for this scene on October 28, 2011.

247 I find myself lying awake: The progress I note is drawn from notes of my visit to Moyock of October 31, 2011.

249 Grinding without goggles: Notes from my visit to Moyock of November 4, 2011.

250 Actually, I learn in speaking: Arney interview of November 9, 2011.

250 Besides, the original chassis: November 4, 2011 notes.

250 Arney is even more enthused: Ibid.

251 With the body coming along: Notes from my Moyock visit of October 31, 2011.

251 We suspend further discussion: November 4, 2011, notes.

253 Halfway through the second week: Notes from my Moyock visit of November 9, 2011.

254 **Arney had to get busy:** I was present during Arney's meeting with Ben Woody on October 27, 2011.

255 **Currituck County surprises him:** I attended the Technical Review Committee meeting at the county courthouse on December 21, 2011.

256 **At the rear of the property:** Notes from my Moyock visit of November 10, 2011.

256 **"It'll be a long, long time":** I witnessed this scene on November 9, 2011.

257 **In mid-November 2011:** Notes from my Moyock visit of November 17, 2011.

258 **He has a propane heater:** Ibid., and notes from my visit of November 22, 2011.

258 **So he cuts away a rusted flange:** Notes from my Moyock visit of November 23, 2011.

259 **On a late November Saturday:** Notes from my Moyock visit of November 28, 2011.

260 **The Dodge is still there:** Kitchens interview of December 5, 2011.

260 **That evening, I find Arney:** I witnessed this scene on November 28, 2011.

261 **But the next morning:** Kitchens told me he'd been fired on Friday, December 16, 2011. I brought up the firing with Arney several times over the next month, expressing my own view that Painter Paul was a dedicated worker.

PART IV—PEDAL TO THE METAL

265 **So Arney has his surveyor:** I attended the meeting between Arney and Woody on January 10, 2012.

266 **The next day, Arney:** Notes from my Moyock visit of June 26, 2012, during which I examined copies of Woody's emails.

266 **Comes now the day:** I was present during Arney's meeting with Woody on January 12, 2012, and the Board of Adjustment meeting that night.

267 **In early February:** Arney interview of February 8, 2012.

267 **Once again, he finds his time:** Arney began work on the building in January 2012. A city fire marshal, suspecting that work had been performed on the premises without a permit, informed Arney on February 16 that he'd have to submit to an inspection of the building's interior. Arney went "berserk," Deputy City Attorney Cynthia Hall told me in an August 26, 2013, interview, and in angry exchanges with city officials revealed to them that he was renting to the Hells Angels. The city responded by informing Arney that the building was zoned for retail, not as a "place of assembly." He'd thus have to declare the intended use of the property before any permits would be issued. Arney responded with a March 6 affidavit, which he signed with the local Hells Angel leader, attesting that the "downstairs space will be used for internet/online retail sales of clothing and accessories." That failed to convince City Hall—and the same went for a floor plan of the space on which a massive bar was labeled an "employee lunch counter."

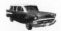

The building was placarded by the city on March 14, "due to current condition deemed a hazard to firefighters and occupants." Hall took command of the city's dealings with Arney the next day.

269 Which might be reasonable advice: Hall letter to Bill Taliaferro of March 22, 2012. Hall supplied me with a copy in August 2013.

270 A few days later his lawyers: I heard Arney's end of the phone conversation during my Moyock visit of March 26, 2012.

270 The upshot is that days pass: The day's events are recorded in my notes of March 26, 2012.

273 They select the first car: Notes from my visit to Moyock of March 27, 2012.

274 Skinhead uses a reciprocating saw: Notes from my Moyock visit of March 28, 2012.

276 Confirmation comes in another: Notes from my Moyock visit of March 29, 2012.

277 The Turbo 350, as motorheads call it: Ibid., and notes from my Moyock visit of June 9, 2012.

277 They roll the donor car's: Notes from my Moyock visit of March 30, 2012.

278 One: Arney orders the parts: Notes from my Moyock visit of May 30, 2012.

278 Two: Whatever Paul did or didn't do: I witnessed the El Camino owner's fretting in Moyock on June 1, 2012.

278 Three: Money, already tight: I witnessed this conversation on May 30, 2012.

279 Arney isn't inclined: I witnessed this exchange on May 18, 2012.

280 In late May, however: Arney interview of June 12, 2012.

280 Not long after, Skinhead finds: Skinhead was served on May 18, 2012. The following passage is from my interview with him of June 25, 2012.

281 We now return to the wagon: Notes from my visit to Moyock of June 1, 2012.

283 True to his word: This section is based on notes from my Moyock visit of June 9, 2012.

283 Early one morning: Arney, McQuillen, and Paul Kitchens interviews of June 25, 2012. Arney shared a copy of O'Boyle's letter, which was written on behalf of U.S. Attorney Neil H. MacBride and dated June 13.

284 Arney has no interest: Arney interview of June 25, 2012.

285 He'll do nothing to help: Ibid.

285 Ibid.

285 He will offer variations: Ibid.

286 Now dust devils whirl: Ibid.

286 The morning after this conversation: Interview with John McQuillen of June 26, 2012.

288 Then, early on Thursday: Interview with John McQuillen of July 13, 2012.

288 **Arney's part in the scheme:** Indictment and "Statement of Facts" filed with Arney's plea agreement on August 24, 2012. See also Tim McGlone, "Six More Charged with Bank Fraud," *Virginian-Pilot*, July 13, 2012; and McGlone, "Ed Woodard Jr.: The Man Behind the Bank," *Virginian-Pilot*, July 15, 2012.

289 **While the lawmen host:** McQuillen interview of July 13, 2012.

290 **That afternoon, Arney:** I was present during the court proceedings of July 12, 2012.

290 **Arney leaves the courthouse:** My interview with Tommy Arney of August 4, 2012.

290 **And truly, the day is not:** Arney interview of July 13, 2012.

291 **Though it hasn't been easy:** Notes from my visit to Moyock of July 16, 2013.

291 **Arney reports as he eats:** The following passage is drawn from notes from my visit to Moyock of July 17, 2013.

293 **In court the next morning:** I witnessed both the courtroom drama and Brad Schuler's visit to Moyock of July 18, 2012. See also Tim McGlone, "Ex-President, Five Others Plead Not Guilty in Bank-Fraud Case," *Virginian-Pilot*, July 19, 2012.

294 **Most of Arney's waking hours:** Notes from my visits to Moyock of July 25 and 26, 2012.

295 **And as if his finances:** Notes from my visit to Moyock of August 6, 2012.

295 **He can't afford not:** Arney interview of August 4, 2012.

296 **Over the same period:** Arney interview of August 4, 2012.

296 **He also seems to develop:** Notes from my visit to Moyock of August 15, 2012.

296 **By late August:** Ibid.

297 **One more thing:** Ibid.

299 **On Friday, August 25:** I was present in court for the session. Arney provided an account of how and why he decided to plead in several interviews.

300 **His fate is now assured:** Arney told me of his color selection in a September 26, 2012, phone interview.

300 **I see it myself a few days later:** I witnessed the events of September 29, 2012, in Moyock.

301 **That Arney's rage:** Interview with Arney on February 2, 2013.

304 **The properties he stubbornly:** The quote is from a phone interview with Arney on March 6, 2013.

305 **He orders parts for the Chevy:** I witnessed the events of February 9, 2013, in Moyock.

308 **If there's a happy sidebar:** I witnessed this exchange on February 2, 2013.

310 **So things seem back:** I received the text on March 9, 2013.

310 **Slick's party proves:** Notes from the birthday party of March 12, 2013, at Havana.

311 **We'll not get bogged down:** I was present in the courtroom for Arney's testimony on March 26, 2013.

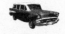

312 **Later, in a long, late-night:** The phone conversation occurred on May 7, 2013.

313 **I certainly wondered:** Krista showed me into Arney's home office on February 10, 2013.

316 **Arney and Skinhead arrive:** I witnessed the events of May 11, 2013.

320 **An hour before dawn:** I witnessed the events of June 28, 2013.

324 **Arney has told me:** The quote is from my interview with Arney of May 7, 2013.

325 **His arrival at Norfolk's:** I witnessed Arney's sentencing on July 22, 2013.

326 **Martin notes that the court:** Arney supplied me with Ryan's letter, from which I quoted more than Martin did.

328 **"There, on the truck":** The reunion took place on Saturday, July 27, 2013. The telephone conversation I mention occurred on July 18, 2013.

330 **I stroll among the guests:** Interview with Alan Wilson in June 2013.

330 **I also knew not to expect:** Interview with Mary Ricketts, February 14, 2005.

331 **Most recently, I called her:** Wood and Hill interviews. Ricketts died May 22, 2011. Her obituary appeared in the *Virginian-Pilot* on June 8, 2011. The memorial I describe took place three days later.

331 **I notice Dave Marcincuk:** The quote is from my interview with Marcincuk of July 19, 2013.

333 **Bill Taliaferro called him:** Arney interview of July 23, 2013.

333 **I've often seen the wagon's:** Telephone interview with Al Godsey on July 29, 2013.